ALLURING MONSTERS

FILM AND CULTURE

FILM AND CULTURE

A series of Columbia University Press

Edited by John Belton

For a complete list of titles, see page 291.

ALLURING MONSTERS

THE PONTIANAK AND CINEMAS OF DECOLONIZATION

ROSALIND GALT

Columbia University Press

New York

Columbia University Press
Publishers Since 1893
New York Chichester, West Sussex
cup.columbia.edu

Copyright © 2021 Columbia University Press
All rights reserved

Library of Congress Cataloging-in-Publication Data
Names: Galt, Rosalind, author.
Title: Alluring monsters : the pontianak and cinemas of decolonization / Rosalind Galt.
Description: New York : Columbia University Press, 2021. | Includes bibliographical references and index.
Identifiers: LCCN 2021004547 | ISBN 9780231201322 (hardback) | ISBN 9780231201339 (trade paperback) | ISBN 9780231554046 (ebook)
Subjects: LCSH: Ghosts in motion pictures. | Ghosts in popular culture—Social aspects—Malaysia. | Ghosts in popular culture—Social aspects—Singapore. | Decolonization—Social aspects—Malaysia. | Decolonization—Social aspects—Singapore.
Classification: LCC PN1995.9.S8 G35 2021 | DDC 791.43/675—dc23
LC record available at https://lccn.loc.gov/2021004547

Cover image: *Lagi Senang Jaga Sekandang Lembu* (Eu, 2017) and the opening sequence of the "Cinema" section of *7 Letters* (Khoo, 2015).
Cover design: Chang Jae Lee

For Adrian and Peter

CONTENTS

Acknowledgments ix

Note on Malay Language xiii

Introduction: On the Trail of the Pontianak 1

1. Popular Horror and the Anticolonial Imaginary 39

2. Troubling Gender with the Pontianak 79

3. Race, Religion, and Malay Identities 119

4. Who Owns the *Kampung*? Heritage, History, and Postcolonial Space 159

5. Animism as Form: A Pontianak Theory of the Forest 197

Notes 237

Bibliography 263

Index 277

ACKNOWLEDGMENTS

This project began in Singapore, when I visited an exhibition on the Golden Age of Malay Cinema at the National Museum, one room of which was dedicated to popular horror film. It's hard to describe just how the pontianak hooked me with her long fingernails, but I feel sure it had much to do with the way people in Singapore welcomed me, fed me, and enthusiastically talked about their ghosts. So many people generously shared ideas, leads, and connections: Meileen Choo, Kathleen Ditzig, Oi Leng Lui, Nelson Mok, Warren Sin, Tan Pin Pin, and Stephen Teo were all important to the project's development. Nurul Huda Rashid offered insights from her own research. Anuradha Ramanujan's friendship and kindness touched me deeply. Karen Chan, Janice Chen, and Chew Tee Pao at the Asian Film Archive were a wonderful resource, and very kindly put up with me mooching around their office for weeks watching films. Chrystal Ng and all at the Wee Kim Wee School of Communication and Information at Nanyang Technological University were welcoming hosts. Sangjoon Lee has been especially kind, and his student Calvin Leong Zhen Cong helped me source some films. Another NTU student was kind enough to bring me a book of Singaporean ghost stories that he had owned since childhood. I was impressed by his thoughtfulness and his passion for local ghost media and I wish I knew his name to thank him more personally. Special thanks go to Wong Han Min, for his generosity and knowledge of Singapore history. This book would not take the form it does if not for his help. Above all, I thank Gerald Sim, Marjorie Sim, Lily Boon, and Raymond and Anna Chan for their boundless hospitality and for teaching me how to eat.

Researching in Malaysia, people were also eager to talk pontianaks with me. In Kuala Lumpur, many people helped me with contemporary filmmaking and

learning Bahasa Melayu. Gaik Cheng Khoo generously shared conversations on Malaysian cinema and fed me the best pineapple pachadi. Everyone in the Institute of the Malay World and Civilization at Universiti Kebangsaan Malaysia was warmly welcoming, especially Junaini Kasdan. Cikgu Maulana Al-Fin generously invited me to his *kampung* for a memorable Hari Raya Aidiladha with his family. I didn't know that one could eat four full meals before noon, but now I do. Thanks also go to Cikgu Nisa Saidin, and to Jo Ann Wang, Sae Sugawara, and the other students in the language program.

I was lucky enough to talk to several filmmakers who generously shared their work and/or agreed to be interviewed: Amanda Nell Eu, Glen Goei, Bee Thiam Tan, Nosa Normanda, and Nanang Istiabudi. Thanks also to the artists and writers who talked to me about monsters, feminism, and the cultures of Singapore and the Malay world: Tania De Rozario, Zarina Muhammad, and Suzana binte Selamat. Suzana also assisted with translations, as did Maulana Al-fin, Therese Quiban and Sidney Chan. Yee I-Lann graciously permitted me to use an image of her artwork, for which thanks also go to the Silverlens Gallery in Manila. I promised to credit Sandi Tan as Chief Pontianakologist, and I might never have been so seduced by the pontianak if not for her beautiful writing.

I'm tremendously grateful to have been the recipient of a Leverhulme Fellowship, which supported my final period of research and writing. I was also privileged to spend several months as a visiting scholar, Lee Kong Chian NUS-Stanford Fellow on Contemporary Southeast Asia at the National University of Singapore, and at Stanford University. Kristen Lee and Lisa Lee at Stanford and Khin San Nwe at NUS provided outstanding support through the many complex processes of spending time at each institution. At NUS, it was wonderful to meet colleagues and students in the Department of Cinema and New Media and to take part in their Queer Studies Reading Group. Thanks especially to Audrey Yue, Michelle Ho, and Patrick Tay Zi Dong. At Stanford, heartfelt thanks are due to Don Emmerson, Gi-Wook Shin, and all at the Walter H. Shorenstein Asia Pacific Research Center. Earlier stages of the project were supported by a King's College London Arts and Humanities Faculty Seed Fund Grant as well as two Faculty Small Grants, which enabled me to take on language study and funded archival trips to Southeast Asia. I've worked on this book in many wonderful libraries, all of whose reference staff deserve appreciation: the British Library, the National Library of Singapore, Perpustakaan Negara Malaysia, as well as libraries at the University of London, NUS, NTU, UKM, the University of California, Santa Cruz, and Stanford.

Many colleagues at King's offered advice, provided institutional support, and helped form a truly nurturing place to do scholarly work: Chris Berry,

Tom Brown, Erica Carter, Jinhee Choi, Sarah Cooper, Victor Fan, Russell Goulbourne, Wing-Fai Leung, Paul McDonald, Ben Nichols, Paul Readman, Jeff Scheible, Mark Shiel, Iain Robert Smith, Jaap Verheul, Belén Vidal, and Ginette Vincendeau. Catherine Wheatley, Lawrence Napper, Michele Pierson, Mark Betz, Erika Balsom, and Elena Gorfinkel listened to me angst about the project and offered much-needed support and cocktails along the way. Rob Templing deserves special recognition for saving my bacon on many, many occasions. My doctoral students Theresa Heath, Robert Mills, and Jacob Engelberg have been wonderful fellow travelers in the endeavor of research and writing, as well as taking me for Queer Beers. Colleagues across the Singapore Cinema and Heritage Research Network staged productive conversations about Singapore history and research futures. At SOAS, I greatly appreciated my excellent Indonesian teacher, Fenny Amalo.

So many people helped me turn my strange fascination with the pontianak into a book, and I appreciate the intellectual engagement and affirmation of colleagues across film, media, and Southeast Asian studies. The very first audience to hear me talk about this project were the participants in the UC Santa Barbara Global-Popular symposium in November 2016. It was a weird, heavy moment for a conference and yet everyone there inspired me with their commitment to theorizing popular culture. I learned a lot from my copanelists at ASAP 2017, Iggy Cortez, Rosalind Diaz, Lauren McLeod Cramer, and Danielle Morgan, and from my 2018 SCMS panel of Bliss Cua Lim, Adam Knee, and Sangita Gopal. There is so much brilliant work being done on the politics of global horror, and making some of those connections was sustaining for me. I'm so grateful to Andrew Moor and Kate Ince for inviting me to keynote the 2019 BAFTSS conference, and to the great audience there. Likewise, my research benefited from invitations from Lydia Papadimitriou at the Liverpool Film Seminar, from Lucy Bollington at the Institute for Advanced Studies at UCL, and from Lucy Bolton's great questions and buoying enthusiasm for the project. Malay cinema is multilingual and I'm grateful to colleagues who have generously drawn my attention to Chineselanguage points that I could not understand. Rey Chow provided a crucial insight at an early stage, and Ruby Cheung offered some very helpful Cantonese analysis. I've been learning about horror from Adam Lowenstein for a long time, and he gave me incredibly generous feedback on the manuscript. Thanks go also to the anonymous reader and to all at Columbia University Press. My editor Philip Leventhal has always supported my work, and I am grateful also to Chang Jae Lee for the book's beautiful cover design, to manuscript editor Robert Demke, production editor Susan Pensak, and everyone else who contributed to these pages. Thanks also to my indexer, Cynthia Savage.

Beyond the official work of conferences and symposia, I've been helped all along the way by networks of brilliant and kind people. Bhaskar Sarkar, Rey Chow, Eng-Beng Lim, and Audrey Yue helped the project in crucial ways. Tim Bergfelder, Cüneyt Çakırlar, Roger Clarke, Bishnupriya Ghosh, Priyamvada Gopal, Nitin Govil, Catherine Grant, Hannah Hamad, Chris Holmlund, Bonnie Honig, Lilya Kaganovsky, Toni Meštrović, Mariam Massood, Nadija Mustapić, Gary Needham, Lloyd Pratt, Rob Rushing, Tracey Sinclair, Simon Su, and Annette-Carina van der Zaag have been amazing interlocutors and dear friends. Online support has come from KPTI, whose members remind me of my true priorities. In San Francisco, Jean Ma and Heather Hendershot kept me well fed. Reconnecting with Kirsten Whissel and her family was such a pleasure, as was going to movies with Mary Ann Doane, drinking cocktails with Damon Young, and shopping with Michael Allan. Closer to home, Karl Schoonover read chapter drafts with brilliant critical acuity, but more than his intellectual generosity, his cherished friendship has always sustained me in too many ways to list. My dearest friends in Glasgow have made a difficult year a lot better. Douglas Martin and James Hogan have been wonderful, and Phyl Wright is absolutely the kindest person I know.

Completing this book in the midst of a pandemic, I'm keenly aware of the importance of those loved ones far and near who shape our worlds. The research and writing of this book have proceeded alongside the flourishing of what I adapt from *Sense8* in calling my cluster. The Wachowskis' queer television series imagines a world connected by multiple and transnational bonds of love, affection, friendship, and care. That is what I am lucky enough to have—although sadly without the distance-erasing teleportation abilities. Thanks to Amy Bomse for her trust and friendship. I'm always learning from Peter Limbrick, and his love and faith in me never fail to astonish. Adrian Goycoolea has been there for everything I've written and I can't imagine a better partner in crime. This book, and so much else, would not be possible without him.

NOTE ON MALAY LANGUAGE

I follow Malay naming conventions, in which people are referred to and alphabeticized by their given name/s, so, for example, Shuhaimi Baba is cited as Shuhaimi and can be found in the bibliography under "S." A common addition to this rule is that men named Mohamad are conventionally referred to by their second given name. For instance, Mohamad Taib Osman is subsequently referred to as Taib, although he is still alphabetized under "M." For ease of finding references, I treat honorifics such as "Syed" and "Sharifah" as intrinsic parts of a name. Disparities in usage also mean that the same person can be referred to using variants of their name across sources, e.g., Jamil Sulong or Jamil bin Sulong. I retain the various published versions in the bibliography but in my own text refer to people in a consistent format. Where it is possible to discern someone's preferred version of their name, I use that, but since citation styles vary, for the sake of clarity, I refer to people by their first name/s as standard. Of course, Malaysia and Singapore are multiethnic cultures, and these conventions only apply to Malay names. Chinese, Indian, and other names follow the usual practices for their languages.

Older forms of Bahasa Melayu used slightly different spelling conventions, so, for example, *kampung* would be *kampong*, and *cinta* would be *chinta*. These shifts sometimes result in inconsistencies in spelling the same word from historical sources to present writing.

ALLURING MONSTERS

INTRODUCTION

On the Trail of the Pontianak

In her influential theory of haunting, Avery Gordon proposes that "the ghost is not simply a dead or missing person, but a social figure, and investigating it can lead to that dense site where history and subjectivity make social life. The ghost or the apparition is one form by which something lost, or barely visible, or seemingly not there to our supposedly well-trained eyes, makes itself known or apparent to us."[1] For Gordon, the ghost allows us to see what is otherwise absent from official histories, in particular the inner life of those subject to the violences of modernity. This book investigates such a ghostly figure as a site of complexly intersecting identities in postcolonial cinema. The spirit in question is called the pontianak, a female vampire who is a much-loved and much-feared folkloric monster in Malay cultures. The pontianak is traditionally a woman who has died as a result of male violence or childbirth and whose return asserts a forcible site of spectral visibility. Her figuration as a terrifying, fanged monster invites feminist interpretation, and certainly the foundation of the pontianak's potency is her overthrowing of gender norms. But she is also a precolonial figure who emerges in the era of anticolonial agitation and whose popularity suggests the resonances of animist worldviews within Malay modernity. What the pontianak makes apparent to us is a space of lively contestation in postcolonial culture, in which injustices both past and present are animated in horrifying form. The pontianak, I propose, illuminates the powerful role of popular cinema in the historical processes of decolonization.

To begin, then, what is a pontianak? In the animist worldview that dominated the Malay Peninsula before the arrival of Islam, she is one of many *hantu*, or "ghosts," and is a childbirth spirit. The earliest written reference to a pontianak is by Portuguese cartographer Manuel Godinho de Erédia, who wrote in 1618 of

"another type of witch called 'ponteanas' who are to be found in trees.... They say that these 'ponteanas' are women who died in childbirth and who, for that reason, are the enemies of men."[2] Walter Skeat, the British colonial civil servant who wrote the first major Anglophone account of Malay folklore, writes of "the spirits which are believed to attack both women and children at childbirth.... the Langsuir, which takes the form of an owl with long claws, which sits and hoots upon the roof-tree, the pontianak which is also a night-owl and is supposed to be the child of the langsuir." Skeat's idea of the pontianak as a child is based on a misunderstanding of the word's etymology (*anak* is Malay for "child," but the pontianak is not a child but a woman who dies giving birth, or *perempuan mati beranak*).[3] As Stu Burns puts it, "examined with the advantage of twenty-first century scholarship, Skeat's widely-disseminated version of Langsuir and Pontianak folklore demonstrates how colonial discourse generated knowledge about tropical cultures with only a nascent apprehension of cultural—and literal— vocabulary."[4] Regardless of this misconception, Skeat's account of the pontianak becomes a key reference point for subsequent scholarship, which reiterates the closeness of the pontianak to other birth spirits such as the *langsuir*. Kirk Endicott refers to a class of birth demons or vampires, including the *bâjang, langsuir*, and *penanggalan*, which attack women at childbirth.[5] Richard Winstedt writes that "throughout Malaysia terror is felt at the cry of the Pontianak, a banshee in the form of a bird that drives her long claws into the belly of an expectant mother, killing her and her child."[6] Indeed, partly what distinguishes the pontianak from the many other *hantu* in Malay belief is the extent to which she is feared. R. J. Wilkinson, writing in 1906, considers that "more malignant ... and far more potent than these spirits of the cemetery are the ghosts of murdered men, of women who have died in childbirth and of the children who have died unborn. The best known of the birth-spirits are the langsuyar (or burong), the pontianak (or mati anak), and the penanggalan (or tenggelong)."[7] J. N. McHugh, who wrote the classic work on spirit belief in modern Malaya, considers the "most fearsome" ghost to be "the vampire, or Hantu Langsuyar, sometimes referred to as the Hantu Pontianak."[8] Mohd. Taib Osman agrees, describing these vampire ghosts as "perhaps the most feared" *hantu*, and his historical account certainly resonates with my own research in Malaysia, where people often express belief in and fear of the pontianak.[9] Surviving both centuries of Islam and the disapproval of British colonial powers, the pontianak remains a lively undead figure in Malaysia and the Malay diaspora.

The pontianak first appears in cinema in a series of hugely popular films in late-colonial Malaya, made in the Singapore-based studio system. Cathay Keris studio made four pontianak films, all directed by B. N. Rao: *Pontianak* (1957) and *Dendam Pontianak / The Pontianak's Vengeance* (1957), both of which have been

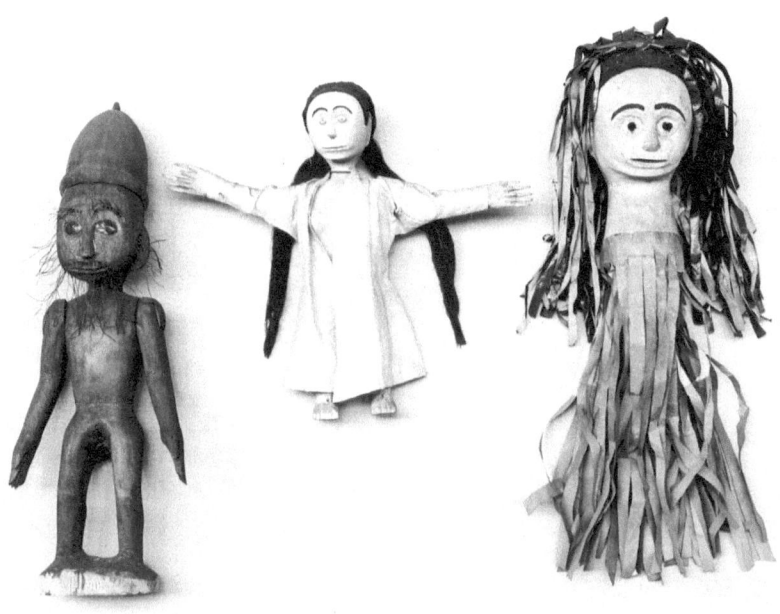

FIGURE 0.1 Figurines of Malay *hantu*, including *jin hitam*, *langsuir*, and *penanggalan* (detail). Reproduced by permission of University of Cambridge Museum of Archaeology and Anthropology (Z 33229).

lost, followed by *Sumpah Pontianak / Curse of the Pontianak* (1958), and finally *Pontianak Gua Musang / The Pontianak of Musang Cave* (1964). In an effort to copy the success of the Cathay Keris series, rival studio Malay Film Productions (owned by the Shaw Brothers) made their own version of the pontianak, with *Anak Pontianak / Son of the Pontianak* (Estella, 1958); *Gergasi / The Giant* (Ghosh, 1958); another lost film, *Pontianak Kembali / Pontianak Returns* (Estella, 1963); and *Pusaka Pontianak / The Accursed Heritage* (Estella, 1965). The pontianak of the studio-era film does not follow the folkloric tales exactly, but some generic codes emerge: She appears to be a beautiful woman with long black hair, but her true face is grotesque and sometimes decomposed. She can be subdued by driving a nail into the nape of her neck—once nailed, she acts as a normal woman and can marry and have children—but when the nail is removed, her terrifying pontianak nature is revealed, and she gains supernatural powers. Despite her monstrous form, the pontianak is often morally ambiguous or even heroic, using her powers to take justified revenge on her killers or to save her loved ones and the community from external threat. The films are set in a rural Malay village, or

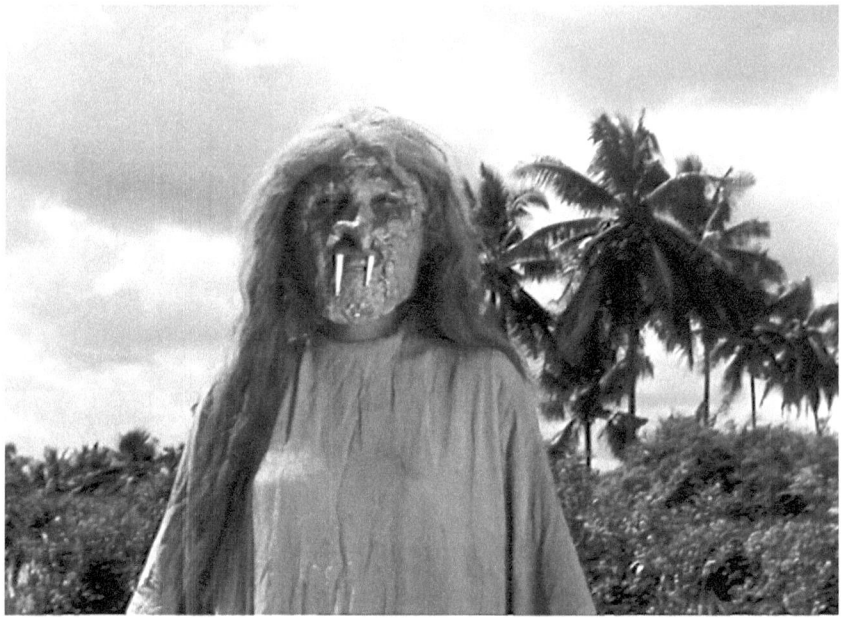

FIGURE 0.2 The iconic figure of the 1950s pontianak in *Sumpah Pontianak* (Rao, 1958).

kampung, and the pontianak is associated with the jungle that surrounds the village.

The pontianak series was an unexpected sensation, playing to multiracial audiences across Singapore and Malaya and propelling the face of the pontianak, Maria Menado, to stardom. By late 1957, the *Singapore Standard* newspaper could write with pride that "Hollywood has her Frankenstein and Boris Karloff, or the Hunchback and Lon Chaney. In Malaya today we have Pontianak and Maria Menado."[10] Throughout the so-called Golden Age of Malay studio filmmaking, the pontianak films were the most successful series and prompted a flourishing of folkloric horror. After the Singapore studio system crashed in the wake of independence, however, the pontianak film suffered from the lack of film production infrastructure in both Singapore and Malaysia. Almost no pontianak films were made for decades, although the Singapore-based coproductions *Pontianak* (Sutton, 1975) and *Return to Pontianak* (Djinn, 2001) demonstrate that the figure was not forgotten. She returned in force in the 2000s when the Malaysian government relaxed censorship rules that had all but banned horror films in the 1990s, and one of the first *filem seram* to be made was a feminist twist on the genre called *Pontianak Harum Sundal Malam / Pontianak of the Tuberose* (Shuhaimi,

2004). Since then, pontianak horror, comedies, and romances have proliferated on Malaysian and Singaporean screens.

This book argues that the pontianak forms a dense site of meaning in Malay cultures, and that her spectral presence through the history of colonial and postcolonial cinemas in Singapore and Malaysia speaks vividly about the pleasures and politics of decolonization. By examining the pontianak film, we trace an image of postcolonial popular cinema that is often less than visible, perhaps because it fits neither with the intellectual trajectories of postcoloniality as political cinema nor with studies of popular genres within larger national cinemas. And yet, the cultural prominence and semiotic richness of the pontianak make her a uniquely valuable cinematic figure. Pontianak films speak of tradition in a time of modernization but their emphasis on female agency resists the more conservative impulses of anticolonial discourse. The studio films illustrate the multiethnic and transnational nature of both mode of production and film-going culture in the late-colonial period, opening up new production histories. The pontianak is Malay but not Muslim, and moreover she is a national icon who is claimed by both Singapore and Malaysia. As a figure of both Malay animist folklore and the postindependence spirit, she has the untimely potential to challenge both traditionalism and nationalism. The pontianak registers a series of intersecting anxieties: about femininity and modernity; about local and transnational cultural influences; about the relationship of Islam to indigenous beliefs; and about globalization and environmental destruction. Her continued popularity illustrates the ongoing relevance of these issues in Southeast Asian societies. By examining the pontianak film from the 1950s to the present, I will argue that this ghostly figure opens onto a new understanding of how cinema mediates the transnational, the postcolonial, and the worldly.

VAMPIRIC CIRCULATIONS

The pontianak is often translated into English as a vampire, in part because she is often represented as consuming the blood or flesh of her victims. The comparison is not perfect, because *hantu* are ghosts or spirits in a somewhat different manner than the European undead. Nonetheless, the pontianak is often described, in Nicolette Yeo's words, as "the Southeast Asian equivalent of Dracula." It's a helpful translation for many Western viewers, but more than this, the comparison helps us unpack the relationship of the pontianak to the vampire as cultural figure and cinematic genre. Critics have often focused on the influence

of European and American vampire films on the pontianak genre. It is often assumed that the pontianak is an authentic Malay myth that has been distorted in cinema by unwelcome Western influences. Genre markers such as rising from the grave, long fangs, and blood sucking are for some critics not indigenous but the result of what Andrew Ng has characterized as "contamination by the Western vampire."[11] Similarly, Adrian Yuen Beng Lee argues that the need to subdue the pontianak with a sharp object—the nail that forms a central device in pontianak iconography—is a trope borrowed from Dracula.[12] Yeo describes the pontianak as "hauntingly beautiful with ebony black hair, luminous fair skin and luscious red lips. But its most distinctive feature is its unusually long and razor-sharp canine teeth, like all good vampires have."[13] In these accounts, the pontianak discloses cinema's transnational history in a way that is implicitly negative—the metaphor of contamination points to a story of cultural imperialism, in which indigenous storytelling is displaced by Western pop culture.

Certainly, such influences exist. The pontianak in the cult 1975 version of the myth has long vampire teeth and a close resemblance to the sexy female vampires of Dracula's lair. Lengthened canines as a signifier can be found in many contemporary texts, such as the television movie *Pontianak Beraya di Kampung Batu* (Amor/AstroRio, 2011), where the pontianaks can hide or extend their teeth in a way conventional to the vampire genre. It is clear that pontianak media draw on Western vampire codes and conventions. However, scholarship on Bram Stoker's *Dracula* indicates that this transnational story is not so simple. As a key example of what Patrick Brantlinger has called "imperial Gothic," *Dracula* the novel emerges from a very particular period of fascination with the folkloric figures of Britain's colonies. Stu Burns has argued that while the influence of Eastern European vampire legends on Stoker is well documented, "Dracula's relationship to folklore from the tropics and other regions of the British Empire has not been interrogated nearly as well."[14] He points to Van Helsing's accounting of all the countries where vampires are to be found. The vampire, Van Helsing says, "is known everywhere that men have been. In old Greece, in old Rome, he flourish in Germany all over, in France, in India, *even in the Chersonese*, and in China, so far from us in all ways, there even is he, and the peoples for him at this day."[15] The Chersonese is an old term for Malaya, so we can see explicitly named in *Dracula* a reference to Malay vampires.

In their analysis of Stoker's research for *Dracula*, Robert Eighteen-Bisang and Elizabeth Miller note only three sources for the idea of the vampire: Emily Gerard's article "Transylvanian Superstitions," Sabine Baring-Gould's *The Book of Were-Wolves*, and Isabella Bird's travel memoir *The Golden Chersonese and the Way Thither*, published in 1883.[16] Stoker copied a long passage from Bird's book about her time in the Malay peninsula into his notebooks, describing the Malays'

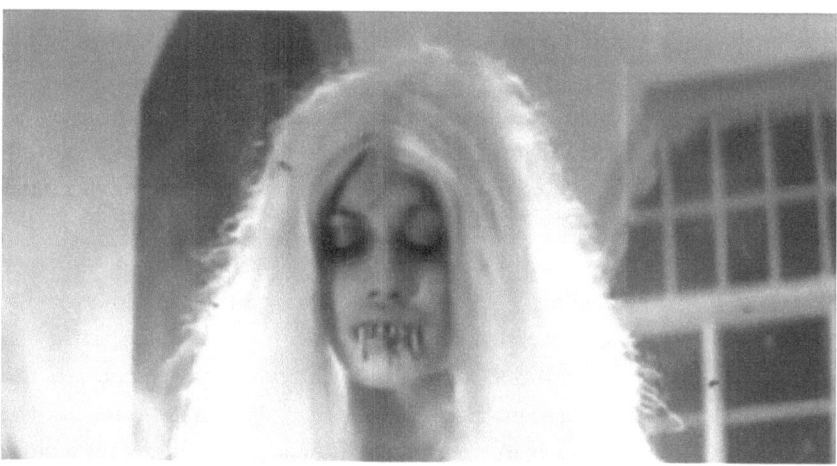

FIGURE 0.3 The protagonist in *Pontianak* (Sutton, 1975) has long teeth like a Western vampire.

"universal belief" in a plethora of supernatural creatures, including that of a woman who dies in childbirth and returns as a large bird, the haunting of forests and graveyards, and women who are possessed, can fly, and crave human blood. Bird writes:

> I have never heard in any country of such universal belief in devils, familiars, omens, ghosts, sorceries, and witchcrafts. The Malays have many queer notions about tigers.... They also believe that some men are tigers by night and men by day. The pelesit, a bad spirit which rode on the tail of Mr Maxwell's horse, is *supposed to be the ghost of a woman who has died in childbirth. In the form of a large bird* uttering a harsh cry it is believed to *haunt forests and burial-grounds* and to afflict children.... The harmless owl has strange superstitions attaching to it, and is called the "spectre bird." ... A vile fiend called the penanggalan takes possession of the forms of women, turns them into witches, and compels them to quit the greater part of their bodies, and *fly away by night to gratify a vampire craving for human blood.*[17]

She doesn't mention the pontianak by name, but a pontianak is what she is describing. Without getting into too much detail about the limitations of colonial-era amateur anthropology, it's fair to say that both Bird and even more canonical figures like Skeat often garbled the attribution of names and mixed up their folkloric figures. Here she describes several different *hantu*, some accurately and some

wrongly. Such confusion notwithstanding, the spirit of a woman who died in childbirth and sometimes takes the shape of a bird is a pontianak and it is this figure that forms one of only three written sources for Stoker's fictional vampires. Stoker may not have read the word *pontianak* but he was inspired by Bird's description of her and of the Malay imaginary of flying, shape-shifting, blood-sucking spirits. Thus, at the source and foundation of modern vampire mythology is the Malay pontianak.

What does it mean if Bram Stoker was influenced by the pontianak and other Malay *hantu*? For one thing, it suggests that a significant strand of horror cinema has Southeast Asian roots that have not yet been studied. Moreover, the history of Stoker's Anglo-Irish borrowing from Malay animism complicates the popular narrative of the pontianak as an "Asian version of Dracula." This cultural history reminds us that cinematic transnationalism not only is about the politics of global circulation in the era of Hollywood domination, but also subtends a more deeply embedded narrative of colonial extraction. Stoker appropriated Malay indigenous narratives long before Malay cinema borrowed back European genre tropes. As Steve Pile puts it, "In many ways, this completes a circuit of vampires. Not only have vampires moved from the edges of empire . . . to its beating heart, London and Paris, they have also traveled across the empire, from Malaysia to London."[18] Taking into account this rather longer historical trajectory might open up a less Eurocentric approach to studies of the vampire. It also implies the necessity of the postcolonial not only as a category for the national cinemas of formerly colonized countries, but as a mode of thinking the circulatory systems of world cinema as such.

Colonialism did not merely provide the context in which Stoker learned about far-flung vampires. Burns notes that "Stoker was obviously aware of vampire folklore's global proliferation and the resonance the exotic undead had with an audience already ill at ease with the unintended consequences of building a world empire."[19] In this reading, the undead are unwelcome bodies from the colonies, corporealizing a fear of the colonized other, in a familiar return of the repressed and of the oppressed. As Ken Gelder puts it, "Vampirism is colonisation—or rather, from the British perspective, reverse colonisation."[20] Brantlinger's imperial gothic describes a history in which the Western horror imaginary is built around the unacknowledged violence of colonialism, and the anxieties of this process are gothicized.[21] Stephen Arata specifies that the reverse colonial narrative is about both fears that "the exploiter becomes exploited, the victimizer victimized," and a kind of cultural guilt. He cites H. G. Wells having found the idea for *The War of the Worlds* in a discussion about exterminating the indigenous Tasmanian population under British rule.[22] Such histories of British colonialism—in the South Pacific as in Southeast Asia—produce the anxious gothic of

the colonists, which imagines that monsters from the colonies might come to Europe to take their revenge. If British colonial culture appropriated Malay *hantu* to figure the horrifying effects of their own overseas violence, what might the pontianak mean to Malay audiences?

Here, we can trace a crucial shift in perspective. Sixty years after the pontianak travels from Malaya to Ireland through colonial circulation, the pontianak film emerges in Singapore precisely at the moment of decolonization. The first film in the series—B. N. Rao's *Pontianak*—was released in 1957, the same year as Malaysian independence from Britain, and the last one—*Pusaka Pontianak*—was made in 1965, the year that Singapore became an independent nation. This periodicity is, I argue, no coincidence. The original pontianak films' return to a precolonial cultural imaginary exactly during the birth of the postcolonial nations signals the role of cinema in popular decolonizing discourse. In the crucial period in which Singaporean and Malaysian civil societies were imagining and shaping new postcolonial nations, the region's most popular films looked back to precolonial figurations of Malay cultural identity. Vampire time is out of joint, and the pontianak's juxtaposition of precolonial, colonial, and postcolonial temporalities prompts exactly such a disturbance. In Singapore, the pontianak does not speak of the fears that white colonizers had of those they subjugated. Instead, both in their return to precolonial folkloric figures and in their reappropriation of Western vampire tropes, the pontianak films demonstrate an anticolonial sensibility and a complex engagement with Malay identities. By returning to indigenous Malay cultures and experiences, I propose, the films participate in creating an anticolonial popular cinema.

In the 1950s and 1960s, anticolonial intellectuals were not especially interested in popular cinema, and the Singapore studio films were largely viewed as "mere entertainment" with little to say about wider society. The contemporary press, however, did note the political timing of the original series' release, with the *Straits Times* highlighting that "Keris films have brought out a new Malay film *The Revenge of the Pontianak* to coincide with Merdeka."[23] More recently, Malaysian filmmaker Amir Muhammad has reread the films of the studio era:

> Interestingly, this deluge of horror began in 1957, the same year the Federation of Malaya Independence Act took effect. Were people really so anxious about self-governance, or saw it as a kind of existential horror, that they suddenly thought of ghosts and demons? I doubt if they were that morbid. I think the horror genre is a sign of confidence, because it's a bold step to take stories that had existed only orally and then use technology to bring them to life. It's an assertion of narrative (and cultural) independence.[24]

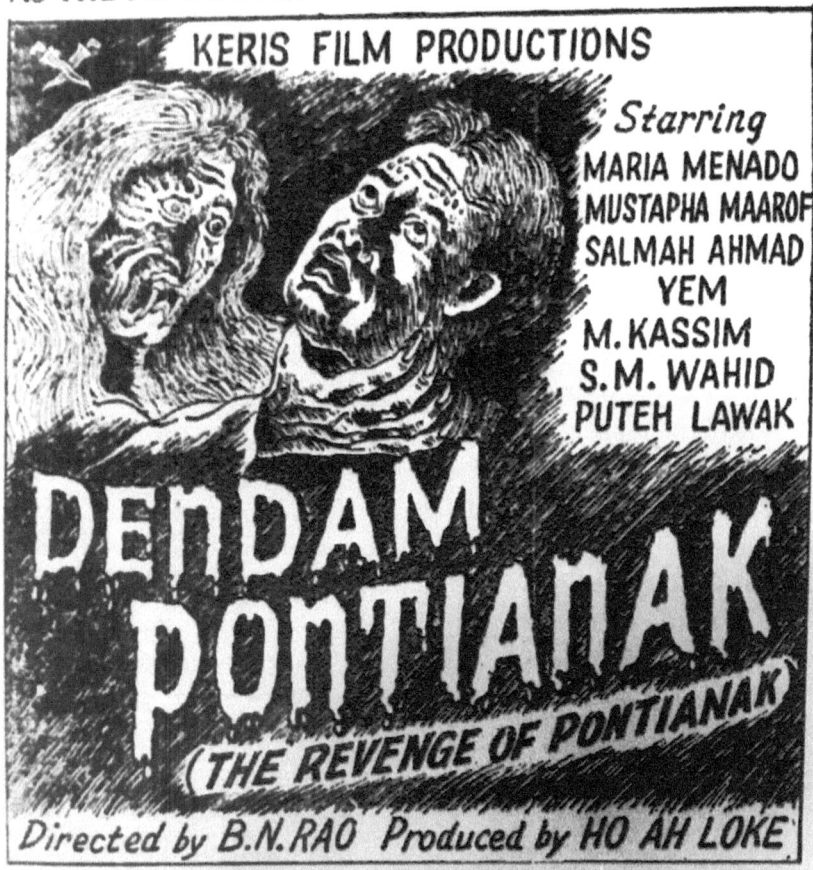

FIGURE 0.4 Publicity for *Dendam Pontianak* (Rao, 1957) promises terror with full English subtitles.

Amir's reading of the pontianak film as an anticolonial use of cinematic technology to stage oral cultures finds echoes across postcolonial popular cinemas, where precolonial supernatural figures often emerge to take on the political threats of the postindependence era. Meheli Sen and Sangita Gopal, among others, have analyzed the histories of Hindi horror film and its engagement with both folkloric monsters and sociopolitical threats.[25] In Jean-Pierre Bekolo's *Les Saignantes / The Bloodiest* (2005), the vampiric *mevoungou* appear in the form of young women to destroy the corrupt political order of postcolonial Cameroon.[26] In Turkey, *Siccin* (Mestçi, 2014) draws on the Islamic figure of the *jinn* to navigate the political anxieties of the Erdogan era.[27] Films that reimagine precolonial folkloric figures for the postcolonial era can be found across the Global South: we can view them as an assemblage that makes visible the cinematic power of juxtaposing the ancient/modern and the precolonial/postcolonial. Building upon Amir's account of the pontianak film as an assertion of independence, I follow the trail of the pontianak through Malaysian and Singaporean cinemas of decolonization.

THE PONTIANAK AND THE HORROR GENRE

The pontianak film is not a genre, and yet the pontianak is a figure of horror: this close but imperfect alignment between the pontianak and the horror film is a is a crucial source of the figure's semiotic dynamism. The pontianak is a figure—whether ghost, vampire, or demon—that fits into histories of supernatural horror. If we see her as a figure, as a representational object that does particular work within texts, then we can think about the work of figuring horror even within nonhorror films. Of course, many pontianak films are straightforwardly horror films, and in this regard we might think of them as a subgenre within the larger system of horror. The classic-era films sit within an emerging genre of *filem seram,* or horror films in the Singapore studio system that included supernatural monsters such as the orang minyak (or oily man) and the harimau jadian (or were-tiger). The new pontianak texts that began to emerge in the 2000s display an abundant generic mix, and although they are certainly marketed primarily as horror, they are often generic hybrids mixing horror with comedy or romance. Beyond this generic mixing, though, the pontianak travels far from any strict delimitation of horror. She can be found in art cinema and in soap operas, in literary novels and in anonymous web clips, in films that circulate at international film festivals and in television movies that address a domestic audience. This diversity and range of pontianak media are important not because

they transcend or evade horror, but because they insist upon a horrific mode of figuration within and across genres and registers.

For example, there is nothing horrific about *Ponti Anak Remaja* (Nizam/Astro Ria, 2009), a wholesome television miniseries in which a pontianak disguises herself as a high school student in order to learn science and save her family. The generic markers of the pontianak—parent/child relationships, supernatural powers, an apparently normal young woman who conceals a secret identity—are bent toward the logic of the high school melodrama instead of toward fear and violence. High school mean girls aim to uncover Ponti's secret, but with the help of her friends, she uses biotechnology to stay in human form and to join a mixed pontianak-human family. *Ponti Anak Remaja* does share some qualities with the pontianak horror film, though: a story that centers on girls, and on the painful inheritances of a familial and national history. But here, the pontianak prompts not fear but hope: the potential to rewrite histories that have gone terribly wrong and to imagine subjectivity and familial bonds anew. There is a reason that it chooses the figure of the pontianak with which to embody this spectral poetics. The pontianak corporealizes a mode of haunting in which horror resides in the figure's ability to disfigure normative modes of representation and being. Indeed, part of what makes her so disruptive is her ability to emerge within apparently nonhorror texts, insisting on the power of the vampire ghost across media forms. She de-forms genres, sometimes in ways that play with already existing genre hybridity, sometimes in ways that are surprising and disjunctive.

Scholars of horror film have accounted for the tendency of the genre toward seepage. Joan Hawkins has theorized the intersections of European art film and avant-garde with the trash aesthetics and low-cultural spaces of horror.[28] Adam Lowenstein traces the transnational logic of the modern horror film, in which what he terms "shocking representation" speaks to historical trauma in classic art horror films like Georges Franju's *Les Yeux sans visage / Eyes Without a Face* (1960) and Michael Powell's *Peeping Tom* (1960).[29] Sometimes, the pontianak plays on exactly the kinds of blurry generic boundaries that these scholars have established, in which the proximity of horror cinema to the forms of art cinema complicates our understanding of both. The pontianak films of Amanda Nell Eu and Glen Goei and Gavin Yap, for example, can be productively understood within transnational histories of art horror. The richly saturated color scheme and studied referentiality of Goei and Yap's *Dendam Pontianak / Revenge of the Pontianak* (2019), for instance, might be compared with Luca Guadagnino's remake of *Suspiria* (2018) or indeed with the gialli that inspired him by Dario Argento, Mario Bava, and others. Eu's revisioning of classic monsters in *Lagi Senang Jaga Sekandang Lembu / It's Easier to Raise Cattle* (2017) and *Vinegar Baths* (2019) could be

compared to *The Company of Wolves*, Neil Jordan's adaptation of Angela Carter's feminist folklore from 1984, or to more recent monster films by female filmmakers such as Jennifer Kent's *The Babadook* (2014) or Juliana Rojas and Mario Dutra's *As Boas Maneiras / Good Manners* (2014). The art-horror pontianak film participates in a mode of genre hybridity that has always been a central aspect of horror's cultural plasticity.

As much as it is valuable to pay attention to horror's mixing of genres, however, it is necessary to specify distinctions, in order to locate pontianak texts within historical, aesthetic, and institutional contexts. The pontianak traverses registers, from degraded body horror to prestigious art horror. Low-budget horror films such as *Pontianak Menjerit* (Yusof, 2005) are produced and exhibited in very different ways from festival films like *Lagi Senang*, and it is crucial to maintain sight of the cultural weight of such differences. Both films play with gender roles, but whereas there is more space for Eu's art film to make a directly feminist intervention, a popular horror film like *Menjerit* uses slapstick comedy to mock dominant models of heteromasculinity. Art films like Eu's are relatively rare in Malaysia. By contrast, mainstream horror films like *Pontianak Menjerit* make up a significant chunk of the Malaysian film industry's output, but are widely regarded as disreputable. William Paul has traced the critical disdain and moral panic sparked by lowbrow horror cinema in the United States and, although the national contexts are very different, lowbrow pontianak horror holds a comparable place in Malaysian film culture.[30] From government policy to industry spaces, nobody thinks of these films as culturally or aesthetically valuable, and indeed horror is often singled out for opprobrium.[31] It is important to remain cognizant of these generic contexts—both the conservative dismissal of lowbrow horror and the transnational circulation of the art film—not to double down on the ideological work of taste and value but to trouble its assumptions. Genre always matters to pontianak media, but not always in the same way. Throughout this book, I will be attentive to the difference that genre makes to the politics and aesthetics of pontianak media, to the places in which horror bleeds across traditional genres, and to the places in which her spectral nature appears at odds with her generic setting.

Films are the central form of pontianak media, but the figure is also visible across television, fiction, gallery art, and web culture. This corpus draws attention to the importance of thinking platforms in contemporary film and screen studies. Generations of audiences grew up watching the studio-era pontianak films on television, where they were frequently rerun in the decades after their production.[32] By the 1990s, repertory programming emerged along with a heritage discourse around classic cinema. In 1997, the Cathay Theatre in Singapore

FIGURE 0.5 *Anak Pontianak* (Shuhaimi/TV3, 2007–2008) brings the historical *hantu* into the modern era.

ran a Cathay Classic Film Festival, featuring multiple sold-out screenings of *Sumpah Pontianak*. Suhaimi Raldi, the cinema manager, noted that the audience was largely made up of people in their forties, who, he conjectured, "watched it when they were young and they remembered how the film scared them. So they came back again but this time as adults who want to relive those memories."[33] Most of these fortysomethings were not old enough to have viewed the film from 1958 in first-run cinemas but might instead have been nostalgic for television viewings as children. In the 2000s, the return of pontianak media in Malaysia was originally driven by cinema exhibition but television versions of the pontianak soon became equally visible. The format was usually that of a stand-alone television movie, e.g., *Pontianak Teng Teng* (Khan/TV3, 2014) but series such as *Anak Pontianak* and *Keluarga Pontimau* (Norhanisham and Bhatia/TV3, 2015–2016) illustrate the figure's representation across narrative forms. She has also found her way into international streaming platforms. The HBO Asia series *Folklore* (2018) features a pontianak-themed episode and Netflix has screened a film about the pontianak's Indonesian sister called *Kuntilanak* (Rizal, 2018). The pontianak, like many popular folkloric figures, spreads promiscuously across cultural spaces and cannot be properly understood without a certain openness with regard to medium. Although I am primarily focused in tracing the pontianak as a cinematic figure, the meaning of cinematicity will be nuanced by consideration of the

various institutional and aesthetic contexts at stake. A key proposition of this book is that by centering a figure of cinematic horror, we can both produce a rich and varied corpus, and address the disparate fields of postcolonial culture that radiate out from the pontianak.

THE PONTIANAK AS CULTURAL ICON

In April 2020, when the coronavirus pandemic led to lockdown orders across the world, a Malaysian man made national news by dressing up as a pontianak in order to scare people in his village into going home and staying inside. Muhammad Urabil Alias posted on Facebook a photograph of himself standing on top of a car in a pontianak costume; the image went viral. When interviewed by the press, he commented that the pontianak seemed to be effective, as "many are no longer keen on leaving their homes at night."[34] That Malaysians would turn to the pontianak as a figure able to frighten people where the threat of a deadly virus could not speaks to her continued horrific potency. But this story also speaks to the pontianak's capacity to bring a community together: Urabil's neighbors likely did not believe that he was truly a vampire ghost, but his performance as a pontianak persuaded them to behave collectively in a way that a government order had apparently failed to do. The pontianak functions as a reminder of a shared culture, history, and way of seeing the world, and this sensibility can be leveraged, as in this instance, toward communitarian action. Belief in, fear of, and/or love for the pontianak constitute an important mode of shared culture in Malaysia, and it is this reservoir of public feeling that made Urabil's pontianak drag so effective and so shareable. This affection for the pontianak resonates across Malaysian and Singaporean cultures, and the iterability of the figure in different cultural contexts is what makes her a vibrant object of study. Wherever we look in Malay cultures, the pontianak will appear.

The pontianak mediates a discourse of belonging, in which knowledge of the mythology enables in-group identification. In the postcolonial era, the ability to play with signifiers of pontianak lore is mediatized in diverse ways. When the original studio films were at their popular height, pontianak stories often found their way into newspapers as ostensibly real events. In July 1960, the *Singapore Free Press* reported on a man who gave a ride in his car to a pretty woman, who "wore a flowing white gown. She was of fair complexion and smelled of Arabian perfume." When he put his hand on her back (just to reassure her, of course) she disappeared.[35] Later that month, a series of letters to the editor debated whether

or not a Mr. Stephen Crawley could truly have encountered a pontianak in Serangoon Gardens, with replies ranging from the affirmative (E. Ranjan saw a "lady in white" on the Norfolk Road and was sure it was "something evil") to the skeptical (S. H. Gaw said, "I live in the area he mentioned but I have yet to see a pretty girl out alone at night much less pontianaks!").[36] Finally in December, a group of Anglos came across a pontianak while hunting flying squirrels in Serangoon and were almost seduced.[37] The lighthearted tone of these stories suggests a play between belief/fear and unbelief/pleasure, with a hint here also of an anticolonial discourse in which Anglos do not know enough to protect themselves from local spirits.

A contemporary version of these tabloid news stories might be the "real pontianak!" videos that proliferate on YouTube. These clips follow the generic conventions of other amateur ghost hunting media. For instance, "Scary Real Pontianak Ghost Captured in Malaysia" shows a group of men working on home repairs at night, filmed on a phone.[38] Nothing happens for two minutes, until the camera pans past a blurry white figure standing under a tree; the sudden halt and change of direction as the person filming runs away are the central formal mechanisms for producing fear. The pleasurable qualities of Southeast Asian *hantu* as a form of cultural belonging are visible in a Twitter thread in which one user writes, "Living in SEA: we are not scared of your werewolves and vampires. We have far scarier things. . . . You can write romance about werewolves and vampires. There's no fucking way to make pocong and pontianak/kuntilanak sexy" (@anonflail, January 23, 2020). Many of the responses involved humorous faux-sexy pontianak stories, while others affirmed the more frightening nature of Southeast Asian ghosts over Western ones. This clash of Western versus Malay ghosts can also be seen in mainstream media spaces: Universal Studios Singapore puts on an annual Halloween Horror Nights show, which mixes American horror characters with local ones. In 2018, it featured a Rumah Pontianak Haunted House exhibit, in which visitors walked through a traditional Malay village full of banana trees, the conventional mise-en-scène of the pontianak film. Its trailer video featured a similar mise-en-scène to the YouTube videos, albeit with significantly higher production values. In it, a young woman is dragged under a house by a monstrous creature in white. Across platforms, pontianak media continues to produce affective forms of Malay cultural identity.

The pontianak is equally at home in low and high forms of culture. She has been a staple of popular genre short stories from the 1980s onward, in several series of supernatural stories. Catherine Lim's *They Do Return . . . But Gently Lead Them Back* (1983) is the earliest English-language horror collection, and short horror fiction becomes a prolific genre through the 1990s and 2000s. Titles include *Curse of the Pontianak* and *Pontianak Nightmares*, as well as more general ghost

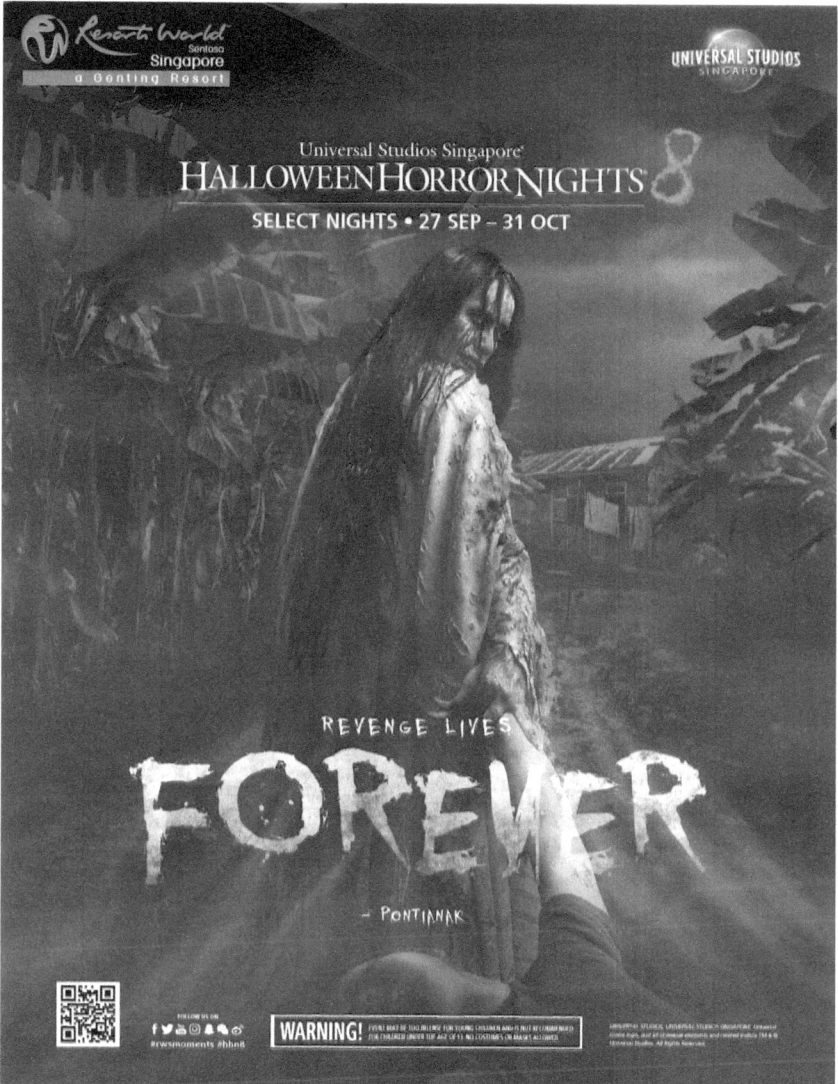

FIGURE 0.6 Universal Studios Singapore draws on pontianak iconography to advertise Halloween Horror Nights.

collections such as *Ghostly Tales from Singapore*, *Paranormal Singapore: Tales from the Kopitiam*, and Russell Lee's long-running series of *True Singapore Ghost Stories*.[39] Carole Faucher proposes these ghost stories as a form of multiethnic collective memory in Singapore, noting that these books always feature a pontianak among a range of Chinese, Indian, Malay, and other ethnic ghosts.[40]

These stories often look to the colonial past, locating both terror and revenge in the racial and gendered hierarchies of sexual power. In "The Moon Princess," for instance, the titular character is a Malay woman who has an affair with a British colonial officer. When he leaves her to marry a white woman, she is seen as tarnished and can never marry. Her mother reveals that both women are pontianaks, and the moon princess takes her revenge by maiming and killing agents of colonial power.[41] In "Kuntilanak," another young girl has a secret relationship with a soldier, and when he leaves her pregnant, her father murders her for bringing dishonor on the family. She becomes a pontianak and haunts the house, possessing the body of another young girl and making her shout "fuck you!" at pious men. Although both of these pontianaks are eventually subdued, these narratives illustrate both the feminist and the anticolonial pleasures inherent in the pontianak's vengeful nature. A significant part of the continued appeal of the pontianak as a cultural figure is that, as much as she is a traditional Malay figure, she reliably disrupts the smooth operation of power. This political and aesthetic impulse to overturn hegemonies and to refuse dominant forms of being is, I will argue, a crucial element of the pontianak's textual force.

We can see the exact same disruptive force in more literary visions of the contemporary pontianak. In his postcolonial revisioning of *Malay Sketches*—the name of a nineteenth-century British collection of stories about Malaya—Singaporean writer Alfian Sa'at includes "A Pontianak Story." In this brief tale, Alfian lays out the gender politics of the pontianak through an encounter between a male doctor and a psychiatric patient who believes herself to be a pontianak. Alfian's writing self-reflexively presses the doctor's modern rational framework, within which the woman must be delusional, up against the patriarchal limitations of both psychoanalysis and gothic literature. Through the doctor's notes, we see that he views the patient as an opportunity for his own authorship: "Can also write about feminism," he notes, "bloodsucking as draining the phallus of its hydraulic fuel."[42] Despite the doctor's awareness of feminist critique of the vampire, he nonetheless views the woman as insane and sees himself as the creator of her story. In her own account of her death and rebirth, by contrast, the woman has no such bird's-eye view. Instead, she describes being buried beneath the earth. There, beetles "undulate as smoothly as black-lacquered tongues," and "hermaphroditic worms . . . seemed to telescope in two opposite directions, torn as they were from the pulls of conflicting libidos."[43] The earth becomes at once grotesque and erotic, mixing desire and decay in a queer and tactile language that slips free of the male narrator's supposedly liberal rationality. The story cleverly navigates among premodern belief, modern medicine, and the modes of feminism, gothic fiction, and psychoanalysis that might be associated with Western

cultural imperialism, but are not exhausted by these alignments. Alfian points to the resilience of the pontianak in the face of modernity, and to the feminist potential of the premodern, while still retaining the critical value of modernity, including Freud, to the Malay experience. The pontianak here disrupts the shibboleths of both the modern and the antimodern.

The feminist qualities of the pontianak form the backbone of her appeal: here is a woman who returns from the dead to take revenge on the men who have wronged her. As Malaysian artist Yee I-Lann puts it, "pontianak can symbolize feminism in the Malay context because she does not bow to patriarchy and she has taken control of her own sexuality and regards herself as equal to men, if not more powerful. Pontianak can also represent the irrational fear Malaysian men may have towards ideals of feminism. 'Eeeee feminist . . . pontianak!'"[44] In other words, the pontianak intervenes in debates over feminism in the contemporary era, symbolizing at once a feminist icon of agency and power *and* a patriarchal slur aimed at women who do not comply with dominant modes of female presentation and behavior. Her potential for feminism is thus more than simply a revenge narrative, and Malaysian and Singaporean artists have often turned to the pontianak to animate the intersection of gender and history. Sandi Tan's novel *The Black Isle* (2012) constructs an imaginary Singapore, within which ghosts play a central role in twentieth-century history. Its protagonist, Cassandra, can see the hordes of spirits who inhabit the island. On her family's rubber plantation before World War II, one of her first ghostly encounters is with the young tapper Mina, who has died in childbirth and returned as a pontianak to murder her abusive father. Sharlene Teo's novel *Ponti* (2018) also writes Singapore's history through the figure of the pontianak. The titular character is an aging actress called Amisa, who was once famous for playing a pontianak in a cult film from the 1970s, and whose decline has left her daughter Szu in a socially marginal position. Amisa's girlhood in an impoverished village is contrasted with Szu's in a suburban neighborhood, with the stardom and glamor of the screen pontianak forming a mirage in relation to which Amisa's and Szu's lives are always felt as disappointing. In the pontianak novel, women's history is a form of spectrality.

The pontianak is also a cross-cultural figure, whose provenance as a Malay ghost is often employed in the postcolonial era as a way to complicate national and ethnic identities. As Alfian put it in a Facebook post on January 19, 2017, "One does not need to be Malay to know what a Pontianak is. One does not have to believe in any religion to entertain the possibility of demonic possession. One does not have to be a Taoist to know that it is somewhat taboo to mess around with Hungry Ghost offerings. . . . This circulation and borrowing of beliefs was hardly self-conscious, and a demonstration of a kind of grassroots

interculturalism.... If multiculturalism is about respecting other people's beliefs, interculturalism goes further, to the point of adopting these beliefs." We see this intercultural mixing in the popular short story collections, which, as Ng Yi-Sheng points out, often represent what he calls immigrant ghosts, such as *mohini* from South Asia, and *jinn* from the Arab world.[45] The pontianak often appears in culturally mixed popular texts, especially in Singapore. For instance, comedians Meenah and Cheenah play with ethnic stereotypes in their shows—their names derive from epithets for Malay and Chinese women—and among the typically Singaporean characters they interpret is a pontianak. The pontianak is a national icon and a site of public memory in Singapore, even though Malays are very much a minority. Indeed, as a figure, the pontianak can make visible the racialization of Singaporean histories and identities. Filmmaker and curator Tan Bee Thiam reflects that he did not understand the Malay language as a child and only experienced it via learning the national anthem at school and watching pontianak films. Here, the pontianak film takes on the quality of a counternational text, the popular underbelly of official Singaporean patriotism.[46]

The disruptive force of the pontianak as counternational figure is vividly illustrated in an installation by Singaporean artist Ila, as part of the "State of Motion: A Fear of Monsters" exhibition in 2019. The installation invited audiences to respond to a series of prompts about monsters and ghosts in Singapore, with Post-it notes provided to build up an unofficial cartography of the city. Ila asked visitors to describe the monsters they feared as children and to reflect on their current favorite monsters. The pontianak is by far the most popular answer to both questions, along with some other well-known cinematic figures such as the *penanggalan* and the *pocong*. One respondent says, "pontianak—a classic, always a classic," while another specifies, "female monsters—medusa, pontianak, langsuir etc." These assembled Post-it notes would be valuable simply as a collection of oral histories, but as the installation continues, Ila's questions begin to prompt different kinds of horror. The prompt to "Share a story of Singapore that scares you" leads participants from the supernatural to the sociopolitical. Responses include "homophobia," "systematic discrimination against minorities and how we never get to hear those stories because of censorship," "racist Chinese Singaporeans," and "'democracy'"—scare quotes included. This apparent reinterpretation of the question might speak to the paucity of outlets for social critique in Singapore and the irresistibility of making a point in an anonymous public forum, but it also speaks to the historical ability of the pontianak to speak about these issues. The pontianak has always encoded ideas about national and racial identities, sexuality, and the future of democracy, and Ila's crowd-sourced mapping prompts these political and nostalgic proximities to emerge.

CULTURES OF DECOLONIZATION

In locating the pontianak within cultures of decolonization in Malaysia and Singapore, I bring together postcolonial scholarship on cinema with that on haunting and spectrality. These are areas with significant overlap. In their study of postcolonial cinema, Sandra Ponzanesi and Marguerite Waller write of "recursiveness, porosity, intrusion, and haunting" as key terms, "as rationalism and mastery lose their persuasiveness."[47] I have already cited Ken Gelder on the colonial vampire, and for him, horror is central to the theorization of postcoloniality. He writes that "the tropes of horror—spectralisation, the return of the repressed, uncanny (mis)recognitions, possession (and dispossession), excess, the 'monstrousness' of hybridity—have often lent a certain structural logic to postcolonial studies."[48] Although, as he notes, canonical postcolonial theorists like Gayatri Spivak and Homi Bhabha do not engage such low-cultural forms, the structures and themes of the horror film lie at the heart of postcolonial studies. These theorizations of postcoloniality in terms of horror focus our attention on several discursive fields of relevance to the pontianak: the force of precolonial belief systems in the face of often violently produced modernities, the discontinuous temporalities of postcolonial experience, the significance of possession (understood as the ownership or usurpation of one's subjectivity or land), the excessive and uncanny processes of remaking identities, and the role of monstrosity in navigating cultural trauma and upheaval. In analyzing pontianak cinema from the late-colonial era to the present day, each chapter of this book will develop one or more of these discourses of decolonization.

The central category in postcolonial horror, of course, is the figure of the revenant herself. Haunting takes on a historical force in Luise White's study of vampire belief in colonial Africa, in which rumors circulated that white colonists were vampires, bent on draining blood from Africans. White argues that although one could read such rumors symptomatically as evidence of anxieties about the exercise of colonial power, such an approach strips the stories of their detail and intensity.[49] By taking vampire rumors seriously, White accesses instead the "aggressive carelessness of colonial extractions," and the "vulnerability and unreasonable relationships" that the tales narrate.[50] Closer to home, Aihwa Ong studies incidences of spirit possession in which young female factory workers in Malaysia come to believe that they have been possessed. In the decades after independence, young women increasingly became part of the labor market, forming a new proletariat in the factories of globalized industries. For Ong,

outbreaks of spirit possession respond to experiences of dislocation in a period of rapid change. She reads them as "culturally specific forms of conflict management that disguise and yet resolve social tensions within indigenous societies."[51] *Hantu* discourse here functions as a response to—and an active negotiation with—changing social relations. "Young, unmarried women in Malay society are expected to be shy, obedient, and deferential, to be observed and not heard," Ong claims. "In spirit possession episodes, they speak in other voices that refuse to be silenced."[52] These troublesome female spirits evoke, in Gordon's words, "what it feels like to be the object of a social totality vexed by the phantoms of modernity's violence."[53] Anthropological studies show the social potency of the postcolonial spirit, and the pontianak's mediatized presence is always in conversation with such troubled, unspeakable embodiments.

Film studies, more than other fields, has interrogated the formal mechanisms of postcolonial horror, paying particular attention to the revenants and monsters of genre cinema. If some critical theory has understood horror in purely abstract or metaphorical terms, film scholars have compellingly revealed supernatural monsters like the vampire and the zombie as creatures of the postcolonial and modern imagination.[54] Whereas the zombie forms a crucial figure for studies of postcolonial haunting in the Caribbean and North America, the ghost—broadly defined—is the figure that stages historical haunting in Southeast Asian culture. Bliss Cua Lim has theorized the cinematic temporality of the ghost, proposing that "ghosts call our calendars into question. The temporality of haunting, through which events and people return from the limits of time and mortality, differs sharply from the modern concept of a linear, progressive, universal time."[55] For Lim, this discrepant temporality of the ghost has a quality of postcolonial knowledge, in which "it discloses the limits of historical time, the frisson of secular historiography's encounter with temporalities emphatically at odds with and not fully miscible to itself."[56] Her spectral objects include the Filipino *aswang*, a cousin of the pontianak, whose appearance in cinema she connects both to a precolonial archaic time and to contemporary moments of political transformation. Lim brings together a film-theoretical critique of what Walter Benjamin termed "homogenous empty time" with a postcolonial one, arguing that modern clock time is also the time of empire. Building on Dipesh Chakrabarty's argument that the categories of capitalist time and history are unable to translate fully the radically disparate experiences of precapitalist peasant revolts, Lim describes his work as offering "a redemptive critique of the supernaturalism of peasant and subaltern worlds" that has "pivotal significance for this study of cinema and the fantastic."[57] For her, fantastic cinema opens up spectral refusals of linear time that resist both modern narrativity and colonial histories.

Lim's understanding of the fantastic is thus intrinsically political, and she draws on a critical trajectory of spectrality studies to propose a cinematic ghost that might speak for the oppressed. She reads ghostly time in relation to Derrida's concept of justice as "being-with specters," and this idea of justice denied resonates with the pontianak, who haunts the community that has wronged her.[58] For María del Pilar Blanco and Esther Pereen, the spectral turn in critical theory deploys theories of the ghostly as a way of thinking the trace, the supplement, and the weight of historical inheritance.[59] This trajectory has also been taken up in film studies, where, as Murray Leeder points out, it is particularly apt for thinking a medium often described as spectral or haunted.[60] Despite this ontological affinity for the trace, however, Leeder sees limitations in an ahistorical or purely conceptual concept of the spectral, preferring analyses rooted in time and place, able to attend to culturally embedded experiences of the supernatural.[61] Asian film scholarship has tended to concur, thinking the spectral in relation to culturally located ghosts and unpacking the weight of specific historical inheritances. Arnika Fuhrmann, for instance, describes haunting in Thai cinema as an incursion of the past into the present, but one that offers the potential for historical reparation.[62] For Fuhrmann, "the pervasive engagement with Buddhist-inflected conceptions allows contemporary cinema not only to parse problematics of desire but also to probe the possibilities of agency of women and queer persons as well as to arbitrate the grievances of minoritized persons."[63] She is speaking of the Thai cultural context, but what stands out in relation to the pontianak is the way that the Southeast Asian ghost speaks of multiple injustices, opening affiliations among women, queers, and other minoritized groups.

To view these supernatural figures as formal manifestations of colonial histories is to insist on the political and aesthetic significance of the *figure* as an object of study, especially in the postcolonial context. The ghost is a particular kind of textual object: it can function as a character but it is more crucially a formal process for seeing something that isn't present, or possible. To organize a book around a figure is to think with the pontianak, paying attention to the cultural, aesthetic, historical, and geopolitical terrain that she traverses. I follow "Cik Pon," or Miss Pontianak, across genres and media, tracing the cultural work of this most feared and beloved *hantu*. The pontianak can be the object of such fear and love because she mediates an array of affective relations to postcolonial histories and contemporary Malay identities. The pontianak is not merely a well-known character within regional pop cultural narratives. She is a figure of disturbance, whose formal and narrative effect is to unsettle dominant narratives of decolonization in Singapore and Malaysia.

WORLD CINEMA AND THE LOCAL GHOST

The pontianak is a fertile figure with much to say about Malay cultures, but a central claim of this book is that she also offers an original way of thinking about world cinema. What does it mean to contend that such a specific regional supernatural figure could speak about world cinema? In one sense, the answer is simply "why should it not?" Priya Jaikumar attends to a version of this question in her study of cinematic space and history, pointing out that "all theory or historical interpretation has an implicit or explicit geographical point of origin," and yet, "knowledge appears placeless in some forms and situated in others."[64] Her case studies are all films shot in India, but Jaikumar resists specifying the book's topic as either Indian cinema or cinema as such, noting that to demand such a distinction is to demonstrate a colonial form of understanding the world. Thus, she writes:

> fundamental categories that explain the world, such as history (in this case, of cinema's past) and philosophy (in this case, of cinema's ontology) are indexed to events and texts that belong to what Dipesh Chakrabarty calls "hyperreal Europe." Others are explained by their qualifying particularity. In film theory, this discrepancy is entrenched in the citational practice of using films, events, and experiences of twentieth-century Western Europe and the United States to explain abstract ideas about cinematic form.[65]

Following Jaikumar, I insist that a study of the pontianak can and should constitute both a study of Malay cinemas and a work of film theory.

The problem that Jaikumar finds with film theory's faux-placeless knowledge can be found also in the scholarly literature on horror film, which is often based on a Eurocentric set of references. For instance, Paul Wells sees an etiology for the horror film in the influence of Marx and Darwin in producing a culture that "has interrogated the deep-seated effects of change and responded to the newly determined grand narratives of social, scientific, and philosophical thought."[66] Although we might well conclude that Marx and Darwin have influenced Southeast Asian cultures, we would still have to imagine European thought as an abstract center and Malaysia as a qualifying particularity. Histories of American cinema are equally normalized as a route to theorizing horror film per se. For instance, Angela Smith's account of disability and the body in classical Hollywood horror asserts that the "'eugenic' response to horror films reminds us that the genre emerged out of a culture used to assigning pathological meanings to

certain body and behavioral traits, and thus justifying the institutionalization, sterilization, and even elimination of certain individuals."[67] How might we theorize the bodies of horror cinema differently if we began in a Malay context, within an animist culture in which ghosts and monsters contain the same life force, or *semangat*, as all other living things? Smith's work is absolutely valuable on its own terms, but the ease with which Hollywood models can lead knowledge production points to the disjunctures in film theory's globalism. When we come up against the challenge of "adapting" Western scholarship to think non-Western film histories, we fall prey to a colonialist mindset. Rather than situate horror genre studies as a neutral set of concepts to be applied to a new set of films, I aim to contribute to a decolonization of genre. To insist on Malay cinema *as* cinema itself, we have to pay attention to how the category of world cinema is constituted and what it means to locate the worldly within the particular.

Debates about world cinema have frequently addressed the category's tendency to recenter Western aesthetic histories. Dudley Andrew among others has warned against viewing world cinema merely as an accretion of auteurs and national cinemas, thereby losing the radical potential of earlier, anticolonial approaches to non-Western cinemas.[68] My approach to world cinema is deeply embedded in national histories while at the same time engaging theoretical questions about the politics and philosophy of worldliness. I build on the work of scholars like Jaikumar for whom cinema prompts questions about the aesthetics and politics of imagining a world. David Martin-Jones investigates world cinema's articulation of colonial modernity, and his engagement with the decolonial theory of Enrique Dussel in Latin America leads him to accounts of both film philosophy and political cinema that are self-consciously anti-Eurocentric.[69] A crucial aspect of Martin-Jones's account of the weight of colonialism on world cinemas is his emphasis on its environmental effects, and the anthropocene forms a central category for his ethics of cinema. Scholarship on global modernities has also revised the shape of world cinema. Peter Limbrick argues for a much greater interpenetration of Arab and European modernisms than has previously been realized, and he thus finds Maghrebi cinemas to be invaluable to understanding world cinema's ambivalent play with anticolonial forms and genres. He argues that an "engagement with modernity is something that occupies [Moumen] Smihi's cinema and Arabic cultural production not as a belated effect of European colonialism but as an extensive project of world-making in its own right."[70] Pulling back to a much more distant view of world-making, Jennifer Fay's work on cinema and the anthropocene entirely reframes the way that cinema remakes the world, urging us to pay attention to cinema's institutional and textual ecologies.[71] She posits that "insofar as cinema has encouraged the production of artificial worlds and

simulated, wholly anthropogenic weather, it is the aesthetic practice of the Anthropocene."[72] These questions of modernity, world-making, and the anthropocene are all foundational to the aesthetic practices of the pontianak. Although their contexts are far from Southeast Asia, each of these scholars provides evidence for the idea that an analysis grounded in cultural and historical specificity is crucial to the theorization of world cinema as a category and a method.

Returning to the horror film, we find the project of tracing the genre's cinematic world to be no less urgent.[73] Scholars of the horror film have investigated its global flows and influences, but once again, this attention to the transnational can work to center European cultural histories. Kay Picart and John Edgar Browning place cinematic vampires in a global context, but there is a tension between their ambition to think internationally and a framework in which non-American vampires are "Dracula's cinematic offspring," through which "global communities continue to reinvent predominantly Dracula figures in film."[74] Having considered Dracula's Malay origins, we can see the imperialist subtext of viewing other vampires as children of a European literary parent. Christopher Frayling's canonical account of vampire mythologies is more careful and more in depth in its exploration of vampires across cultures from Greece to Mongolia. Nonetheless, it's a cultural history from a European perspective, which can state that "we normally associate the myth with eastern Europe or Greece," because the book is addressed to a readership ("we") that is more familiar with European literature and thought.[75] Indeed, contemporary pontianak films sometimes self-consciously play with the assumption that Western vampires have become a global norm. In *Tolong! Awek Aku Pontianak / Help! My Girlfriend Is a Pontianak* (Lee, 2011), the protagonists Faizal and Pian fill their kitchen with garlic in an attempt to prove that their mysterious neighbors are pontianaks. Liyana (who is in fact a pontianak) is unaffected by the presence of garlic. The men have to pretend to be making garlic bread to save face, and afterward, Faizal ponders that their scheme didn't work because "she's a Malay vampire not a Western one." The scene's joke works by disclosing that Malaysians might be subject to Eurocentric thinking, with the distinction between a vampire and a pontianak operating as the signifier of Eurocentric versus Southeast Asian ways of framing the world. Like Faizal, we must decolonize the vampire.

Scholars of Asian cinema have been at the forefront of navigating the national, regional, and transnational aspects of the horror film. Stephen Teo sees the pontianak as representative of the Asian female ghost, and as emblematic of the Asian ghost film's "sociality of spirits," in which ghosts are, or desire to be, part of a community.[76] Teo compares the pontianak to various East Asian ghostly women with long black hair, in films such as *Ju-On / The Grudge* (Shimizu, 2002) and

the "Black Hair" episode in *Kwaidan* (Kobayashi, 1964). Teo presents Asian horror films as "cognitively cross-cultural," and this claim on the circulability of Asian horror is echoed by Jinhee Choi and Mitsuyo Wada-Marciano's work on Asian extreme horror, in which they highlight "the global processes embedded in a regional formation of screen culture."[77] The ability of horror films to travel internationally is often used as evidence of the genre's strength and adaptability to globalization. Dana Och and Kirsten Strayer argue for modern horror films such as *Ringu / The Ring* (Nakata, 1998) as "not significantly constrained by traditional cultural or cinematic binaries" such as those of the "regional and national," and as characterized by their ability "to circumvent borders and delimit territories."[78] There is something celebratory in these descriptions of frictionless travel, however, which passes over those texts that remain stickily local.

Pontianak films have not found the global success of J-Horror or K-Horror, and Jennifer Feeley contrasts them to Singaporean films like *The Maid* (Tong, 2005), which aim for a more pan-Asian style.[79] For Feeley, the pontianak film represents an older, national culture that is rejected by a Singaporean film industry that aspires to be globally legible. *The Maid* exemplifies a turn toward the themes and styles of pan-Asian horror, as well as Singapore's embrace of the transnational routes of Sinophone cinema. Peter Aquilia concurs, finding that recent Malaysian and Singaporean horror has adopted Western storytelling forms, retaining only a vague "Asian cultural flavour."[80] He also points to *The Maid* as an example, arguing that it uses Hollywood and East Asian structures in a self-conscious attempt to reach transnational audiences.[81] In these readings, the local specificity of the pontianak myth is precisely what prevents the pontianak film from going global. Whereas films that adopt the well-known codes and conventions of East Asian or American horror can circulate, Southeast Asian cultural signifiers offer less of a global passport. Language is also a factor, with Sinophone films gaining access to a significant regional and diasporic market. More broadly, these arguments suggest that films deeply embedded in local cultures might have less access to the circulatory systems of world cinema than those that include only a light dusting of cultural flavor.

If, as Lim argues, "Asian horror" as a heuristic is always implicated in a kind of Western gaze, then a better way to understand the pontianak's place in the world is through Southeast Asian regional histories.[82] The Austronesian language group ranges across an expansive area that spreads from Taiwan to Madagascar, and although Malay cultural identity is a more limited and modern concept, traces of common beliefs and folktales can be found across many Southeast Asian countries. Thus, the Malay pontianak is a close cousin to the Indonesian *kuntilanak*, the Thai *Nang Nak*, and the Filipino *tiyanak*. She has resonances also with the

FIGURE 0.7 Malaysian telefilms such as *Terpaku Pontianak* (Emi Suffian/TV9, 2014) use the seductive pontianak to address a primarily domestic market.

Indonesian *sundelbolong*, and with the Cambodian banana tree ghost. Across Southeast Asia, stories proliferate of women who died in childbirth and who return to seek revenge, justice, or love. I have already mentioned Lim's work on the *aswang* and Fuhrmann's on the *Nang Nak*: by locating the pontianak within this regional ambit, a different set of theoretical and historical issues comes into focus. The pontianak thus makes a case for a different mode of world cinema, one not easily plugged into the circulatory mechanisms of cinema's global flow or even into the transnationalism of pan-Asian horror, but more productively analyzed in relation to more local cultural forms and politics of decolonization. Films that appeal to global markets are not the only ones that must deal with the world, and the pontianak provides a counterweight to the "Asian flavor" vision of frictionless circulation.

The editors of the *Routledge Companion to World Cinema* begin from a discussion of how "local tensions and worldwide transformations interact," and this deceptively simple formulation demands, in their words, "new means of measurement and fresh tools of analysis."[83] One such tool might be Anna Lowenhaupt Tsing's theory of friction, which replaces the smooth capitalist operation of flow with an account of "global encounters across difference."[84] Tsing's fieldwork is based in the Indonesian rainforest, a space both culturally and geographically adjacent to the forests of Malaysia, so although her disciplinary location is far from cinema, her object of study is proximate to the pontianak. In analyzing

deforestation, Tsing makes the case that local communities are not merely adapting to or accommodating of global forces, but that globalized forces themselves emerge from such local encounters or, in other words, that "global forces are themselves congeries of local/global interaction."[85] This description of global friction resonates with the worlds created by cinema, and it implies that the pontianak film does not need to circulate around the world to be global. As I have argued earlier with regard to *Dracula*'s history of colonial extraction, the Malay vampire is always already transnational, her cinematic existence deeply embedded in the traffics of colonialism. The materials of the pontianak film, including the Malay forests that it depicts, are constructed from the global force of the colonial encounter, and world cinema is immanent in the networks of postcolonial traffic that flow through its images.

THE PONTIANAK AND MALAY CINEMAS

Let's zoom in more closely and locate the pontianak in her home. Southeast Asian cinemas are still relatively understudied. In terms of Asian film studies, the dominance of cinemas from China, Hong Kong, Taiwan, Japan, and South Korea has focused most film studies research on East Asian nations. Likewise, the scholarship on postcoloniality in cinema has emerged in relation to African, South Asian, and Latin American cinema and political theory rather than around the distinct experiences of colonialism in Southeast Asia. William van der Heide points out that Geoffrey Nowell Smith's *Oxford History of World Cinema* doesn't even mention Malaysian cinema, despite the country having produced almost as many films as Australia.[86] There is rather more work on Singaporean cinema, but most of it focuses on contemporary Chinese-language films rather than on the Malay history of the studio era.[87] Thinking about pontianak cinema thus opens out some areas of world cinema that have not been sufficiently considered. More than this: it is not simply the case that Malaysian and Singaporean cinemas represent a gap in the critical literature and could be beneficially added to the scope of world cinema. Looking at the pontianak film enables us to see formations of world cinema that have been marginalized for ideologically significant reasons. For example, in Singapore, Sinophone dominance has relegated the Malay-language cinema of the late-colonial studio system to a marginal status, and in Malaysia, religious disapprobation has structured the contemporary horror film as massively popular at the box office but culturally disprized. The return of recent filmmakers and artists to the complex legacy of the pontianak is only fully

legible in relation to these trajectories of exclusion. Tracing the textual history of the pontianak provides counterhistories, both to the way that existing transnational frameworks have overlooked Southeast Asian cinemas, and to the ways that national cinema approaches within Malaysia and Singapore have excluded the perspective of the Malay *hantu*.

Malaysian and Malay cinemas have a particularly limited scholarly history; indeed Heide's book published in 2002 is the first English-language monograph on the topic. Despite being very much an overview, and one that includes the Singapore-based cinema of the colonial era, Heide does not once mention the pontianak. It is a notable omission, considering the historical significance of and huge audience for the studio-era pontianak films. He does refer briefly to the popularity of horror film, which he considers to be influenced by Hong Kong genre films, but he clearly does not recognize the flowering of horror based on Malay animist figures as culturally significant.[88] A similar generic hierarchy is evident in histories by Malaysian authors. Abi's history of studio production from colonial Singapore to contemporary Malaysia does not mention the pontianak film, nor does Jamil Sulong, Hamzah Hussin, and Abul Malik Mokhtar's industry-oriented history of Malay film.[89] The latter includes a chronology of significant films and events, which includes canonical films such as *Hang Tuah* (Majumdar, 1956) and *Penarek Beca / The Trishaw Man* (P. Ramlee, 1955) but also tracks popular genre films such as *Mat Tiga Suku / Crazy Mat* (Mat Sentol, 1964). Again, however, it does not consider the pontianak series to merit inclusion.[90] This type of historiography—written in the case of Jamil, Hamzah, and Abul Malik by important industry insiders—gives a sense of the dominant and canonical view of Malay cinema, in which some of the most popular films ever made are largely omitted from the history books.

The Singapore-based, Malay-language studio cinema is claimed by both Singapore and Malaysia as part of their national heritage. For Singaporeans, the studio films were not only self-evidently produced in Singapore; they also represent part of the nation's multicultural vision of its history, alongside the films shot by studios such as Kong Ngee in Mandarin, Hokkien, and Cantonese, and the widespread distribution and exhibition of films in English, Hindi, and Tamil. For Malaysians, however, the films made by Cathay Keris and Malay Film Productions represent a colonial-era precursor to the Malaysian film industry, as evidenced by the gradual movement of talent to Ho Ah Loke's Merdeka Studio in Kuala Lumpur throughout the 1960s. The commonality of language and of many personnel argues for a continuity of Malay cinema. This "joint custody" of the 1950s and 1960s studio films leads to a situation in which this era is included in the historical narratives of both Singaporean and Malaysian national cinemas.

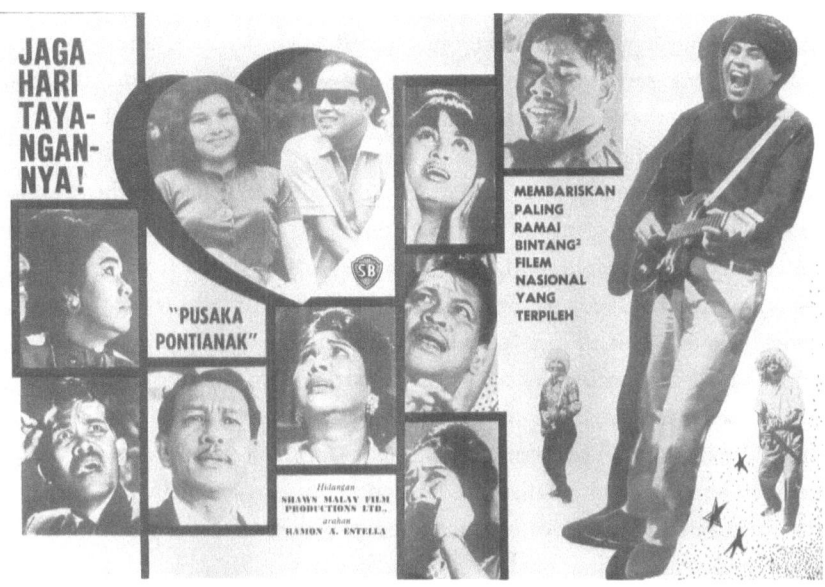

FIGURE 0.8 Magazine advertising for *Pusaka Pontianak* (Estella, 1965) emphasizes the star power of these popular studio films. (Image courtesy of Wong Han Min.)

This contested history perhaps illustrates the limitations of a national cinema model, especially in postcolonial contexts in which the constitution of the nation has been determined as much by contingent geopolitical wrangling as by any "rich legacy of memories," as Ernest Renan put it in his classic account of the European nation-state.[91] Nonetheless, the situation of the Malay studio films within the history of both national cinemas makes it necessary to read the pontianak film across both Singaporean and Malaysian cultures, paying attention to the moments in which they can be read together and the places in which they part ways. Mohamad Hatta Azad Khan writes an influential revisionist account of Malay cinema, in which he analyzes the mode of production of studio cinema, finding a source of Malay identity in the forms and practices of popular culture.[92] His approach is influenced by British debates on national cinema, and, although Badrul Redzuan Abu Hassan argues that his idea of national cinema is too purist for a postcolonial nation, Hatta does demonstrate the progressive potential of reading Malay-ness in the studio system.[93]

More recent scholarship on both Malaysian and Singaporean cinemas has developed this potential in ways that are helpful to imagining the cinematic space of the pontianak. Adil Johan's work on film music in the studio system teases out

the development of cultural nationalism in the postcolonial context. He argues that "film music produced in the 1950s and 1960s articulates, through cosmopolitan practices, the cultural intimacies of postcolonial nation-making based on a conception of Malay ethnonationalism that was initially fluid, but eventually became homogenised as 'national' culture."[94] His reading of what he calls "cosmopolitan intimacies" textures the more nationalist tenor of earlier histories and teases out the relationships of indigenous and transnational musical forms in the construction of modern Malaysian culture. Adil writes from a musicological perspective and only briefly footnotes the pontianak films for which Zubir Said wrote the music. But his focus on popular music resonates with the historical tensions that I will examine through film form. In his account of the film scores of P. Ramlee and Zubir, he writes, "agency was not achieved through indigenous practices but through modern ideas and mediums that recontextualised indigeneity in the form of nationalism."[95] The pontianak provides just such a combination of indigenous, modern, and cosmopolitan elements, which are intimately connected to ideas of national identity and belonging, but which also unseat the homogenized visions of ethnonationalism. In the Singaporean context, historiographic inclusion of the Malay studio system remains relatively rare. To take an example from popular media, the Wikipedia entry for "Cinema of Singapore" begins in 1990, despite strong currents of nostalgia around the "Golden Age" of Singapore cinema within popular culture. Gerald Sim "proposes expanding the view of contemporary Singapore cinema into a broader frame of reference to include the earlier films, whose historical context involves greater consideration of the country's colonial past that continues to exert an influence, alongside present forces of globalization, on both national identity and cinema."[96] Contrary to studies that view Singaporean cinema only in relation to globalization, Sim insists on the necessity of a postcolonial and multilingual approach to Singaporean cultural identities. Such an approach will provide crucial context for the return of the pontianak film in Singapore, in which the relationship between colonial past and globalized present becomes newly vivid.

In constructing the cultural significance of the pontianak, my research is naturally in conversation with the work of those scholars who have written about the figure. Most readers of the pontianak are drawn to the ambivalence in which, on the one hand, she offers potential for feminism through her unruly behavior and supernatural power and yet, on the other hand, the narrative of the beautiful woman who becomes a terrifying monster discloses an undoubtedly patriarchal framework. To varying degrees, scholars of the pontianak emphasize either the sexist narrative grounding or the figure's spectacular modes of resistance. Kenneth Paul Tan has drawn out the disturbing intersection of nationalism and

misogyny in many pontianak-themed horror films, whereas Alicia Izharuddin and Adrian Yuen Beng Lee have found feminist potential in her presentation of transgressive modes of femininity.[97] Jac S. M. Kee insists on the queerness of the pontianak, whom she argues "embraces every sexual abnormality and deviance that has ever been heaped upon a woman."[98] For Kee:

> The body is a figurative site for social order.... Wanita keras [butch], lelaki lembut [effeminate or gay man], pengkid [lesbian], poligami, sodomi, ibu tunggal [single mother], anak tak sah taraf [illegitimate children etc.]: contemporary creatures born of our contesting conversations around fear and power.... Our continued embracing of pontianak tales tells of our ambivalent dialogue and journey with sexual boundaries.[99]

Both the feminism and the queerness of the pontianak form a crucial aspect of my argument. Kee's notion of sexual boundaries is helpful in articulating a feminist reading of the pontianak that does not depend on analysis of her power and agency, but that rather reveals the formal effects of ideological disruption that she produces.

These disruptions of gender and sexuality intertwine with histories of decolonization, in which the pontianak resists postcolonial models of Malay racialization and dominant national and religious identities. Here, I look to the work of scholars such as Sophia Siddique Harvey, who reads Singaporean postcoloniality as haunted by the pontianak.[100] In Singapore's modern "air-conditioned nation," the pontianak comes to represent what she calls a "spectral tropicality," in which "Malay folk beliefs are firmly contained and displaced within a rural, untamed, tropical space and cannot be reconciled nor represented within Singapore's urban space ... and its national imaginary of a 'first world' city-nation."[101] Such a contrast of postcolonial modernity with precolonial beliefs and practices is also central to Gaik Cheng Khoo's work on the Malay concept of *adat*.[102] *Adat* is an Arabic loanword that names the Malay laws and customs that predate the coming of Islam and Khoo argues for its progressive rediscovery in contemporary Malaysian culture, especially as it pertains to gender, sexuality, and religious identity. For Khoo, the return of the pontianak film to Malaysian screens in the 2000s illustrates a postcolonial appropriation of the precolonial and pre-Islamic Malay imaginary. The renaissance of the pontianak film after 2002 has also contributed to a new scholarly interest in Malaysian horror film. Azlina Asaari and Jamaluddin Aziz have countered the tendency of previous scholars to ignore horror, focusing on the popularity of the horror film in contemporary Malaysia and insisting on the importance of the pontianak to

national cinema history.[103] They note that an average of seven horror films are produced annually in Malaysia, and in 2011 horror films made up 31 percent of national film production.[104] Considering the significance of the pontianak film to national cinema discourse enables us to articulate institutional histories with ideological histories, and in particular the ways that constructions of the pre- and postcolonial work to produce contested modes of belonging.

FOLLOWING THE TRAIL OF THE PONTIANAK

This book is structured thematically, around chapter topics that work to elucidate two parallel registers of thoughts. Firstly, each chapter addresses an aspect of postcolonial culture in Malaysia and Singapore. Chapter 1 examines anticolonial thought and activism within the late-colonial film industry; chapter 2 addresses gender and sexuality, with feminism and queerness forming sites for mediating experiences of modernization and globality; chapter 3 interrogates race and religion as historically definitional categories of Malay identity; chapter 4 considers land ownership, development, and environmental destruction as sites of political contestation; and chapter 5 addresses the cultural importance of animist belief systems in the postcolonial era. By locating the pontianak film at the center of these diverse political and cultural debates, I aim to reframe postcolonial film studies through a broad array of contemporary questions that resonate beyond Southeast Asia. Ponzanesi and Waller write that they "envision postcolonial cinema in relation to dynamic departures from colonial paradigms of knowledge and power. It matters less what a film is thematically about and more about how it engages with history, subjectivity, epistemology, and the political ramifications of all of these."[105] Pontianak films reimagine Malay histories, subjectivities, and epistemologies, and one of the threads running through the book is that these supernatural imaginaries are engaged in producing cultures of decolonization. Kuan-Hsing Chen memorably argued for the need to "put . . . the history of colonialism and imperialism back into globalization studies."[106] By reading the transnational history of the pontianak film in relation to these variegated facets of postcoloniality, I similarly aim to produce a postcolonial study of world cinema.

This thought leads to the second organizing principle, which is film-theoretical and historical. Each chapter also addresses an area in contemporary film studies, and in particular considers its relationship to world cinema as a category. Framed from this perspective, chapter 1 traces production histories,

locating the late-colonial studio system in Singapore in relation to transnational flows of talent and aesthetic influence; chapter 2 centers on feminist and queer film theory, considering how these methodologies might intersect with more located gender histories and theories; chapter 3 engages the representational politics of race in a cinematic context that is highly racialized but not around whiteness, and analyzes cultures of religious piety in relation to cinematic form; chapter 4 centers on cinematic space, returning to heritage film debates in relation to postcolonial landscapes and built environments; and chapter 5 considers the turn to animist theory across the humanities, using Malay animism and aesthetics to theorize the cinematic form of the jungle. In this film-theoretical register, the larger claim of the book is that the pontianak can and does speak beyond her immediate geographical context, that the pontianak offers compelling contributions to the conceptualization of world cinema studies as a theoretical and historiographic project.

The first chapter is the most historical in scope: it examines the late-colonial studio system in Singapore, considering its uniquely transnational mode of production, its intersection of Chinese, Malay, and Indian talent, as well as the anticolonial activism and intellectual milieu of the period. The original pontianak films were produced during the intensive period of anticolonial agitation, independence for Malaya, the merger of Singapore with the Federation of Malaya, and finally the expulsion of Singapore from the new nation of Malaysia, and this historical context makes it crucial to interrogate these films in relation to their mode of production and their popular reception. Drawing on fan magazines, newspapers, and oral histories, this chapter outlines how the pontianak came to be such a cultural icon and how those most closely involved with creating the films intersected with anticolonial movements in Singapore. Historicizing discourses of Malay identity, it argues that even in her earliest forms, the cinematic pontianak troubled both colonial rationality and ethnonationalist ideas of identity and culture.

Chapter 2 argues that by analyzing the disruptive gender politics of the pontianak film, we can reimagine both Malay identities in the postcolonial era and the relationship between feminist film theory and world cinema. Although Western feminist film scholarship on horror has grounded much of the existing literature on the pontianak, this chapter insists that feminist and queer readings of the pontianak emerge most productively from the colonial and postcolonial histories of Malaysia and Singapore. The horrific agency of the pontianak is intimately bound up with debates on the modern Malay woman and with the perspectives of transnational feminism. The figure has always appealed to feminism, and a large measure of the pontianak's endurance as a cultural figure

comes from the threat she poses to patriarchy. She takes on a power that comes into conflict with conservative versions of proper Malay femininity, and as such, she can be read as demonstrating a misogynistic fear of women as monsters or as a feminist response to patriarchal oppression. Several recent artists and filmmakers have evoked the pontianak as a feminist icon, and this chapter interrogates the potential of this revisionist move. It argues for a feminist reading of the pontianak that moves beyond celebrations of her monstrous agency. Rather, it proposes the pontianak as a figure of textual disturbance, whose ability to disrupt forms of Malay patriarchy are formal and structural. The pontianak film queers gender, putting the status of all women into question, and it places the ambivalences of gender at the heart of Malay modernity.

Whereas gender is an obvious thematic concern of the female vampire film, questions of race might seem more marginal to a genre that is tied to Malay folklore. And yet, chapter 3 proposes that national, racial, and religious identities are fascinatingly contested in the pontianak film. Both Malaysia and Singapore are nation-states defined and sustained by systems of racialization, and their cinemas have been consequentially structured by race, in terms of both representation and institutions. Moreover, religion is inevitably intertwined with national identity in Malaysia, where adherence to Islam is a technical requirement of citizenship. The pontianak may be a Malay figure, but she fits uneasily within these postcolonial structures of citizenship and belonging: she is Malay but not Muslim, she is both Malaysian and Singaporean, and she has often been harnessed to forge identifications and affiliations across ethnic lines. This chapter examines how contemporary films deploy the pontianak to unsettle dominant discourses of ethnonationalism. It locates the pontianak both in relation to postindependence histories of racialized politics and in relation to the increased piety spurred by the Islamic revival movement. The divisions and imbalances of race and religion haunt both national cultures, in significant part as an inheritance of colonial forms of racial control. The pontianak film highlights the racial and religious tensions at play in popular culture, but it also imagines different images of Malayness. In its vampiric decolonizing imaginary, it tempers bloodthirsty revenge with cross-cultural bonds.

Moving on from the identity formations of the prior two chapters, chapter 4 gathers around the Malay village, or *kampung*. The *kampung* centers discourses of nostalgia and tradition in Malay thought, as well as being a space continually leveraged for political purposes. It forms a key location for ideas of heritage, both as an imagined Golden Age of rural life and as the space in which Malay cultural forms such as traditional arts and foodways take place. In the decades since independence, however, the *kampungs* and the forested land around them have

undergone rapid and often destructive development. Singapore no longer has *kampungs*, and in Malaysia, conversion of land via logging and palm oil plantation has radically altered the countryside. The conventional setting of the pontianak film in the *kampung* and the jungle, then, is overdetermined: this mise-en-scène enables horror films to speak about history and heritage, as well as about the transformations wrought in the postcolonial era. This chapter explores revisionist histories, in which the pontianak film animates injustices of land ownership, development, and environmental politics. It argues that *hantu* stories are intrinsically about land ownership, and that the jungle and *kampung* in pontianak films are political landscapes that push on cultural narratives of both modernization and tradition.

The final chapter considers the animist universe of the pontianak. Animism was the worldview of the Malay archipelago before the coming of Islam and the belief systems of the region have always been highly syncretic. The pontianak stages contemporary syncretisms, animating the intersections of animism, Islam, and scientific rationality in the era of decolonization. But animism has also emerged as a theoretical model in the humanities, deployed to think antimodernisms, as well as issues from indigeneity to ecocriticism and posthumanism. While engaging with these ideas, this chapter proposes a located account of animism that traces its aesthetic and political influences in Malay visual culture. It argues for animism as cinematic form, exploring the films' formal modes of representing the Malay forest as part of an animate field. It traces art histories of the jungle, including representations of trees, leaves, and animals, in order to understand how the pontianak film imagines itself as part of an animate world. Linking back to chapter 4's account of environmental degradation, this chapter argues that animist aesthetics in the pontianak film proposes a cinematic ecology of the Malay jungle. Rather than using animism as an abstract foil to modernity, this chapter considers animism as a cultural logic, one that imbues nonhuman nature with forms of agency and value.

Across its chapters, this book asks: What can the figure of the pontianak tell us about the cultural processes of decolonization in Southeast Asia and beyond? Why did cinema in late-colonial Singapore turn to the premodern past when the political process was constructing an independent future? And what haunts contemporary Malaysia and Singapore in the shape of the pontianak? In answering these questions, I conclude that a study of pontianak films contributes not only to our understanding of Southeast Asian cinema but also to theories of postcolonial cinema in a global context. I locate the pontianak at the center of a network of discourses that articulate postcolonial aesthetics and politics. Rebecca Weaver-Hightower and Peter Hulme narrate a shift in postcolonial film studies

away from a focus on the era of anticolonial struggle and Third Cinema and toward issues that represent contemporary concerns in postcolonial nations, for instance, terrorism, diaspora, and religion.[107] The pontianak film similarly engages with the manifold consequences and aftereffects of colonialism. The inheritances of British colonialism in Malaya include, for example, forms of racialization that have continued to stratify the postcolonial polities, affecting film production as well as cinematic representation, while naturalizing a discourse of racial pluralism. Also crucial is the rise of religious conservatism and anti-LGBT policies, and, by contrast, queer, feminist, and antiracist resistance to these structures. In the era of independence, the fault lines of postcoloniality are to be found in discord over gender, racial, and religious identities, in discourses of national heritage, ownership, and indigeneity, and in the politics of rural development and environmental degradation. By investigating the pontianak, I propose a methodology that takes in an expansive view of what might constitute the politics and aesthetics of postcoloniality. If we understand popular culture, in Stuart Hall's terms, as a site of contestation, then the pontianak film enables us to reimagine the cultural, aesthetic, and political stakes of Malaysia's and Singapore's cinemas in a global frame.[108]

CHAPTER 1

POPULAR HORROR AND THE ANTICOLONIAL IMAGINARY

On April 27, 1957, B. N. Rao's *Pontianak* opened at Cathay's flagship cinema in Dhoby Gaut in Singapore. Malay-language films were not usually screened in this main city center cinema, and it was only planned for *Pontianak* to show for two days as a special holiday event.¹ However, the film was wildly popular and, rather than transferring to a local cinema, it continued at the Cathay for two months.² It soon became a sensation across Malaya. A week into its run, the *Singapore Standard* reported that a fight had broken out in the foyer of the Cathay when people cut the ticket line. Furious patrons attacked the line jumpers and the fracas ended with a broken screen and the police being called to institute crowd control.³ By mid-May, Cathay was taking out newspaper ads to announce that "*Pontianak* has set an all-time box-office record for any locally-made Malay picture," and lead actor Maria Menado was making personal appearances at screenings.⁴ The huge success of *Pontianak* was significant in many respects. Although not the first horror film to be made by a Singapore studio, it was the one that sparked the emergence of the *hantu* film as a popular genre. It was the first Cathay Keris film to make a profit, turning the studio into a cultural force.⁵ But each of these concerns—its significance for genre and the studio system—should be understood in relation to the most striking aspect of the film's popularity, which is to say, its cross-cultural appeal. As Ng Yi-Sheng puts it, "the pontianak tale is fondly remembered by people of all races in Malaysia and Singapore."⁶ *Pontianak*'s popularity beyond the Malay audience marks a turning point in late-colonial cinema and, I propose, makes the pontianak series central to understanding the popular cinema of decolonization.

Late-colonial Malaya was racially diverse, with significant Chinese and Indian populations, as well as Malays. Cinema-going was extremely popular: according

to Timothy White, Malaya in the 1950s led the world in per capita cinema attendance, and its rich film culture offered screenings addressed to the many backgrounds of its audiences. That the studios assumed a linguistic or ethnic siloing of spectatorship is suggested by that fact that separate departments managed the distribution of English-language, Chinese, Malay, and Indian films.[7] Audiences could view films addressed to their own ethnic and language group, whether produced in Singapore or internationally. In February 1958, for instance, English-speaking audiences could have seen *Pal Joey* (Sidney, 1957), Chinese audiences *Diamond Flower* (Mok, 1953), Hindi speakers *Aag* (Kapoor, 1948), Tamil speakers *Ambikapathi* (Neelakantan, 1957), and Malay speakers *Dendam Pontianak / The Pontianak's Vengeance* (1957).[8] What was different about *Pontianak* was the multiracial makeup of its audience. Despite the film's Malay cultural theme, audiences of all races flocked to see it: according to contemporary director and producer Hamzah Hussin, 60 percent of the audience were Malay, 30 percent were Chinese, and 10 percent were Indian, British, or other.[9] Cathay director Laksamanan Krishnan believed that the film made so much money because of this cross-ethnic appeal: "because the Chinese came, everybody walked into the cinema."[10] We can track this unusual success in *Pontianak*'s multilingual release history. It was the first Malay film to be subtitled in Chinese, and to be dubbed in Mandarin,[11] and it was also dubbed in English and Cantonese for release in Hong Kong.[12] But its appeal to non-Malays is not merely a result of translation practices, since the success of its original run came before the subtitled version was released and many Chinese people in Singapore did not speak Mandarin. Rather, people who spoke only basic Malay nonetheless went to see the film, destabilizing both the racialized norms of exhibition practice and, I argue, engrained ideas about Malay popular culture.

The unexpected and enduring popularity of *Pontianak* and its sequels makes these films uniquely important to understanding the role of popular cinema in the history of decolonization in Malaysia and Singapore. *Pontianak* was released just three months before Malaysia achieved independence from Britain on August 31, 1957, and the last of the series—*Pusaka Pontianak / The Accursed Heritage*, directed by Ramon Estella—was made in 1965, the year that Singapore became an independent nation. Between these years, the processes of socially, politically, and imaginatively constructing new national identities were unfolding across many public spheres. As we shall see, popular cinema was not generally understood to participate in serious questions of anticolonial thought, but this chapter argues that we should take the pontianak seriously as an avatar of decolonization. That the most popular films of the era were based on a reimagining of traditional Malay beliefs, and yet appealed to a racially diverse audience, reveals a structuring tension between pluralism and Malay nationalism that I will argue

POPULAR HORROR AND THE ANTICOLONIAL IMAGINARY 41

FIGURE 1.1 A Chinese-language advert for *Anak Pontianak* (Estella, 1958) illustrates the film's multilingual address. (Image courtesy of Wong Han Min.)

is central to understanding both the culture of the period and the semiotic potency of the pontianak. This tension must be understood in relation to the industrial context within which the pontianak films were produced. The Singapore-based, Malay-language studio system reveals both the effects of British colonialism and the ways in which anticolonialism remade the institutions of popular cinema. By locating the *Pontianak* series within histories of the studio system and the concurrent political transformations of the 1950s and 1960s, this chapter aims to illuminate the role of the pontianak—and Malay cinema more broadly—in creating cultures of decolonization.

COLONIAL TRANSNATIONALISM IN THE MALAY FILM STUDIOS

Filmmaking in colonial Singapore was transnational from its beginnings. The first film made there was *Xin Ke / The Immigrant* (Guo, 1926). It was produced by Lui

Peh Jing, who wanted to make films for the Chinese immigrant population, so transnational movement and multiracial citizenship were visible at the outset of Singaporean film production.[13] Mohd. Zamberi Malek and Aami Jarr date the beginnings of the Malay-language industry to 1933, "when a group of film producers from India came to Singapore."[14] The first Malay film, *Laila Majnun* (Rajhans, 1933), was produced by the Motilal Chemical Company of Bombay (based on an Arabic story, itself popularized by a Persian poem), and it featured Egyptian costumes and dances, so even the film lauded by Malay scholars as the start of a national film industry is profoundly transnational in nature.[15] William van der Heide argues that one can't apply a national cinema model to Malaysia because it doesn't have a homogenous central culture.[16] Although this claim might fall into the common trap of simplifying national cinema studies, it does raise the difficulty of thinking the nation in Malaysia and Singapore, where the politics of internal heterogeneity are particularly thorny. British colonialism in Singapore and Malaya produced migrations of Indian and Chinese populations, including film industry talent and immigrant audiences. And the Malay film studios—Cathay Keris and Shaw Brothers—are part of this mode of colonial transnationalism.

To ground our understanding of the global flows that traverse the pontianak film, we must consider its production context. The Singapore studio system was structured by a transnational division of labor that illustrates both the racializing effects of British colonialism and the circulatory flows of world cinema in the 1950s. Hamzah writes that "the Malaysian film industry was founded on Chinese money, Indian imagination and Malay labour," and this pithy formulation sums up a complex series of class and racial hierarchies.[17] In both major studios, most directors were hired from India or the Philippines. Many of the crew were Chinese, often from Hong Kong or Shanghai, but almost everyone in front of the camera was Muslim Malay. In the early years, actors came from traditional Malay theater and opera. In what was a highly segregated culture, the film industry was one of the few places where Indian, Chinese, and Malay people worked together and this polyglot mix surely made for a challenging creative environment. Scripts were generally written in Hindi, Tamil, Telegu, or English, and translated into Malay, and dialogue could end up as a mixture of "bazaar Malay, Indonesian and Chinese."[18] The actors often only spoke Malay, while the immigrant directors sometimes did not speak Malay, and many above-the-line crew spoke primarily Chinese.[19] Although many people in Singapore were multilingual, there was no dependable lingua franca on set, and labor intersected with linguistic competence and translatability in ways that were both ideologically inflected and creatively consequential. Each element of this system contributed to what we

FIGURE 1.2 A behind-the-scenes publicity shot for *Dendam Pontianak* (Rao, 1957) shows the colonial cosmopolitan mode of production. (Image courtesy of Wong Han Min.)

might call the colonial cosmopolitan mode of production, and in turn affected the form of the films themselves.

The only apparently indigenous aspect of the studio system is the influence of traditional Malay opera and theater, called *bangsawan* and *sandiwara*, respectively. However, these forms are themselves tangled in colonial and transnational histories, and cannot be simply categorized as either "traditional" or "Malay." *Bangsawan* is based on Parsi theater, brought to Penang in the nineteenth century and adapted to use the Malay language and Malay cultural references, along with incorporating European, Indonesian, and Chinese elements.[20] Like cinema, *bangsawan* emerges at the intersection of modernity, technology, and colonial cultures.[21] Tan Sooi Beng argues that *bangsawan* was a transforming popular form in the early twentieth century, and became a common culture for various ethnic groups in Malaya. It was neither wholly traditional nor wholly Malay, but was, like the films it influenced, responsive and hybrid. It is only after the 1970s that Malaysian governments Malayized it, inventing the myth of a purely indigenous tradition.[22] We can see the transnationality of *bangsawan* in *Laila Majnun*, which had been filmed many times in

India, before becoming first a *bangsawan* play and then a Malay film. As Hassan Muthalib and Wong Tuck Cheong describe it, "It was a localized version of Indian culture that was presented to the audience in a format with which they were familiar."[23] Following Tan's account of *bangsawan*'s responsiveness to diverse local cultures, I argue that it is this transnational plasticity that made it so useful for the developing Malay film industry.

For Sharifah Zinjuaher Ariffin and Hang Tuah Arshad, *bangsawan* was crucial to the development of Malay studio film style because most actors in the early 1950s came from theater. Stars such as Kasma Booty began their acting careers in *bangsawan* and so the dominant performance styles and narrative tropes of *bangsawan* and *sandiwara* transferred into cinema.[24] From *bangsawan*, films took a focus on myths and legends, or on contemporary social issues narrated through stock character types.[25] Whether historical or contemporary, stories circulated as repeatable and recognizable, with a play of similarity and difference that translated easily to genre film. Acting style was more performative than naturalistic, characterized by melodramatic exaggeration and emotional display.[26] Songs were also a central part of *bangsawan*, often in routines only tangentially related to the plot, and Timothy White has argued that the musical numbers in Malay films derive from this tradition rather than from earlier modes of the film musical.[27] Both *bangsawan* and *sandiwara* led to long takes and frontality in their cinematic versions, and Jamil Sulong admits that they could seem stagey.[28] For White, though, it's important to recognize the lack of concern for Western verisimilitude in this presentational style, which he identifies with Asian theatrical modes.[29] Many early Shaw films were based on *sandiwara*, and its influence can be seen in films such as *Mutiara* (Hou and Wan, 1938) and *Mata Hantu* (Hou and Wan, 1938).[30] Jamil, who was one of the most prominent directors at Shaw, noted that most of his films had been *bangsawan* plays before being adapted for cinema.[31] Residue of these theatrical forms can be discerned in the pontianak series. Certainly, we will see song sequences and stock characters across the films—Hanita Mokhtar-Ritchie points to comic servant characters as one such type, and they appear in *Gergasi / The Giant* (Ghosh, 1958) and *Sumpah Pontianak / Curse of the Pontianak* (Rao, 1958).[32] There are more direct links too. According to Abdul Razak, the screenwriter of the original *Pontianak*, that film was adapted from a successful *sandiwara* play, and Jan Udhe and Yvonne Ng Uhde claim that its sequel, *Dendam Pontianak*, included aspects of *bangsawan*.[33] However, as Mohamad Hatta Azad Khan points out, the influence of theater waned through the 1950s as staged plays gave way to new cinematic forms.[34]

The most significant transnational aspect of the colonial mode of production was the reliance on foreign directors. Beginning with B. S. Rajhans in 1933, Indian

directors were central to both Shaw's and Cathay's productions. In 1949, Shaw hired a number of Indians, including Krishnan and S. Ramanathan. In 1952–1953, they were joined by K. M. Basker, K. R. Sastry, and B.N. Rao, who would go on to direct several pontianak films.[35] When Krishnan, Rajhans, and Rao moved to Cathay, Shaw replaced them with directors like Phani Majumdar, who would go on to make key films such as *Hang Tuah*. Malay film historians tend to paint the work of these directors in a somewhat grudging light, noting their skills but emphasizing their lack of understanding of Malay customs. Looked at from the perspective of the transnationality of their contribution, however, we can see the breadth of influence that they brought to the industry. The directors came from across India's regional film industries—Sastry was from Karnataka and was a significant figure in Kannada theater and film, Krishnan was from Madras, and Rao was from Kerala. Rao began his career with the Hindi film *Veer Kumari* (1935) but he also made films in Tamil and Telegu both before and after his time in Singapore. The influence of these Indian filmmakers on the Malay industry is indisputable, and it offers another material substrate for the transnational qualities of the pontianak. Kerala has its own version of the pontianak, called a *yakshi*, as well as a rich history of supernatural belief. Rao's affiliation with the pontianak story may well have been prompted by its resonance with the popular spirit cultures of Kerala.

Many studio films were originally Indian scripts translated into Malay, so it is no surprise that aspects of Indian cinematic narrative and form were imported along with the directors. The generic mixing that saw horror films include both romantic and comedic interludes can be traced to Hindi and other regional Indian cinemas, as can the prevalence of song sequences across all genres. Jamil notes that the frequency of songs set in bedrooms and gardens is drawn from Hindi cinema, although, as we have seen, the use of song also derives from *bangsawan*, and we can add Chinese musicals to the list of influences.[36] The generic qualities of Malay cinema often have multiple pathways of descent. Nonetheless, it is the Indian influence that is most strongly recognized by Malay critics. In a history from 1987, Abi writes that "performances have Indian characteristics in which the storyline is embroidered, with the actors dancing and singing in various sad and happy conditions."[37] Mokhtar-Ritchie has described the Indian influence in more concrete terms of melodramatic traditions, citing Ravi Vasudevan's work on Hindi cinema to explain Malay cinema's animating narrative binaries of city and country, sexuality and purity, East and West.[38] Shahrom Mohd. Dom locates a contrast between Malay content and Hindi cinematic form. For him, "the form, that is, the technique and the style, such as treatment, characterisation, use of angles and camera, framing, space, time, editing and music, are very

much Hindustani."³⁹ Shaw and Cathay-Keris attracted Filipino directors too, establishing a different set of transnational influences. The first director to arrive from the Philippines was Eddy Infante, in 1955, followed by T. C. Santos and Ramon Estella in 1957 and Rolf Bayer and Lamberto Avellana in 1958.⁴⁰ Estella would go on to direct *Anak Pontianak / Son of the Pontianak* in 1958, a year after his arrival, and *Pusaka Pontianak* in 1964. Zamberi and Aami have argued that whereas the Indian directors brought a focus on performance, comedy, and music, the Filipino directors introduced more naturalistic acting styles, imaginative camerawork, and faster editing.⁴¹ In these stylistic differences, we can see how the migration of transnational talent exerted multiple pressures on the development of studio films.

In seeking to understand why Shaw and Cathay leaned so heavily on foreign directors, Malay critics often see cultural connections at the foundation of the practice. Rolando Tolentino claims that "Philippine artisans assisted in the development of an informal yet significant pan-Malay cinema, as the countries involved . . . stressed on the ethnic identity of a trans-Malay identity."⁴² In this logic, Filipino directors could be recuperated as not foreign but ethnically Malay. Similarly, dominant accounts of the use of Indian directors follow Hatta Azad Khan in locating an affinity in the long history of Indian civilizations in Malaya. From the region's period under Hindu rule, Malay culture adapted literature such as the Ramayana and the Mahabharata into traditional art forms like *wayang kulit* and *mak yong*. Indian cultural heritage and ways of telling stories are familiar in Malaya, and Malay contains many Sanskrit loanwords. For these reasons, he argues, Indian films were popular even among Malay audiences, who could follow a little Hindi, and "stars like Nargis, Madhubala, Suraya, Dilip Kumar and Raj Kapoor became household names to the Malay film-goers."⁴³ However, even in this affirmative argument, Hatta Azad Khan acknowledges there were hard-nosed economic reasons for the practice. Given the depressed state of the Indian economy after independence, Indians offered cheap creative labor. Moreover, lower-level directors might have struggled to find regular employment in the more competitive Indian studio systems and would be tempted by opportunities in Singapore.⁴⁴ The real question, as Rebiah Md Yusof points out, is not why the studios hired Indians, but why they did *not* hire Malays.⁴⁵ The Singapore film industry welcomed overseas directors yet Malays themselves were excluded from the top jobs.

The colonial cosmopolitan mode of production was thus at once racially diverse and highly racialized. Whereas Indian, Chinese, and European people populated all areas of production behind the camera, Malay workers mostly remained in technical jobs and could not rise to above-the-line positions. Hatta Azad Khan

describes the involvement of Malay technical staff in the early 1950s as "very minimal," and notes that most Malays in the industry got their start as boom operators, as focus pullers, or in continuity. Abdul Rahman became the first Malay cameraperson in 1953 and the highest-level job held by a Malay in the early 1950s was first assistant director.[46] In *Penghidupan / Life* (Krishnan, 1951), *Pontianak* star Maria Menado's first film, the assistant camera person, assistant sound person, and assistant director were all Malay, but the directors of photography and sound were Chinese, and the director Indian. By the late 1950s, a few Malays were reaching the level of editor and art director, but not director. Salleh Ghani argues that the importation of foreign directors directly caused the lack of opportunities for Malay talent, and this belief is standard across Malay writing on the period.[47] For Malay film historians, the situation of Malays being excluded from directing vividly illustrates colonial discrimination.[48]

The hiring of Malays as assistant directors bears closer examination, because the development of this particular role reveals much about the way colonial racialization restructured modes of production. First assistant directors (ADs) generally organize the set and are responsible for communicating with everyone and keeping the production moving to schedule. In the Malay studio system, the first AD role was adapted to include translating between director and cast, in order to compensate for the linguistic gap between foreign directors and Malay actors. Scripts were often written by the directors in English and thus the cast could not read them, or were written in Malay and thus the director could not read them.[49] In either case, a significant amount of translation was needed. In the case of *Penghidupan*, first AD Haji Mahadi was credited with writing dialogue, although the story credit went to Krishnan. Because the role required fluency in English and Malay, all first ADs were Malay.[50] For Hatta Azad Khan, "The all-Malay cast might have given them some problems, but with a sufficient working knowledge of English and a helper who would then translate the directions and dialogues, the Indian directors managed to have good creative control of the films."[51] In practice, this meant that the assistant director's role morphed from being production-oriented into demanding a more creative contribution through the direction of actors. For example, in this photograph from the set of *Pontianak Gua Musang / The Pontianak of Musang Cave* (Rao, 1964), assistant director Shariff Medan is clearly directing the performance of Suraya, working with her on acting coy. We might imagine the frustration of these assistant directors who, perhaps in addition to their usual role, were also directing actors, even if they were to some degree relaying the instructions of the director. Sharifah Zinjuaher and Hang Tuah articulate the feeling of Malays in the industry who asked what the role of a film director who doesn't know the language of the script even is.[52]

Penolong pengarah Sharif Medan bersunggoh2 mengajar seniwati Suraya dalam satu adigan "malu2 kuching" yang bekali2 agak payah di-lakunkan oleh Suraya. Namun, akhir-nya Suraya berjaya juga membawa peranan "malu2 kuching" itu menurut kahendak pengarah.

FIGURE 1.3 Popular movie magazine *Mastika Filem* highlights the work of Malay assistant directors in directing actors. (Image courtesy of Wong Han Min.)

Salleh adds to this situation the work of cultural translation, in which first ADs helped directors to represent Muslim and Malay customs with less inaccuracy: "The assistant director was also responsible for maintaining Malay customs, if there were scenes in the film that referred to Malay *adat*."[53] Sometimes, this task would focus on the quotidian, as in *Mahsuri* (1958), where the assistant director told Rao that it would not be historically accurate for a character to wear a skullcap indoors.[54] In other cases, the interpretation of *adat*—Malay customary laws that predate Islam—might be open to debate and certainly more ideologically weighted. Hatta Azad Khan provides two examples. One is with Rao, shooting

Gelora Hidup (1954), in which a young woman tries to get an office job, a situation that the assistant director complained only a rich, urban woman would do. Such questions of women's access to the modern public sphere were thematically central to studio-era films and I will return to them in the next chapter. For now, we simply note that Khan's further complaint that "Malay women were portrayed as ill-mannered and full of lust" speaks more to conservative perspectives on women's sexuality in modernity than to the narrow issue of ensuring cultural accuracy as a production process.[55] In any case, this system was not designed to produce either cross-cultural understanding or a smooth chain of command on set. Hassan and Wong note that the cast and crew were not always highly educated and their "native informant" status did not always produce accurate information, while Salleh describes frequent disputes between directors and ADs over the perceived need to represent *adat* correctly.[56] This adaptation of conventional production practices illustrates at once the transnational nature of the colonial studio system and the racialized hierarchy that required such cumbersome accommodations.

Popular movie magazines and newspapers provide evidence that anticolonial discourse about the need for Malay talent in the film industry circulated to a wider public. For instance, that the role of Malay assistant directors was politically overdetermined can be seen not only materially, in the mode of production itself, but in the way that popular journalism talks about these figures. *Majallah Filem* of October 1964 reported that "assistant director S. Sudarmadji, who has worked as assistant director to P. Ramlee, is now put on task by M. F. P. to assist Ramon A. Estella in the making of *Pusaka Pontianak*."[57] Similarly, a preview article on *Pontianak Gua Musang* in daily newspaper *Berita Harian* references Rao as director and Shariff Medan as assistant director.[58] It would be unlikely for the assistant director of a film to be mentioned with such prominence and frequency in other studio systems. Rather, the reporting on Sudarmadji and Shariff in 1964 illustrates a discursive effort to support the careers of Malays and to boost their work. Indeed, by the time *Pontianak Gua Musang* was released in 1964, a non-Malay director was seen as a liability in the popular press. One highly negative review insists that "only the Malay people can build and improve the status of the Malays in the field of politics. And the same applies to the film industry. Specifically, only Malay directors know how to fulfil fans' appetites as well as to highlight clearly the living conditions of their society in films." What the article sees as the film's plot inconsistencies and longueurs are attributed directly to Rao's status as a non-Malay, who is thus unable to understand what will appeal to Malay audiences. It is not simply that Malays should not suffer discrimination, but that Indian directors are "outdated" and unable to connect with an ethnically imagined

audience.⁵⁹ Foreign directors are associated with decline and outdated aesthetics, whereas Malay directors are linked to youth, vitality, and the future of the industry and, implicitly, the nation.

The pontianak films are made in the period in which this racialized mode of production is transformed, which is also to say, in the volatile and contested years of decolonization. The decade from 1946, when the Malayan Union was founded, to the declaration of Malaysian independence in 1957 was characterized by anticolonial agitation and the development of political parties and systems of governance in Malaya and Singapore. In this period of managed decolonization, the British government had a strong economic stake in presenting itself in a positive light: because of its tin and rubber resources, Malaya in the 1940s contributed more to the United Kingdom than all of its other colonies combined.⁶⁰ Britain had a vested interest in taking an active role in determining the future geopolitical orientation of the postcolonial states to come. As I will discuss in more detail later, racial politics was a central vector of this relationship, with overt declarations about the need for racial equality underwritten by a typical colonial history of "divide and rule" politics. At the same time, Singapore's relationship to its northern neighbor was also a source of conflict in these years. Between 1957 and 1963, Singapore was still a British colony, although it was granted autonomy and self-government in 1959. Thus, debates over the postcolonial future in Singapore developed in sometimes-distinct ways from those in Malaysia, and the decision to join Malaysia in September 1963 was a key moment of contestation. The relationship of Malay culture to Chinese culture was fraught, with the question of which group could claim majority status as an explicit sticking point in debates over national identity and political power. In August 1965, the Malaysian parliament voted unanimously for the expulsion of Singapore from the union, in part over Singaporean demands for equal status for Chinese citizens. Even from this brief account, it should be clear that to produce and advocate for Malay films in Singapore during these years is not a practice that can stand outside of anticolonial politics.

I argue that the Singapore studio system is a significant center of anticolonial cultural change, and that the textual politics of the pontianak film should be read in dialogue with shifts in this mode of production. Virginia Hooker has studied the wider culture of late-colonial Singapore and explains that, "as the centre of broadcasting, publishing, printing and a young film industry, Singapore attracted hopeful journalists, writers, singers, musicians and film stars. As a minority in a cosmopolitan, competitive and lively international city, which was close to the events of the Indonesian Revolution and then the independent Republic, the educated Malays who had gathered in Singapore were inspired to action."⁶¹ As things became more difficult for leftists and radicals in Malaya under the

Emergency, Singapore became even more of a hub for activism. According to T. N. Harper, "Performance became one of the last refuges of the Malay radicals. The world of the movies, cabaret bands and starlets was a network of gifted individuals who set the tone of anti-colonial cultural politics. Important political networks were formed in the war—of journalists, actors, film-makers and propagandists."[62] One example for Harper is S. Roomai Noor, one of the first Malay directors, who was a member of the left-wing Malay Nationalist party (Parti Kebangsaan Melayu Malaya) and "energetically promoted Malay culture in film circles."[63] S. Roomai Noor exemplifies the new generation of Malay creative talent who were agitating to change the studio system, and a parallel effort took place through popular journalism. Writers for film magazines such as *Majallah Filem* and *Berita Filem* argued that "directors who directed Malay films must first of all understand Malay customs and traditions."[64] Through the 1950s, one aim of anticolonial activism was to get more Malays into above-the-line positions in the film industry, both to open up career paths for Malay creative talent and to change the nature of the stories that were being told.

This effort was successful: the first film directed by a Malay—*Permata di Perlimbahan / Jewel in the Slum* was directed by Haji Mahadi in 1952 and was considered by Shaw to be such a flop that no other Malay directed a feature for three years, until P. Ramlee's first film, *Penarek Beca*, in 1955. But from 1955 onward, things began to change rapidly. In 1956, S. Roomai Noor directed and starred in *Adam*, Cathay Keris's first Malay-directed feature, and soon former assistant directors like Jamil Sulong were working on Malay-centered films, such as historical epics set in the precolonial era and stories based on Malay myths.[65] Cathay hired M. Amin to direct the historical romance *Lancang Kuning* (1962) as part of a plan to develop more Malay directors: Amin had previously been an assistant director to Hussein Haniff and K. M. Basker. Lim Kay Tong argues that Hussein, who made classics such as *Hang Jebat* (1961) and *Dang Anom* (1962), was the first Malay director to make films without any Hindi elements.[66] As more Malays moved into directing, both the narratives and the style of studio films changed. A similar shift took place in the source of scripts. Some Indian directors turned to Malay stories and screenwriters: for example, Krishnan adapted the Malay novel *Cinta Gadis Rimba* by Harun Aminurrashid into *Virgin of Borneo* (1958).[67] Malay directors even more so drew from literary and historical stories and also developed more realist representations of contemporary Malay life. Horror films don't fit neatly into the quality discourses of either historical epics or contemporary realism, but they do nonetheless draw strongly on Malay culture. When Zamberi and Aami speak of Malay identity becoming evident in studio films, their examples include the horror films *Hantu Jerangkung* (Basker, 1957) and *Anak Pontianak*.[68] In 1964, Loke Wan Tho appointed

S. Roomai Noor as associate film producer, in charge of all Malay film production. Loke said, "It is now time for us to have Malay film producers of Malay films."[69] By 1965, *Pusaka Pontianak* was the very last film at Shaw to be directed by a non-Malay. Within a decade, the role of Malays in the industry had been completely reconfigured.

The pontianak films provide an illuminating example both of the colonial cosmopolitan mode of production and of its dismantling. I have already noted B. N. Rao's prominence in both South Indian and Malay filmmaking. Ramon Estella, who directed the Shaw films, had worked in Vietnam, Italy, and the United States as well as in Singapore and the Philippines. The transnationality of the films' mode of production is visible across their credits. *Sumpah Pontianak*, for example, had a Chinese sound crew (Chua Hung Boon and Chai Yong Chang), an Australian director of photography (Laurie Friedman), and a Malay editor (Hussein Haniff). However, unlike films that simply translated Indian scripts into Malay, the pontianak series was based on indigenous stories. A *Straits Times* article published in *Pontianak*'s opening week finds that "local films of the calibre of 'Pontianak' are welcome and stimulating, not only as a means of developing Malayan screen talent, but because they form a link with the old Malaya and keep its rich traditions alive."[70] Another article reports on the film's press conference, noting, "It is Mr Loke's contention that, for the major motion pictures of the future, the motion picture industry is going to have to look to—and depend upon—interpretations of fabulous legends of Malay folklore."[71] From the very beginning of the series, pontianak films are explicitly linked to the cultural value of telling traditional Malay stories and, at the same time, the nurturing of local Malay talent. The Cathay films were written by Malay writer Abdul Razak, in collaboration with the films' Indonesian star and his then-partner Maria Menado, who drew on the shared animist beliefs of Malaya and Indonesia. (Chapter 5 will address the role of animism in the films in depth.) Although historical epics told stories of Malay national heroes, the pontianak series is the first to reconfigure a popular genre through a Malay worldview. Both Abdul and Maria went on to become key figures in introducing Malay cultural narratives to postcolonial cinema, and Maria's career is particularly illuminating.

MARIA MENADO AND MALAY STARDOM

Although she is one of the most famous stars of Malay studio cinema, Maria Menado is Indonesian. She was born in Sulawesi in 1931 as Liesbet Dutulong and

came to Singapore as part of an international beauty pageant, in which she won both International Beauty and Kebaya Queen. As a result of this success, she was offered a screen test and subsequently a film contract with Shaw. She shot her first film, *Penghidupan*, at the age of nineteen. Even at this early point of her career, we can see in the categories of the pageant a popular enactment of both transnationalism and Malay identity. The *baju kebaya* is traditional Malay dress for women, which itself navigates between discourses of modesty and sexiness. Likewise in her own national background, Maria came from the same region and was easily accommodated as a local star, even as she retained a certain foreignness or appeal to an identity beyond the nation. Her stage name resonates with this regional identity, and with colonial and anticolonial histories. She was born in Tunsia, in the province of Menado. Thus, when choosing a professional name, she took as a family name a part of Indonesia, marking herself as ethnically Malay but not from peninsular Malaya. When she was still a child, the fighting between nationalist forces and the Dutch colonists prompted the family to move to Jakarta.[72] Folded within her personal journey from Menado to Jakarta and thence to Singapore is a violent anticolonial narrative that might well resonate in Malaya, where the Indonesian struggle for independence was a strong political reference point.

If the name "Menado" cannily navigates Malay belonging with regional difference, Maria's choice of given name is stranger, creating an uncanny colonial echo. In 1950, the region was gripped by a scandal that centered on a white Dutch-Indonesian child named Huberdina Maria Hertogh. During the war, Hertogh's mother had left her in the care of a Muslim friend of the family, but had been captured by the Japanese before she could retrieve her daughter. For reasons that are not entirely clear, the woman who was looking after Maria, Che Aminah binti Mohamed, determined to keep her permanently, and renamed her Nadra binti Ma'arof. Her Dutch family spent years searching for her and eventually traced her to Terengganu, Malaya, at which point the child had no memory of her original family. A court case ensued, and when the judge determined that thirteen-year-old Maria/Nadra had to be returned to her birth parents, riots broke out in Singapore, in which eighteen people were killed. The affair was framed as one of Islam versus Christianity, and anticolonial versus colonial power, with the affectively powerful figure of the innocent girl at its semiotic core. In interviews, Maria states that she was fascinated by this story and that it influenced her choice of stage name.[73] The name "Maria" certainly had plenty of currency in Singapore in 1950, but as Hertogh's Dutch name, it makes an odd choice for an up-and-coming Malay celebrity. Indeed, since Maria Menado was a Christian and only converted to Islam upon marriage, her choice of Hertogh's

Christian name adds another signifier of difference to the identities encompassed in her name. Maria's star persona, like her name, plays with similarity and difference: she navigates the local and the transnational, the demure Malay woman and the modern, sexy film star, Christian and Muslim, insider and outsider.

Examining Maria's star persona opens up the intersection of gender with the questions of race and anticolonial politics that I've been analyzing. Chapter 2 will address the gender and sexuality of the pontianak in relation to cinematic representation, but Maria's career illustrates its integral importance to institutional histories too. Her emergence as a starlet through a beauty pageant does not suggest a feminist narrative, but Maria became an advocate both for strong female roles and for cinema's role in developing Malay culture. *Pontianak* is the first film in which Maria is able to develop these two passions, both in her performance as the lead and in her role in developing the script. The screenplay is credited to her then-husband, Abdul Razak, but as she explains, "I helped him with some ideas. When I was living in Indonesia, we had tales about the pontianak who is a woman who died during childbirth. Before she is buried, needles are placed on her fingers so that when the pontianak she becomes tries to climb trees, the needles would prick her fingers and stop her from climbing. She is a very beautiful woman whose feet never touch the ground.... I used to tell him these stories, and when he wrote the story at night, he would write it in his room and not outside. He got quite scared!"[74] Maria's joke about Abdul's fear of the pontianak works here to cover the awkwardness of disclosing that she originated the ideas for the film. Whatever the dynamics of their partnership, Maria developed a star image characterized by playing Malay women with strength and purpose.

After the success of the pontianak films, Maria shifted studios to take on a very different female protagonist role for Shaw in *Mata Hari / The Rape of Malaya* (Estella, 1958). In this World War II drama, she plays the daughter of a village leader who is captured by the Japanese during the Occupation and, after witnessing atrocities, forms a guerrilla force to fight back. Publicity shots of Maria in the jungle carrying a machine gun speak to her desire to act in realist films as well as folkloric ones and to be seen as a serious actor and not only a beauty. In an interview, she emphasizes female agency, saying that "Mata Hari herself is an active character, who plays a leading part in the Resistance Movement against the Japanese."[75] It is not hard to see how this narrative of resistance to an occupying power might have anticolonial resonance in the late 1950s, while at the same time leveraging memories of the war to inspire patriotic affect. In the early 1960s, Maria took on several historical roles—in a genre that often replicates patriarchal tales of kings and knights—and here again she chose to highlight stories of fearless women. Thus, in *Tun Fatimah* (Salleh, 1962) she plays a female

FIGURE 1.4 On the cover of *Mutiara* magazine, Maria Menado embodies a traditional Malay beauty; in the press kit for *Mata Hari* (Estella, 1958), she takes on a more active persona. (Images courtesy of Wong Han Min.)

warrior from Malay court history, who patriotically raises an all-female army to fight the invading Portuguese colonists. In *Siti Zubaidah* (Rao, 1961) she plays another historical figure, this time a Sultanah who rescues her husband from kidnappers. In each of these roles, Maria's character fights for Malaya, taking up a struggle when men are weak or absent. We can see from this selection of her best-known roles that a key part of Maria's star appeal—and this emerges first in the *Pontianak* series—was a feminist embodiment of active female protagonists, combined with an anticolonial commitment to representing a heroic vision of Malay culture on-screen.

At the same time as she was developing this quite radical star persona, Maria was establishing a power within the industry that was unprecedented for a woman. She first gained industry leverage with the kind of accolades that reward female actors for their appearance. In November 1957 she was named the "Most Beautiful Woman in Malaya" and the "Best Dressed Woman in Southeast Asia."[76] Maria used her fame to make atypical decisions. In December 1958 she was summarily sacked by Shaw Brothers when the *Straits Times* reported that she was planning to star in an independent production, *Lion of Malaya*.[77] Shaw considered this to

be "a flagrant breach" of her contract, but Maria retorted that the production would have taken place after her contract with Shaw had ended, and insisted that the real problem was that she had allowed a photograph of her to be published without Shaw's permission.[78] Her sacking was front-page news, and the story provided space for her to complain about the studio's excessive control over her image. After leaving Shaw, Maria went to Indonesia to shoot *Hilang Gelap Datang Terang / Every Cloud Has a Silver Lining* (Ho and Usmar, 1959) and the following year she traveled to India to film *Singapore* (Samanta, 1960) with Shammi Kapoor, even learning some Hindi for the part.[79] She turned her sacking in Singapore into an opportunity to make international films, something very few Malay actors were able to do. Working on Indonesian and Indian productions suggests that Maria's advocacy of Malay culture was not based on a narrow Malay nationalism, a point to which I will return later.

Maria's most significant achievement was to set up Maria Menado Productions, making her the first woman to become a film producer in Singapore. In the vertically integrated studio system, it was hard for independent producers to find a foothold. Maria took advantage of her relationship with Cathay, making a deal in which she gained use of their studio facilities in return for a cut of her films' profits.[80] Maria Menado Productions produced a string of successful films, always partnering with her pontianak directors, including *Siti Zubaidah*, *Raja Bersiong / The Fanged King* (Estella, 1963), *Darahku / My Blood* (Estella, 1963), *Bunga Tanjong / Cape of Flowers* (Estella, 1963), and *Pontianak Kembali / Pontianak Returns* (Estella, 1963). Many of the films, like *Siti Zubaidah* and *Bunga Tanjong*, were female-centered. Maria also continued her focus on Malay legends with *Raja Bersiong*, a supernatural historical epic that features a king who becomes a vampire. Her last film as producer was *Pontianak Kembali*, in which she returns to her most famous role. Her star persona incorporated a reputation for hard work and exceptional achievement: an article about the production of *Bunga Tanjong* boasted that nobody can compete with Maria Menado, who can work up to sixteen hours a day.[81] Indeed, although she is long retired, Maria gave an interview in January 2019 in which she called upon female filmmakers to be bold and to make films that would enliven the local industry.[82]

If Maria's image as an actor and producer speaks of the intersection of female agency and Malay cultural advocacy in the studio system, then the next chapter in her life makes all too clear the continued forces of patriarchy in traditional Malay power structures. In 1963, she married the sultan of Pahang, Sultan Abu Bakar Ri'ayatuddin Al-Muadzam Shah. The sultan decided not only that Maria should quit her acting career (which, by all accounts, she was happy to do), but that her films should no longer be screened. Immediately, Maria shifted from

being one of the most famous and recognizable public figures in Malay cinema to being invisible. There are conflicting versions of what happened next, but the core of the story is that Cathay producer Ho Ah Loke was so incensed at being unable to screen his most valuable films that he destroyed the negatives. In the account that has attained "print the legend" status, he threw them into a river.[83] Some sources suggest that it was not until a decade later that he discarded them, and more out of a lack of storage than frustration over his star's marriage.[84] In any case, *Pontianak*, *Dendam Pontianak*, and *Pontianak Kembali* are lost, and although fans have long hoped that a positive print or a television transfer might emerge one day, this hope has been disappointed. Maria herself blamed Ho. She says, "I was so angry and sad as all my hard work had gone to waste. Those were the movies that depicted my youth and talent. It was supposed to be passed down to my children and grandchildren as heritage.... I had sleepless nights thinking about what happened. It was like losing someone you love. I was so hurt I could not forgive Ho. I never spoke to him again."[85] The destruction of these films is a great loss for film history, but the story is also legible in relation to the cultural politics that I have argued Maria's career animates. The films are lost because one powerful man didn't want other men looking at his wife, and because another could not extract value from his investment in her image. Patriarchal ideas of women as property and looking relations as sites of social and religious power are the themes of the films and also the exact power dynamics that have led to their destruction. I haven't seen them and neither have you because the sultan of Pahang believed that he owned all past and future images of Maria Menado, and because Ho Ah Loke responded to being thwarted with violence against those very images. From her role as the pontianak to her off-screen achievements, Maria's career speaks vividly of the intersection of gender with anticolonial discourse in the Malay film industry.

ANTICOLONIAL CULTURE AND THE PLACE OF CINEMA

The efforts of figures such as Maria Menado, Jamil Sulong, and S. Roomai Noor to transform the studio system participated in a larger anticolonial debate on the place of Malay politics, culture, and language in the modern world. An editorial in *Mastika* in 1953 declaimed that "we cannot wait for the country to become independent, nor the people to become prosperous before the question of culture is discussed."[86] The concentration of leftists and other radical thinkers in Singapore in the 1950s made for a rich mulch of activism. As

Timothy Barnard and Jan van der Putten put it, "Although quite diverse and individualistic, post-war Malay political, journalistic, and artistic networks, with roots in the Malay peninsula as well as Indonesia, intersected to such an extent that every journalist was potentially a politician, an author of fiction, a publisher, a graphic designer or cartoonist, or an actor in a theatrical troupe or on film."[87] Indeed, because of the political crackdown in Malaya when Britain declared the Emergency in 1948, it became all the more important to develop anticolonialism as a cultural force. Thus, for Harper, "It was precisely because the opportunities for open anti-colonial politics diminished, that in the arena of cultural life the space was found to mount the most effective challenges to the new imperialism of the 1950s."[88] By considering the broader context of anticolonial culture, we can see how cinema in general and the pontianak film in particular spoke to pressing questions of Malay modernity and worldliness.

The most significant cultural organization of the period was ASAS 50 (Angkatan Sasterawan 50), a group of writers, broadcasters, and journalists launched in 1950 by Jyny Asmara, Kamaluddin Mohammad (known as Keris Mas), and over twenty others. The group grew to almost one hundred members, and anticolonial ideas were central to their mission, along with critiques of Malay feudalism and calls for modernization.[89] They spoke in favor of writing that "had the purpose of arousing a spirit of independence, a spirit of 'standing on your own feet' like a people which were respected and had their own identity, to defend justice and oppose oppression."[90] Their slogan was "Seni untuk Masyarakat" ("Art for Society") and this sense of social, political, and pedagogic purpose encapsulates the stakes of culture for anticolonial activists of the period. Scholars of Malay film history have excavated the links between ASAS 50 and cinema's anticolonialism. Barnard notes that Jamil Sulong, Hamzah Hussin, and S. Roomai Noor were all members, while B. N. Rao was known for his support for the group's ideals. Even P. Ramlee, the most influential studio star, made public statements that were in line with the ideas of the group.[91] The film magazine *Bintang*, which Ramlee published, shared an office with ASAS 50, and the magazine's editor, Fatimah Murad, was married to an ASAS 50 writer.[92] Many of the major players in the transformation of the studio system were important participants in this very public-facing network of anticolonial debate.

However, despite these strong connections between the anticolonial writers' movement and the film industry, Malay anticolonialism found it hard to imagine cinema as a venue for any kind of cultural change. The ASAS 50 writers were highly invested in modernization, but cinema was not the mode of modernity that they found to be valuable. According to Hooker, they felt that Malay literature lagged behind that of the West and they studied European and American

literary forms. Magazines such as *Mastika* published translations of Chekhov and other high-cultural figures.[93] They certainly had an elitist viewpoint in which only high culture could be a significant force for change whereas popular culture could at best disseminate existing ideas. Barnard and Putten write that the Malay intelligentsia saw films merely as "an avenue for reaching a mass audience" and this attitude suffuses anticolonial writing on culture.[94] In addition to this bourgeois attitude, part of the problem may have been that the terms of debate for the ASAS 50 writers just didn't make sense for cinema. Keris Mas, Hamzah Hussin, and others debated questions of realism and pedagogy in literature, interrogating whether art should focus on guiding the people toward a particular destiny in the postcolonial era, or whether this approach risked becoming propagandistic. Hooker points out that, given Malay traditions of didactic literature, ideas of engaged realism made more sense in the national context than an art-for-art's-sake logic.[95] But neither pedagogic realism nor European modernism had much relevance for popular genre cinema, and so cinema simply didn't figure in the period's most urgent debates on politics and aesthetics.

Worse, for anticolonial writers, cinema often figured not as a space of potential for indigenous representation but as part of a moral panic about so-called "yellow culture," which is to say the nefarious influence of Western values. Harper cites one newspaper's claim that "the anti–yellow culture movement cannot be separated from the merdeka movement," and so moral panic was discursively bound to Malay nationalism.[96] Popular cinema was a prime example of Western immorality, and calls to increase film censorship went hand in hand with demands to restrict the status of women in public life. In some ways, this is a conservative strand of anticolonial thought, or at least one that led to conservative policy in the postcolonial era. But its logic is complexly entwined with debates on how to be in the world as a postcolonial nation and how to navigate those global, capitalist flows that were impossible to avoid. These double binds of postcoloniality were clear to the editors of *Penulis*, which was the journal of the Malay National Writers' Association and a central venue for ASAS 50 writers. In their first editorial, the editors draw a distinction between valuable ways of drawing from the West—for instance, through science and technology—and those features of Western society that should be avoided. They critique those in the field of art and culture who blindly follow the West because they see it as international and modern, arguing that "the national spirit in Asian and African countries is fundamentally a desire to defend themselves from Western influences."[97] This rhetoric switches from acknowledging that newly free nations are surrounded by "oceans of Western culture" to presenting that culture as fundamentally a moral problem. They write that, "It's clear to see that we are in the habit of accepting the

very worst elements of Western culture" and the word choice (*terburuk*) implies not merely lower quality but crude, violent, and crass.[98] The outcome, they say, is that "the culture that they export, whether its films, records, or books, are filled with content that can undermine the morality and ethics of our nation."[99] Film is rarely mentioned in *Penulis*, but here it appears specifically as an example of Western immorality and obscenity.

There's a tension here between, on the one hand, the positive language of modernization, learning from Western literature and science in a narrative of postcolonial progress and international cooperation, and, on the other hand, a strongly worded attack on Western popular culture as dangerous and immoral. This negative attitude toward popular culture affected how these cultural gatekeepers would view domestic cinema too. That anger toward Western influence focused so strongly on popular culture rather than on art and literature, or even on Britain's economic relationship with Malaysia and Singapore in the 1960s, illustrates the growth of cultural conservatism in anticolonial circles as well as the continued dominance of class elites to the imagining of postcolonial life. *Penulis* writers saw Western high culture as valuable within the spheres enjoyed by male elites in government, business, and the arts, but the popular culture enjoyed by ordinary Malays as dangerous. Modernization forced thousands of people away from rural communities, and moral panic conjured visions of a vulnerable *kampung* girl endangered by the sinful world of the big city. Aihwa Ong describes young female factory workers accessing Western pop music, fashion, and cinema, and anti–yellow culture discourse played on fears of pop culture's detrimental moral effects.[100] A poem published in *Mastika* in 1959 refers to "the shame of girls playing in entertainment" and "our daughters being thrown into the middle of the street."[101] There is a fear of urbanization here, in which daughters would be safe in the *kampung* but are being exposed to the wilds of the city. The idea of the "street" and "entertainment" as places that are especially shameful and are exposing for women has resonance with discourses of European and American modernity, in which film culture was also seen by conservatives as a threat to young women. Whereas activists in the film industry saw their push for Malay representation as anticolonial, for many anticolonial writers, cinema was tainted by Western morality from the start.[102]

Hooker cites Partha Chatterjee's influential argument about the material and spiritual spheres of culture as a way of explaining the Malay embrace of Western technology but rejection of so-called Western values, and we can extend this reference to account for anticolonial attitudes to cinema.[103] Chatterjee argues that "anticolonial nationalism creates its own domain of sovereignty within colonial society well before it begins its political battle with the imperial power. It does

this by dividing the world of social institutions and practices into two domains—
the material and the spiritual." He continues, "The greater one's success in imitating Western skills in the material domain, therefore, the greater the need to preserve the distinctness of one's spiritual culture. This formula is, I think, a fundamental feature of anticolonial nationalisms in Asia and Africa."[104] This logic is absolutely at work in the discussions in *Penulis* around worldliness, in which the external spheres of science, technology, and even literature constitute a form of valuable modernity and globalizing progress for Malay culture, but Western popular culture represents an urgent threat to the spiritual realm of Malay values and identities. Chatterjee's theory explains the extent of the campaign against yellow culture, in which outrage against the supposed immorality of cultural imports could gin up support for guarding spiritual Malayness within anticolonial politics. Arguments against Western cinema helped produce Malay ethnonationalism, a deeply problematic quality of both anticolonial and postcolonial culture that continues to shape Malaysian politics and popular culture into the twenty-first century. But Chatterjee also argues for a transformation of the inner realm: "The colonial state, in other words, is kept out of the 'inner' domain of national culture; but it is not as though this so-called spiritual domain is left unchanged. In fact, here nationalism launches its most powerful, creative, and historically significant project: to fashion a 'modern' national culture that is nevertheless not Western."[105] In this turn, Chatterjee offers the potential to think about popular Malay cinema in a way not considered by the high-cultural discourse of the ASAS 50 and *Penulis* writers. If the novel and other forms of high culture were conceived of as part of the public, outer sphere that might be globally modern, then the popular cinema enjoyed by women and the lower classes might be better understood as located within the inner sphere of culture. However, this inner sphere is not a sacrosanct and unchanging truth but a site of ideological conflict in which national culture is transformed. In the next section, I turn to the pontianak film as the location of precisely such a contestation between reactionary ethnonationalism and modern Malay identities.

THE PONTIANAK AND MALAY IDENTITY

The most troubling aspect of postcolonial Malay culture and politics is the entrenched mode of ethnonationalism known as *ketuanan Melayu*, or "Malay supremacy." This racist form of nationalism had become ascendant by the 1950s, when all the emerging political parties were based on racial allegiance,

anticolonial thought was deeply imbued with communalism, and calls for racial equality and multifaith citizenship were subject to strong resistance. Dominant discourses of Malay nationalism viewed the immigration of a Chinese mercantile class and Indian rubber-plantation workers as threats to the native population and sought to limit both their numbers and their social position. As Harper puts it, "The core notion that arose out of these debates, that of the Malay bumiputera, of son of the soil, and of his entitlement to special rights and privileges in economic life, became the ideological cornerstone of the modern Malaysian state."[106] Anticolonialism called for a *bangsa Melayu*, or "Malay nation," but *bangsa* in Malay also means "race" and the conflation of nation and race has had significant implications both for Malay political and cultural identities and for the status of non-Malay Malaysians in the postcolonial era. Malay studio cinema, which as we have seen was both multiethnic in its mode of production and almost entirely Malay in its screen image, provides a crucial set of texts with which to interrogate this slippery ideological terrain. Whereas anticolonial thinkers of the period had little time for the lowbrow pleasures of popular genres, I argue that the pontianak disturbs dominant visions of Malay identity. In order to understand the ideological realignment from anticolonial activism to ethnonationalism, however, we first have to understand something of the history of racial politics in colonial Malaya.

In his canonical account of the region's ethnic stratification, Charles Hirschman notes that "most important in the creation of Malaysia's present day multiethnic society was the period of British colonial rule."[107] Earlier periods were also characterized by complex transnational social structures, but the British colonial period sets in place the framework of "Malay, Chinese, Indian, and others" that continues to structure Malay racialized politics. From the later eighteenth century, Chinese people emigrated to the peninsula, both fleeing from wars in China and drawn by opportunities in the tin-mining industry. By the end of the nineteenth century, there were more Chinese people than Malays in the state of Johor.[108] Khoo Kay Kim describes the arrival of Indians from the 1830s onward, first to work on British sugar plantations and then during the rubber boom in the early twentieth century.[109] Whereas the immigrants of earlier centuries were traders who mixed together in cosmopolitan port cities, many of the Chinese and Indian people who came to Malaya in the nineteenth and twentieth centuries were indentured laborers, whose conditions of employment were exploitative, and who were trapped on plantations with no opportunity to develop connections with local communities.[110] As a result, Khoo points to the development of almost entirely separate communities. Hirschman compares Malaysia with other multiethnic societies such as Brazil and Mexico in which, significant

structures of racism notwithstanding, some intermarriage has occurred. In Malaysia, by contrast, such intermarriage is in his words "extremely rare" as a result of the geographical, religious, and linguistic separation of ethnic groups that was installed in the colonial period.[111]

Opinion is divided among historians as to what degree the segregation of racialized groups was a deliberate policy of "divide and rule" on the part of the British, or the unintended consequence of colonial economic policy. The idea of a plural society (as opposed to a multicultural one), first proposed by J. S. Furnivall, is one in which different ethnic groups "mix but do not combine. Each group holds by its own religion, its own culture and language, its own ideas and ways. As individuals they meet, but only in the market-place.... Even in the economic sphere, there is division of labor along racial lines, Natives, Chinese, Indians, and Europeans all have different functions."[112] Malaysia is typically discussed as a plural society, and for Daniel P. S. Goh and Philip Holden, British policy created this deliberate segregation through town planning and labor practices.[113] Khoo, who is an eminent Malaysian historian, takes up a revisionist position by disagreeing with the idea of divide and rule. He claims that the idea is perpetuated by the Malay state but he sees it as completely unexamined. He concludes that "ethnic separation was not deliberately designed by the British administration which, in fact, did not know how to overcome the cultural wall which prevented one group from integrating with another."[114] This debate is important in part because, as Khoo implies, the discourse of plural society as a British invention has been deployed not only in the way one might expect, as postcolonial critique, but also in service of the Malaysian state's opposition to racial equality. We will come back to the ideological implications of pluralism, but for now we can conclude that British policy certainly functioned to create communities highly stratified by race, nationality, and class. Whereas Chinese communities formed an urban middle class, Malays were restricted to rural subsistence farming in *kampungs*. Taib argues that British colonial structures worked to modernize Malaya but to keep the benefits away from Malays, and this structure baked racial resentment into Malay anticolonialism.[115]

The real and urgent need to uplift Malay communities was transformed through the 1950s into a much more troubling ideology of Malay supremacy, and it is this overdetermined Malayness that forms the political context in which late-colonial film must be viewed. Malay writing on film history generally dismisses any nationalist value in the films directed by non-Malays. Hassan and Wong argue that "Malay cinema has rarely functioned as a site of exploration of national identity and ideology, and has never truly questioned it. Notions of identity, nationalism or feelings of repression under colonial rule are nonexistent." For

them, "anti-colonial sentiments and agitation . . . only surfaced in newspapers and novels. None of this appeared in the Malay feature films of the period."[116] Similarly, Hatta Azad Khan contends that "Malay nationalism of the late forties and early fifties was never stirred through films," instead seeing *bangsawan* and literature as sources of Malay nationalism.[117] Contemporary writers have been much more willing to see cinema as part of nationalist culture. Kahn, for example, argues that cinema participated in the creation of a Malay public sphere, concluding that "the relatively new Malay language cinema . . . succeeded in broadening the public appeal of popular versions of the nationalist narrative."[118] The most compelling case for the radicality of studio-era cinema comes from the independent filmmaker and writer Amir Muhammad, who contextualizes feudal melodramas *Hang Jebat* and *Dang Anom* in relation to the influence within the film industry of socialist writings by Kassim Ahmad and Usman Awang, which, he argues, valued independence and educating people "to be free from repressive, outdated ideas of authority."[119] Amir also points to the current of ethnonationalist racism in the way that some writers only consider national cinema to begin with ethnically Malay directors. He cites *Malaysian Films: The Beginning*, published by national film organization FINAS, which describes the work of Indian directors as "contradictory to the culture of the audience."[120] The history of Malay assistant directors helping Indian directors is easily revised from a story about colonial discrimination to one in which non-Malay Malaysians are written out of the region's cultural history.

The pontianak films seem at first to fit within this framework of increasing Malay nationalism. Given the diverse makeup of the production crew, what stands out most strongly in the studio films of the period is the almost total repression of this multiethnic mode of production on-screen. Almost all the actors in Cathay Keris and Shaw films are ethnically Malay and the films emphasize traditionally Malay social settings and signifiers such as *kampungs*, markets, Malay courts, and traditional costume. This representational logic erases the existence of the significant Chinese and Indian minorities in Malaya and imagines a Malay nation without racial tensions because without racial difference. Rather than representing a multiethnic diegesis, the films envision a largely Malay-only world. It's a strange tension, that a studio system so structured by colonial discrimination against Malays should nonetheless make films predominantly for and about Malays, in which those nationalities who held positions of power in the studio were marginalized textually. Audiences were understood to be racially segregated, with Malay, Chinese, and Indian audiences attending the films made in their own languages, and cinematic representation matched this cultural siloing. However, the pontianak films trouble these spaces of Malayness, offering a more complex

FIGURE 1.5 Satay-hawker Ali embodies village traditions in *Sumpah Pontianak* (Rao, 1958).

textual representation of Malay culture and ultimately addressing a significantly mixed audience. Although the pontianak is an indigenous Malay figure, the films do not straightforwardly serve the nascent project of Malay ethnonationalism. The representation of a precolonial Malay figure in the cinema of decolonization could not be neutral, and the pontianak produces an identity-troubling ideological turbulence. Made in the ferment of both anticolonialism and ethnonationalism, the pontianak film demonstrates how ideas of Malay identity were being both developed and contested in the era of decolonization.

Kahn describes how "a much broader public was emerging for Malay nationalist narratives," and the pontianak films in some ways perfectly illustrate his point, offering a popular image of old-fashioned *kampung* life with a wide array of cultural touchstones that would resonate with a Malay audience.[121] Beyond mere background, though, the films unfold a sophisticated set of discourses on the cultural objects of Malay identity, activating their terms and meanings in ways that are both playful and sometimes transgressive. One of the most notable ways in which the films speak about identity is through food, which is a constant source of humor and an evocation of belonging, but is also a way to stage conflict and ethnic difference. In both *Sumpah* and *Gua Musang*, comedy

subplots center on the rivalry of two street food vendors: a satay-hawker called Ali, played by Wahid Satay—who took his stage name from the popularity of this character—and a noodle seller called Maidin, played by Mat Sentol. In *Sumpah*, we are introduced to Ali as he enters the village singing a song about his delicious satay. It's funny (and catchy), and it also uses Muslim Malay foodways as a vehicle to invite in-group humor. He sings about selling goat satay, chicken satay, stomach satay, and liver satay, and then almost says "pork satay" (*satay babi*), elongating the first syllable of the word *babi* suspensefully before finishing it as *baru* (fresh) instead. Ali and Maidin are part of the group who help the pontianak to save her daughter in *Sumpah* but they function more as comic relief than as significant narrative actors. What they do contribute to the films is an ongoing story of food rivalry that name-checks a whole series of well-loved Malay dishes. Where Ali sings about his spicy and tender satay with *ketupat*, Maidin tells us his *mee goreng* and *mee rebus* noodles are the best. They trash talk each other constantly, culminating in a scene in *Gua Musang* in which Maidin dumps noodles over Ali's head and Ali retaliates with a vat of satay sauce. Their rivalry is lighthearted, but the way they talk about food lends it a connotation of religious difference. Maidin repeatedly accuses Ali of using "dead cow" to make his satay and insists there is no beef in his noodles, suggesting that he might be Hindu. Food thus mediates intercommunal tensions, which in the friendship of Ali and Maidin are both a constant source of conflict and a comic double act. Malay culinary identity here is presented, like the market, as a space of belonging but also as one defined by the public navigation of difference.

Malay identity is also signified by frequent reference to other cultural forms. In *Sumpah*, a group of men looking for Maria camp for the night and cheer themselves up by singing *pantuns*, a Malay oral tradition that, like the pontianak, is associated with the *kampung*.[122] In *Gua Musang*, the Malay martial art *silat* appears, in a narratively unmotivated scene in which two men dressed as tigers perform *silat* in a graveyard. Three of the films feature weddings: in *Gergasi*, the fateful wedding from which Mutiara is kidnapped includes a celebratory song about beef, *Dendam Pontianak* includes a wedding feast in which the guests wear traditional Malay dress, and a review of the original *Pontianak* notes that "one of the most charming scenes is a bersanding ceremony," the sitting together of the bride and groom that is a central feature of a traditional Malay wedding.[123] These spectacles of Malay culture all enable a positive discourse of tradition and belonging that could contribute to anticolonial nationalism, but they have something else in common. The *pantun*, *silat*, and the *bersanding* ceremony are all pre-Islamic forms that have been syncretically folded into Malay culture. Indeed, in the contemporary era, some couples avoid the *bersanding* part of the wedding

ceremony because it is not aligned with strict Islamic practice. (We will discuss the relationship of the pontianak film to Islam further in chapter 3.) For the films to include so many pre-Islamic forms—in addition to the pontianak herself—suggests a more mixed and syncretic vision of Malay identity than that promoted by a conservative ethnonationalism.

Of course, signifiers of cultural identity are always ideologically implicated and never more so than in periods of decolonization. I would argue that the pontianak film's deployment of a syncretic and mixed account of Malay "tradition" works to resist subtly the process by which Malay ethnonationalism reinvented tradition to its own ends. Clive Kessler builds on Hobsbawm's concept of the invention of tradition to explain how modernity conjured a very particular "traditional" Malay past.[124] For Kessler, as for Hobsbawm, the very concept of tradition is a product of modernity, as a historical era in which it is possible to develop an attachment to an idea of the past and to recognize it as different in ways that have consequences for how we view the present. Thus, "The unacknowledged product of disjunctive modernity rather than of unfolding cultural continuity, a view of the 'traditional' past is invoked to serve as an alternative to disruptive modernization; it is unwittingly preferred as the remedy for a condition of which it is itself an unrecognized symptom."[125] This argument intrinsically resists the ethnonationalist claim on a spiritual truth to identity, laying bare both the modernity of "tradition" and, by extension, the need to examine what ends are served by its imagined solutions to the problems of the modern world. The propensity toward what Theodore Bester calls "traditionalism," which is to say, "the manipulation, invention, and recombination of cultural patterns, symbols, and motifs so as to legitimate contemporary social realities by imbuing them with a patina of venerable historicity,"[126] can be found across modernities, but Kessler finds that Malay culture is unusually politically constructed. Ideas of the *kerajaan*, or "kingdom," and the splendors of Malay royalty are for him clear effects of British colonialism, and he concludes that fantasies of ancient ceremony and dress work equally well in the service of British or Malay elites.[127]

Indeed, it can be argued that the entire concept of Malay racial identity was a product of British colonialism and its adoption by Malay ethnonationalism a perverse yet unsurprising artifact of postcolonial nationalism. Anthony Milner makes the case for the first proposition, finding that nationalist appropriation of the entire Muslim period as "Malay" is historically dubious. He argues that there were many kingdoms and city-states, many of whom certainly would not have understood themselves as "Malay" or even have recognized that as a meaningful category.[128] Anthony Reid has interrogated the role of Sir Stamford Raffles in creating the idea of a Malay race, concluding that Raffles "should probably be

regarded as the most important voice in projecting the idea of a 'Malay' race or nation, not limited to the traditional Malay sultans or even their supporters, but embracing a large if unspecified part of the Archipelago."[129] Reid places Raffles in the context of several intersecting nineteenth-century European epistemologies: colonial exploration, the Linnean drive toward racialized scientific taxonomy of peoples, and a Romantic sense of ethnic nationalism. Raffles and his friend Dr. John Leyden, a Scottish surgeon who knew Sir Walter Scott, "formed their vision of the Malays as one of the language-based 'nations' that Johann Gottfried Herder and his counterparts in the English [sic] Romantic movement, such as Scott, had seen the world divided into."[130] Such Romantic and racialized versions of Malay identity grew throughout the nineteenth century and in the twentieth century, British education conveniently emphasized the intrinsic loyalty of Malays to their rulers. R. O. Winstedt, who led the colonial school system, produced the first modern history book, which "encouraged the modern nationalist understanding of Malayness. It was no longer the product of an Archipelago diaspora, nor a civilisation into which all could assimilate, but a racial sense of lost grandeur set within the geographical boundaries established in 1909."[131] Reid goes on to trace this discourse in the emergence of Malay nationalism in the 1930s and the concept of *bangsa Melayu*.[132] The dominant strand of anticolonial thought thus did not seek to overthrow colonial racial categories but rather to leverage their most fantasmatic and hierarchical qualities.

What this history illustrates is that representations of the Malay past are absolutely central to the development of ethnonationalism. The very ideas of Malay "tradition," "history," and "identity" are overdetermined by colonial epistemologies from the outset, and the way that popular films imagine history, including folkloric and imaginary pasts, cannot be separated from the politics of nationalism. To the extent that the pontianak film appeals to this Romantic Malay identity, it continues an essentially colonial project that has transmogrified, in the postcolonial era, into an exclusionary ethnonationalism. We can see traces of this discourse in the films' historicity, which evokes recent events in and through fantasmatic *hantu* pasts. For example, *Pontianak Gua Musang* is set around the titular caves in Kelantan, and for contemporary audiences, the name Gua Musang would be more likely to conjure the proximate history of (mostly Chinese) Communist guerrillas than Malay spirits. The Malayan Nationalist Liberation Army (MNLA) launched their war against the British in Gua Musang in 1948 and press for the film did not fail to make the connection. *Mastika* wrote, "In the olden days, Gua Musang was a place that scared people who passed through the area because it was the burial place of communist guerrillas." In a similar vein, *Majallah Filem* say, "It is known throughout history as a hiding place for communist

guerrillas.... Perhaps after the communist guerrillas were driven away, it was the PONTIANAK who made the cave her home." If *Pontianak Gua Musang* is haunted by these unrepresentable figures of left-wing anticolonialism, such haunting is ambivalent: for the pontianak to overwrite the location of the Chinese guerrilla soldier with traditional Malay culture might be read as either erasing or drawing attention to the work of historical conflict in creating identities. The films' evocation of tradition is likewise ambivalent: they certainly do appeal to nostalgic visions of life in the *kampung* and yet never in the service of an aristocratic vision. Instead of the splendor of the *rajas*, we find a popular emphasis on quotidian cultures, foodways, and folk art. Clearly, an appeal to the popular can bolster ethnonationalism, but the pontianak films undercut the racializing work of *bangsa Melayu* discourse with their references to pre-Islamic cultures and racial diversity.

Although the pontianak films feature almost all Malay actors, they do offer moments of resistance to the habitual erasure of non-Malay characters on screen. The films include non-Malay characters and they appear in suggestive ways. Both *Gergasi* and *Gua Musang* feature Chinese ghost-hunters, to whom the village elders turn for help. The representations are stereotypical, surely racist by contemporary standards—the ghost-hunters have a Fu Manchu appearance, sometimes speak questionable Mandarin, and in *Gergasi* the ghost-hunter has a "comedy" name (Mee Goreng) that means fried noodles in Malay. Nonetheless, these Chinese characters are not figures of fun. In *Gua Musang*, the ghost-hunter comes with a Mandarin translator who explains that he wants to catch all ghosts, whether Chinese or Malay. The village head tells him that the Indian villagers are also trying to catch the ghost and have been looking in the graveyard. He goes on, pointedly, to express thanks to the multiracial inhabitants of the village who want to work together to find a solution to the *hantu* problem. Indeed, *Gua Musang* repeatedly foregrounds its non-Malay characters. We have already met Maidin the noodle seller, who does not cook with beef and who may therefore be a Hindu. Maidin is also coded as an immigrant: in one scene, he tells the others that his wife lives in a faraway country and that he has nothing in Singapore. His identity is ambiguous, as despite his invocation of Hindu dietary restrictions, he dresses in a traditional Muslim Malay style, but his overseas wife suggests recent immigration. Later in the film, Comel is protected by an indigenous, or Orang Asli, man wearing a traditional wooden necklace and headband. The innocent daughter of the pontianak is protected through the film by a multiethnic array of villagers including Malay, Chinese, Indian, and indigenous people.

In *Anak Pontianak*, this progressive discourse on cultural pluralism meets the unruly femininity of the pontianak in a scene that illustrates the intersection of

FIGURE 1.6 The Chinese ghost-hunter in *Pontianak Gua Musang* (Rao, 1964) uses a translator to communicate with his Malay hosts.

gender, race, and social roles. A Chinese servant, Acik, is played by a Malay actor, who sometimes speaks awkward Cantonese. After seeing a pontianak, he recounts his terrifying experience to friends at the market. A beautiful woman walks by in a Chinese cheongsam, and the men stare at her in a way that foregrounds an aggressive male gaze. The woman asks for directions in Cantonese so Acik goes over to translate. In this exchange, several axes of difference are at play. Most obvious is the patriarchal leering to which the woman is subject by the group of men, emphasized by point-of-view shots and a fetishistic shot of her legs as she walks into the frame. But her Chineseness is equally emphasized through her dress and language. Finally, there is a class discourse in which the men are coded as working class (through their jobs and ability to hang out at the market) while the woman's accent marks her as of a higher social class. While Acik gives directions, the other villagers talk about the woman in Malay. One man jokes that if she is a pontianak, he will subdue her and marry her. Revealing that she understands Malay, she walks over to him and says, "how do you know I'm not a pontianak?" Her sassy reversal of both the male gaze and the Malay assumption of linguistic

exclusivity neatly dovetails a resistance to gendered and racialized power structures, and does so through the possibility that she might possess pontianak agency. Here we begin to see the pontianak as the Malay figure that undermines aggressive forms of Malay dominance.

When we turn to the figuration of the pontianak herself, the ambivalent nature of the film's image of Malay identity becomes striking. Yes, she is a Malay figure, deeply embedded in the folk culture of the region, but she does not fit neatly with the conservative visions of Malay ethnonationalism. She is a figure from outside of Islam, who can only be accommodated with difficulty to discourses of Muslim Malay identity. Moreover, she is a woman with agency, whose entire raison d'être is to frighten patriarchal authority. We might expect the pontianak film therefore to focus on the terrifying and antisocial qualities of the *hantu*, in order to gather the community together to oppose her threat. Some more recent films are structured in this way, but the studio-era films do not present the pontianak as a threat. Instead, in several films, the pontianak saves the *kampung* from some other danger. She does not function as the monstrous antagonist but rather is the heroine who rescues innocents and protects her community. Often, she does so despite being misunderstood and attacked by the people of the *kampung*, and suspense is produced out of the spectator's knowledge that the pontianak is essentially good while many of the films' other characters suspect her of being evil. The public sphere of *kampung* men misjudges her, and the spectator takes the pontianak's side against that of the majority. This vision of the community is thus not entirely aligned with conservative views of the nation.

In *Sumpah Pontianak* and *Gergasi* the pontianak saves the *kampung* and yet is still excluded from it. In *Sumpah*, Kampung Pasar Baru is suffering from a series of attacks on people and livestock and the inhabitants believe that a pontianak is to blame. Comel has come to the village in search of work, having become homeless as a result of the pontianak curse. When the villagers are tipped off that she is a pontianak, they tie Comel to a tree and, when she escapes, a mob chases her with torches. Despite being feared and hated by the *kampung*, Comel helps the village by killing two of the *hantu* who are assailing them. She flies to the *orang hutan*'s cave and kills him, and in the film's climactic scene, she fights with the *hantu raya* and rescues her daughter, Maria. However, whereas Samad—who kills a lizard creature—is feted by the village leaders, Comel remains on the sidelines of the celebration and can never be fully accepted into the community. In the end, she urges Maria to go back to her conventional life while she flies off alone. The plot of *Gergasi* follows a similar path: the *kampung* is this time menaced by an ogre and the pontianak Manis must destroy the ogre and rescue her daughter Mutiara. The ogre kidnaps Mutiara at her own wedding, prompting Manis to fly

to her rescue. She kills the mad scientist who has created the monster, and then, in a spectacular fight sequence in which Manis repeatedly scratches the ogre's naked torso, she kills him too. When the men of the village arrive, knives in hand, the fight is over and they are no longer needed. Once again, the pontianak cannot rejoin the community she has rescued, and the film's final shot is Manis walking alone into the rainy jungle. In a mediating structure, the pontianak must remain outside normativity while she works to save others within it. She protects the *kampung*, but she also demonstrates through her own exclusion that this same community is often intolerant to outsiders.

THE ONTOLOGICAL STATUS OF THE PONTIANAK

That the pontianak film becomes a key site for struggles over postcolonial identity can be seen in the changing status of the figure herself. In the first five films, the pontianak is unquestionably real, and the existence of *hantu* brings Malay animist belief into the modern horror film. This entry of the pontianak into cinema constitutes the anticolonial move of Abdul Razak and Maria Menado, who insist that precolonial Malay beliefs should form a part of anticolonial popular culture. But at the same time that this move depends on the precolonial figure, it also brings that figure into the modern structures of the horror film. There is a particularly modern tension between the supernatural and the rational, of which contemporary discourse on the films was fully aware. An article about *Anak Pontianak* in *Movie News* describes Abdul doing "months of research work into books on Malay legends, interviewing people in various parts of the Federation of Malaya who claim to have come into contact with these supernatural creatures."[133] *Hantu* are here no longer a form of folk knowledge—a part of the world to which everyone already has access—but instead become a subject of specialist research, requiring books and interview subjects. Knowledge about *hantu* becomes a construct of modernity and *hantu* themselves a remnant of the past rather than a feature of everyday life. And yet the article does not quite give up on the idea of *hantu* as real. It describes Abdul having created "as accurately as possible the true resemblance of these creatures."[134] This ambivalence—and indeed the arch tone that makes the piece seem ambivalent about its own ambivalence—is echoed in the studio's promotional materials for the film, which assert that "Malay film productions present the boldest question of this sputnik era—transformation powers—fact or fantasy?"[135] Are folkloric shapeshifting powers the boldest question of the sputnik era? The question is as

hyperbolic as many mid-century film ads, but the opposition of *hantu* to the technological world of the sputnik poses modernity as the discursive field of pontianak existence.

Across the studio films, we see a gradual shift away from a real pontianak with genuine supernatural powers and toward plots in which the pontianak turns out to be fake or imaginary. In the first three Cathay films up to *Sumpah*, Comel is genuinely cursed, and *hantu* such as a *hantu raya* and *orang hutan* form real threats to the *kampung*. Similarly, *Anak* represents as real a whole array of *hantu*, including the pontianak, the *polong*, and the *hantu ular*. In *Gergasi*, we see inklings of rationalism. Rahman begins by saying that pontianaks don't exist, but his modern lack of faith has already been proven wrong in the opening scene in which we have seen Manis transform. Here, the modern idea of *hantu* as mere superstition is included, but disproved. By the time *Gua Musang* is released in 1964, things are much more ambivalent. The film opens with a voiceover that addresses the audience as those who believe or don't believe in the supernatural. The voiceover wishes happy viewing to both groups but, it says, if you believe, we will present you with a story about *hantu*. In the narrative, Rohani seems to return as a ghostly pontianak to haunt her murderer Halimah, but we only ever see her in Halimah's dreams. Is Rohani merely the condensation of Halimah's guilty conscience, or are dreams the place in which the pontianak's genuine haunting takes place? When the terrified Halimah tells her mother that she is being haunted, her mother says it's just a dream, caused by going to bed with a full stomach and not covering her feet. Her explanation is material and bodily, but runs counter to what the spectator has seen. The film takes narrative advantage of this uncanny ambiguity, and it also textualizes it comedically. In one scene, Maidin says that he doesn't believe in ghosts. His friend Ali warns him that spirits do exist. Maidin challenges him to call a pontianak to them, and when otherworldly screams ensue, both men panic and run. Rather than a ghost, ambivalence is manifested. The film's denouement leaves little space for supernatural forces. When Halimah is accused of Rohani's murder, she runs off into the long grass and is eaten by a tiger.[136] Justice is restored not by an avenging pontianak but by a grouping of forces: the indigenous man who reveals Comel's true identity, the tiger who kills Halimah, and the village head who calls for nonviolence. Malay identity is strongly marked in these forces of good, but a Malayness that moves away both from the explicitly supernatural and from female agency.

We can see this shift away from *hantu* belief in contemporary reviews of *Gua Musang*, many of which make note of the change in public discourse. *Berita Filem* writes that "it's different from the other ghost stories that have been performed. *Pontianak Gua Musang* includes incidents that reflect beliefs that are not widely

FIGURE 1.7 In *Pontianak Gua Musang*, murdered Rohani haunts her killer's dreams.

accepted right now."[137] A sense of disapprobation around *hantu* belief changes the culture of pontianak films, yet the potential for belief is still a significant phenomenon. The magazine hedges its bets by stating in another article, "These stories are still talked about and some still believe that these supernatural tales really did happen."[138] *Filem Malaysia*, meanwhile, says that it has been "quite a while since films surrounding ghosts and spirits have been presented to the community by any studios in Malaysia." *Gua Musang* comes only five years after the previous pontianak film but the gap is significant in terms of public discourse on Malay culture. They see *Gua Musang* as "striving to bring back that horror experience," but as "different from other ghost stories" because it has an emphasis on "heartfelt drama."[139] Despite these journalistic attempts to reframe the pontianak film for a new era, *Gua Musang* was less well received than the previous films. The move toward fake or imagined pontianaks in the films of the 1960s correlates with the decline of the genre, and it is worth looking more closely at some of the explanations that might be offered for this change.

Several critics have pointed to modernization as the culprit, although they read the cultural and ideological forces at play rather differently. Uhde and Uhde see

a loss of Malay specificity across the films, which they map onto the move away from *kampung* life and toward urbanization in Malaysia and Singapore through the 1950s. As actual *kampungs* were being bulldozed across Singapore to make way for new urban developments, the environment became less and less welcoming to a belief in real pontianaks. Looking at *Pusaka Pontianak*, they write that "the traditional—and in a way timeless—kampong setting was replaced by an urban one; the main characters shed their colourful sarongs for western-style attire; Malay tunes gave way to jazz and pop music. More importantly, the supernatural activities of the monsters were replaced by events that could be explained rationally."[140] *Pusaka* doesn't even equivocate in the way that *Gua Musang* does over the status of dream hauntings: in this film, the *hantu* is revealed to be a person in disguise seeking to steal a rich man's fortune. For Andrew Ng, this modernization exemplifies the conservative mode of Malay nationalism. He reads *Gua Musang* and *Pusaka* symptomatically as figuring a move toward a patriarchal national identity. The pontianak as a female figure of Malay identity can no longer exist and instead the film's key female agents are adulterous, childless, and/or un-Islamic.[141] For Ng, the exclusion of a real pontianak illustrates the foreclosure of a certain progressive space within Malay nationalism. Amir Muhammad offers a somewhat more positive account of *Pusaka*'s fake pontianak, wondering if audiences had become so "much more enlightened and rational."[142] For him, the film "brought the pontianak out into the harsh modern light of parody and cynicism, away from the shadows of whispered superstition and taboo where she thrived."[143] Here, the fake *hantu* stages modern rationalism, but also signals the end of the pontianak as a figure of cinematic fear.

Where these critics saw the fake pontianak as a response to social change, Hamzah Hussin proposes that it was rather a residual piece of colonial propaganda. Hussin points to the influence of Tom Hodge, who took over Cathay Keris in 1958 after Ho Ah Loke moved to Malaysia to set up Merdeka Studios. Hodge was British and had formerly worked for the Foreign Office and the Malayan Film Unit, making imperial information films.[144] One of Hodge's aims at Cathay—and indeed back when he worked for the British colonial film unit—was to discourage what he saw as primitive superstition. Hamzah sees the fake pontianak narrative as part of this effort and not one that was successful. Whereas the 1950s films were hugely popular, the continuation of the series with *Pontianak Kembali* and *Gua Musang* was, in his words, disastrous, with ticket sales not even reaching a quarter of the box office of the earlier films.[145] Rather triumphantly, he notes that "once again, the efforts of Tom Hodge to 'educate' the thinking of Malay people through film by 'modernizing' their superstitious beliefs failed."[146] Hamzah recounts that when it was revealed that these films didn't have proper

pontianaks but only criminals wearing masks to frighten *kampung* dwellers and to hide their crimes, audiences felt that their beliefs (*kepercayaan*) had been mocked. Viewers in the 1960s, he argues, did not like their cultural values to be toyed with in this way, particularly because the pontianak was the *hantu* most widely believed to exist in real life.[147] Hamzah understands the link between Hodge's pedagogic mission and a colonial attitude, as British practice was to discourage animist belief while linking the benefits of economic and social modernization to mainstream religions.[148] If we read the late pontianak films in this way as examples of a colonial ideology, we can see more vividly how the real pontianak of the earlier films made such an anticolonial statement. The fact that Hodge considered the pontianak to be a site of Malay belief that had to be unlearned illustrates precisely the radicality of her supernatural agency.

However, although Hamzah is correct that Hodge was motivated by a paternalistic understanding of Malay beliefs, the same refusal of "superstition" was circulating across popular culture in the very different languages of nationalism and Islam. *Kembali* illustrates the cultural purchase of these debates both textually and in its reception. (The film itself has been lost, but we can gain a sense of its narrative and some of its imagery from the popular press.) Its plot centers on a teacher, Cikgu Aman, who arrives in a *kampung* and tries to instill modern ideas in the local population. According to *Berita Filem*, Aman "emphasizes the importance of progressive ideas for the community."[149] In this context, progressive ideas mean a turn to Islam to replace animism. "In fact, Che'Gu Aman tries to restore the faith of the villagers so that they will no longer believe in superstitions such as the 'pontianak,' of whom they are afraid." Thus, "Aman wholeheartedly launches a campaign against such superstitious beliefs and conveys to the villagers that there is no 'Pontianak' as she is just a figment of their fearful imagination."[150] This setup echoes the real-world influence of Sultan Idris Training College, which educated a generation of Malay teachers in progressive and often anticolonial ideas, before sending them to postings across rural *kampung* schools.[151] The college became a center for modern Malay thought and the character of the rationalist teacher who educates the *kampung* would have been a recognizable contemporary figure to audiences. In *Kembali*, the antagonist is a smuggler, Kamal, who is possessive of his girlfriend Comel and spreads rumors that she is a pontianak. As in *Gua Musang*, the villagers almost kill Comel and so the film offers another parable about how *hantu* belief leads to witch hunts and violence against innocents. The villagers drag Comel into a field and threaten to nail her. *Berita Filem* describes the denouement in explicitly religious terms: "But God is almighty. A moment before the nail goes through Chomel's brain, a police car arrives to arrest Kamal, who is not only charged for the attempted

murder of Chomel, but also with dangerous robbery crimes in which he was the mastermind."[152] The film's own ideological structure repeats that of Aman within the narrative, proposing a modern combination of Islam and rationalism as an alternative to animist belief. As *Berita Filem* puts it, "Although indirectly *Pontianak Kembali* is a film that entertains, supposedly it will also help eradicate the remnants of superstitious beliefs that some people still hold on to."[153]

Popular writing on both *Kembali* and *Pusaka* works constantly to manage the relationship between modernity and belief. One article on *Kembali* argues that "it doesn't matter if you believe this strange occurrence or not because the larger society in Malaya and the Philippines still believe that the Pontianak exists."[154] The address is to an evolved readership that likely does not believe and yet must acknowledge that there is a wide regional public that still does. Another article defends the film from rationalist attack: "With regards to the production of the film, *Pontianak Kembali*, many people said that this film is no longer relevant in a community that is modern because in this day and age, people are more aware and are not easily taken in by fairy tales such as *One Thousand and One Nights* and that also includes ghost stories. There are people out there who regard these films as lacking in spirit and that their only aim is to make money."[155] This article conjures the opposite public to the gullible one proposed by the previous writer: here in the modern age, people do not believe and they are thus likely to see *hantu* films as exploitative. But even in this moment of describing how an audience might reject *hantu* films as "lacking spirit," the piece posits a spirit that ought to be respected. In dismissing these hypothetical critiques, it insists that *Kembali* is "very different from what is expected and from the other 'Pontianak' films that have been watched by the community."[156]

We see the same rhetoric in discussions of *Pusaka*, which invariably downplay the supernatural and discuss instead the film's novel twist on the genre. One reviewer describes Ahmad Daud's character, saying, "As part of the new generation of young people who receive a western education, it is not surprising that he is not able to accept superstitions such as Pontianak."[157] Western modernity is a major theme in the film, with European fashions, cars, and music filling the mise-en-scène. Ahmad Daud is part of the band that plays the film's cheery Monkees-like pop song, "Dendang Pontianak (Shake dan Twist)," which gives a sense of the film's positive approach to hybridized modernities. *Majallah Filem* is keen to separate these modern pleasures from tricky questions of animist belief:

> It is evident in the title that the film deals with elements of fear and horror, which is often associated with Pontianak, but in reality the theme of the story is one of originality.... More accurately, the film *Pusaka Pontianak* is a story for the

future. This is an age that values deep thought, and integrity above deception. . . . In a typical Pontianak film, it is common to find many events and incidents that support the belief in ghosts, spirits and other occult forces. However, the story of *Pusaka Pontianak* does the opposite.[158]

Whereas Hamzah finds the fake pontianak as a weakness for Malay cultural expression, the popular press leverages fakeness to promote the films as looking to the future. Of course, these popular magazines often served as marketing venues for the studios, so it's not surprising that they find ways to puff the films. But what's significant is the rhetorical effort they exert to predict and take account of a rapidly changing public discourse on *hantu* belief, and the way that rational and religious modernities form the terms within which pontianak narratives can be justified. This rhetorical problem is still visible in the present day. In 2011, an editorial in *Berita Harian* fulminates against *hantu* films, claiming that the horror genre "can promote superstition. It doesn't help to build a productive society."[159] Conservative popular discourse still considers pontianak films to be troubling and disruptive to society, and, like the emergent nationalists of the 1930s, this editorial deploys Malay history as a tool of persuasion. Asserting that "we're in the 21st century now and not the 1960s, and there are other stories we can tell," it argues that contemporary Malaysia should forget the days of *Pontianak Gua Musang*, *Sumpah Pontianak*, and *Orang Minyak*, and should mark its modernity by no longer telling *hantu* stories. The pontianak has not lost her power to trouble Malay cultures and the pontianak film continues to be the form against which Malay modernity is measured.

CHAPTER 2

TROUBLING GENDER WITH THE PONTIANAK

In embodying a beautiful woman who reveals herself to be a terrifying undead vampire, the pontianak surely manifests a misogynistic fear of women as monstrous figures who must be subdued. Such a patriarchal attitude is vividly on display in Walter Skeat's colonial account of Malay folklore. Skeat describes "a woman of dazzling beauty, who died from the shock of hearing that her child was stillborn, and had taken the shape of the Pontianak."[1] He continues:

> She may be known by her robe of green, by her tapering nails of extraordinary length (a mark of beauty), and by the long jet black tresses which she allows to fall down to her ankles ... only, alas! (for the truth must be told) in order to conceal the hole in the back of her neck through which she sucks the blood of children! These vampire-like proclivities of hers may, however, be successfully combatted if the right means are adopted, for if you are able to catch her, cut short her nails and luxuriant tresses, and stuff them into the hole in her neck, she will become tame and indistinguishable from an ordinary woman, remaining so for years. Cases have been known indeed, in which she has become a wife and a mother, until she was allowed to dance at a village merry-making, when she at once reverted to her ghostly form, and flew off into the dark and gloomy forest from whence she came.[2]

Skeat inadvertently lays out so much of the misogynist logic that underlies pontianak belief in the colonial era, and anticipates its staging in cinema. We see the anxiety around a beauty perceived as deceptive, and the hole that must be stuffed in order to vanquish her power. Moreover, Skeat evinces the belief that ordinary

women are "tame," and yet discloses the worry that any such apparently tame woman might secretly be a pontianak and that, therefore, it is better not to allow women access to whatever public and private pleasures might be conjured by dancing. Skeat's interpretation of the myth aligns with Western epistemologies in which women are deceptive and their bodies ultimately grotesque, and this logic is also visible in postcolonial Malaysia and Singapore.

And yet, as a woman who returns from the dead, can fly, and often fights wrongdoers, the pontianak is also a compelling figure of female agency both in cinema and across Malay cultures. Traditionally created when a woman dies in childbirth, the pontianak gains a power not given to conventionally "good" Malay women. Instead, she takes murderous revenge (often against men) and uses her supernatural abilities to protect her community. There is an obvious feminist potential in such a potent female figure, and female artists have vibrantly evoked the pontianak's power. In "Blame," queer Singaporean poet Tania De Rozario responds to a real rape case in which the defense attorney suggested in court that the woman could have stopped the assault by closing her legs. De Rozario rewrites this dispiriting episode of victim-blaming through the lens of the pontianak story, in which a *hantu* who encounters male violence does have the ability to change the narrative:

> So sorry for not stopping
> your wanting while I still could, for not pushing
> your hand from my knee, not resisting, not
> insisting you stop the car.
> So sorry for the lipstick
> on your collar and blood on your seat.
> For my beauty and your morals, both skin deep.
> For the length of my teeth and the depth of your fear.[3]

This pontianak articulates feminist rage at injustice through the literary conjuring of a utopian violence and a wholly ironic mode of female apology. Moreover, "Blame" also demonstrates that pontianak agency is not only a quality of a strong woman type of character. Yes, the pontianak takes action, and her violent revenge on men offers narrative satisfaction, but more than simply character strength, what this chapter identifies and describes is a formal overthrowing of the terms of patriarchy. In De Rozario's poem, this effect is produced in literary language: the work of irony is to transform meaning, in an instant, from the assumption of female subservience to the revelation of violent retribution. In cinema, similar effects are created through the construction of looking relations

and spectacles of embodiment. Across media forms, the pontianak unseats the epistemologies of patriarchy, and does so in ways that create spaces for feminist and queer ways of seeing. From the animist beginnings of the pontianak through the colonial era to the present day, the figure cannot be understood apart from the politics of gender and its relationship to popular culture and to structures of belief, identity, and power.

It is not surprising that existing scholarly debate on the genre tends to focus on gender, and in particular the question of whether the pontianak film is merely sexist or whether it has feminist potential. Kenneth Paul Tan finds recent pontianak horror films to be reactionary, allaying geopolitical anxieties by subjecting female figures to patriarchal discipline.[4] More positively, Andrew Hock-Soon Ng argues that the pontianak's "independent streak" makes her "a woman whose resourcefulness and autonomy define her as dangerously 'unfeminine.'" Ng considers that female monsters in Southeast Asia give women agency in a patriarchal culture, and are dissident of gender norms and hierarchies.[5] Most critics navigate between these two positions, finding the pontianak to be structurally ambivalent. Adrian Yuen Beng Lee emphasizes the ambiguity of the films' patriarchal logic, in which the pontianak must be killed for social order to be restored, and yet her transgressive vengeance does more than "merely articulate male fears of female empowerment."[6] And Jamaluddin Aziz and Azlina Asaari see "female liberatory possibilities" but conclude that the films still "trap the female characters within a patriarchal realm."[7] What do we do with a genre in which most of the female protagonists die horribly, yet in which they also embody cinematic effects of resistance, power, and desire? This is a familiar question for feminist film theory: Should we read female monsters and killers as projections of a misogynist culture or as sites of feminist refusal? Do we foreground ideology critique or spectatorial pleasure and the potential for resistant reading? That these debates are so established in feminist film criticism might lead us to conclude that the work to be done is simply to apply existing (Western) models to new (non-Western) objects. The insights of feminist film theory do remain relevant, and many of the Southeast Asian film scholars I cite make use of the work of Carol Clover, Barbara Creed, and other Western scholars of the horror film.[8] However, the value of the pontianak to feminist film theory is not merely additive. The space that she inhabits intersects with questions of sexuality, race, religion, indigeneity, and nation in ways that insist on its postcolonial dimensions. Through this chapter—and indeed across the entire book—we will see the wide-ranging effects of the pontianak's gender disruptions across intersecting domains of Malay life.

This chapter interrogates the pontianak's complex negotiation of gender and sexuality, both in the classical-era horror films and in contemporary revisions of

the figure. It begins by tackling head-on the ambivalence of the pontianak, considering the push and pull that the texts themselves offer between radical and reactionary meaning and affect. In advance of any critical choice of with- or against-the-grain reading, pontianak films are often themselves a rich mulch of ideological ambiguity. In order to grapple with this ambivalence, I propose that we read the pontianak as a feminist figure who causes trouble for patriarchal textuality. This approach is almost the exact opposite to what one might conclude from the earlier examples, i.e., that the pontianak is a misogynist myth that has been appropriated and resignified by writers like De Rozario. Rather, I argue that the pontianak is and always has been a feminist figure, but that she exists in a patriarchal culture that often places her in misogynist textual systems. Viewed in this way, we can read the ambivalence of many pontianak films differently, paying attention to how the figure of the pontianak troubles the operation of dominant visual and narrative forms. Interrogating a range of popular horror films from the 1950s to the present day, this chapter begins by unpacking pontianak iconography and by locating the feminist polemic that is (more or less successfully) contained within it.

Moving on from the question of whether the pontianak is feminist, the next section asks what a pontianak feminism could look like. Alicia Izharuddin sees the pontianak as an "excessive psychosocial articulation of traditional Malay femininity gone awry," in which the figure "analogizes the violence against women whose body is the anxious focus of politico-religious and cultural control in Malaysia."[9] This claim, along with De Rozario's reference to a criminal case in Singapore, points to the ability of the pontianak to speak about contemporary situations of social and symbolic violence. Not only *can* the pontianak speak about injustice and violence, she necessarily does so. The cinematic emergence of the pontianak in the *merdeka* years produces a unique combination of premodern and anticolonial affiliations, which resonate through her afterlife in the era of decolonization. The pontianak is not a neutral folkloric figure: her premodern qualities encode complex ideas about Malay racial, religious, and national identities, at the same time as her representation in the present leverages disaffiliations with aspects of modernization and nationalism. Pontianak feminism involves paying attention to the interweaving of gender politics in postcolonial Malaysia and Singapore with histories of modernization, which include issues of urbanization, racial inequality, and Islamization. For example, tensions between religious conservatives and feminist and queer groups have become a fault line for debates on family law, dress codes, violence against women, homophobia, and trans rights. Against recent cases of state violence in Malaysia such as the lesbian couple sentenced to caning in Terengganu in 2018, progressive groups such

as Sisters in Islam and Justice for Sisters advocate for women's autonomy.[10] To understand the cultural force of the pontianak as a feminist figure, I argue that we must locate her feminism within the matrices of Malay postcoloniality.

The pontianak vividly screens the violence of Malay patriarchy, but it is her ability to reverse the terms of that violence that animates feminist and queer disruptions to those norms. The final sections of the chapter trace some of these disruptions, teasing out intertwined strands of history, gender, and sexuality. We move from the ideological ambiguity of the contemporary horror film toward texts in which the pontianak does explicitly feminist or queer work. Of course, these categories are not so neatly siloed, and the queer and feminist power of the pontianak often combines messily with misogyny, transphobia, and homophobia. Analyzing the pontianak in relation to postcolonial histories, feminism, and queerness aims not to separate or hierarchize these modes but rather to insist on their foundational interconnection. The earliest pontianak films trouble ideas about gender presentation and Malay identity in ways that set the terms for contemporary forms of gender dissidence. The nonhuman nature of the pontianak disrupts the smooth surface of the gendered image, raising questions about the status and nature of women that cannot be addressed without reference to queer and trans identities, or without consideration of the role of race and religion in constructing postcolonial femininities. In attempting to delineate pontianak feminism in cinema, this chapter argues that the historical forms and meanings of gender are central to an understanding of Malay postcoloniality, and vice versa: thus, that a feminist theoretical critique of the pontianak needs to be rooted in the postcolonial histories of Malaysia and Singapore, and that the pontianak film is uniquely able to shed light on these histories precisely because of its textualization of Malay identity in terms of femininity and its discontents.

MISOGYNY AND REVENGE: AMBIVALENCE IN THE PONTIANAK FILM

I see the pontianak as a powerfully feminist figure, whose disruptive abilities resonate across all areas of the cultural texts that invoke her. But many of these texts are structured by misogyny, and to understand the pontianak as a cinematic figure, we must unpack the ideological ambivalences that suffuse the horror films in which she is most frequently found. The pontianak embodies patriarchal anxieties around femininity and, in particular, what it means to be a proper woman. Women are turned into pontianaks when they have failed to follow

gender rules. From the very beginning, in the first (lost) Cathay film, the protagonist Comel fails to do what her father tells her. He is a wizard who instructs her to burn his spells when he dies. Instead, she performs a spell to make herself beautiful. All seems to be well, and she marries and has a daughter—fulfilling Skeat's anxious claim that the pontianak can be tamed and appear to be a regular wife and mother—but the spell demands that she never taste human blood. One day she sucks a sting out of her husband and accidentally tastes a drop of his blood. The curse is activated and she turns into a pontianak. The opening of *Sumpah Pontianak / Curse of the Pontianak* (Rao, 1958) finds Comel at her father's grave, where a deathly voice-off intones, "if you had listened to me you would have lived in peace." Comel cries that she repents but her father insists that she has to suffer for her whole life. Because she is now ugly, she loses her husband and is ostracized from the community, becoming homeless. By taking on the patriarchal prerogative of casting spells she has turned ugly and ugliness in a woman means that she has no means to survive, because she's not desirable as a wife. Normativity is closely policed.

The more conventional mode of becoming a pontianak is to die in childbirth, and, given the emphasis placed on reproduction in traditional Malay culture, to die this way is to fail at the proper business of womanhood. The pontianak as failure of reproduction represents both a fear and a punishment for women. In *Pontianak Gua Musang / The Pontianak of Musang Cave* (Rao, 1964), the punitive aspect is emphasized, as Rohani has extramarital sex and this failure of virtue leads inevitably to death in pregnancy. At the start of the film, Rohani is in love with Amran, who invites her to Gua Musang for a picnic. The picnic scene is bucolic, with the lovers singing to each other in the forest. Amran announces that he wants to marry Rohani, but that he needs to visit his family on Tioman Island first. What follows is melodramatically overcoded: a wind picks up and blows Rohani into Amran's arms, and then suddenly stops. The gust upsets her, but he responds that "it's only natural in the forest." The question of what is natural is left open—the weather, or them having sex? Next comes a disjunctive elision, during which Rohani has become disheveled and Amran's scarf has come off. The implication is that they have consummated their relationship in the space between shots. Although the narrative makes clear that Amran was the instigator of their sex, Rohani is immediately warned by her cousin Halimah that she will lose her good name in the *kampung*. Halimah says that the village will judge her if she is not pure; however Halimah is jealous and wants Amran for herself, which rather undercuts the ideological force of her warnings. Halimah persuades Rohani into a boat and then scuppers it, leaving her to die by the riverside after almost drowning while giving birth. Although

FIGURE 2.1 The first pontianak films' discourse on feminine beauty and monstrosity is vividly illustrated in this *International Screen* layout. (Image courtesy of Wong Han Min.)

Halimah is hardly a force of moral authority, the film's central narrative move is nonetheless to punish a woman with death for premarital sex.

Turning to the post-2002 horror film, the association of the pontianak with punishment for a woman's illicit sexual activity is often ramped up in more violently misogynist ways. In the Indonesian film *Terowongan Casablanca / Casablanca Tunnel* (Nanang, 2007), Astari is buried alive after a botched abortion, doubling down on the implication that death in childbirth is a woman's own fault. As with *Gua Musang*, the young woman is pressured into agreeing to penetrative sex: when Astari worries that it's a sin and asks what if she gets pregnant, her male partner Reva mocks her old-fashioned thinking and promises to be responsible should anything happen. Of course, when she does become pregnant, Reva does not stand by her but takes her to get a back-street abortion. When things go wrong, Astari is buried alive, along with her fetus. She returns as a pontianak, holding her dead baby, and the majority of the narrative is dedicated to her attempts to take revenge on Reva and on the friends who abandoned her.

Terowongan Casablanca illuminates both the deeply ambivalent gender politics of the pontianak film and its inescapable misogyny. When Astari begins to haunt Reva and his friends, it is easy to enjoy the film as a rape revenge fantasy in which the spectator is very much on the side of the pontianak. It is possible to retain this reading right to the end, in which Reva is reduced to a shell, sitting alone in a wheelchair in a gloomy hospital room. However, these pleasures run

FIGURE 2.2 In *Terowongan Casablanca* (Nanang, 2007), Astari haunts the boyfriend who was responsible for her death.

against the grain of the film's own moralism. Reva's undoing functions primarily to refuse a happy ending to a participant in socially unacceptable sex, speaking more to the film's sexual conservatism than to any equality in its gender politics or soft-pedaling of its misogyny. *Casablanca* unequivocally punishes Astari more for this sex act—she is abandoned, dies, becomes a *hantu*, and is condemned to walk the Earth with her crying baby. As much as her revenge against Reva feels righteous, the film dwells more pruriently on violence against her. In a climactic scene, Astari is exorcized by a *bomoh*. During the ceremony, a group of seminaked men encircle her and raise their hands over her head. The sheer physicality of these male torsos looming over a lone woman forms a powerful image of the male body as a source of normative power, and the *bomoh* strikes a nail into Astari's head in a violent penetrative conclusion. A feminist potential for counterreading is there, but *Casablanca*'s misogyny is too unpalatable for it to offer much pleasure.

Across the contemporary pontianak film, sexism is endemic, with the imaginary violence of the pontianak being represented as terrifying but the ever-present reality of patriarchal threat as merely humorous. In *Pontianak Teng Teng* (Khan/TV3, 2014), Indah arrives as a stranger in a new *kampung*. When she walks through the village for the first time, the scene lingers on men who stare openly at her, using point-of-view shots and slow motion to emphasize an extreme male gaze. The men shout at her, demanding that she talk to them, inviting her to live with them, and questioning her relationship status. It's a chilling assertion of patriarchal power, but in the film's terms this behavior is presented as amusing flirtation. Such threat of male violence is a constant locus of humor. *Paku Kuntilanak / Nail Demon* (Findo, 2009) features a bizarre scene in which protagonist Mona is in a car with two male coworkers, as a *hantu* approaches. They are all ghost-hunters and should be focused on the kuntilanak at large, but instead the two men cannot stop sexually assaulting her for long enough to notice the danger. They lean against her breasts and, it is implied, are touching her legs or genitals below the frame line. In fact, almost every time a woman gets into a car in a pontianak film, a man makes sexual advances on her. Although these scenes could be read against the grain as an exposé of everyday sexism, they more directly produce an oppressive pedagogy of immobility, in which women learn that they will be assaulted if they go anywhere alone. As the starting point of a feminist critique, it is important to name the misogyny that suffuses the pontianak film.

If misogyny is the environment in which the pontianak emerges—and the ideology that dominates many pontianak films themselves—it is precisely for this reason that her powerful and violent agency is so compelling. The pontianak functions formally as a rupture in the codes of Malay gender, even and perhaps especially in cultural texts that are not, themselves, resistant to dominant gender

ideologies. Even small acts of revenge are overdetermined in relation to patriarchy. For example, in *Paku Kuntilanak*, the kuntilanak turns sites of oppression on their head. In one scene, a satay seller comes by in a nod to the studio-era films, but rather than the benign figure of Wahid Satay, this vendor makes sexual advances on the kuntilanak. When he breaches Muslim taboos of propriety by touching her, she reveals herself to be a *hantu* by making her arm come off in his hands. She literalizes his "taking" of her arm by detaching it from her body. This act of petty revenge is nonviolent, but what's striking is that the joke is on the sexist satay seller and not on the violated woman. To escape, she gets into a taxi, in which the driver also makes sexual advances. She demands that he stop, leading him to fear that she will leave without paying. Instead, she gives him a large banknote, allowing him to think that she enjoyed his creepy attentions. As soon as she's gone, however, the money turns into a leaf and he finds himself alone in a cemetery. His car won't start and he has to flee on foot from the kuntilanak whom he tried to exploit. Because he wouldn't drive her safely to her destination, she removes *his* ability to move in the world without fear. Even where the humor of the pontianak film is sexist, the figure herself works to reverse dominant structures of gendered power.

This pattern of narrative reversal, in which the pontianak takes pleasurable revenge against men, characterizes the figure across cultural forms. In his account from 1955 of Malay *hantu* belief, J. N. McHugh points out that in some regions it is believed that pontianaks prefer to frighten men and their victims will often die if a woman doesn't come along and help them.[11] Singaporean popular fiction is full of stories in which pontianaks take revenge on abusive men. For instance, in the short story "The Devil's Concubine," published in 2004, an English man who has affairs with two Malay sisters gets his comeuppance when one sister turns out to be a pontianak and tortures him. Here, the regulation of sexuality is also overlaid by colonial relations, a recurring theme in these narratives in which women are exploited sexually not only because of their gender but also their subalternity.[12] In the pontianak film also, narrative reversals work to flip larger social scripts. In *Pontianak* (Sutton, 1975), the *hantu* kills men who try to seduce her, and murders her new husband on their wedding night. She punishes men within structures of patriarchal sexuality that threaten symbolic or literal violence to women. In a pointed visual joke, she emerges from her wedding night to hand her mother-in-law a sheet that is significantly bloodier than expected. And in the short film *Pontianak* (Raihan Harun, 2005), a widower learns that his late wife knew of his affairs and has returned as a spirit to punish him. The pontianak is not a fan of heteronormative gender roles or of sexual exploitation.

If we focus on the agency of the pontianak, we notice a shift from the studio films in which the pontianak herself is the protagonist to the post-1990 films, which more often center on male characters who encounter pontianaks. Indeed, it is possible to view contemporary pontianak narratives as parables of what popular feminism dubs toxic masculinity, in which every aspect of male entitlement and violence common in (although hardly specific to) Malay cultures is explicitly and repeatedly laid bare. Whereas extreme beauty and ugliness are central to the meaning and value of female characters, male protagonists are cast as ordinary Joe types, with whom male spectators could comfortably identify. They are never played by very handsome actors, and the narratives pivot between male fantasies that beautiful women would fall for average men and a deep-seated male sexual resentment about beautiful women who are not interested in them. This structure speaks eloquently to feminist critiques of rape culture, which point out how the resentment of the privileged underwrites popular cultural forms.

The narrative of *Paku Pontianak* (Ismail, 2013), for example, hinges on the jealousy of one beautiful woman, Seri, that ordinary Adam is in love with another beauty, Melati, rather than with her. Pontianaks constantly fall for unprepossessing men, with such unequal pairings repeated in *Pontianak Sesat dalam Kampung* (Azmi/Astro Ria, 2016), *Paku Kuntilanak*, and many others. It is when the pontianak does not respond to the attention of these men that violence occurs. *Pontianak Teng Teng* is entirely about the problem of a woman—who is even named Indah, "beautiful" in Malay—who unaccountably does not want to marry any of the village men. We have seen how the men harass her in public, and their entitlement forms the engine of the film's narrative. One of the men, Rasyid, proposes to Indah with a monologue: "'Indah! Indah, I want to tell you something. Can I ask for your hand in marriage? Just tell me what you want as dowry.... Indah, I want to give you diamonds and rubies.... Silence means agreement! Looks like I too can get married!'" Rasyid's eagerness is played as comedy: he persuades himself that Indah's silence means she agrees to marry him, to the point that he dresses up in a groom's costume and demands to see a marriage officiant. This behavior is represented as wrongheaded but endearing, and Rasyid's silliness makes it easier to see him as a figure of fun rather than of threat. Nonetheless, in the next scene, Rasyid is dead, killed by Indah, who cannot speak up as a woman but can more successfully insist on her lack of consent as a pontianak. Despite itself, the film lays out both the implicit violence of the men's harassment and the need for pontianak feminism in response.

THE ICONOGRAPHY AND IDEOLOGY OF THE NAIL

Perhaps the most vivid manifestation of the pontianak film's ambivalent gender politics can be found in its treatment of a key piece of folkloric iconography: the belief that a pontianak can be subdued by hammering a nail into her neck. Unlike the role of the wooden stake in killing the European vampire, the nail does not kill a pontianak. Rather, when she has a nail in place, she appears to be a normal woman, and can live undetected among humans. Only when the nail is removed will she reveal her true undead self. The nail mythology thereby enables three affective modes: an often misogynist satisfaction in violently penetrating a pontianak; an often feminist pleasure in the removal of the nail and the pontianak's regaining of her powers; and an anxious uncertainty around the status of a woman—perhaps any woman—who may be a pontianak in disguise. The ways in which films deploy these modalities reveal much about their attitudes to gender, and begin to point beyond the binary of sexist vs. feminist textuality toward a troubling of gender as a category.

Sticking the nail into the pontianak is often represented as a cathartically violent act, a trope we see right from the beginning of the genre. One of the only existing frame stills of *Pontianak Kembali* (Estella, 1963) depicts an imperiled woman surrounded by men, being held by her shoulders as another man approaches her head with a hammer and nail. In that film, she escapes, but by the *Pontianak* of 1975, we see the titular character being nailed in a fight, at which point she screams, meows (it's an odd film), and turns into a decomposing monster. The pleasurable violence of nailing is emphasized in the precredit sequence of *Paku Pontianak*. The film begins with a traditionally dressed Malay man walking among trees. He carries a torch, placing the spectator immediately in a premodern *kampung* setting. A pontianak flies overhead, moving at an unnatural speed, in a way typical of East Asian ghost films. (Thus, the film efficiently signals both that it will refer to Malay pontianak conventions and that it will be a modern horror film.) The man sneaks up behind the pontianak and tries to nail her. She turns around and attacks him, revealing her monstrous face. When he plunges the nail into her neck, she throws her head back and screams, and the film's triumphant attitude to the violence of nailing is encapsulated in an overhead shot that looks down on her anguished face. *Paku* means "nail" in Malay—hence the popularity of the term in film titles such as *Paku* (P. Rameesh, 2013) and *Paku Kuntilanak*—and the giant rusty nail centering the poster for *Paku Pontianak* illustrates how central this tool to subdue unruly women is to the genre.

The sexual overtones of nailing are obvious. Ng argues that the violent hammering in of nails is influenced by the Western staking of vampires, and certainly there is much feminist critique that compares the staking of Lucy in *Dracula* to rape.[13] Carol A. Senf writes, "The scene in which Arthur drives the stake through Lucy's body while the other men watch thoughtfully is filled with a violent sexuality.... The scene resembles nothing so much as the combined group rape and murder of an unconscious woman."[14] However, the sexual implications of nailing as a form of violent penetration are visible not only to Western audiences familiar with psychoanalysis. In *Pontianak Bidan Gayah* (Adam, 2003), one character asks why the pontianak is scared of nails. His friend replies that if their hole is entered by a nail, then they are transformed into beautiful women and you can marry them. The friend leeringly responds that he has a big nail and will be ready. Similarly, in *Langsuir* (Osman, 2018), a group of macho young men decide to catch a *langsuir*. When one of them falls for a beautiful *hantu*, another friend announces that he plans to nail her that night with the big nail he's been ostentatiously sharpening. He makes a thrusting gesture to indicate the nailing will involve gang rape. If most films do not articulate nailing as sexual penetration quite so explicitly, the codification of nailing as a way to pacify women into wives makes the point structurally. Lee points to this patriarchal shift from violent conquering to socially sanctioned ownership when he writes, evoking Skeat's earlier description, that "cutting her nails and hair and stuffing it into a hole may subdue her. In doing so she becomes a woman and is capable of being a wife and mother."[15] Nailing enables a genre shift, from horror to marriage plot.

In her anthropological study of contemporary *hantu* belief, Cheryl Nicholas writes, "In human form, the Pontianak epitomizes female beauty and behavior ideals. She is not only beautiful but can be the perfect wife, mother, and daughter to anyone who owns her (ownership occurs during the nail piercing.)"[16] Thus, women's transition from independence to marriage is also narrated as a function and consequence of nailing's sexual power and control. In *Kembali*, one character boasts, "I'm strong and I'm not afraid of the pontianak. If the pontianak comes, leave it to me. The pontianak is after all a woman.... I'll just marry her." Marrying a pontianak denudes her of her power, and there is nothing to be afraid of when you can marry a *hantu*, turn her into a woman, and thus control her. This speech comes from a comic character, however, and his pretense at not being scared is revealed as false when he shakes all over. In films that narrate gender through horror and violence, controlling a pontianak through marriage is a risky business. However, the nailed pontianak also provides an opportunity to transform ownership into romance. *Gergasi* begins with Rahman meeting Manis, a pontianak, under a tree in the jungle. At first, he is

terrified of her, but upon learning about nailing, he returns to the jungle and captures her. When he sticks the nail into her neck, she transforms into her beautiful form, and they embrace. He takes her home and we cut to Manis singing to a baby doll, which dissolves into a real baby. The nailing of a pontianak can be very efficiently narrated as a heteronormative transit of male desire into marriage and reproduction.

By contrast, scenes of nail removal provide climactic moments of both terror and feminist pleasure, in which the pontianak undergoes a visible shift from passive femininity to dangerous agency. She becomes a figure of power, not in an against-the-grain reading but within the terms of the films' own narratives. The nail-free pontianak often saves the day, for instance, in *Sumpah*, where Comel begs her male friends to pull out her nail so that she can save her daughter from a wild man. They are so scared of what she will become that they attach a long rope to the nail and pull it out from a distance. The film takes advantage of its widescreen format to frame a long horizontal rope separating Comel from the men. As soon as her nail is out, she regains the power of flight and swoops in to fight the *orang hutan* and save Maria. Similarly in *Gergasi*, when her nail is removed, Manis flies to save her daughter Mutiara from an ogre. The studio-era films generally represent nail removal as exciting rather than terrifying, whereas more recent films emphasize the shock and horror of this physical transformation. In *Teng Teng*, Indah has murdered several unwanted suitors, and when the village men finally confront her, she pulls out her own nail and flies at them. As frightening as this moment might be, it is always a satisfying and spectacular payoff for the films' narrative suspense. In comedy horror films, the switch to active femininity is played for laughs, and in these films, anxiety around normative gender roles becomes, if anything, even more explicitly dissected. *Tolong! Awek Aku Pontianak / Help! My Girlfriend Is a Pontianak* (Lee, 2011) exemplifies this scenario in a scene in which a self-important *bomoh* and his helpers surround the pontianak Nadia and tell her that they are going to kill her. She plays pointedly with her red lace headscarf as the nervous men move into place. She laughs at the men, and we cut to a shot from behind her in which the camera lingers on the back of her head. She pulls out her nail, which was disguised as a hairpin, and whips around with a demonic face before flying out of the house with a dismissive cry of "whatever!" Here, the feminist triumph of the pontianak over figures of patriarchal religious authority is decisive, and nail removal is a signifier of refusal.

As pleasurable as these moments of liberation can be, however, the most significant affect prompted by the nailed pontianak is an anxiety about the true nature of women. The nail mediates between the pontianak as beautiful woman and as grotesque monster, and the fact that one cannot tell the difference is a

FIGURE 2.3 Anxiety about the true nature of women is disclosed in shots of necks, e.g., *Pontianak Harum Sundal Malam* (Shuhaimi, 2004).

fundamental deficit in the patriarchal relationship of vision and knowledge. It is hard to know who might be a pontianak, because she can look like a regular woman when nailed, and there is always a possibility that she might reveal her true face, which is grotesque and terrifying. The association of deformity with monstrosity is not limited to Malay cinema, and Angela Smith has analyzed the ideological ambivalence with which horror films treat unusual bodies.[17] What is striking in the pontianak film is the extent to which it interrogates the implications of such bodily difference for women. The pontianak's status as a human is uncertain—is she a person or a *hantu*, alive or undead?—and that ambiguity becomes visible in the difference between feminine beauty and monstrous ugliness. Conventionally feminine presentation becomes linked to being—or being treated as—human.

Moreover, the status of *all* women is thereby put into question, until nervous men check the napes of our necks for telltale nail heads. Pontianak films play out this patriarchal fear in spades. There are frequent scenes in which worried men look for the nail in the back of a woman's neck. In *Pontianak Harum Sundal Malam / Pontianak of the Tuberose* (Shuhaimi, 2004), Madi notices a small round mark on Maria's neck. In *Sesat*, Yamin sees a nail head in Rose's foot. In *Paku Pontianak*, the wise man tells Adam to look behind his wife's neck to see the truth. If a nailed pontianak can appear to be a regular woman, then any woman could

be a pontianak. This is what makes the figure so frightening, for it implies that all women might have access to nonhuman powers and desires, and indeed, any woman might not really be a person. In this accounting, gender is slippery and contingent in ways that may begin from patriarchal logic but that are very unsuccessfully contained by it. I will return in the final sections to the consequences of this queer uncertainty.

THE POSTCOLONIAL POLITICS OF PONTIANAK FEMINISM

The ambivalences outlined earlier lead to an impasse in feminist approaches to the pontianak. To move past this theoretical aporia, I propose a shift from feminist criticism of the pontianak toward the development of a pontianak feminism. Existing scholarship has begun to texture feminist theory with Malay historical specificities, thinking psychoanalytic theory in an Asian context. Alicia Izharuddin makes this move clear in her combination of Barbara Creed's concept of the "monstrous-feminine" with Stephen Teo's idea of the "Asian monstrous-feminine."[18] More recently, she deploys Hélène Cixous's "Laugh of the Medusa" to consider how the pontianak's grotesque laughter both breaches socially acceptable forms of Malay feminine behavior and "anticipates the terror and painful death of male victims, setting the stage for the collapse of desire and patriarchal order, forcing open potentialities for feminist affective knowledge."[19] Addressing Singaporean horror films such as *Return to Pontianak* (Djinn, 2001) and *The Maid* (Tong, 2005), Kenneth Paul Tan links Creed's monstrous-feminine to a geopolitical argument in which the pontianak signals the return of the nation's repressed—a primitive past that threatens its entry into advanced global capitalism. For Tan, contemporary horror films assuage these geopolitical anxieties by subjecting figures of the primitive past to patriarchal discipline.[20] Ng similarly combines psychoanalysis with history. His account of the pontianak as an "excessive body" that breaks apart the Symbolic draws on Irigaray, but he also grounds this Imaginary work in a return of a premodern Malay repressed.[21] For him, the post-1970s pontianak figures what's seductive about abandoning the modern. Ng, like Tan, maps facets of Malay modernity (global capitalism, Islam) onto the films' dominant regimes and posits the pontianak as the Oedipal mother who must be quashed in order to establish the rule of the nation/Islam as Father.[22] Such intersections of psychoanalytic universalism with Southeast Asian historical specificity are important, for they open up a postcolonial feminist account of the pontianak.

The insistence of these scholars on the place of Malay history within critical theory crucially moves the debate past a universalizing feminism that could only read the pontianak as another example of horror film's misogyny or empowerment. The tendency to apply psychoanalytic categories to nations and national histories, however, can be criticized as an overly schematic vision of history. How, then, can feminist theory engage the sexual politics of the pontianak in a way that accounts more fully for her Malay specificity? I propose that we do so by theorizing gender in relation to an expanded view of postcoloniality in the region. The pontianak provides insight into the tensions of Malay gender politics, to be sure, but she does so also in the context of negotiating cultures of decolonization. To understand the space of pontianak feminism, the figure must be read in relation to issues that are central to Southeast Asian postcolonial histories: modernity and precolonial worldviews, religion and secularism, race and identity, heritage and inheritance, and development and the environment. The pontianak disrupts the smooth operation of each of these discursive fields, in ways that emerge precisely from her insistent ambivalence. She bespeaks the Malay past but not simply a conservative invented tradition. She disturbs racial and religious identities and demands new visions of Malay belonging. She suggests that the "good" Malay woman is a construction that might vanish when the nail comes out. With the pontianak, gender is not what it seems, and neither are religion, national or ethnic identities, or modernity. I propose thinking postcolonial histories in relation to the pontianak's feminism, which means addressing intersecting historical processes. To do so also means conceiving of the textual work of the pontianak in different terms. How can the pontianak call us to theorize history and gender? In other words, where can we locate a pontianak feminism?

Let's return to Avery Gordon's idea of the ghost as a social figure, who helps us to see the role of absences in constructing social life. The pontianak speaks about areas of women's lives that might otherwise be invisible. Her haunting presence reveals the gaps and absences of Malay femininity, and presses on the instabilities of familial and sexual relations in postcolonial society. For example, the pontianak can break social taboos to speak about women's sexual lives. Sex remains a taboo subject and in the studio films is not represented directly. Nonetheless, the desire for and social risk of sex is made apparent, as in the high winds that appear out of nowhere in *Gua Musang*, when Rohani gets intimate with Amran in the jungle, or in *Gergasi*, where there is a similar sudden shift from romantic moonlight to thunder and lightning when Guntur kisses Mutiara. The perilous nature of sexual desire for women is refracted atmospherically across the entire mise-en-scène. In the contemporary films, sex becomes a locus of pontianak disturbance. In *Paku*, the reanimated Riana is more eager for sex

than her husband Fahmi expects. At a candlelit dinner, she grabs him from behind, and then in a rare sex scene, her eyes turn white, her nails grow long, and she scratches his back. Female pleasure is linked to uncontrollable pontianak urges, and, conversely, being a pontianak enables the experience (and representation) of sexual pleasure. In *Paku Pontianak*, Melati's *hantu* nature has the opposite effect. On their wedding night, her husband tries to kiss her but she seems wooden and uninvolved. He pulls her onto the bed but she is not interested. Her lack of desire is an indicator that something is not right about her, and forms a resistance to norms of feminine behavior. The pontianak disturbs femininity by refusing sex as well as by enjoying it.

Because the pontianak is traditionally created when a person dies in childbirth, she becomes an evocative figure with which to speak about the risks of sex and maternity. The pontianak can concretize anxieties about the dangers of pregnancy, either through the fear of becoming a pontianak or in narratives about pontianaks who attack pregnant women. Yeo reports that "the pontianak is said to rip apart a pregnant woman's belly and consume the foetus," and popular fiction often focuses on reproductive horror.[23] *Pontianak* from 1975 has a cheap and gory scene in which the protagonist visits a heavily pregnant woman, rubs her belly with oil, and then scratches it with bloody claw-nails. More recently, the short film *Punggol Road End*, directed by Liv Rianty binte Noor Hishamudin (2015), makes the pontianak's arrival at the house of a pregnant woman its final scare. The films provide an expression of real fears of pregnancy and childbirth as sites of pain or death. What permeates them more consistently, however, are maternal narratives of mother-daughter bonding and female inheritance. Almost all of the studio-era pontianaks have daughters, and the sadness of their separation fuels the affective logic of the films. In *Sumpah*, Maria walks outside and sees the ghost of her mother appear among the trees, only to vanish a moment later. Their intimacy and fateful separation are figured in the framing of what would be a classical two-shot if only Comel could remain visible. When Maria calls out to her, Comel reappears, but the two women are never placed in the same shot. *Gua Musang* has a very similar scene in which the pontianak's daughter sings a ballad to her lost mother in the jungle. And *Anak Pontianak / Son of the Pontianak* (Estella, 1958) combines both of these maternal threads: it begins with Manis dying in childbirth and revealing to her husband that she has been a pontianak all through their marriage. She comes back from the dead to be with her child. The emphasis on maternal relationships is melodramatic more than horrific, and like classical melodrama, the pontianak film deploys the emotion of familial relationships to engage wider social structures.[24]

Another way in which spaces of exclusion become visible is in the pontianak film's reiteration and reworking of folkloric tales. *Gua Musang* chimes with the traditional "Legend of Mahsuri."[25] When Mahsuri's husband goes away, another woman, Wan Mahora, spreads rumors of her infidelity and turns the *kampung* against her. In both stories, the protagonist is pregnant, and in both she is believed to have had socially unacceptable sex and is killed as a consequence. Repeatedly, accusations of adultery are central, where women are imperiled at the hands of men, as well as the treacherous social operations of status, in which women find outlets for their frustration. By reiterating this legend, *Gua Musang* articulates how dangerous it is to be a woman and how violence can emerge from any social relation. *PHSM* makes the first overtly feminist revision of traditional tales. It draws from the legend of Radin Mas, a princess who was murdered on her wedding day. In the story, Prince Pengeran marries a beautiful court dancer, Radin Mas, but his older brother disapproves. When Pengeran is out of town, the brother's men come and murder the dancer.[26] Each of these plot points—the marriage, the disapproval, the husband leaving town, and the murder—repeats in *PHSM*. These echoes of stories that circulate as Malay heritage link the precolonial and pre-Islamic periods to the present day; however, they do so not to reinstate traditional national identities but rather to assert the violence that has always lived in these tales. It is a question not of whether the pontianak tale is feminist or repressive, but of how the pontianak figures gendered violence, refusing to let injustice be forgotten and insisting on speaking about the lives of women.

Gaik Cheng Khoo has theorized this return to pre-Islamic culture as an anticolonial reclamation of *adat*, the "the local customs or customary laws that existed before the advent of Islam."[27] Khoo describes the new discourse that emerges in the 1990s, in the wake of Prime Minister Mahathir Mohamad's proposal of a "bangsa Malaysia" instead of a "bangsa Melayu": in other words, a national identity that might be racially inclusive. She argues that

> modernity facilitates the conscious and unconscious recuperation of adat, usually through a focus on sexuality or a return to forms of the archaic such as magic or traditional healing. This reclamation of adat is simultaneously a postcolonial or anti-imperial strategy and a subversion of more restrictive notions of Islamic discourse that emerged since the 1980s. Middle-class Malay cultural producers struggle to reconcile their adat with resurgent forms of Islam and to enunciate their place and identity in global modernity, whether in literature or cinema.[28]

This confluence of sexuality, the supernatural, anticolonialism, and subversion perfectly describes the structure of the pontianak and it is thus no surprise that,

among her case studies in cinema and literature, Khoo includes a pontianak film. She considers Shuhaimi Baba's *PHSM* to be exemplary of this progressive reclamation of *adat*. The first pontianak film to be directed by a woman, *PHSM* self-consciously evokes *adat* through its traditional music and dance, as well as its mysticism. Khoo finds these visually colorful and gestural elements of the mise-en-scène to be "touristy," critiquing the film as both generically middlebrow and ideologically fuzzy.[29] I don't disagree, but I would argue that the pontianak genre depends on this mixing of old and new Malay identities, and that *PHSM*'s middlebrow qualities create a crucial space for their renegotiation. Khoo aligns the new discourse of *adat* with secularism and modernization as well as with tradition and mysticism, and argues that texts that draw upon it work "to subvert state-constructed ideological positions for women within the nation and to reclaim agency."[30] We can build on Khoo's theory of feminist *adat* to consider the pontianak herself as a feminist and postcolonial figure, a specter of pre-Islamic and anticolonial worldviews emerging within an often reactionary Malay modernity.

The role of women between family and public sphere has been a contested topic in postcolonial Malaysia, and the pontianak film's representation of women's lives returns frequently to staging the tensions at play in these social shifts. Raja Rohana Raja Mamat points out that although the constitution of 1957 enshrines equality before the law, it does not mention sex as a form of discrimination to be banned, and limits antidiscrimination law narrowly to apply "only"

FIGURE 2.4 Pre-Islamic culture is aligned to feminism in *Pontianak Harum Sundal Malam*.

to "religion, race, descent or place of birth."[31] Maila Stivens describes the family in late-twentieth-century Malaysia as "highly politicised" with a trend of moral panics about working mothers.[32] She finds that "a new 'Asian' ethics and morality are [invoked] to provide a buffer against the undesirable aspects of modernisation, especially the 'toxic' imports of western 'culture,' and to provide an alternative 'Asian' path to modernity."[33] This construction of an Asian-specific morality and set of family values is reminiscent of the anticolonial discourse of the 1950s and 1960s, in which Western finance capital and technology were welcomed but Western culture was perceived as immoral and undesirable. In the context of the late twentieth century, the word *culture* refers to popular culture such as film and television, but even more explicitly than in the 1960s, it also refers to representations of feminism, women's ability to take up public space, and critiques of the traditional family. The rapid changes in women's roles in the home and workplace in the postcolonial era have produced responses both repressive and liberatory.

Social scientists have written extensively on the relationship between postcolonial economics and gender politics in Malaysia. Stivens points to the mixed effects of development. On the one hand, urbanization and industrialization opened up new possibilities for employment, independence, and ways of living outside the traditional *kampung*. On the other hand, discriminatory laws and poor working conditions, along with a renewed social pressure on reproduction, functioned to restrict women's lives.[34] Aihwa Ong finds that the introduction of the New Economic Policy in 1972 worked to "sponsor the large-scale entry of young women into mass education and industry," and when women work outside the *kampung*, they cannot be so easily regulated by village men, and there are more opportunities for the races to mix.[35] Thus, the movement of women into the workplace was seen as threatening to conservative values across several axes of difference: women moved from rural to urban spaces, moved from domestic labor to wage labor, and mixed with non-Malays and with non-Muslims. In response to these dangerous new freedoms, women came under social pressure to wear the veil and to maintain segregation in mixed gender or race environments. As Alicia puts it, women's bodies are caught in competing discourses of state and Islam, subjected to discipline and "normalizing discourses" that seek to Islamicize gender relations.[36] In this context, the pontianak's agency, sexuality, and mode of being female intervene in a heavily overdetermined nexus of ideas about women's public and private roles. Where the studio pictures take on the project of reimagining Malay identity—including female identity—as an anticolonial project, the post-1992 films respond to the reconfigurations of gender in the era of decolonization.

I argue that the pontianak's embedding in—and transgression of—conservative gender roles forms a key site of contestation in postcolonial Malay societies. In several films, the question of who the pontianak *is* (human or nonhuman, good or evil) is narrated as a question of what a woman should *do*. In *Teng Teng*, the question of whether Indah should work in the rubber plantation becomes a major site of narrative conflict. The men do not want her to work and argue that labor would spoil her beauty. Their argument neatly illustrates the turn between not *making* her do something and not *letting* her do it. Women's independence in the public sphere structures the film, and by insisting on a role outside the home, the premodern pontianak demands a postmodernization approach to gender. *Paku Pontianak* similarly stages the question of what a woman should do in the world. Adam's family takes in the amnesiac Melati, but her presence initiates a problem of what the family should do with an unrelated woman. Her lack of an established social role is visualized in a scene in which Melati sits in a large garden, reading a newspaper. In long shot, she appears ill at ease in this open space, and a cut to a close-up of the newspaper reveals headlines such as "More Employment Opportunities for Women." Like the working woman, the pontianak film disrupts the ideological equilibrium of the Malay family, physically moving women into mises-en-scènes in which they have no traditional role. *Paku Pontianak* articulates this problem by splitting Melati into different versions: the evil pontianak and the demure woman who wants to be pregnant. The film's central mystery is which version of Melati is the truth and, by extension, which version of womanhood will prevail. This multiplication of female subjectivity visualizes the contested space of Malay femininity, in which the pontianak troubles any easy association of the premodern with a traditional reproductive role. For a pontianak feminism, the cultural work of female spectrality traverses the postcolonial public sphere.

GESTURES OF RESISTANCE

Given the semiotic richness and continuing power of the pontianak myth, it is not surprising that feminist artists and filmmakers have been attracted to her. We do not need to rely on against-the-grain readings of the pontianak to see her as a figure of feminist resistance: artists from the Malay archipelago and its diasporas from Maria Menado onward have already understood her in these terms. When we gather together some of the more explicitly feminist representations of the pontianak created by female artists, what becomes visible is a formal politics

of gesture. As persons assumed to be women, pontianaks are constantly the object of the gaze and frequently subject to male violence. The narratives of most pontianak feature films move from oppression to revenge, and their more overt feminist pleasures derive from the pontianak's creation of justice through her dramatic and violent actions. It's for this reason that agency is a useful term in thinking the horror films' generic pleasures. When we turn to female-authored texts, however, the formal elaboration of the pontianak becomes more important. In these texts, the premodern and supernatural qualities of the pontianak nourish bodily gestures that do not conform to gendered, religious, or national norms. Pontianaks transgress corporeal prohibitions through dance, touch, proximity, and engulfment. They take pleasure in their bodies and in the bodies of other women. Their gestures of pontianak embodiment produce affective bonds of love, friendship, and solidarity, and these bonds are formed in opposition to the normative conventions of Malay sociality.

In this section, I address three examples of feminist pontianak embodiment, each of which utilizes a somewhat different visual mode than the popular horror film, although all are in close and often affectionate conversation with the genre. First, *PHSM*, which is a mainstream horror film, but with elements of art horror and melodrama. Director Shuhaimi Baba was part of the Malay New Wave in the 1990s, and she retains an auteurist reputation while making popular genre films. Khoo describes her films as "touristy" in a way that speaks to a middlebrow heritage aesthetic, or what I have previously referred to as the popular art film.[37] Amanda Nell Eu's *Lagi Senang Jaga Sekandang Lembu / It's Easier to Raise Cattle* (2017) is a short film that has circulated at international film festivals and that traffics in a more contemplative art cinematic idiom. Eu is an emerging filmmaker with an interest in reimagining the cinematic possibilities of the Malay *hantu*. Her film *Vinegar Baths* (2018) reimagines the pontianak's sister ghost, the baby-eating *penanggalan*, as an obstetric nurse, and her first feature will be about a were-tiger. I end by moving away from narrative film altogether with a consideration of artist Yee I-lann's installation *Like the Banana Tree at the Gate* (2016), in which pontianak embodiment is partitioned into photographic tableaux and a video of women talking, their voices audible but their faces obscured by long black hair. Yee is a Bornean artist whose work persistently investigates the relationships among gender, colonial histories, and indigenous cultures. Across these different audiovisual modes, I argue that we find a formal persistence of defiant—and intimate—bodily gesture.

The turning point for feminist pontianak representation is Shuhaimi Baba's *PHSM*, which in 2003 became the first *hantu* film made in Malaysia in a decade, and one of only a few since the 1970s. *Filem seram* were subject to censorship as

un-Islamic, and although a few horror films had been made which were seen as sufficiently supportive of Islamic teachings, the representation of *hantu* was next to impossible.[38] It is significant, therefore, that the first to make it past the censorship system was a feminist pontianak film directed by a woman. Shuhaimi commented at the time of the film's release that "we had to rewrite our script five times. Only when it was finally approved did we schedule filming so that the scenes would not end up on the editing floor later on."[39] The censors insisted that the pontianak only be seen in dream-like sequences, continuing the attempt made by Tom Hodge in the studio era to defuse her animist power. Despite these obstacles, *PHSM* was a huge success, earning 3.2 million RM.[40] It was also one of few Malaysian films to circulate internationally, playing in Indonesia and Thailand, as well as at film festivals in Asia and beyond.[41] As we shall see, *PHSM*'s place as the first contemporary pontianak film has ensured a scholarly attention to both its place in Malaysian film history and its gender politics. Moreover, its inspiration to other filmmakers and appeal to audiences are undeniable. As Norman Yusoff puts it, "Ever since the release of *Pontianak Harum Sundal Malam*, horror has emerged as the most popular film genre in Malaysian cinema."[42]

The film was controversial—the title includes a word ("sundal") that also means "whore" so its transgression of polite speech about gender is very much up front, as is its discourse on the violent policing of female sexuality. The first half of the film depicts Meriam, a famous dancer who is assaulted by violent male entitlement. Although she is not interested in Marsani sexually, he constantly pressures her and voyeuristically spies on her private moments. On the street, a stranger demands sexual favors from Meriam, and later she is kidnapped and almost raped. After Meriam marries Marsani's friend Daniel, the pathologically jealous Marsani murders her. In the gory denouement of the film's first act, Marsani's henchmen stab the heavily pregnant Meriam, leaving her servant Laila to cut the baby from her dying body before herself being killed. The film constructs a feminist narrative about male aggression, making explicit the gap that the genre always implies between its violent subjugation of women's bodies and the pleasure it offers us in return and revenge.

The second half of the narrative occurs thirty years later, with Meriam haunting Marsani and his family to demand revenge. Alicia reads this revenge narrative in feminist terms, arguing that the film is a "women-oriented rejoinder to . . . the misogynistic tale of the pontianak," and that it resignifies the misogyny of the myth by locating women as both object and bearer of the gaze.[43] Thus, while Meriam is constantly the object of the male gaze, the film makes us see that gaze as oppressive and incipiently violent; and in the film's second half, female characters take control of the film's regime of vision. Becoming a pontianak

provides female characters with an opportunity to mock the normative gender roles that Meriam embodied in life. Marsani accuses Meriam's daughter Maria of being a pontianak, and she ventriloquizes a submissive woman, saying "I'm scared" in an exaggerated way before returning to a confident tone and a satisfied smile. Maria secretly practices the same *mak yong* dance that Meriam was famous for, and when she opens a box of artifacts, she seems to summon the pontianak. In one of the film's most visually arresting shots, Meriam appears superimposed on fire, and, addressing Marsani, promises, "I will seize what you have seized from me." Maria becomes possessed by Meriam's spirit, doubling her body into colonial and modern temporalities at once. Her practice of *mak yong*—a pre-Islamic art form—exemplifies Khoo's feminist reinvention of *adat*. Maria is at once modern (a single, independent, working woman) and ancient (drawing on pre-Islamic cultural practices and possessed by an animist spirit). Pontianak Maria does take bloody revenge on Marsani's family, but the images of Meriam in the form of Maria's body exert a more melancholic form of haunting. Both the ancient history of *mak yong* and the proximate one of Meriam's murder are conjured and reiterated in Maria's bodily gestures.

Ng argues that the pontianak in *Sundal* works "as a metaphor for the Malay woman's schizophrenic identity," and the film oscillates vividly from scenes of patriarchal oppression to those of pontianak vengeance.[44] The pleasures of transgression are complicated, however, in the film's sequel, *PHSM 2* (Shuhaimi,

FIGURE 2.5 In a dramatic superimposition in *Pontianak Harum Sundal Malam*, Meriam vows to seize back her property.

2005). This film takes on the ethical problem of the pontianak, when pleasurable female revenge curdles into a cycle of violence and the ability of women to take on masculine violence ultimately fails to imagine a better world. The sequel returns to the original scene of the murder, and follows the rescue of Meriam's baby, Maria. Maria is raised by one of Meriam's servants and finds herself as a young woman being possessed by her dead mother. In the end, Maria confronts Meriam, and Meriam apologizes for imposing on her soul. From Maria's perspective, her mother has been attacking innocent people and continuing bloodshed and hatred. Meriam explains that nobody heard her cry or saw her years of loneliness, and that their family name was ruined, but she admits that she lost her sense of self. There is a different feminist move at work in giving moral complexity to the pontianak. Her rationale for revenge includes a sense of erasure, of her voice not being heard, and her emotions not recognized, as well as a traditionally male logic of avenging the family name. Meriam recognizes that in her righteous revenge she lost her own morality and became the monster she sought to kill. Women in contemporary pontianak films are not usually allowed this moral complexity, although the figure of the pontianak often depends on precisely this moral ambivalence. By making Maria's body the site of a palimpsestic haunting, the *PHSM* films explore the weight and intimacy of inheritances of violence.

Amanda Nell Eu's short film *Lagi Senang Jaga Sekandang Lembu* never uses the word *pontianak*, but it beautifully deploys her as a figure of female anger, resilience, and solidarity. The film begins as a realist coming of age story in a remote village, and its style is reminiscent of the work of Apichatpong Weerasethakul, another director for whom slow cinematic realism and an observational attention to the spaces of rural Southeast Asia nonetheless include the existence of spirits. The film's title comes from a Malay saying that it is easier to raise cattle than daughters, and the film flips that patriarchal logic on its head by focusing on how hard it is to *be* a daughter. A tween girl called Rahmah looks up to a slightly older teenager, unnamed in the film, who smokes, climbs trees, and goes out at night. The film begins with Rahmah, looking awkward in a shapeless T-shirt, approaching a tree in which the older girl lounges on a high branch, facing away from the camera, her long black hair falling down her back. We cut to a crane shot that moves up Older's bare leg, past the hand loosely holding a cigarette, to her pouting face. Older is the very image of a Bad Girl. In an extreme close up of the lower part of her face, she pulls a long hair through her lips: the shot is eroticizing but it also frames her boredom and self-involvement. In this proximate composition of lips and hair, Older is represented as sensually alluring but not displayed for the male gaze.

FIGURE 2.6 In *Lagi Senang Jaga Sekandang Lembu* (Eu, 2017), the pontianak is a rebellious teenager.

Instead, the film pays attention to the intimacies of female relationships, and to the proximities between girls that can form an escape from patriarchal surveillance. When Older comes down from her tree, she chases Rahmah, and the crosscut scene evokes a sense of joy and freedom in the girls' bodies running, their hair trailing in the wind. The film's realism is tactile, paying close attention to bodies in motion, to gesture and the everyday activities of girls as marginal subjects to whom such close attention is not often granted. When Older catches Rahmah, she pulls her down in a tumble that is shot from a distance, but is followed by a disjunctive cut to a close-up of Rahmah's face as Older licks her cheek. Rahmah grimaces and runs away, but the shot both creates a familial intimacy, like sisters teasing, and also hints at a more transgressive sensuality in which physical boundaries might be less well maintained. The potential duplicity of bodies increases in a later scene, which begins with another extreme close up, this time of a hairy leg being plucked with tweezers. These shots work to create proximities outside of patriarchal vision. (The tweezing also runs counter to Islamic doctrine on female bodily presentation, so there is a running thread of

religious transgression by these unveiled girls.) Older tells Rahmah about a website that pays for photographs of girls in bikinis with bruises on their bodies. Meanwhile, the camera traverses Older's body, disturbingly covered in bruises. Rahmah joins them up with a sharpie, mapping Older's body in a way that is not sexual, and taking ownership by writing on the body, quite literally. It is a perfect evocation of how young girls see their bodies: she views the bruises in a childish way as gross and fascinating and weirdly beautiful, rather than through an adult gaze that might ask how they got there in the first place. Older asks Rahmah to give her a black eye, so that she can pose for the website wearing a bikini and a hijab, covered in bruises. Rahmah looks horrified by this request but surprises herself by punching Older in the face, an action that makes both girls laugh. Incrementally, violence intrudes upon the intimacies of girlhood.

We learn something about Older's bruises in the next scene, at night, where we see her bent over an older man—her father—who is seated on the house's verandah. Although the camera keeps a distance, she appears to be giving him a blowjob. We cut to a close-up of her neck as he pulls her hair aside, and there is a glimpse of a scar or *something* on the nape of her neck. *Lagi Senang* gestures to the discourse of pontianak anxiety, but our perspective is no longer that of the nervous man, but that of a female spectator who hopes that Older has a power that could help her in this abusive situation. She stands up, looking upset, and runs away while the man sits expressionless. The next day, Rahmah is back by her tree, but Older is missing. Most of the film distends time, deploying naturalism to stage the boredom and lack of agency felt by the girls. Its art cinematic conventions lead us to expect small gestures and temporal drift. However, this slowness is suddenly overthrown in a cut to nighttime, with Rahmah running through the jungle, squealing as if she were playing a childish game of tag. Her game is interrupted by a primal scene of sorts, in which she discovers Older crouched over the body of her father, his white shirt covered in blood. Rahmah approaches her and reaches out to touch her friend, while Older, making a muted purring sound and with long pontianak fingers quivering in the night air, continues to devour the flesh of her abuser.

In a reversal of art cinematic expectation, the physical intimacy of girlhood becomes a secret space of pontianak revenge. The film ends with a return to the quotidian, however, in an extended sequence of the two girls dancing in sync, enjoying the freedom and carnality of their bodies. Eu describes the film in terms of this relationship between girls, saying, "I was never planning to make an all-out 'Pontianak' film—there are so many great ones out there already. I was more interested in breaking down the spell of the pontianak, mainly questioning 'what if she was my best friend?'" She continues, "I already personally love the

FIGURE 2.7 "What if she was my best friend?" *Lagi Senang Jaga Sekandang Lembu* ends with a celebration of girlhood.

pontianak and totally respect and admire her. I also feel her pain and understand her need for vengeance."[45] Eu takes the feminist admiration of the pontianak literally, and imagines the pontianak as a childhood best friend. Rahmah wants more than anything to be *like* the pontianak but she is also empathetic to her suffering. In the final scene, *Lagi Senang* switches from the satisfying violence of revenge to a bodily pleasure that does not require men, dead or otherwise. Older shares her phone's headphones with Rahmah so that they can listen to the same pop song, and gives her instructions on how to dance. Older tosses her hair sexily, as Rahmah struggles to copy her moves. In this final sequence, the film's sensuous realism returns from the dark and sticky sensations of eating flesh to the apparently more wholesome pleasures of dancing. With Older's father removed from the scene, the girls are free to use their bodies as they please and the film ends with a pure sensual pleasure of untamed corporeality. For Eu, both girls are ultimately pontianaks in their potential and their freedom.

Malaysian artist Yee I-Lann understands the pontianak quite explicitly as a figure of feminist resistance, and links this politics to postcoloniality in her photo

series *Like the Banana Tree at the Gate* from 2016. The work comprises several large-format photographs of women in long black pontianak wigs, their faces covered by hair, posed in a white studio setting among banana plants and plastic stools. They are wearing casual, modern clothes and are posed like models: one with her hips cocked, another lying on her side. Their bodies are arranged without context, their pontianak figuration abstract and gestural. But there are also real banana trees in the frame as well as plastic stools, detritus from Malaysian street culture. The exhibition also includes a Polaroid photo series of banana trees in situ, titled "Ghost in the Banana Tree," which creates a tiled effect of hundreds of Malaysian landscapes. The Polaroid format connotes a nostalgic capturing of reality, but no ghosts are visible. By contrast, two videos give contrasting voices to the pontianak. One, "The Resource Room," features a montage of film clips from Malaysia, Singapore, Indonesia, and Cambodia, reiterating the Southeast Asian cultural history of the figure. The other, "Imagining Pontianak: I've Got Sunshine on a Cloudy Day," is a three-channel video in which women, wearing pontianak wigs to cover their faces, speak about issues that are generally considered taboo, like sex and abortion, as well as those seen as too domestic and feminine for public airing, such as children and their love for pop cultural figures. Both photographs and video play on the iconicity of the pontianak, using her long black hair at once to identify the women as pontianaks and to render them anonymous as women. Under cover of the iconic pontianak hair, women have a freedom to speak and perhaps to act.

The title of the exhibition is a reference to a seventeenth-century sultan in Borneo who advised against planting a banana tree close to one's front gates so as

FIGURE 2.8 *Like the Banana Tree at the Gate: A Leaf in the Storm* (Yee I-Lann, 2016). (Image courtesy of Silverlens.)

not to advertise the wealth within to invading colonists. According to Michael Dove, the phrase has become "a folk metaphor for a resource that is simply too attractive and vulnerable to others, just as a ripe banana in front of your house will be picked and eaten by someone passing by."[46] Yee's feminist rereading of the phrase understands a history of viewing women as possessions, whose beauty makes them vulnerable to men in the public sphere. In this version of Malay femininity, the pontianak is a threat. She describes moralistic uses of the figure as a warning to girls and women who are insufficiently desirable, as in, "Go brush your hair, you look like pontianak."[47] But the title also links women to folk knowledge, and to the pontianak who is traditionally found in banana trees and who will take revenge on any man who should try to 'pick' her in that way. As we have seen, pontianak films are full of men who try to pick up women whom they find alone at night, and on whom the pontianak enacts revenge. Yee's framing of women with banana leaves and her tiling of numerous banana tree landscapes promise a visual field filled with female spirits, forming an unseen force across the Malaysian landscape. In an interview, Yee says, "All these stories refer to the woman as vengeful, out of control, a failed woman. The stories negate or remove woman's political agency in a community or worse, dismiss her potential agency."[48] Her work reconnects the women to political agency through the power of the pontianak: for instance, in *An Essay of Hauntings: Dance of the Fragrant Flowers* (begun in 2016 and ongoing), she reimagines the women of the Indonesian Gerwani feminist movement of the 1950s as kuntilanaks. The women, who were linked to the Indonesian Communist Party and who killed six army generals, were discredited at the time as sexual deviants. Yee reappropriates that sense of feminine transgression by figuring the women as anticolonial pontianak heroines. For Yee, the pontianak "continues to haunt us in twenty-first century patriarchal Southeast Asia.... She is potential and power and resource."[49] Or, as Amanda Nell Eu asserts, "All women are pontianaks."[50]

QUEER PONTIANAKS

Nosa Normanda's short film *Pontianak* from 2017 overthrows several categories of expectation about the nature and identity of the pontianak. The film begins with a pregnant Chinese woman apparently being attacked by a pontianak. The figure approaches the house and removes the hood of her long white dress to reveal herself as a beautiful Malay woman and a dangerous *hantu*. The pontianak tries to access the house but is rebuffed by protective spells. The woman's use of rice, a

broom, and a mirror to protect herself evokes the phrase *dapur-sumur-kasur*, or "kitchen-well-bed," which speaks to a woman's traditional roles of cooking, cleaning, and providing sex. The protagonist aims to use these tenets of patriarchal femininity to protect herself, but the pontianak persists, breaking the mirror with her monstrous face. However, this attack does not proceed as we expect. The film spends a lot of time with the heavily pregnant protagonist's ungainly and effortful movements. She sits down to gather up rice and then struggles to get up. Instead of those pregnant women who function as symbols of Malay womanhood or of sinful premarital sex, her body is material and laboring, and tells a story of being alone and unsupported. When both women are on the verandah, the protagonist cannot see the pontianak. They are facing in opposite directions, with the pregnant woman in the foreground and the pontianak, out of focus and facing away from the spectator, in deep frame space. Although we believe the pregnant woman is in danger, the framing does not work to create narrative suspense but rather makes us want the women to turn around and acknowledge each other. When they finally face each other, the pontianak says, "Enough. I can't stand seeing you like this. He is never coming back. Come home with me." It's an unexpected first line from a *hantu*.

We realize that the Chinese woman has been abandoned by yet another of the genre's loser men, and that the pontianak is her friend, come to persuade her to stop waiting for him. The pregnant woman insists, "I love him and he loves me

FIGURE 2.9 *Pontianak* (Nosa, 2017) proposes a queer tension between a pontianak and a pregnant women.

too," as she pushes the pontianak away, wielding a pair of scissors against her. The blades make the pontianak's face dissolve repeatedly but she doesn't give up. The pregnant woman's words insist on heteronormativity, but with desperation, and the pontianak tries to rescue her from this fate. The two women move closer to each other. In a double reversal of expectations, the pontianak pulls the nail out of her friend's neck, revealing her to be a pontianak also, and the relationship between the two women transforms from *hantu* threat into one of care and intimacy. That a Chinese woman could be a pontianak overthrows the engrained racialization of Malay culture, and suggests an affiliation or even intermixing of Malay and Chinese spirits. In the final scene, she wears a deep crimson dress in a nod to a Chinese spirit known as the woman in red.[51] Moreover, the women's friendship becomes romantic as the Chinese pontianak tenderly strokes the other's hair, and the Malay *hantu* leans happily on her comrade's belly. The film offers a radical revision of the relationship between the pontianak and the pregnant woman. Rather than preying on women in this dangerous state, these pontianaks disconnect reproduction from violence. Nosa speaks of the influence of Indonesian feminist horror writer Intan Paramaditha on his work, and of the idea of transforming demonization into freedom.[52] In a queer revision of the pontianak's mission to heal the community, these *hantu* reject the human world of men and house-cleaning, choosing to return to the spirit world as friends and lovers. In the final shot, the two pontianaks disappear together into the jungle in queer interracial vampire solidarity.

We might imagine a queer pontianak to be a recent invention, but if the utopian vision of *Pontianak* is new, the queerness of the figure certainly is not. The Chinese translation of the word *pontianak* on the poster for the original film from 1958 uses the term *rén yāo*, a colloquial term in Southeast Asia for a transgender stage performer. The term is today widely seen as offensive, but its use here is striking when other translations of the female vampire concept would have made more obvious sense. Meaning both "human monster" and "alluring person," this translation asserts what I propose as a gender anxiety at the heart of the pontianak's queer appeal. Horror scholars have elsewhere linked gender performance with the monster's ambivalence: Rhona Berenstein uses drag as a way to conceptualize the appeal of the classic American horror film monster, arguing that, "like transvestites, fiends are interstitial; they transgress conventional categories of sexual and human identity and incite fear and desire in those whom they encounter."[53] The pontianak has always encoded a queer ambiguity about desirability and repulsion, femininity and monstrosity. The structure of male anxiety around the figure is that an attractive woman might reveal a nonhuman horror beneath the surface of femininity. Monstrosity corporealizes the wrong

kind of subject and an attraction to the wrong object, category errors in patriarchy that can only be borne by transforming an alluring person into a human monster. The pontianak threatens normative systems of both gender and sexual orientation, and, as with the question of misogyny, pontianak films must be seen as both deeply reactionary and filled with queer potential.

Queerness emerges repeatedly in the studio-era films, from comic characters who perform masculinity in nonconventional ways to more sustained narrative play with gender. In *Sumpah*, the servant Dol falls asleep when he's supposed to be on watch and dreams that a beautiful pontianak beckons him. He follows, sleepwalking, as the pontianak directs his steps, only to wake up in the arms of one of his male buddies. In his pontianak vision, he dreams of kissing a beautiful woman but in reality he was about to kiss one of the other men. The friend wakes up and shouts, alarmed, "he kissed me!" The effect of the pontianak—even an imagined one—is to disrupt gender relations and to produce queer acts. In *Gua Musang*, the noodle seller Maidin decides to teach his rival Ali a lesson. To do so, he waylays him in the jungle, dressed as a woman. Ali is scared at first, but when he sees it is a woman, he stops to flirt and sell her satay. Maidin sits down, flirtatiously covering his face with a lacy headscarf. Ali offers Maidin sticks of satay, salaciously suggesting that he can guarantee she'll be happy with his longer stick. At this point, Maidin turns around wearing a pontianak mask and terrifies Ali. Again, the film uses comedy to alibi its representation of gender dissidence and same-sex desire, and it's the figure of the pontianak—as taken up by a male-bodied character—that creates the opportunity for such nonnormative scenarios to emerge.

Contemporary pontianak films refer frequently to their studio-era precursors, and the uncertainty around gender, humanity, and embodiment that produces the alluring monster is even more visible in the 2000s. Sometimes, as with Nosa's lesbian *hantu*, the queerness of the pontianak is welcomed. Glen Goei and Gavin Yap's *Dendam Pontianak / Revenge of the Pontianak* (2019) includes a fascinating moment of queerness when Mina, the pontianak, possesses a male character. He immediately begins acting as Mina, which in effect involves him presenting as effeminate. His bodily stance sags into a contrapposto, he waves his hand expressively, and he mimics a feminine vocal cadence. Although we understand that narratively he is inhabited by the spirit of a woman, his gestures are immediately legible as effeminate, so that he seems to turn not from a man into a woman but from a straight man into a gay one. The pontianak disturbs Malay gender and here she does so quite directly by using spirit possession to compel a man to perform his gender differently. The moment is playful, addressing the spectator who is knowing, rather than one who is phobic, and this mode

of queer address fits *Revenge*'s overall refusal of a heteronormative gaze. Throughout the film, the male lead, Remy Ishak, is framed with a dreamy eroticism, often half-dressed, whereas the female stars are presented as elegant and beautiful, but not fetishized in the same way. That the film is made by a queer director, Goei, whose theater work often draws on drag and camp, further supports its investment in the pontianak's queer potential.

Where Goei, Yap, and Nosa offer affirmative queer images, other films stage gender anxiety in painfully phobic ways. Comedy is often produced out of homosexual panic, where men are so afraid of the pontianak that they end up in each other's arms. In *Paku Kuntilanak*, Joko's mother admits she is relieved that he is dating a *hantu* because she thought he was a homosexual. The films police masculinity and male behavior by likening nonnormative gender presentation to the female monstrosity of the pontianak. For instance, in *Pontianak Menjerit* (Yusof, 2005), a character called Mazlan is represented as campy and effeminate. He works in an Almodovar-esque boutique, and sports 1980s-style blond tips, a thin mustache, and colorful, wide-collared outfits. His performance hits on multiple gay and effeminate stereotypes, including flipping his hair and being literally limp-wristed. When one of the protagonists, Yassin, encounters Mazlan wearing a sheet mask on his face, Yassin thinks he is a pontianak and runs away in fright. Mazlan's beauty routine turns his face white and unrecognizable, and thus his effeminate gender presentation makes him comedically comparable to a pontianak. Later, the film spells out its coding of his gender when he avows, "I may look like a sissy, but I'm brave!" using the word *lembut*, a common term for gay and transfeminine people. *Teng Teng* has an almost identical character in Rasyid, who makes his own colorful clothes and uses effeminate gestures. Even though he tries to marry the pontianak, a female friend describes him as *lembut-lembut*, or "very soft."[54] Both films go out of their way to associate the pontianak with gender dissidence and it attempts to manage the threat of such dissidence with transphobic and homophobic comedy.

Trans-panic comedy becomes explicit in several films that depict trans women, indirectly and sometimes quite directly associating them with pontianaks. In *Paku*, two trans sex workers encounter Riana, a pontianak. They warn her off, shouting, "Hey girl, this street is for men to look for ladyboys like us not women like you." When Riana doesn't reply, they ask if she is a pontianak and then mockingly warn her to be careful because her husband might fall in love with a trans woman. Riana is eventually riled enough to respond, and she turns with her frightening pontianak face, which prompts one of the sex workers to faint and the other to run away in panic. Good Malay women are not supposed to walk the streets alone at night, and Riana's ability to do so both aligns her with sex

workers and aligns them with pontianaks—both are alluring, dangerous, and, in the film's terms, monstrous. In *Pompuan, Pontianak dan...* (Asmat/SSTV, 2004) implication is replaced with direct transformation. This film invents a new generic myth, in which if a pontianak's tear falls on the ground, she will turn into a trans woman. When she allows a man to remove her nail, a tear slowly rolls down her face and onto the ground. The sequence holds off on a reverse shot, finally revealing not pontianak makeup on the same cis female actor, but a different actor entirely, playing her transness as horrifying. The man recoils as the trans-pontianak tries to kiss him, responding as if she were a frightening monster. This phobic transformation scene plays on the audience's genre knowledge in which we expect nail removal to render the pontianak grotesque and dangerous. The pontianak is a woman who doesn't conform to normative expectations about restrained appearance and docile behavior, and who, when her nail is removed, is set free to transgress and threaten patriarchy. In these phobic comedy scenes, the sheer threat of gender dissidence is made powerfully visible, along with the need to manage it constantly for a fearful male audience.

Just as scholars have pointed to the misogyny of the pontianak film, it is necessary to name their transphobia. Nonetheless, in their insistent representation of gender dissidence, pontianak films can't stop associating this figure, so popular and so closely associated with Malay identity, with queerness and the disruption of hegemonic social formations. *Pontianak vs Orang Minyak* (Afdlin, 2012), for instance, makes gender transformation into its central narrative contrivance. When a pontianak kills a man by mistake, the victim becomes a male pontianak, breaking the genre's most basic rules. He is taken to meet the pontianak queen, and the assembled *hantu* society debate whether he should be killed as an aberration or whether their creed demands that they take care of one another, whether they are male or female. Having decided that they have an ethical obligation to Ponti, the pontianaks must teach him how to fly and, most challengingly, how to seduce a man. Ponti must wear a dress, shave his legs, and learn to present as a female *hantu*. The film does not see him as a woman, but it is also not clear that he is straightforwardly in drag. He *is* a pontianak and thus femaleness is as much an intrinsic part of his identity as maleness. The *orang minyak*, or "oily man," character also makes gender into a narrative problem. In the film's opening scene, a friend tells Ketiak that he should be manlier because women don't like soft men. Masculinity is immediately at stake. A voiceover explains that, because he is *lembut*, Ketiak can't find a woman, and that desperate people are haunted by demons. There is a direct link between his nonstandard gender presentation and his susceptibility to *hantu*. Ketiak is turned into an *orang minyak*, a *hantu* known for raping virgins. Whereas the masculine guy is turned

into a female *hantu*, the effeminate man is made to embody a hypermasculine one. As much as comedy-horror films work tirelessly (and often tiresomely) to reassure male viewers about their potency, they also continually disrupt the terms of ethnonationalist patriarchy.

The pontianak as an "alluring monster" creates a space in which the relationships between gender dissidence and postcolonial Malay identities can be reimagined. In *Misteri Bisikan Pontianak* (M. Subash, 2013), gender dissidence centers the narrative of a murdered trans woman who appears to return as a vengeful ghost. The film transforms transphobic violence into a site of queer revenge, offering both the generic pleasures of queer monstrosity and a claim on social justice. Patriarchal repressions are joined by violence against queer people as causes for supernatural revenge and the pontianak's rejection of gender normativities is deployed to advocate for trans (or, in the film's terms, *waria*) acceptance. *Misteri*'s narrative proceeds along two tracks: in the present day, Haqim is haunted by a pontianak, and in flashback we follow trans woman Geena and her grandmother. Geena is repeatedly violently abused by men. Haqim's friends challenge him to pick Geena up, and when she ignores his crude catcalls, he chases her, demanding, "How dare you embarrass me in front of my friends!" Eventually, Haqim rapes and murders Geena. Male entitlement and fragile masculinity are a source of threat and female agency is met with male violence. However, in the present, the pontianak does not allow Haqim to get away with his crime, and the haunting forces him to confess. These tales of past injustice and retributive haunting echo the spectral temporality that Bliss Cua Lim finds in the Asian ghost film. For Lim, the ghost speaks of justice denied, forming a Derridean hauntology.[55] The pontianak is a such a specter, witnessing antiqueer violence at once to the unredeemable Haqim and to the wider audience.

Misteri's project is to locate trans rights within Islam, or in other words, to ask whether the community can accept difference. In an early scene, Geena cries, "I didn't ask to be born this way.... Sometimes I blame God." Her grandmother responds, "God creates us without any flaws.... Others don't understand His will." Grandma uses religion to insist that Geena is perfect as she is, and that it is the community's understanding of both Islam and humanity that is flawed. Later, she insists that Allah created Geena and she has a right to live in this world. "There are many kinds of human," she says. Working within the dominance of Islam in Malaysian public culture, the film quite explicitly deploys a liberal theology to advocate for trans acceptance. Moreover, the spaces in which Geena is accepted are overdetermined as Malay. Trans life is imagined neither as marginal nor as foreign but through the most nationally and culturally beloved signifiers. In one scene, Geena puts makeup on her Grandma, telling her she'll look like Mariani,

FIGURE 2.10 The trans protagonist of *Misteri Bisikan Pontianak* (M. Subash, 2013) serves *nasi lemak* at the heart of her community.

the studio-era Malay film star who was the sister-in-law of cinematic legend P. Ramlee. The reference to Mariani is not only nostalgic, but evocative of the Malay popular cinema that we have seen to have thrived in the era of decolonization. Outside of the family, Geena works in a café, where she is friendly with the other women, and where we learn that she aspires to open her own *nasi lemak* stall. Food, and especially street food, bespeaks Malay cultural identity and Geena's ambition to sell what is often viewed as the national dish indicates her desire to live in the heart of the community. In the shift from Geena's easy connection with her customers to the melodramatic scene in which, after Geena's death, grandma finds a letter describing how customers will love her unique recipes, the film asks whether Malay culture can accommodate difference.

We believe the pontianak who haunts Haqim to be Geena's vengeful ghost, but in a twist, it is revealed that there is no pontianak and that Haqim's sister Kayak hired an actress to play the pontianak and thereby to force him to confess his crime. To be sure, this twist can be read as retrograde. The queer subject has no agency because she is dead, and neither does the pontianak, because she doesn't really exist. What is most transgressive about the myth is, in a way, dissolved in a narrative that insists that it was a hoax. The film refuses to let its trans character have the agency that the pontianak usually has. Moreover, a cisgender woman takes on agency on Geena's behalf, just like the liberal filmmaker speaking in place

of trans subjects. But *Misteri* nonetheless does something intriguing with the fake pontianak plot. As we have seen, in the context of Malaysian censorship, it is significantly easier to pass a film in which apparently supernatural events turn out to have a rational explanation, and this is even more true in a film that aspires to include Islamic teachings. Horror films respond to and accommodate this institutional challenge in various ways, but one recurring strategy is to add a rational twist that produces surprise without losing the affective qualities of the ghostly. *Misteri* leverages the cinematic history of the pontianak both to include trans women in the category of women and to descry transphobic violence by deploying the same visual rhetoric used by the older films in relation to patriarchal violence. In shifting agency away from Geena in its rationalist conclusion, it works not to dissipate pontianak power but rather to attribute it to women collectively. In the final scene, Kayak goes to tell grandma that Haqim is in prison, and the women embrace. The pontianak becomes something women invent in the defense of women. While she is not real, she does become a figure of justice.

Lim, in discussing queer appropriations of the Filipino *aswang* (a ghostly figure that has familial similarities to the pontianak), argues that "such texts point to an emerging structure of feeling that posits felt solidarities between the social expulsion levied against aswang and experiences of marginalization endured by queer subjects."[56] We can see a similar affinity in the pontianak film: the pontianak exposes social marginalization, and in *Misteri*, that marginalization is explicitly levied to speak for a queer subject. What's distinct here is that *Misteri* doesn't quite work at the level of allegory, the way in which the monster of horror film has been understood to be like a queer (or the queer to be like a monster).[57] Instead, the ending insists that the ghost was really a person in disguise and that Geena is just a subject, a person who was murdered. The queer and the monster are separated but not disaffiliated. The pontianak becomes the figure who can speak when the queer subject cannot. Rather than using allegory, the film deploys the historically accrued meanings of this not-quite-human figure. The pontianak becomes a resource for fighting patriarchy and gender normativities, for imagining Malay genders differently, and for speaking against conservative dogma. As much as *Misteri* is a liberal human rights narrative with all the deficiencies that entails, it remains striking that the pontianak is the figure to whom a Malaysian filmmaker turns in trying to advocate, in a popular genre, for trans rights.

Misteri returns us to the reconfigured discourse of *adat* that Khoo locates in contemporary Malay culture. Its combination of archiac cultural forms with greater gender equality forms the basis of its progressive resistance to conservative versions of Islam. The film poses an activist challenge through the pontianak's premodern history as well as through granny's liberal modernity, since neither

liberalism nor animist *hantu* is accepted within conservative ethnonationalism. Malay culture has long been defined by a syncretism that combined elements of animism, Hinduism, Islam, and scientific thought, and by their very existence, pontianak films insist on a cultural syncretism that is anathema to the Islamist elements of Malay political culture. Even the most retrograde examples of the genre are thus troublesome to a political culture that would prefer not to see unruly women and animist worldviews gaining large popular audiences. The former prime minister Mahathir Mohamad has spoken out against *hantu* films, using them to leverage a cultural conservatism that posits popular culture as a threat to religious values.[58] For *Misteri* to use the figure of the vengeful pontianak to advocate for a modern, feminist, and trans-inclusive form of Malay Muslim identity is perhaps a bolder move than it might at first appear.

The films I have considered in this chapter are not always easily recognizable as feminist or queer texts, but I argue that in their insistence on speaking about gender, power, and violence, they participate in a discourse on decolonization that was begun in 1957, and that from the outset understood feminism as a key component of anticolonial thought. As Ong puts it, in analyzing postcolonial Malaysia, "The twists and turns in gender contestations show vividly that gender politics are seldom merely about gender; they represent and crystallize nationwide struggles over a crisis of cultural identity, development, class formation, and the changing kinds of imagined community that are envisioned."[59] Pontianak films draw on precolonial and pre-Islamic imaginaries in order to resist reactionary forms of gender, nationalism, and Islam in the present, and to imagine in the figure of the pontianak new forms of political embodiment and agency. Since the election of 2018, Malaysia's government has cracked down on queer spaces and has emboldened perpetrators of homophobic and transphobic violence. The government has condemned LGBT rights, and in its first year in office, nightclubs were closed down, the work of queer artists was removed from a major exhibition, and queer people have been arrested and subjected to state violence.[60] Thilaga Sulathireh, cofounder of the trans rights group Justice for Sisters, says: "We are under attack in an unprecedented way."[61] In this context, the potential for popular cinema to animate feminism and gender dissidence from within Malay worldviews and traditions seems all the more urgent a project.

CHAPTER 3

RACE, RELIGION, AND MALAY IDENTITIES

Made as part of the celebrations of Singapore's fiftieth anniversary as an independent nation, *7 Letters* (Khoo, Boo, Neo, Tong, Rajagopal, Tan, P. P., and Tan, R., 2015) is a portmanteau film consisting of seven tales of contemporary Singaporean life. The first episode, directed by Eric Khoo, is called "Cinema" and it is about pontianak films. The simplicity of this title is telling: in Singapore, it might be said that the pontianak film *is* cinema, with no further specification needed. What we see in this episode is a tight binding of the pontianak to forms of identity that make affective claims on nation and race, evoked through a self-reflexive meditation on the nature of cinematicity. The film opens in black and white, with the look of a studio-era film. A woman wearing a Nyonya *kebaya* stands in the midst of dense jungle foliage, singing in Malay a plaintive song of a lost child. She walks gradually closer, until, at the end of the song, she looks directly to camera and her expression changes from sadness to anger. A mist crosses the screen and when it dissipates the woman has transformed into a monstrous pontianak who lurches forward into an extreme close-up. Her pontianak form is reminiscent of Maria Menado's, with a lumpy, dark mask that covers her face completely and very long teeth. We cut to a *kampung* scene of children seated on the ground at an outdoor cinema, screaming at the terrifying scene we have just viewed. The screen is a bed sheet, and on it we see the title of what has been revealed as a film-within-a-film: *Kepulangan Pontianak*, or *Return of the Pontianak*. No such film exists, but the title is similar to those of the original studio films. Moreover, *kepulangan* carries a meaning of returning home, intimating that the film we are watching offers, also, an experience of homecoming for the pontianak in Singapore.

FIGURE 3.1 Nostalgia for the cinema of the 1950s is evoked by a fictional pontianak film in "Cinema" (Khoo, 2015).

This nostalgic opening sequence is revealed to be a flashback, and the remainder of "Cinema" takes place in the present day. In the next scene, instead of children watching a pontianak film outdoors, a group of elderly people in a nursing home gather in wheelchairs around a small television to view the same movie. We close in on one particular viewer, an old man with an oxygen mask, who gazes adoringly at the beautiful pontianak as she sings her sad song. When he returns to his bed, he takes out a box of souvenirs, including a Super-8mm camera and a reel of film, cinema tickets from the Capitol and Rex movie palaces, and a set of old photographs. The material traces of cinema—not just the films themselves but histories of film production and cultures of moviegoing—are conjured as a conduit for memory and for a nationally specific set of cathexes to the past. When we see the old man's photographs, the pontianak is there as well, in behind-the-scenes shots from the production of the films. A business card proclaims him as Fan Fan Law, a film producer with Law Brothers (a fictional company with a logo very similar to that of Shaw Brothers). The actress we have just seen on-screen is shown to be one of Law Brothers' stars and one, it is implied, who was special to him. The rest of the film consists of Fan Fan contacting old colleagues in order to return to the studio and re-create the song sequence with which we began. Finally back on set, with everyone involved so many years older, the actress sings the same song again as the assembled crew watch and listen in wonder. As the camera tracks past their faces, the spectator is invited to feel the same emotion as that represented: a nostalgia for lost youth and beauty, and for a film culture that has passed.

Khoo's episode deploys cinema's ability to turn temporality into affect, using the sense of pastness and loss that inheres in the cinematic image to construct a melancholic and evocative experience of Singapore's cultural memory. Given the popularity of the Shaw and Cathay pontianak films, it should come as no surprise to find them at the center of such a commemorative project. But this nostalgia performs some very specific cultural work. "Cinema" is, first of all, the first pontianak film made in Singapore in well over a decade, and the first since the original studio films to be made by a well-known director and prominently reviewed. For many viewers, "Cinema" marks the return (*kepulangan*) of the pontianak to Singaporean cinema. Thus, while the majority of the films considered in the previous chapter were Malaysian, "Cinema" marks a renewed claim on the Singaporean identity of the pontianak. This national identity is also racially marked, or rather, is marked as racially inclusive. The central characters are the Malay pontianak and her Chinese film producer, and the reassembled crew represent a diverse array of ethnicities. Whereas the 1950s and 1960s studio films conjured a diegetic world that was largely racially homogenous, "Cinema" pulls back to present the studio system itself as a kind of multiracial ideal. The episode ends with an intertitle reading, "On the film set, race, language and religion did not matter." I argued in chapter 1 that the studio system was not quite so utopian, but it is significant that the pontianak is the figure from the golden age of Singapore cinema that Khoo uses to leverage this national nostalgia. The racial diversity of the remembered studio era effects a claim on Singapore's official discourse of multiracialism in the present. Thus, Khoo is an ethnically Chinese filmmaker using a Malay figure to invoke Singaporean identity. Khoo revives the idea that the pontianak film brought together "people of all races" in the 1950s and 1960s, and "Cinema" proposes the pontianak film as a privileged site in which a national imaginary might be felt.

This chapter argues that the pontianak is a figure through whom national, racial, and religious identities are contested in postcolonial Singaporean and Malaysian cinemas. Just as we have seen in chapter 2 that she troubles dominant forms of gender, producing both a pontianak feminism and a queer destabilization of gender norms, I argue here that she disrupts hegemonic ideas about race and national identity. The pontianak might seem less apt to critique racial or ethnic hierarchies than those of gender: whereas she is a rebellious and violent woman whose monstrosity places her outside of conventional femininity, her identity as Malay might appear to be unproblematic. As a precolonial folkloric figure, the pontianak emerges from a deeply embedded popular lifeworld of peninsular Malaya, and yet the postcolonial contradictions of that identity also underwrite her cinematic life. As a figure with pre-Islamic origins, the

pontianak does not fit easily into the political discourse of all Malays as Muslim. The category of "Malay," like all categories of racial-ethnic-national identity, is unstable, and I will argue that in the contemporary era, it is called upon to do much racializing work in both Singapore and Malaysia. As we shall see, racialization is so central to Malaysian and Singaporean cultures that we can understand it as a structuring discourse of postcoloniality. Religion has become increasingly important to ideas of racial identity, especially in Malaysia. If modern Malay identity is defined by structuring tensions around culture, religion, and the postcolonial racial state, then the pontianak renders the contradictory nature of these identities visible in cinematic terms.

The "Cinema" episode of *7 Letters* illustrates that the pontianak is always speaking about the affective pull of identity: to represent her is to conjure both nostalgic memories and contemporary visions of Malay popular culture. But "Cinema" also opens up the complexity of Malay identity—Is the pontianak Malaysian or Singaporean? What if she were both? The pontianak thus makes impossible any neat separation of the two countries' cultures of decolonization, as well as any simple overlay of Malay with Malaysian. Does she speak of the ethnically Malay culture of *Kepulangan Pontianak*'s actress or the multiracial culture of its film crew and diegetic audience? Because the pontianak is so closely associated with the studio-era films, she is always at once a Malaysian *hantu* and a Singaporean pop-cultural figure. She exists simultaneously within a Malay-specific folkloric tradition and within a multiracial commercial culture. She fits completely within neither a racialized schema nor a national one. As much as the pontianak is an icon of Malay culture, she rarely works to suture a seamless account of this identity. Moreover, as we saw in chapter 1, the idea of Malay identity as ontologically meaningful is itself a product of colonialism. This chapter will build on that history of colonial-era racializing epistemology to consider the ways in which ideas of racial identity have shaped Malay culture in the postcolonial era. As scholars such as Anthony Milner have noted, the idea of Malay as a coherent category is inevitably fractured.[1] The Malaysian constitution defines a Malay as a person who practices Islam, speaks *Bahasa Melayu*, and follows *adat*. This definition immediately disqualifies the over 40 percent of the population who are not Muslim, enshrining a slippage between "Malay" and "Malaysian" that marginalizes citizens who practice other religions. This definition also produces "Malay" as a cultural category, defined by practices, rather than an essentialist racial one; but rather than opening access to identity and citizenship, the effect of this definition was to gather language, religion, and cultural practice under the heading of race. In analyzing Malay identity in the pontianak film, therefore, this chapter considers race and religion as closely intertwined

fields of inquiry. It argues that, in postcolonial films, the pontianak becomes a figure of disturbance whose presence provokes formal disruptions in the cinematic logic of Malay racial, religious, and national identities.

RACE AND RACIALIZATION IN MALAYSIA AND SINGAPORE

In opening the category of race in the postcolonial pontianak film, it is necessary to reflect on the historical constitution of race as a discourse in Malaysia and Singapore. Chapter 1 analyzed the racialized hierarchy of the colonial-era studio system and touched on the history of Malay identity as, essentially, a colonial invention. Charles Hirschman is the scholar most associated with the argument that racial tensions in Malaya were the result of British colonialism and not an inevitable clash of cultures. Thus, he argues "that modern 'race relations' in Peninsular Malaysia, in the sense of impenetrable group boundaries, were a by-product of British colonialism of the late nineteenth and early twentieth centuries.... Direct colonial rule brought European racial theory and constructed a social and economic order structured by 'race.'"[2] Robert W. Hefner agrees, finding that, "where before there had been a canopied civilizational identity that facilitated easy cultural exchange among many (although never all) of the region's ethnic groups, European colonialism laid the foundation for the rigidly oppositional identities of 'plural societies' fame."[3] Understanding the history of racial ideology in Malaya is crucial if we are to understand the discursive construction of "race" in the pontianak film. Moreover, part of the significance of the pontianak for film studies is her ability to speak about race, religion, and identity within popular cinematic forms. The models of racialization that have developed in Singapore and Malaysia form a very different context from those of other postcolonial countries, and this history affects how popular cinemas navigate ideas of national belonging. Hefner proposes that "few areas of the non-Western world illustrate the legacy and challenge of cultural pluralism in a manner more striking than the Southeast Asian countries of Malaysia, Singapore, and Indonesia."[4] This legacy also produces an opportunity to refine our theorization of postcoloniality in world cinema.

In the immediate context of decolonization, diverse anticolonial thinkers debated how Malay identity should be defined as a matter of state and culture. Progressive voices included Burhanuddin Al-Helmy, who argued that people of any race should be considered Malay so long as they were faithful to the nation. His idea of *kebangsaan Melayu*, or "Malay nationality," "proposed the use of the

ethnic category Melayu for all residents of the Malay states, including the immigrant Chinese and Indian population."[5] This radical idea would have removed any racializing content from Malay identity, offering a political community available to all who lived within its borders. As Maznah Mohamad and Syed Muhd Khairudin Aljunied point out, the failure of this idea demonstrates the power of racialization in the emerging postcolonial order. They write, "The postcolonial state in Malaysia adopted just the opposite of what was idealized by Burhanuddin—that instead of nationalizing Melayu, there emerged a robust political program of racializing the Malays."[6] Both Malaysia and Singapore emerge as states with authoritarian models of democracy and highly racialized social hierarchies. In both cases, political systems of racialization developed out of conflicting strands of anticolonialism, including both reactionary ethnonationalisms and progressive attempts to produce fairer societies than those inherited from the British. In Malaysia, ethnic Malays had a lower social status and less wealth than the Chinese as a consequence of British policies supporting Chinese entrepreneurism and keeping Malays in the rural farming sector. Indians, many of whom worked on rubber plantations, were marginalized both economically and geographically. Thus, debate on race was underwritten by already severe racial inequality. The question of how to ameliorate these inequalities was addressed almost entirely within existing racial categories, which is to say that the problems caused by colonial racialization were tackled without confronting that system itself.

Daniel P. S. Goh and Philip Holden compare ethnic pluralism in Southeast Asia with Western multiculturalism and argue that we need to specify the distinctiveness of the former. Whereas in Western models of government, race is often elided by appeals to ethnicity, culture, or immigration, they point out that in Singapore and Malaysia, race is a commonplace vocabulary in official discourse.[7] Moreover, although "the principles of liberal democracy . . . are often taken as representative of modernity," many Southeast Asian nations are both highly modernized and lacking in aspects of liberal democracy. Rather than see this situation as contradictory, they ask, what if "the conditions for existence of the developmental state in each country were profoundly shaped by a racial governmentality"?[8] This question seems less surprising in 2020, in an era in which liberal democracy and racial governmentality are no longer so easily viewed as contradictory, but the urgency of the problem is precisely why this history is significant. The imbrication of race, modernity, and illiberal governmentality are central to the politics and culture of postcolonial Malaysia and Singapore. Sharmani P. Gabriel describes race as "a fundamental organizing principle in Malaysian society [that is] ascendant over other markers such as class, gender and religion." It is assigned at birth, recorded on one's national identity card, and

cannot be changed. Gabriel concludes: "Such . . . are the social, political and economic contexts and institutional arrangements of society that most Malaysians assume that one's race as a 'Malay' or 'Chinese' or 'Indian' is a fixed category with its own ontological 'reality.' "[9] Race is also a governmental category in Singapore, where, as Michael D. Barr and Zlatko Skrbiš describe, "The three main racial groups are portrayed as distinct, each playing a discrete part in the ideology of multiracialism, and society at large. In Singapore, racial ascriptions inform every aspect of people's lives. In the highly structured and micromanaged context of Singapore, race is a fundamental instrument of social engineering and the means for the organization of social complexity."[10] Although Singapore is officially committed to a multicultural and secular state, in contradistinction to Malaysia's mode of religious pluralism, the city-state is no less racialized. Lian Kwen Fee and Narayanan Ganapathy describe a "racial ideology [that] has been established over decades of a racialized discourse that has been sustained at all levels of Singapore society."[11] Or, as Malay Singaporean artist Alfian Sa'at put it in a Facebook post on July 31, 2019, "who was it who said that we don't really have racial harmony in Singapore, what we have is racist harmony?"

The postindependence histories of racialized politics in both countries are too dense to easily summarize, but one way to illustrate them is by considering attempts to improve the situation of Malays in Malaysia. Sheila Nair describes the first decade of independence as one in which "The lower economic status of the Malay majority did not generate . . . a compelling critique or movement to address social inequalities. Instead the United Malays National Organisation (UMNO) together with its Alliance partners propagated a political strategy designed to secure ethnic privilege. Consequently, the integrity of self-understandings about ethnicity nurtured during colonial rule and its relationship to economic exploitation were preserved intact."[12] Instead of developing economic and social policies aimed at making society more equal for all, the UMNO and Alliance government sought ethnic solutions for what were perceived as ethnic problems, doubling down on racialization and writing it into policy. In the 1970s, the New Economic Policy (NEP) instituted an extensive affirmative action program that advantaged Malays in education, housing, employment, and other areas of public life. By classifying Malays as *bumiputera*, or "native," these policies further entrenched an ethnonationalism that viewed Malays as deserving of special rights because of their racial preeminence in the region. Ooi Kee Beng argues that "with real benefits coming to those classified as Malays or Bumiputera, a conceptual majoritisation took place that drew sustenance from notions of indigenousness. A new 'race'—nothing less than a new primordialism—came into being that soon threatened to make

institutional racism a permanent feature of Malaysian culture."[13] The affirmative action policies were theoretically imagined to be a temporary measure, held in place only until a more equitable distribution of opportunity and outcome had been reached. But there were no processes in place to remove special status for Malays, and as Judith Nagata explains, "During a succession of political crises, the ethos of special rights became more pervasive in inter-ethnic relations, gradually evolving into today's received wisdom of Malay dominance, *ketuanan melayu*.... Although never intended by the constitution, special rights have mutated into Malay hegemony on the strength of ethnic birthright."[14] We can see even in this brief history the uneasy tension between Malays as a disadvantaged group in need of affirmative action programs and Malays as a political majority creating a two-tier citizenship in which minorities have fewer rights.

Perhaps the most striking example of this contradictory racial discourse is Mahathir Mohamad's book *The Malay Dilemma*, a nationalist polemic written in 1970 before he became Malaysia's longest-serving prime minister. In it, Mahathir argues that every country has a "definitive people" who were the first to create a state and who therefore enjoy ownership of the land.[15] His examples include Malays in Malaya and white Christians in the United States and Australia. For Mahathir to use the philosophical foundations of settler colonialism as the basis for a postcolonial Malay ethnonationalism is perverse, to say the least. The theory that those people who first create a state may claim a land originates from Locke's Enlightenment account of property. For Locke, those who live off the land without mastering it cannot be said to own it, whereas those who cultivate and improve the land can rightly lay claim to ownership.[16] This argument lays the foundation for the dispossession of indigenous peoples around the world and recent scholarship by Aníbal Quijano and Judith Butler and Athena Athanasiou, among others, has linked Locke's theory of property both to the oppressive operations of colonial modes of knowledge and to the subject formations of liberal modernity.[17] It is, therefore, a strange choice of rhetoric for a postcolonial manifesto and especially one by a politician known for his committed anti-Western stance. Mahathir's argument reveals the tangle of Malay claims to racial preeminence. By staking a claim to be the definitive people of Malaya over and above those indigenous peoples who live off the land, Mahathir thus tacitly admits that the Orang Asli were in fact the first peoples of the peninsula. Indeed, in the current language of Malay special rights, Orang Asli in the Malay peninsula are excluded from the category of indigenous people and do not receive any of the benefits that accrue to Malays.[18] Malay supremacist claims of indigeneity are made, paradoxically, through a settler-colonial philosophy of dispossession.

Mahathir's political aim was a modernizing form of Malay identity that might combat what he saw as Malay backwardness. For Nair, this vision of backwardness is symptomatic of the ongoing effects of colonial discourse. She turns to Syed Hussein Alatas's influential study *The Myth of the Lazy Native*, noting that he "draws our attention to the inability of the colonised to resist and to develop a subjectivity . . . distinct from its production in colonial ideology."[19] Syed Hussein describes the problem of postcoloniality as one of a "captive mind" and argues that this discursive trap is caused by the influence of Western culture as the largest imperial power in world history.[20] By this logic, Mahathir aligns himself with the rhetoric of white supremacy (Malays are backward) in order to take up a reconfigured alignment with supremacist thought, in which Malays are at once the victims of colonial-era marginalization *and* the rightful owners of the land, whose racial preeminence must be recognized. This doubled and re-doubled logic of racial oppression and supremacy pinpoints the importance of thinking about cinematic representations of "race" in the Malay context, where it is so ambivalently overdetermined. In Malaysia, Malays are the dominant group and the benefactors of a system of racialization that denies equal rights to other races. Geoffrey Wade has dubbed the country an "ethnocracy," in which political power accrues according to ethnicity.[21] And yet we cannot simply compare this structure to white racism, since Malay claims to special rights emerge from the fraught inheritances of colonialism, both material and intellectual. Malayness is never as securely unmarked in Malaysian films as whiteness is in European or American films, because the system of racialization in the region is built on a fundamental contradiction around the constitution of racial possession and dispossession.

What becomes abundantly clear in these historical accounts is the inescapable quality of racial discourse in postcolonial Singapore and Malaysia, and the concomitant difficulty of problematizing "race" as a discursive category. In the Singaporean context, Chua Beng-Huat argues that, "as a national policy, multiracialism requires for its rationality a discourse of race, constituted by the multiple ways through which the ontology of race is discursively thematized and insinuated into the social body as a 'relevant' phenomenon, the better to rationalize strategies of social discipline."[22] Like Chua, Maznah Mohamad identifies the stickiness of race as a category of discourse. In an account of progressive groups in Malaysia, she sees "a constant movement toward dissent and diversity although such efforts seldom reach an apogee of deconstructionism, as race, 'once imagined' may not be 'easily unimagined.'"[23] In reading the pontianak film through the lens of race, my aim is firstly to demonstrate how the films expose a process that is otherwise systematically repressed, and secondly to unpack how the figure of the pontianak disturbs the smooth reproduction of racializing discourse.

REFIGURING MALAYNESS IN CINEMATIC DISCOURSE

The pontianak film is one of the most popular discourses in Malaysia and Singapore for imagining and reimagining Malayness. How might we conceive of cinema's role in reproducing—or, in Stuart Hall's terms, positioning—the meaning of race in the Malay context?[24] It is always useful to turn to Richard Dyer's account of cinematic whiteness, in which he asserts that "the point is to see the specificity of whiteness, even when the text itself is not trying to show it to you, doesn't even know that it is there to be shown."[25] Dyer considers the cinematic aesthetics and narrative form of depicting white bodies: the association of white skin with light, or the narrative logic of the muscular hero and the delicate white woman, for example. If we attempted to apply a similar approach to the representation of *Melayu* as a raced category, we would not have recourse to an entire white supremacist history of cinematic technology. Camera lenses and studio lights have not been designed precisely for the skin tones of Malay people. The regional specificity of Malay racial schemas is embedded within—and can never be entirely separated from—the histories of colonialism and white racism that have shaped film history and technology as much as they have influenced postcolonial racial hierarchies. Yet Dyer's approach is still instructive, because it reminds us that racialization is an integral part of cinematic form. In the Malay context, we might think about the stubborn and patriotic hero in the mold of Hang Tuah, who models cinematic visions of Malay masculinity; the hierarchies of status that refer verbal and bodily presentation to Malay royalty; the practice of traditional cultural forms such as *kuda kepang* or *mak yong*; and the accretive construction of race through mise-en-scène: traditional costume, *kampung* architecture, and the location of bodies within jungle spaces. These essentially cultural forms operate as racial markers, and it is not coincidental that the generic signifiers of the pontianak film adhere so closely to key signifiers of Malay identity. The mise-en-scène of the pontianak film almost always centers on these conventionally Malay racial signifiers, but its narrative preempts the status of the patriotic hero in favor of a figuration of Malayness that is both monstrous and ambiguous. Whereas other genres of contemporary cinema, such as the crime thriller or romcom, can position race as an unspoken norm, pontianak films are always visibly about the constitutive discourses of Malayness. They constantly repeat and reimagine the visual signifiers and narrative codes of Malay racial identity, never allowing their ideological production to be settled. Ironically, it is the pontianak's status as a Malay figure par excellence that grounds her ability to put Malayness into question.

In the films made in Singapore between the studio era and horror's post-2002 reemergence in Malaysia, racial and national identities form a recurring source of formal disturbance. *Pontianak* (Sutton, 1975) plays repeatedly with signifiers of indigenous and colonial cultures: a striking scene is set in a Melanesian-themed nightclub where the *hantu* picks up her first victim. The band plays American-style pop music but the mise-en-scène plays with an "exotic" vision of Pacific Island cultures, in which the traditional art of the Malay world returns as kitsch. The film goes on to fill the mise-en-scène with more Malay artifacts—the investigator has Indonesian masks hanging in his office, to which we cut in unmotivated close-ups. *Pontianak* has a cult film's generic propensity for unmotivated editing and disjunctive shifts in tone, so these images are explicable in purely genre terms. However, the way in which ethnicized images circulate in the mise-en-scène produces an excess, in Kristin Thompson's sense, speaking Malay identity over and over in ways that the narrative cannot quite digest.[26] Moreover, Andrew Ng points out that the film is racially diverse in its casting. The pontianak is played by a Punjabi-Malaysian actor, Jennifer Kaur, her main victim is Chinese, and the comedian Hamid Bond sings a classic Indian song.[27] The effect of such inclusion is not a diversity in a contemporary liberal sense, but rather a pervasive formal disturbance of the dominant logic of the pontianak film as exclusively Malay.

Racial difference is even more prominent in *Return to Pontianak* (Djinn, 2001), in which a biracial Asian-American woman travels to Borneo with her Chinese, British, and Singaporean friends in search of her Malay birth mother.

FIGURE 3.2 An unmotivated close-up of a Balinese mask illustrates the circulation of indigeneity as excess in *Pontianak* (Sutton, 1975).

Sophia Siddique Harvey describes the film in terms of its ethnoscape, noting not only the array of nationalities of the doomed group of friends, but the ethnic overdetermination of the film's pontianak protagonist.[28] Charity Yamaguchi has a Japanese family name but her mother is Malay. Moreover, the character is played by a Vietnamese-American actor, all of which creates distance from the conventional image of an ethnically Malay pontianak. Her name, appearance, and accent seem to locate Charity as coming from elsewhere, and the film's surprise is that she is in fact the daughter of a pontianak. In dreams, her mother exhorts her to "return to your origins," and those origins turn out to be frightening. As Kenneth Paul Tan argues, "The fear of the pre-modern is also a racialised discourse," in which the pontianak violence of Charity's Malay origins overrides the civilized veneer of her Japanese-American adoptive family.[29] Thus, he continues, Singapore "has appropriated colonial power structures and ideologies of racial difference for a totally administered state whose disciplined, industrious, thrifty and self-controlled citizens are terrified that the re-colonised and repressed indigenous Malay threat will return to weaken the neo-colonial order."[30] For both Tan and Siddique Harvey, the film posits Malayness as the return of a repressed primitive nature that provides a source of postcolonial fear in Singapore. In both of these films, race forms an uncontainable excess, although only *Return to Pontianak* uses Malayness as, in itself, a source of horror.

The contemporary pontianak text persistently returns to race as a narrative and representational problem, but unlike the "new primordialism" that we see in *Return to Pontianak*, some recent iterations of the figure use her Malay identity to upset reactionary models of race and national identity. This effect is visible across popular culture, and it is instructive to turn first to an example from literature. Malaysian writer Zen Cho's *House of Aunts* reimagines the pontianak as a Chinese teen, rewriting the racialization of the figure as part of a postcolonial feminism. In this novella, sixteen-year-old Ah Lee lives with her aunts, all of whom are also pontianaks, so that the travails of being a teenager are compounded by the challenge of being the only pontianak at school. The premise of strict Chinese aunts who are also pontianaks plays humorously with the interstices of Chinese and Malay cultures, as well as blending naturalism and folklore. Ah Lee complains to her aunties, "Who ask you to eat my schoolmate?... How'm I suppose to go back to school now? So lose face!"[31] Later, she quotes her aunties on why her family only eats men: "It's already suffering enough to be a woman, Ah Lee recited, Don't need people to eat you some more." Here, pontianak feminism is the wisdom of older women. Cho deploys the distinctive rhythms of Singlish both to create the humor of having meddling *hantu* aunts and to locate Ah Lee in a specifically Southeast Asian Chinese milieu. This multicultural English

enables a constant play on the logics of language and cultural belonging, as when Ah Lee calls herself a "vampire" because it feels safer than "pontianak." The English term might be funny or sexy, but the Malay word would be too frightening. Thus, "Ah Lee never said her real name herself." Similarly, the story plays with the transnational nature of the pontianak myth: these aunts do not have fang teeth because they do not drink blood like a Western vampire; rather, they scoop out their victims' intestines with their long fingernails. When Ah Lee falls in love with a Muslim boy, she has to explain to him that the reason she won't share her nuggets with him is not because they are pork, as he assumes, but because they are human. Race, here, is mediated through religion and foodways, both practices that recur in films. The Chinese pontianak, though, throws into disarray the neat alignment of these terms (race/language/religion) in Malaysian public discourse. This pontianak is Malaysian but not Malay, and Cho's ability to combine Malay folklore with Chinese-Malaysian experience works to reshape the discourse of Malayness. Cho describes her motivation for writing supernatural fiction by saying, "I am afraid of death and hantu and am trying to defang both by writing cute stories about them. It is part of my process of decolonisation. It's as good a form for understanding the world as any other."[32] For Cho, undoing racialization is precisely the work of decolonization and it is this process that locates her fiction in a world and creates a relationship to the world. I want to keep these lessons in mind in turning to two recent film and television texts in which pontianak folklore converges with realist accounts of racialized milieux.

Tolong! Awek Aku Pontianak / Help! My Girlfriend Is a Pontianak (2011) was directed by James Lee, one of the pioneers of independent filmmaking in Malaysia in the 2000s. Such a lowbrow genre film might seem like a strange fit for an indie film auteur but Lee's career is symptomatic of the centrality of the supernatural in Malaysian film culture. His early films include *Room to Let / You fang chu zu* (2002), which is fundamentally a haunted house movie, and *The Beautiful Washing Machine / Mei li de xi yi ji* (2004), in which a young woman may be the embodied soul of a household appliance. Even the more mainstream work, such as *Breathing in Mud / Bernafas dalam Lumpur*, a television film released in 2008, centers on a woman whose first husband inconveniently returns from the dead after her remarriage. *Tolong*, as the title suggests, is a mixture of horror and comedy, developing much of its humor from the plight of its hapless Malay protagonist, Bob, falling in love with a pontianak, Maya. The setup is similar to that of many romantic comedies that feature ordinary men falling for beautiful women, and the impossibility of a human-pontianak relationship highlights the potential for the pontianak to allegorize racial difference in ways familiar in horror film history.[33]

Indeed, the film seems to play with this possibility in a climactic scene at a costume party, in which Bob dresses as Dracula, his best friend Pian as a Naavi from *Avatar* (Cameron, 2009), and another friend as Wolverine from *X-Men* (Singer, 2000). The scene evokes multiple registers of meaning with the juxtaposition of folkloric figures with mass cultural fantasy figures, Asian and Western mythologies, and real and fake vampires. When a *bomoh* arrives and tries to exorcise the Naavi, the humor plays on a lack of communication between Malay traditionalism and contemporary culture, but it also responds to *Avatar*'s own racialization of the Naavi as primitive innocents. When the *bomoh* treats Pian-as-Naavi as a dangerous Other who must be destroyed, the joke is twofold: it firstly depends on a realization that the pontianak, like fantasy characters in Hollywood film, is often burdened with representing racial difference, and it is also a satirical commentary on particularly Malay forms of racist violence and Othering. Where the Naavi represent settler-colonial fantasies of encounters with indigenous people, and the X-Men are commonly read as fantasmatic figures of sexual dissidence, the pontianak is at once an indigenous figure and one that is racially, sexually, and religiously dangerous.

However, *Tolong* does not limit its articulation of race to the allegorical. Unlike much contemporary Malaysian cinema, its fantastical horror-comedy is set in a realist multiracial Kuala Lumpur. Indeed, race and the constitution of Malaysian identities become significant strands of the plot, interwoven with a discourse on real estate, class, and modern capitalism. We are introduced to this cluster of issues via Bob and Pian's search for a new apartment. They have been living in the

FIGURE 3.3 During a costume party scene in *Tolong! Awek Aku Pontianak* (Lee, 2011), the Naavi are misread as demons who must be exorcized.

gentrified Bangsar neighborhood but can no longer afford it. A realtor drives them to an apartment building that he boasts is up to "international standards" and has "international residents." When they arrive, however, the complex is run down and dirty, with no doorman and junked furniture piled up in the corridors. When Pian reminds him of his promise of international residents, the realtor responds that they are from "Africa, Bangladesh, Myanmar, Nepal, even Indonesia. . . . If I were you I'd put another two locks on the door." The realtor's attitude is evidently racist, playing on familiar histories of real estate as a site of black and brown exclusion from middle-class communities. The moment is shocking, and at first, the spectator might conclude that the film itself is the kind of reactionary text that would find the realtor's joke acceptable. But the moment also exposes Pian and Bob's assumption that "international residents" was code for Western affluent people, and reveals the workings of a distinction between supposedly desirable (white, wealthy) foreigners and those immigrants who do not fit into normative categories that Gaik Cheng Khoo describes as a "Chinese-Malay-Indian-Dan-Lain-Lain" way of thinking about race and identity.[34] For Khoo, the typical phrasing of "Chinese, Malay, Indian, and Others" leaves those others as marginalized and outside of discourse. As the narrative unfolds, it becomes clear that *Tolong* is engaged in making visible both KL's immigrant minorities and the processes of racialization that create the culture that Alfian termed "racist harmony."

When Bob and Pian enter the apartment building, they start to suspect that its unwanted inhabitants might not be immigrants but spirits, setting up a parallel between Malay and foreign figures of alterity. Pian is suspicious that the apartment is too cheap, and asks the realtor directly if it is haunted. Vampires, like immigrants, work to depress property prices. Bob brushes off his fears but Pian insists that when he lived in a *kampung*, he was sensitive to *hantu*. Folk knowledge, as we will see in chapter 4, is usually superior to urban ways of life. Bob decides to rent the apartment and soon meets his new neighbors—two beautiful women with long black hair. We cut to the inside of their apartment, where the two women are revealed as pontianaks who are worried that Bob and Pian might find out their true nature. Maya does not want to run away though, saying, "wherever we go, there will always be humans." This scene provides the spectator with key information (the neighbors are pontianaks) but it also tells us that the pontianaks are afraid of humans. When Bob next arrives home, he meets some of the building's other residents, a group of black men playing music in the courtyard. The realtor was correct that many migrant workers live there, and after they get talking (with English as a lingua franca), the men invite Bob to join in with a song from their African homeland. The pontianaks, Maya and Liyana, are

FIGURE 3.4 In *Tolong! Awek Aku Pontianak*, Bob befriends his African neighbors.

watching this scene from behind some bushes. Maya is confused, noting that "he doesn't even mind being around those foreigners!" Liyana responds, "they are stupid, losers, that's why they are living here," but Maya points out that "we rarely see locals befriending foreigners." She is intrigued by this unusual human behavior. Here, the film's discourse on Malay identity and foreignness becomes quite explicit. Bob is the film's everyman hero and by forging connections with his African neighbors, he counters the expectations of both the realtor and the pontianaks. Maya functions as an outsider to humanity, whose perspective reveals the ideological functioning of Malay racism. The pontianaks' conversation registers very clearly that the logic of Malaysian and foreigner is a racialized imaginary and one that normalizes exclusion.

Bob's friendship with the African immigrants is folded into the film's workplace narrative, in which Bob and Pian are exploited by a lazy manager who makes them do all the work. Faizal embodies the worst elements of corporate modernity: he sexually harasses female interns, bullies his staff, and takes credit for their work. When he learns that Maya is a pontianak, he teams up with the *bomoh* to try to get rid of her, so this version of exploitative capitalist modernity can align with tradition to attack difference. Bob has recorded the African song that he sang with his neighbors and he presents it to Faizal as a pitch for an advert. Faizal responds that it is not suitable because it is foreign and local people don't want to hear foreign music.[35] Bob's openness is contrasted with Faizal's myopia, but at the next meeting, Faizal appropriates the idea, presenting the song to his boss with

the claim that music is an element of culture that can be accepted by everyone. *Tolong*'s office setting enables it to unfold a class critique—ordinary workers exploited by the managerial class—and that class critique is revealed to include racializing ideas about the suitability of foreign culture to participate in Malaysian modernity. In contrast to Faizal, who only pretends to accept foreign culture when he can exploit it financially, and who wants to destroy the pontianaks, Bob is open to genuine connection with both his African immigrant neighbors and his pontianak neighbors. By constructing such a close parallel between the pontianak as a figure of indigenous Malayness and the Africans as outsiders, *Tolong* unravels the hierarchies of racialization that usually attend images of Malay identity.

Sumit Mandal makes a distinction between what he calls "transethnic solidarities" and "the language of inter-ethnic harmony" that has been promulgated by the Malaysian state to promote itself as inclusive, but "at whose heart lies an unquestioned acceptance of 'race' and racialisation."[36] Such transethnic solidarities are as yet marginalized, but he considers culture to be one place that they can emerge. His cinematic example is Amir Muhammad, whose film *The Big Durian* (2003) was produced by Lee. *The Big Durian*, a mix of documentary and fiction, speaks very directly about racial and religious tensions in Kuala Lumpur, and Amir is a prominent progressive voice. In a newspaper column, for example, he writes, "Not all Malaysians are Malay. This fact should be startlingly obvious. Blab it out to someone and you won't exactly get into a quarrel. . . . But no matter how obvious said fact may be, there are Certain Quarters that still don't know how to play properly, and seem to insist that the two words are synonymous."[37] Lee and Amir are part of the group of Malaysian filmmakers who are committed to breaking down both overt Malay supremacy and the more insidious state-sponsored language of racial harmony that supports it. Khoo has also identified independent film as a potential site of resistance to Malay supremacy and she contextualizes this effort in relation to political and cultural histories of "cosmopolitanism as a strategy to undo racialization in Malaysia." Nonetheless, she cautions that even the antiracist discourses of alternative media often exclude noncitizens such as immigrants and refugees.[38] *Tolong* is therefore striking if only in its very visible inclusion of noncitizens. It goes beyond simple representation, however, in the way that the immigrants and the pontianaks are closely linked as marginalized figures who can be offered hospitality and ultimately love.

Transethnic solidarities are also at the heart of Eric Khoo's second pontianak story. *Folklore* (2018) is an anthology series produced by HBO Asia, in which each episode is a stand-alone story based on a different supernatural figure from one of six Asian countries. Khoo is both the showrunner and director of the

Singaporean episode, entitled "Nobody." Another episode (directed by Pen-Ek Ratanaruang) features a pob ghost from Thailand, and another (directed by Ho Yuhang) a toyol from Malaysia. Following from Khoo's use of the pontianak in his episode of *7 Letters*, it is striking to see one of Singapore's most successful filmmakers return to the figure in a longer-form narrative that again aspires to represent Singapore on an international stage. *7 Letters* was very much addressed to Singaporean audiences who will engage with its web of local references and experiences. *Folklore*, by contrast, screens on a global streaming platform, HBO, and is available to worldwide audiences. It is marketed toward fans of horror media who may be interested to learn about new aspects of Asian popular culture. In his episode, Khoo once again locates the pontianak as Singaporean and, moreover, in the framework of the series, the supernatural figures addressed are taxonomized as national. This structure produces some disjunctures: the pontianak and *toyol* are not uniquely Singaporean or Malaysian, and could easily have been switched. Unlike the Indonesian *wewe gombel* or South Korean *mongdal*, the pontianak is not a uniquely national figure. Khoo makes use of this disjuncture in "Nobody" by setting the story in a construction site, a space that is at once perfectly representative of contemporary Singapore and is transnational and multiracial in its habitation. Khoo's pontianak bespeaks a Malay identity, but she belongs to (and haunts) people of all races in Singapore.

The episode begins conventionally, with an overhead shot of a jungle. As we will see in chapter 5, jungles are the defining habitat of the pontianak, and new texts like this and *Dendam Pontianak / Revenge of the Pontianak* (Goei and Yap, 2019) are highly self-reflexive about the significance of such forest landscapes to the genre. The camera moves down almost to ground level and follows a young girl as she moves through the undergrowth. Grassy stalks flip past the camera, creating a haptic sense of immersion by placing the spectator within the vegetation. With a saturated green and black color palette, this precredit sequence promises a tropical Gothic, perhaps along the lines of *Return to Pontianak*. It is a jarring surprise, therefore, when the first shot after the credit sequence is a construction site in bright, hard daylight. This setting immediately stages a set of oppositions in relation to genre expectations—rural/urban, nature/industry, shaded/bright—which indicate that the pontianak is not going to appear in a wholly traditional way. This transition also efficiently narrates a history, in which the jungles of the past have been transformed into the urban Singapore of the present. The girl who dies in that forest will be discovered on the construction site, and her body is what anchors these two places in the same space. The radically reordered space of a demolished jungle and a not-yet-built apartment building promises to bridge the conceptual gap between the pontianak story of the past

and the global Singapore of the present. Whereas, in *7 Letters*, Khoo linked Singapore's past and present via nostalgic memory for a cinematic character who remained in the past, here he brings the concerns of the pontianak into the Singaporean present.

The construction site as a setting radically overthrows the pontianak film's historical limitation to a Malay-dominant cast, providing from the outset a primer on Singapore's racialized hierarchy of labor. A Chinese foreman is berated angrily by his superior in Mandarin, and then he in turn translates the dressing-down to a Tamil worker in English. Racial and linguistic diversity and hierarchy are articulated early on, and constitute the primary material with which the text speaks. A girl's body is discovered during digging, wrapped in a shroud and clearly having been murdered. Race and class hierarchies assert themselves in what happens to the body: the big boss, Mr. Kang, wears white trousers and a Versace-style shirt. He is coded as belonging to a significantly a higher class bracket than the workers. Although the workers want to call the police, Kang insists that if the discovery got out, nobody would want to live in the apartments they are building. He orders the workers to get rid of the body, and in a repetition of the formula we have already seen, the foreman tells one worker in Malay to burn the body, and then repeats the same thing to another in Mandarin. This crime is multilingual.

FIGURE 3.5 The *Folklore* episode "Nobody" (Khoo, 2018) begins on a construction site, where a multiethnic group of workers surrounds the pontianak's grave.

The multiracial constitution of Singapore's immigrant labor pool has consequences for the pontianak story. Peng, the Chinese man tasked with burning the body of the girl, is from the mainland and does not know about Malay folklore. He feels empathetic toward the dead girl, telling her that he hopes that she did not suffer. As he opens up her shroud, we see a large nail sticking out of her neck. The spectator might know what this means—the Singaporean managers certainly would, if they had not delegated the job to immigrants—but Peng does not recognize its significance. He pulls out the nail in a gesture of undoing some of the violence that she has experienced. The shot is visceral, with blood around the wound representing it as a site of bodily pain. Unknowingly, Peng has unleashed the pontianak and as life at the construction site continues, she begins to haunt him. In one scene, Peng uses a payphone to call home to his daughter in China. She is living with her grandmother because both Peng and her mother are working overseas. The pontianak silently watches the phone call. In another scene, the pontianak climbs over a row of sleeping men in the site's dormitory to reach Peng, and then sits quietly over him and considers his bedside photograph of his daughter. In many ways, these scenes are reminiscent of Tsai Ming-liang's *I Don't Want to Sleep Alone / Hei yan quan* (2006), with both films featuring sequences of basic bodily care undertaken in minimal conditions of privacy and in the context of globalized labor. Peng and some other workers wash themselves under outdoor taps, the Indians teasing him for wearing a sarong, and the pontianak appears behind him as he cleans his teeth. "Nobody" draws from the socially critical realism of contemporary Asian art cinema but overlays its long-take naturalism with conventions of Malay horror.

Olivia Khoo argues that Singaporean films that narrate the dark side of economic modernization are able to travel internationally, because this image is recognizable to foreign audiences.[39] The precarity of the Tamil, Chinese, and Malay workers on the construction site is indeed a familiar topic for contemporary global art cinema, but the intertwining of this theme with folkloric horror asks the spectator to situate it within a logic of decolonization. Gerald Sim has argued that Singaporean film is too often understood only in relation to globalization rather than in terms of postcoloniality. For him, this framing enables both an uncritical celebration of hypercapitalist development and a lack of historical perspective.[40] The appearance of the pontianak in otherwise realist scenes of the migrant workers' quotidian lives creates a tension between art cinema's depiction of globalized precarity and the postcolonial history of Singaporean horror. The site's history becomes visible when the foreman Lim brings in a Malay *bomoh*. The *bomoh* can see the past, motivating a flashback in which we learn that the girl from the precredit sequence was raped and tortured by a group of men in the jungle. It

takes a Malay perspective to see this past, and the *bomoh*'s ceremony returns the *kampung* to the construction site. This scene forms a cinematic registration of Singapore's transformation, and, like the pontianak, works to fold the past onto the present. Following horror convention, the pontianak's appearances are restricted at first and become increasingly interventionist, leading to the first real scare scene in which she reveals her true face to Malay worker Saiful. In contrast to the sad and beautiful girl ghost we have seen following Peng, she now has a mouth full of sharp teeth, veins all over her face, and whited-out eyes, and she angrily drags Saiful away and kills him. History makes itself felt in the shift from the neorealist laboring body to the horror genre's distorted body in pain. Here, the pontianak is not only a ghost who haunts characters within the diegesis but her figure creates a formal disturbance that breaks up the terms of the contemporary art film. In this disturbance we find a way of reconfiguring Malay identity. The art film speaks about migrant labor in the globalized present, but the intrusion of the pontianak into this scene insists on its postcolonial form. The pontianak articulates something beyond a globalized precarity that could be (and is) everywhere, situating this particular history of development and racialization in a historically grounded Singapore.

If "Nobody" creates a tension between Singapore's past and present, however, it does not offer the simple racialization of *Return to Pontianak* in which the present is a cosmopolitan contrast to the nightmarish premodern past. Rather, in the manner of Avery Gordon's work of haunting, Khoo's story speaks of the inner life of those subject to the violence of modernity, and in doing so it seeks to speak otherwise about the present. As we have seen, when the pontianak begins to haunt Peng, she merely watches him. Her observation of the living conditions of the builders proceeds along with the spectator's and her responses are equally empathetic. At breakfast, an Indian worker called Arup complains about the meager food the workers receive, in contrast with the chicken enjoyed by Lim, the Chinese foreman. Lim responds angrily, docking Arup's pay and throwing his food away. Immediately afterward, Lim starts to choke and the men watch without much sympathy. Eventually, Saiful comes to his aid, and Lim coughs up a nail. The pontianak, it is clear, is on the side of the workers. The exploitation escalates when Kang demands the men work dangerous amounts of overtime to meet an unreasonable deadline. When Arup complains that this is unsafe, Kang fires him, saying, "You are going back to Thanjavur tomorrow." When Peng backs up Arup, Kang dismisses him too, calling all of the workers "nobodies" as the group of predominantly brown workers is framed in wide shot. This question of who is granted humanity versus who is a nobody connects the pontianak (who was an expendable, rape-able girl in life) to the migrant workers (who are just bodies to

be exploited). In defending the dignity of the workers, the pontianak disrupts not only the patriarchal norms of male violence but also the racialized norms of Singaporean capitalism.

Both *Folklore* and *Tolong* represent transethnic solidarity through an exposure of unfair labor practices. And in both, the pontianak sides with the workers (of different ethnicities) over the exploitative bosses. The pontianak emerges in the context of 1950s anticolonial visions of national identity but she has become, in the twenty-first century, a response to racialized and exploitative forms of postcolonial globalization. Official state discourse tends to separate moral rejection of Western culture (whether in terms of human rights, feminism, or individualism versus Asian values) from enthusiastic acceptance of what's perceived as Western capitalist modernity (technology, finance capital, environmental destruction, removal of welfare provision). By contrast, these films locate the pontianak's Malay identity in critiques of neoliberal capitalism and patriarchal violence. Thus, rather than reject globalization in the name of an ethnonationalist Malay identity that fetishizes invented tradition and racialized sociality, these films dislodge that vision by rejecting the hierarchies of both globalized class relations and the colonial inheritance of race. In both films, Malays are exploited alongside workers from other countries and of other ethnicities. Nonetheless, the films' intervention is not only to create sympathetic or inclusive representation (although this is still significant and rare). The mode of neoliberalism seen in the office and the building site depends on a racializing hierarchy that is friendly toward ethnonationalism and the antidemocratic siloing of identities. This is the case, albeit differently, in both Singapore and Malaysia, and in both contexts, the pontianak disturbs this dominant mode of national and racial identity.

In comparing *Tolong* with *Folklore*, we can see a distinction between Malaysian films, in which Malay identity is hegemonic and the work of disturbance is often to trouble Malay dominance, and Singaporean films, in which Malays are a marginalized minority and the appearance of the pontianak makes visible the structures of Chinese dominance. Both discursive structures, however, emerge from colonial racialization and the pontianak film from both nations stages the semiotic instability of Malay identity in the era of decolonization. Postcolonial racialization haunts these films' Malay spaces, as much as the pontianak haunts gendered normativities. At the end of "Nobody," the pontianak follows Kang to his upscale modernist home, where we witness him being rude to his maid. The maid remains off-screen, another nobody. The pontianak kills him in his luxurious bath, although we also do not see the murder onscreen, cutting instead to the plate of dinner that the maid has made over to his specifications. Over a close-up of the insipid-looking plate of Western-style food, we hear the maid saying, "Sir,

FIGURE 3.6 *Folklore*'s pontianak takes revenge on the exploitative boss.

dinner is ready," and then an unpleasant slurping sound. When we cut back to the bathroom, the pontianak is sitting on the floor, eating Kang's heart.

Is the original rape-revenge narrative overwritten by a class-revenge fantasy, in which the exploitation of the multiracial class of migrant workers becomes the violence to be avenged? I propose that "Nobody" does not erase the gendered violence of the pontianak story but rather draws out its postcolonial potential. The violence ends when Peng refuses to nail the pontianak, instead letting her kill his boss. He calls her "the little girl" and in the end conflates her with his daughter, another girl who exists only off-screen and whose life is radically altered by postcolonial capital flows. The racialization of Malays and that of Chinese and Indian migrant workers is and has always been connected in the Malay peninsula, and patriarchy intersects with this history in many ways. "Nobody" renders visible the physical embodiment of exploitation and expropriation from the nail in the neck to the heart on the floor. The multiple senses of what it means to be nobody—to have no body at all, or no body that matters—are what bind together the pontianak with the migrant worker. The gendered body of the sexually abused girl and the raced body of the foreign worker have both been made socially invisible and indeed worthless, and the pontianak uses her monstrous, nonhuman embodiment to force visibility and to reverse violently the terms of physical expropriation. This meditation on being no-body translates between the registers of art cinema and horror, between gendered and racialized

hierarchies, and between universalizing discourses of globalization and locally embedded histories of violence.

THE PONTIANAK AND ISLAM

Nowhere is the pontianak's Malay identity placed under more pressure than in her relationship to religion. As an animist figure, she lays claim to an ancient and culturally resonant form of Malay belief, and yet in the modern era, Malayness is defined through the practice of Islam. As Nagata puts it, "it could be argued that the most potent symbol of Malayness in Malaysia today is in fact a transcendent Islam overriding bangsa and constitution in redefining Malay ethnicity, culture and civilisation."[41] Religion is an intrinsic part of Malay racialization, enshrined in the constitution. Nagata points out that Malays are the only Malaysian citizens without freedom of religion, and "for them, to abandon Islam is to abandon Malayness and by the logic of the constitution, to have no recognized ethnic or national identity in Malaysia."[42] It is no wonder, then, that Islam should be folded into the political and cultural processes of racialization through which postcolonial Malayness is reproduced. In this intimate discursive interlacing of race and religion, Malay raciality becomes increasingly understood in religious terms. As Ahmad Fauzi Abdul Hamid complains, "That Malayness and Islam are made legally coterminous racializes Islam," and, I would add, at the same time, it Islamizes race.[43]

The pontianak visually incarnates the tensions involved in this logic of religious racialization, since she is undoubtedly Malay and yet pre-Islamic. She does not fit within the belief system of Islam and has been variously, but always uneasily, incorporated by modes of syncretism.[44] Walter Skeat writes in 1900 that the pontianak is the only *hantu* that reaches the status of a *jinn*, and he quotes a charm to banish her that mixes animist and Islamic elements:

> O Pontianak the Stillborn,
> May you be struck dead by the soil from the grave-mound.
> Thus (we) cut the bamboo joints, the long and the short,
> To cook therein the liver of the Jin Pontianak.
> By the grace of "There is no god but God."[45]

Whereas animist and Islamic cultures have historically coexisted, postindependence Malaysian culture increasingly discouraged syncretism. For devout

Muslims, either the pontianak is considered to be a primitive misnomer for what is really an Islamic *syaitan* or demon, or belief in *hantu* is discouraged entirely. In either case, it is difficult to reconcile Islamic belief with the pontianak's enduring cultural status. Ng considers that Southeast Asian official religious cultures have tried to expel the remnants of animist belief, and that modern states "must negotiate with [these beliefs] uncomfortably."[46] In Malaysia, the pontianak disrupts the neat official discourse in which race, culture, and religion perfectly align. For the pontianak film, they either do not align at all (in which case the films are banned or censored), or to make them align becomes a textual labor. The difficulty of reconciling Islam and horror leads the films to narrative and visual excess, disruptive or belabored moments that become visible signs of the ideological work of identity. Can the pontianak be a figure of Malay identity despite not being Muslim? What, then, would that mean for a Malayness in which religion is a proxy for race? It is in relation to religion that the pontianak's status as Malay is most unstable, and in grappling with this relationship, contemporary pontianak films become a site in which the meaning of Malay identity is visibly under pressure.

In the studio-era pontianak films, Islam is a minor presence, although elsewhere films such as *Isi Neraka* (Jamil, 1960) and *Noor Islam / The Light of Islam* (Basker, 1960) thematized the coming of Islam to Malaya. Amir Muhammad sees these religious films as containing an implicit anticolonial discourse, given their emphasis on Islam as an equitable system that would treat people the same regardless of social class.[47] In the context of anticolonial thought, Islam was most often aligned with modernization, education, and reform. Muhamad Ali has argued that "the ideas and actions associated with modernity were formed as an outcome of the interplay between Islamic reform and European colonialism." He goes on to say that "the promotion of Western science and technology was considered part of the modernisation package, since science was linked with rationality and there was an assumption that traditional beliefs and the resort to 'magic' and 'superstition' would decline as modern education advanced."[48] This attitude can be found, for instance, in *Pontianak Kembali* (Estella, 1963), where the protagonist is a teacher who aims to bring the villagers back to Islam so that they will reject superstitious belief in *hantu* like the pontianak. Of course, there is a tension in this project, since the pontianak film depends to some degree on the audience's belief, or at least cultural investment, in the *hantu*, and their desire to see (and perhaps believe in) them. For the genre to work, Islam cannot completely banish superstition, at the level of enjoyment and cathexis, if not literal belief. *Gergasi / The Giant* (Ghosh, 1958) navigates among the three competing discourses of animism, Islam, and scientific modernity in its story of an ogre who is created by a mad scientist and defeated by a pontianak. The villagers

debate whether the monster is a *hantu* or merely a person trying to shake their faith. It turns out to be neither, and the monster created with science is defeated by the pontianak while the village head recites from the Qur'an. In this era, tension between Islam and pre-Islamic tradition is muted, and is generally mediated by rationalism and modernity.

This syncretic impulse is delightfully exemplified by the production of *Dendam Pontianak / The Pontianak's Vengeance* (Rao, 1957), the lost sequel to the original film. Hamzah Hussin writes that on the first day of shooting, the producers brought an imam from a *kampung* to read from the Qur'an in order to repel pontianaks from the set.[49] Hamzah notes that this was done with the blessing of the director, B. N. Rao, who was a Hindu, and of course many of the Chinese crew of the film were not Muslims either. Nonetheless, the *Sunday Standard* reported that all of the cast and crew participated in a prayer before sharing a chicken biryani. The story was accompanied by a photograph of cast members praying.[50] This event can be interpreted in two ways. If taken seriously on its face, it demonstrates a high degree of syncretism in late-colonial film culture, in which an imam might be called upon to stave off the real possibility of a pontianak attack, and in which cast and crew of different faiths would share in a Muslim-animist-Malay ceremony. This interpretation accords with Eric Khoo's vision of transethnic solidarity in "Cinema." More cynically, we might suspect this event of being exactly the kind of public relations stunt at which the studios excelled, similar to the newspaper stories they concocted about escaped talking mouse deer.[51] In this reading, the studios appropriate religious belief for the purposes of ballyhoo in exactly the same way that they deployed obviously fictional figures like the talking mouse deer. Islam is only one signifier of Malayness among many. Syncretism here works seamlessly, and although Islam is visible in these films, it does not disturb their textuality. This situation will change drastically in the poststudio era.

We have already seen that almost no pontianak films were made between the end of the studio era and *Pontianak Harum Sundal Malam / Pontianak of the Tuberose* (Shuhaimi, 2004). This gap maps closely onto the growing process of Islamization in Malaysia, and although we could point to broader weaknesses in film production in the years after the collapse of the studio system, I argue that changing attitudes to cultural expression within Islam played a greater role. What is generally termed Islamization in Malaysia began in the early 1970s. Jason P. Abbott and Sophie Gregorios-Pippas describe the process as "the intensification of Islamic influence on social, cultural, economic and political relations."[52] It was not that more people became Muslim, but that the experience of both Muslim and non-Muslim citizens in the public sphere

underwent transformation. Changes included the introduction of Islamic banking, the rapid development of Islamic schools and universities, the conversion of public buildings to include prayer-rooms, the growth of halal-compliance, the reform of religious dress codes, the expansion of Islamic television and radio stations, and the upgrading of Syariah law to an equal status in the courts. The Islamic Consultative Council was set up specifically in order to propose new policies for Islamization.[53] Azmi Aziz and A. B. Shamsul describe the rise in visible codes of piety in everyday life: many more women began wearing the hijab and there was a shift from Malay to Arabic as the language of everyday greeting. They conclude that "there is a conscious and conspicuous Islamicization at the level of structure and agency amongst Malay-Muslims since the Islamic revival era of the 1970s, both at the observable and structural levels."[54] Abbot and Gregorios-Pippas contrast this new culture with the syncretism noted in the studio era, finding that "since the 1970s the form and prevalence of Islam in Malaysia has slowly and steadily changed, moving away from its syncretic Hindu and animist roots towards an ever-more conservative and Arabic form."[55]

There is an expansive literature considering the question of how and why this Islamization took place, although most historians agree on the range of factors at play. One instigating factor was the so-called "race riot" in May 1969, in which Malays, angry that the non-Malay opposition had made gains in the general election, violently attacked Chinese communities. The army intervened and, according to official reports, 196 people were killed, though observers suggested the number was significantly higher.[56] Although the language of a "race riot" suggests the uprising of a marginalized minority, this violence was instigated by the racial majority, fearful of losing power. In its wake, new laws were passed expressly designed to quell ethnic unrest by bolstering further the social position of Malays.[57] Zainah Anwar contextualizes the riots as "the catalyst for the turn toward Islam."[58] For her, "Extensive government policies designed to promote rapid Malay advancement in the Malaysian economy have thrown Malays, in large numbers and within a short period, from the familiarity of a peasant society into the anxieties of a modern, competitive urban life."[59] A second major cause of Islamization, then, was the government response to this Malay discontent. The ruling party, UMNO, presented itself as moderate and secular, and it had to maintain its coalition with the Chinese and Indian parties. It was thus at risk from opposition by the Islamist PAS (Pan Islamic Malaysian Party), who demanded an Islamic state. In an attempt to defang PAS's attacks, UMNO co-opted their policies, instituting an increasing Islamization program of their own. Joseph Chinyong Liow, among others, has argued that UMNO's attempts to neutralize PAS backfired, creating "an incoherent strategy against

the Islamic opposition that serve[d] only to intensify rather than check the process of the politicisation of Islam initiated by PAS."[60] As UMNO committed to Islamization, PAS, too, moved to the right. As Farish Noor describes it, "Abandoning the discourse of progressive Islamism and anti-colonialism ... the new leaders of PAS began to speak the language of Malay racial, cultural and political supremacy instead."[61]

Calls for a society organized around Islam thus enabled an intensification of Malay racial ideology. The *dakwah*, or proselytizing, movement encouraged the separation of Muslim Malays from other races in everyday life, and religion became an effective proxy for race. Michael D. Barr and Anantha Raman Govindasamy argue that Islamization is "basically a variation of the original Malay ethnonationalism," in which

> A relatively benign regime of Malay ethnocentrism had gradually been replaced with a much more assertive and personally intrusive form of Islamic religious nationalism that has successfully elevated Muslim identity to the status of being a central element of Malaysian national identity. What had changed was that the notion that Malaysia was the product of many varied historic forces and ethnic groups had been completely supplanted by a vision of Malaysia as the product of a glorious 1400-year-old Islamic civilisation.[62]

They identify an important tension in this rhetoric, however, between Islam as an ethnic worldview, looking toward the Malay Archipelago, and Islam as a religious worldview, which transcends race and nation.[63] Revivalist groups increasingly looked to a global Islamic community, and, as Ong argues, "In thus defining a new *umma*, [*dakwah* groups] were inventing practices harking back to a mythic, homogeneous past, while rejecting their Malay-Muslim heritage."[64] It is for this reason that Ahmad Fauzi complains about racializing Islam, for example, and we can see a relevant example of the supplanting of racial identities by religious ones in the work of Dahlia Martin. Her audience research demonstrates how Malay women use television spectatorship to construct their identities in terms of "religiosity rather than ethnicity."[65] In other words, the Islamic revival movement enabled both the transformation of Malay ethnonationalism into a new and more covertly racist form, and, at the same time, the potential to erase or deprioritize Malay identities within a global ummah.[66]

In understanding this globalized identity, it's useful to see how the inspirations for the *dakwah* movement in Malaysia were global in scope. Scholars have pointed to the influence of the Iranian revolution, the Arab-Israeli war, and the formation of OPEC as global shifts that inspired Islamic revivals across the Muslim

world.[67] More conservative, neorevivalist thought spread from the Middle East and South Asia to Southeast Asia in the 1970s and 1980s, and for Zainah and others it was the influence of Pakistani and Egyptian religious teachers that first shifted young Malaysians from progressive to fundamentalist forms of belief.[68] More recently, criticism has focused on the influence of Saudi Arabia, which has exported an ultraconservative Wahabist vision of Islam via significant financial support, outreach programs, and scholarships to many countries, including Malaysia. More recently, these ties have come under scrutiny, especially given the close association of Saudi funding to the corrupt regime of Najib Razak.[69] Some resistance to Wahabism has come on religious grounds, while other opposition has centered on the claim that it erodes the traditional practices of a multiethnic nation.[70] Thus, Marina Mahathir, speaking as the head of feminist group Sisters in Islam, condemned the government for allowing an "Arabization" process that "has come at the expense of traditional Malay culture."[71] Similarly, Ahmad Farouk Musa, head of the progressive Islamic Renaissance Front (IRF), concludes that "this doctrine of the Salafists and Wahhabists has created so much disruption in a plural society like ours."[72] Thus, insofar as Islamization can be seen as a mode of globalization, it comes into tension both with traditionally Malay culture and with Malaysia's multiracial society.

Cinema is one of the places in which we can trace the influence of Islamization, both in terms of textual representation and at the level of state policy and censorship. The National Film Censorship Board (LPFM) was established in 1966, and in 1971 censorship provisions of the Film Act of 1952 were updated. The LPFM worked under the aegis of the Home Affairs ministry, which was led in this period by Mahathir, a proponent of strong film censorship.[73] In this new culture of censorship, making horror film became very difficult. Ng links this new code to the UMNO's "period of aggressive Islamicization," in which horror films were low-hanging fruit for a conservative morality campaign.[74] In the 1970s, the pontianak did not accord with emerging Islamist views on the dubious morality of cinema in general, and representations of the supernatural in particular. In the 1980s, the Malaysian government put more effort into supporting the film industry and was more open to genre films, but according to Azlina Asaari and Jamaluddin Aziz, they allowed only horror films that conformed with Islamic teachings, such as *Mangsa* (Zalina, 1981) and *Perjanjian Syaitan* (S. Sudarmaji, 1981).[75] In the 1990s, even this narrow window was closed down. A new media censorship code was introduced in 1995, banning all representations of VHSC, or Violence, Horror, Sex, and Counterculture.[76] The policy was controversial but film producers and television stations were required to comply. At almost the same time, the government cracked down on domestic horror film, banning

Fantasi (Aziz, 1992) for being un-Islamic. Aziz reported that the censorship board had told him that filmmakers could not represent the dead.[77] Thus, although the VHSC ban on horror films was not consistently enforced, horror films were heavily censored, especially if they included non-Islamic elements or the undead. Moreover, the law was vague, not specifying clearly what types of image would be censored, and this instability made the production of a pontianak film impractical.

We can see the pontianak as a figure—not only textually but in film culture more broadly—of the space available for a certain kind of Malay culture within Islamized Malaysia. That the most popular character in classical Malay cinema should be effectively banned for thirty years is a strong index of conservative success in transforming the meaning of Malay identity. Even the classic pontianak film *Gergasi* was banned in 2003 for having un-Islamic elements.[78] This is why Shuhaimi Baba's ability to make *PHSM* represents such an achievement for a progressive vision of Malay culture. *PHSM*'s release in 2004 came just a year after Mahathir stepped down as prime minister, a transition that marked the beginning of a more open approach to popular culture. Even so, filmmakers face both cultural and practical obstacles in making *hantu* films. Attacks on the genre, couched in religious terms, remain common. The UMNO youth wing called for an outright ban on horror films, "claiming such films can weaken the faith of Muslims in the country," and the National Fatwa Council called horror films "counter-productive to building a developed society."[79] Moreover, Hassan Muthalib and Wong Tuck Cheong report that censorship is inconsistent, making it hard for filmmakers to avoid expensive reshoots.[80] The narrative status accorded to *hantu* is limited, since the Film Censorship Board generally demands that Islam must win out over the supernatural in the end.[81] Despite such political disapproval, horror films are among the most popular in Malaysia: the top two highest-grossing local films ever are horror films (*Munafik 2* [Syamsul, 2018] and *Hantu Kak Limah* [Mamat, 2018]).[82] Moreover, filmmakers revel in the Malay qualities of their horror. The director of *Langsuir* (2018), Osman Ali, asserts that "our cultural and traditional beliefs in the supernatural are still present in our communities today."[83]

The tension between animism and Islam, and between the pontianak and the state, can be discerned in textual traces of censorship, both diegetic and nondiegetic. Many pontianak films include an opening title that either disavows or prevaricates on the question of whether what follows is to be believed or not. *Paku* (Rameesh, 2013) begins with two intertitles, the first saying that the film is not based on any facts, but the second warning viewers not to try to replicate any of its spells without first consulting a religious scholar. By cleverly invoking religious

expertise, the film manages both to state that the pontianak is fictional and to suggest that the spells depicted might be real. *Pontianak Sesat dalam Kampung* (Azmi/Astro Ria, 2016) has an opening intertitle that insists that the story is fictional and not suitable for people who take life too seriously. There is a defensiveness in the rhetorical summoning of hypothetical viewers who *are* too serious and who *would* read the text too literally. Since, as we will discuss later, this is one of the more religious films in the genre, it is especially notable that its opening labors imagine and dismiss the kind of scripturally minded viewer who would find the film objectionable. Other films explicitly wield Islamic credentials. The opening intertitle of *Paku Pontianak* (Ismail, 2013) is a Qur'anic verse, An-Nisa 120: "Syaitan makes promises and arouses desire in them. But Syaitan does not promise except to deceive."[84] These intertitles illustrate the range of strategies for navigating the relationship between Malay animism and Islam in an era in which syncretism is much less acceptable: relegate the pontianak to pure, escapist fiction; incorporate her wholly into Islam as a type of *syaitan*; or attempt to maintain both belief systems through a complex textual work of irony, humor, and ambiguity.

Pontianak Menjerit (Yusof, 2005) is highly self-referential about the ways in which censorship has shaped its textuality. It opens with a precredit sequence in which a young man is attacked by a pontianak on a dark road at night. Just as the sequence reaches a climax, we cut to a cinema audience and the reveal that this scene was fictional. No sooner are we relieved/disappointed that the *hantu* was only on-screen than the next shot reveals the young man's neighbor in the cinema to be a pontianak. This kind of surprise is fairly conventional in modern horror, but here the question of whether or not the pontianak is real has an added cultural weight. This play with the pontianak's existence structures the film—and it will turn out that the *hantu* is faked as part of an inheritance plot—but in one scene the relationship of pontianak representation to religion is quite directly textualized. Saiful is reading a novel called *Pontianak Menjerit* and Yassin disapproves. He tells Saiful he should stop reading it, and Saiful responds, "This novel is so realistic. But do pontianaks exist nowadays? There used to be so many Malay movies about pontianaks, but movies like these aren't allowed to be shown on TV. Why is that?" Yassin responds that it's *syirik*, a term meaning worshiping of false gods. (Farish describes the diffusion of Islamist vocabulary into political discourse in Malaysia, and *syirik* is one of his examples. Its use here illustrates the influence of conservative Islam in popular culture too.)[85] Saiful goes on to ask what about Western, Thai, or Japanese horror movies, which can be shown and which Malays enjoy. The answer, of course, is a double standard in the censorship regime that allows more flexibility for

international culture than for domestic filmmakers. In this self-reflexive moment, the pontianak film's troubling of Islamist discourse comes into sharp focus.

Contemporary pontianak films also labor to align pre-Islamic Malay identity with the newer, Islamized cultural norms. Religious texts and observance become increasingly visible as ways of defeating the pontianak. In the *Pontianak* from 1975, the heroine Melati is saved from certain death because she carries a miniature Qur'an as a talisman. In the same way that a Western vampire is afraid of a Bible, and in the manner of Skeat's early-twentieth-century charm, the pontianak is vanquished by Islamic text. Human characters become increasingly observant. For example, in *Langsuir*, the hero is shown praying while his unsympathetic friends sing and take selfies. After the *hantu* attack them, all four remaining men pray together, their desire for observance having grown under threat of the *langsuir*. In *Paku Pontianak*, a religious teacher orders the pontianak wife to recite a prayer for repentance. This example raises the question of the status of the pontianak herself. The Western vampire's fear of symbols of Christianity is a useful generic reference point, but if the pontianak were to be viewed as fully opposed to Islam, then a film might be in danger of advocating its own censorship. Thus, while some films, like *Paku Pontianak*, represent the pontianak as frightening because she is a *syaitan* who must be vanquished by a return to Islamic authority and practice, others demonstrate an ambivalence in locating her relationship to Islam. In *PHSM 2* (Shuhaimi, 2005), Meriam returns to see her old friend Laila before she dies. She asks if she can come in, but before she can do so she needs Laila to move the Qur'an that is sitting on the table. Meriam is not an evil figure in this film, and the narrative works toward finding justice for her murder, yet she is still repelled by signifiers of Islam. This contradiction is illustrative of the problem that Islamization poses for the pontianak film: it is almost impossible for the pontianak to be at once Malay heroine and Islamic *syaitan*.

Timothy P. Daniels has charted the growth of Islamic popular culture in Malaysia in the wake of the *dakwah* movement, attempting "to explicate the multifaceted influence of forms of Islamic piety upon aesthetic practices, and more deeply penetrate the connections between aesthetic practices, piety, and sociopolitical projects."[86] He argues that Malaysian Muslim attitudes toward art and culture remain conservative, and that the ideological work of Islamic television dramas and films is primarily to "contest discourses of ethnic and religious pluralism and liberal Islam," and to "transcode Malay Muslim distinctiveness, exclusivity, and normative Islamic piety."[87] That piety is both a racializing discourse and a form of nationalist politics can be seen in the way that recent films figure evil in the form of female characters who are not pious, not Muslim, or not Malay.[88] In *Sesat*, Leha is presented as both modern and immodest: she does

not wear a headscarf and wears high-heeled shoes and tight dresses. When she hears something following her on a dark path at night, a close-up on her wedge heels demonstrates that she cannot run to safety in them. Dressing in an immodest way makes her vulnerable. Usually, it is the pontianak herself who is excluded from Malay Muslim distinctiveness, as in *Paku*, where the pontianak Riana screams in pain when another character prays. The conflation of racial and religious forms of nationalism is fascinatingly visible in *Konpaku* (Remi, 2019), an independent horror film in which the fact that it is not a pontianak film can be seen as an extension of this tendency. The central *hantu* is very similar to a pontianak: she has long black hair and seduces men. However, she is not Malay but Japanese and it is precisely her foreignness that makes her so horrifying. The male protagonist falls in love with her, but because she is not Muslim-Malay (and because she is an evil succubus), the relationship is doomed. Islam centers the film's response to the *konpaku*, in which an imam conducts a grisly exorcism. Islamic authority in the forms of prayer and violence against non-Muslim and non-Malay bodies is necessary to remove them from the diegesis. For a true cinema of piety, the pontianak must eventually be expelled as a foreign body from the Malay-Muslim screen.[89]

If a full theological rejection of the pontianak as a *syaitan* leads to a representational dead end, it is perhaps not surprising that she has instead undergone a process of Islamization herself. Karin van Nieuwkirk describes a shift in the Islamic world in which piety movements have embraced forms of Islamic popular culture and this global trend might help account for the development of a new mode of pontianak narrative.[90] In these Islamized texts, conservative forms of gender relations determine *kampung* life and the pontianak is transformed into a figure of piety. We can see the former effect in the way that the arrival of a pontianak produces a problem for social organization in *kampungs* that have no space of social identity available for single women. In *Paku Pontianak*, Adam takes home a woman he has hit with his car, and who has amnesia. This act of kindness disrupts social norms, however, and his mother complains, "Melati has no familial relations with us. How can she live here for so long?" Only family bonds can justify the presence of a woman within domestic space, and Adam's mother suggests that he marry her so that he can continue to look after her. *Pontianak Teng Teng* (Khan/TV3, 2014) sets up the same problem when Indah arrives in the *kampung*, having been banished from her home because, as a widow, she was accused of stealing husbands. Fendi and his wife agree to take her in but insist that they become her foster parents. Again, there is no social space for an independent woman and, since she represents a threat to social order, she must immediately be given a familial role. Aihwa Ong writes about the way that Islamization worked to draw boundaries between men and women that had

never existed in the past. For her, "This Arabization of Malay society depended in part on implementing a rigid separation between male public roles and female domestic ones, a concrete realization of the architecture of male rationality (*akal*) and female eroticism (*nafsu*) that went way beyond any arrangement found in indigenous village arrangements where *akal* and *nafsu* are found in both women and men."[91] The pontianak's *hantu* eroticism, of course, transpires to be even more dangerous than these villagers imagine. If these films construct a conservative vision of *kampung* society, they also stage the pontianak as a disruption to it.

The more radical solution to the pontianak's threat is to convert her to Islam and thus to align Malay racial identities with religious ones. This transformation has become increasingly visible in contemporary films and TV movies, although it can never fully erase the pontianak's animist character. In these texts, the pontianak figures the labor of Islamization and its imperfect ability to smooth over the contradictions at play in Malay religious racialization. *Pontianak Sesat dalam Kampung* is noteworthy in this subgenre as one of the only films in which the pontianak wears a headscarf. Despite the prevalence of the headscarf in Malay society, female actors in popular films do not usually wear the Malay *tudung*. Press responses to the film invariably discussed this feature. One article begins by saying that pontianaks are usually women with flowing hair but that this film is very different.[92] Another starts by pointing out that the well-known actor Emma Maembong is playing a veiled pontianak.[93] As Malaysian feminist activist Jac S. M. Kee points out, in an essay on the cultural politics of the pontianak, the intersection of the *hantu*'s long black hair with Muslim bodily codes creates a particular ideological charge. She draws out the cultural politics of hair as resistance in Malaysia, "'Tomboys' and pengkids [lesbians] go from wearing their pants long and their hair short to having perhubungan seks sejenis [same-sex relationships].... It is not by accident that female fiends gain so much of their power and terror through hair."[94] Thus, for Rose in *Sesat* to wear a veil is an overdetermined shift from countercultural threat to dominant ideological compliance. Kee writes, "We commonly understand female hair as aurat—a body part that evokes ideas of dignity, piety, shame and sexuality. Its control is one of the quickest and most evident ways to demonstrate that a public space is moving towards godliness."[95] Indeed, the film participates in an extratextual debate around piety and celebrity: Maembong had announced her decision to wear the *tudung* in 2013 and had increasingly done so in her on-screen roles. In 2019, she unveiled and complained of online religious bullying and of having experienced an intense pressure to adopt increasingly conservative dress codes.[96] In this cultural context, the veiled pontianak makes a very specific statement about piety and popular cinema.

Beyond Maembong's character Rose being veiled, *Sesat* is structured by a piety discourse in which the pontianak must be rewritten to be wholly virtuous. The film invents a new pontianak mythology in which there is a King Vampire who has ordered Rose to the human realm to bring him blood from the most wicked person on Earth. In this patriarchal hierarchy, Rose is a dutiful daughter rather than an avenging women. The pontianak world is stripped of indigeneity: the King Vampire's house is furnished in the style of a prerevolutionary French chateau and his costume and makeup are strongly reminiscent of Dracula. Malayness is evacuated from the world of the pontianaks and relocated in Rose's Islamic modes of behavior and dress when she arrives in the *kampung*. Rose doesn't want to kill anyone and when she finds herself in the village, she befriends a little girl called Biha. Biha finds Rose some old clothes so that she can dress properly, and hence helps her toward piety. In what looks like a romcom montage sequence, Rose and Biha laugh together, walk through the village, and buy food as locals look on approvingly. In connecting to a small child, Rose is infantilized, acting as giddily as Biha does. She is under the control of her father, yet, having gotten lost, is not even able to complete his mission. Rather than being a powerful and violent woman, she is childish and incompetent. The film strips Rose of power, an absence that becomes visible when she transforms into her supposedly monstrous pontianak form, only for it to be more or less the same as her beautiful appearance, but in a white dress. This image of the good pontianak comports with

FIGURE 3.7 The pontianak in *Pontianak Sesat dalam Kampung* (Azmi/Astro Ria, 2016) wears a headscarf and adopts bodily gestures of piety.

religious standards for feminine behavior but makes for a disjunctive revision of pontianak visual coding.

Piety organizes the pontianak's bodily movements throughout the film. In one scene, Biha and Rose want to cycle to the river with two male friends, but they have only two bikes and Yamim argues that it would not be appropriate for either of them to give Rose a lift.[97] Once at the river, Rose's nail falls out accidentally and she desperately searches for it in the water, scared that the men will see her in her pontianak form. This scene reverses the structure in which nail removal is a source of power for pontianaks. Rather than being a moment of triumphant transformation, it is framed as Rose's body betraying her, like the production of women's bodies as uncontrollably abject within patriarchy. She makes a loud laughing screaming sound that she cannot stop—being a pontianak involves involuntary bodily disclosures and her loud vocalizations are not a weapon to scare men but an unwanted revelation of her true self. Although her pontianak form is still veiled, Rose's panic that the men might see her in this state figures *hantu* embodiment as a form of religious immodesty. This discourse of bodily control and gender segregation reflects what Zainah has described as the negative influence of patriarchal Arab forms of Islam, such that "women in Malaysia have seen a steady erosion of freedom and rights in the areas of law and access to the shariah legal system, as well as in rights of dress, family, public participation, and socialization between the sexes. In public we are seeing increasing segregation of men and women."[98] In this context, the Islamic pontianak figures both the desire for piety and the difficulty of accommodating the pontianak genre within such a worldview. In *Sesat*'s Islamic logic, Rose's difference cannot be accommodated within the community, but its romantic narrative also demands that she marry Biha's brother. It resolves this conflict by first banishing her as an un-Islamic *hantu*, and then allowing her spirit to return within the body of another female character. This revelation makes for a rushed and unsatisfying ending, and Rose's partially embodied reappearance figures formally the difficulty that the film has in constructing a happy ending for a pontianak within systems of piety.

A more progressive version of the observant pontianak can be seen in two other television films, *Pontianak Beraya di Kampung Batu* (Amor Rizan/Astro Ria, 2011) and its sequel, *Pontianak Masih Beraya di Kampung Batu* (Ang/Astro Ria, 2012). Both films screened during the Hari Raya season, in the weeks after the end of Ramadan, which is to say that they are both holiday films, broadcast in a period in which many Malaysians take vacation time and in which television stations use special event television to compete for viewers.[99] Both films are also Ramadan-themed: they are holiday films in the sense of building religious

traditions into genre narratives in a sentimental and light-hearted way. For these films to fold pontianak mythology into Ramadan stories for Malay audiences is to offer a more easygoing attitude to syncretism than that of *Sesat*. In these films, the pontianaks are once again essentially good and have converted to Islam. They have sworn off drinking the blood of humans and instead subsist on cow's blood. In the first film, Riana was trapped in a tree, where she says she had a lot of time to think about her sins, and she has now decided to show kindness to others. There's a kind of recovery work here, in which the pontianak must atone for her past sins in order to be included in the post-*dakwah* mediascape. In *Masih Beraya*, the female *bomoh* gave up the practice of animist magic because she didn't want to do anything counter to Islam, and yet the pontianaks still come to her for help and they live in a world in which werewolves and other supernatural beings exist. The incongruity between Muslim and animist representational systems remains highly visible but, unlike in *Sesat*, these films accommodate the contradictory elements without resolving them.

Masih Beraya focuses much of its comedy on the difficulties that the pontianaks encounter in fasting during Ramadan. In one scene, Nita asks if pontianaks also need to fast, and Tira replies that of course they do. Tira is constructed as more devout than her sister and the humor emerges from Nita's attempts to lie about her own practices. Tira asks how many days she fasted for in the previous year. Nita begins by saying the whole month, and then gradually revises her claim to twenty-eight days, fifteen days, and finally, to the outrage of her observant sister, only six days. Later, Nita tries to sneak some blood from the fridge, only to find that Tira has wrapped chains around it to prevent her from breaking her fast. Here we have a comedy version of piety, which utilizes the idea that pontianaks might find religious observance especially challenging to transform the tension between animism and Islam into humor. Breaking fast is also central to the film's mystery plot. Tira finds it strange that her visitor Dahlia does not eat given they have been fasting all day. Dahlia admits that she has poisoned Tira's food, revealing that she is part of the plot to kill pontianaks during Ramadan. The film imagines a revision to pontianak mythology, in which the *hantu* are weak during Ramadan—as much as they might follow Islamic rules, the pontianaks cannot be admitted to the category of the human. This weakness is a narrative remnant of their construction as evil demons, but instead of casting them out of society, their status as *hantu* is here a challenge to be overcome. In the first film, Tira is determined to catch the rogue pontianak before Ramadan comes to sap her powers, declaring, "I will make sure that Kampung Batu is peaceful again on Hari Raya!" Syncretism is very much on the surface of these texts.

FIGURE 3.8 Tira confronts one of the racially supremacist pontianaks in *Pontianak Masih Beraya di Kampung Batu* (Ang, 2012).

As well as privileging syncretism, the *Kampung Batu* films make visible—and comedic—the racialization of religious culture in Malaysia. Near the beginning of the first film, a customer in Tira's dress store says, "We must help each other, our own kind," and gives her a knowing look. The spectator might interpret this as racializing language, but it is quickly revealed that by "our own kind," the customer means pontianaks. We have noted the potential for racial allegory in the pontianak film in regard to *Tolong*, and here the categorization of humans, pontianaks, and others is central to the films' recuperation of the pontianak in both racial and religious terms. The mystery in the sequel centers on a shadowy group who are taking advantage of the pontianaks' weakness during Ramadan to kill them. It turns out that the human killers see themselves as a superior race who, by eating the hearts of pontianaks, can become immortal. By pitting the religious observance of the pontianaks against the racially supremacist killers, the film surprisingly puts the pontianaks on the side of Islam and marks the humans as religious and racial outsiders. The imperfect Islam of the pontianaks forms a virtuous resistance to the deranged racial language of the killers. The pontianaks may be mediocre Muslims, the film implies, but they are better people. This virtue plays out comedically when the drugged pontianaks do not understand the killers' bombastic claims to be an eternal race, mishearing the word *abadi* (immortal) as "Adabi," a brand of curry powder, and "Kavadi," part

FIGURE 3.9 Both *Kampung Batu* films end with a joyful Hari Raya party.

of the Tamil Thaipusam festival. In their mishearings, they conjure signifiers of other Malaysian races, insisting on a quotidian multiculturalism that the racist humans refuse. The endings of both films hint at such a cross-cultural celebration. Both conclude with a Hari Raya party in the house of the pontianaks, in a domestic mise-en-scène that sparkles with holiday lights. Although the group is not especially racially diverse, all visitors are welcomed, including the *bomoh*, a pontianak from America, and a white vampire from Hungary. These television movies imagine an audience that Dina Zaman has termed "cosmo-pious," describing a more open version of Malay-Muslim identity than that attracted to the piety films, and one that accepts pre-Islamic aspects of Malay culture.[100]

Sim proposes that "despite the obvious and understandable sensitivity to incongruities within the so-called 'postcolonial'—between its epistemological narrowness and the social and political diversity of the world that it refers to—the term persists with a limited connotative range within film studies."[101] For him, the limited geographical focus of Anglo-American postcolonial film studies has resulted in a lack of attention to the different forms and histories of postcoloniality in Southeast Asia. Given the importance of Asian cinema in general to the discipline, and the emergence onto global film circuits of Southeast Asian filmmakers such as Apichatpong Weerasethakul and Yasmin Ahmad in particular, Sim finds it unfortunate that Southeast Asian cinema has been so little studied in terms of postcoloniality. Interrogating the pontianak film's relationship to

histories of racial and religious identities offers a response to this call. The visual and discursive construction of raciality in Malay cinemas has clear geopolitical roots, which can be traced just as chapter 1 traced the material factors that determined the colonial functioning of the studio mode of production. By locating pontianak films within histories of decolonization, it becomes possible to see their place in world cinema rather differently. Whereas a purely generic approach might connect the pontianak to other Asian spirits such as Sadako from *Ringu / The Ring* (Nakata, 1998), a postcolonial focus enables us to locate the films within Malay, Southeast Asian, and Islamic conceptual worlds. Whether with the conservative vision of *Sesat* or the more progressive comedy of *Kampung Batu*, contemporary pontianak media visualizes the contradictions of Malay identity in the post-*dakwah* period. Even in a film like *Sesat* that is committed to Islamic social relations, the pontianak makes piety disjunctive. Religion and race do not line up as easily as official discourse would suggest, and the pontianak film becomes a site in which the meanings of Malay-Muslim identity are contested. Across this chapter, I have focused on film and television texts in which dominant accounts of Malay racial, religious, and national identity are disturbed by the appearance of the pontianak. Across both Malaysian and Singaporean cinemas, the pontianak does not allow Malayness—or Chineseness or racial pluralism—to proceed unremarked or unimpeded. The pontianak film disturbs racialization, just as it destabilizes the operation of religious identities as proxies for race. The Hari Raya parties that end the *Kampung Batu* films are less affective than the nostalgic utopia that concludes "Cinema," but they may in the end be more able to envision a Malay identity beyond the colonial imaginary.

CHAPTER 4

WHO OWNS THE *KAMPUNG*?

Heritage, History, and Postcolonial Space

A scene from *Darah Muda* / *Young in Heart*, a melodrama written and directed in 1963 by Jamil Sulong, vividly stages the role of the Malay *kampung*, or "village," within late-colonial discourses of tradition and modernity. In the film, modest and old-fashioned Fauziah looks after her frail father whereas her sister-in-law Ramlah is depicted as selfish and materialistic. The contrast between these attitudes crystallizes in a sequence in which deliverymen carry a giant radio through the *kampung*, under palm and banana trees, to Ramlah's house. It is difficult work because they are obliged to carry the radio awkwardly across the unpaved common space of the village. The disjunctive image of such a modern media object making its way through the village milieu at once links the modernity of mass media forms with the importation of Western consumerism and implies that such forms of culture are inappropriate to—out of place in—the traditional settings of Malay life. The space of the *kampung* here mediates visually an ideological resistance to a modernity that takes the form of mass culture and its potential to derail women from their role as self-sacrificing familial caregivers. This scene crystallizes a series of historical and cinematic discourses around space and place: the way cinematic space can visualize historical change, the representation of landscapes and rural environments, the ideological weight in postcolonial cultures of property, development, and modernization, and the politics and aesthetics of cultural tradition and heritage. In turning to the space of the *kampung* as an organizing principle, this chapter brings together the material history of postcolonial land ownership with film-theoretical questions of heritage and historicity, and it builds from *Darah Muda*'s image of mediatic modernity invading rural tradition to read the cinematic *kampung* in terms of both time and space.

Of course, the terms *tradition* and *modernity* are overdetermined discursive assemblages. Lye Tuck-Po warns that "for anthropologists 'tradition' and 'modernity' are at best heurisms and at worst political ideologies that are deployed to obfuscate the true nature of power relations between state and local social entities."[1] Rather than see them as obfuscatory, however, I propose that the discursive history of tradition and modernity in Malay cultures provides an illuminating lens through which to view the cinema of decolonization. As I discussed in chapter 1, ideas of unchanging Malay tradition emerge during the colonial period as what Clive Kessler calls *traditionalism*: a reaction to the disjunctures of rapid social change characterized by the imbuing of invented or revised cultural codes with a weight of historicity. The work of inventing tradition is a feature of modernity and in the late-colonial period the Singapore studio cinema vividly stages tensions around the desirability of both terms. Scholars of Malay cinema have characterized the studio era in terms of a "binary battle between tradition and modernity, the kampong and the city," and in this formulation we can see how temporal discourses of historical change have been mapped neatly onto spatial ones of rural and urban life.[2]

The *kampung* is imagined—both in cinema and more broadly—as ahistorical, a place of endless traditional time, but in that process it also becomes a key space in which the transformations of modernization are registered. Priya Jaikumar has argued that the spatiality of cinema is as important as its temporality, and that as cinematic institutions construct space, so the discursive formations of national histories are mapped. For her, "spatial film historiographies ... allow the discipline of film and media studies to tackle two challenges: first, the challenge posed by Henri Lefebvre and geographers in his wake to all historians; and second, the challenge posed by subaltern historians to Western historiography."[3] For Jaikumar, both space and subalternity challenge the nature of film history, and this insight is apt for understanding the significance of the *kampung* image in postcolonial Malay cinemas. In Malaysia and Singapore, as in India, the wresting of the land from an imperial power leads to a postcolonial process of remaking space, in which the material and the imaginary are constantly intertwined. The *kampung* is arguably the preeminent site of this process. It is a locus of nostalgia, ideological projection, and fantasy, and as such, the cinematic representation of the *kampung* animates the meaning of the past within Malay postcoloniality.

The pontianak film is almost always set in a *kampung* and it seems, in the binary of tradition and modernity, to fall squarely on the side of tradition. The studio-era pontianak films are set not only in villages but in the precolonial past. A *Singapore Standard* article previewing *Dendam Pontianak / The Pontianak's*

WHO OWNS THE *KAMPUNG*? 🕯 161

FIGURE 4.1 A seventeenth-century *kampung* is reconstructed in this production still for *Dendam Pontianak* (Rao, 1957). (Image courtesy of Wong Han Min.)

Vengeance (Rao, 1957) describes its "authentic Malayan locales" and the studio set's "exact replica of a seventeenth-century Malay village."[4] This investment in re-creating a precolonial Malay world contrasts with other contemporaneous horror films, which locate their monstrous *hantu* within urban modernity. For example, *Orang Minyak / Oily Man* (Krishnan, 1958) opens with a noirish shot of a shadow falling on a brick wall, immediately signaling its urban location. After a scene of panic in city streets in which inhabitants bar doors and windows against an unseen assailant, we cut to a police station, where an investigation is underway. Instead of a village *penghulu*, the film's figure of authority is a detective and representative of the bureaucratic state. *Orang Minyak* plays on this disjuncture between folkloric *hantu* and modern urban setting in what appears to be a scene set in a *kampung*. Crowds gather round to watch a ceremonial dance, but when a scream interrupts the performance and people run off-screen, a match-on-action cut relocates us unexpectedly to a city street. We were never really in a *kampung*, it is revealed, but on a theater stage. The *kampung* is a fiction in this film and the

oily man is located firmly in modern Singapore. The pontianak films are notably different. *Sumpah Pontianak / Curse of the Pontianak* (Rao, 1958) is set in the same fictional world as *Dendam*'s seventeenth-century village, and although both *Anak Pontianak / Son of the Pontianak* (Estella, 1958) and *Gergasi / The Giant* (Ghosh, 1958) indicate the existence of a modern world (via telephones, bicycles, and midcentury fashion), their settings otherwise aspire to timelessness. In contrast to the many studio-era films that look back with some anxiety on a disappearing *kampung*, the pontianak films insist on its endurance.

The same syntax applies in the contemporary pontianak story: a *kampung* setting is the most consistent generic marker. Eric Khoo's episode of the HBO horror series *Folklore* (2018), set on a building site, stands out as a deliberate break from generic expectations and indeed the site is revealed to be the location of a former *kampung* from an earlier moment in Singapore's history. But in most horror films, the village setting is ubiquitous. The trailer for *Pontianak vs Orang Minyak* (Afdlin, 2012) begins by introducing Kampung Puaka as a place where *hantu* cannot penetrate. The opening scenes of both *Pontianak Sesat dalam Kampung* (Azmi/Astro Ria, 2016) and *Pontianak Teng Teng* (Khan/TV3, 2014) deploy classical narrative efficiency by using road signs both to locate the narrative and to set up its generic expectations. In *Sesat*, the pontianak flies into the Kampung Keriang sign and falls down, constructing the supernatural as funny rather than frightening. In *Teng Teng*, things are more threatening: no sooner do we see a sign reading "Selamat datang / ke Kampung Indah," or "welcome to Kampung Indah," than it breaks in half, leaving only "datang dah," or "it has come." In films that begin in the city, the protagonists often leave in order to encounter *hantu*. In *Pontianak Menjerit* (Yusof, 2005), for instance, all of the characters must leave their modern urban lives and travel to their late relative's country house to hear the reading of his will. In one scene, Ziana and Azlee even discuss why they can't just hear the will read in a lawyer's office in Kuala Lumpur—not only must the narrative move them to the *kampung* but it must narrativize the necessity of doing so. As soon as they reach the ancestral home, the pontianak attacks begin, for as soon as there is a *kampung*, there is a pontianak. The contemporary horror film insists that the pontianak lives in rural environments and it constructs both the *hantu* and the *kampung* as traditional forms of being that survive within modernity.

This chapter argues that the pontianak film's *kampung* setting constructs a heritage imaginary, which is to say that the mise-en-scène and narration of the *kampung* evoke a sense of pastness that articulates ideas about cultural inheritance and the retrospective value of imagining history. The pontianak film's haunted *kampungs* might seem distant from what we usually think of as a

heritage film, but the idea of the heritage film as a genre has always been flexible. Claire Monk has argued that " 'heritage cinema' is most usefully understood as a critical construct rather than as a description of any concrete film cycle or genre," and this sense of heritage as a concept dispersed across genres allows us to think beyond the confines of the European costume drama.[5] In a canonical account of the genre, Andrew Higson describes heritage films as "intimate epics of national identity played out in a historical context," and this phrasing could not be more apt to the pontianak film.[6] In fact, the times and spaces of heritage—rural communities, premodern ways of life, old houses, inheritance—are equally resonant for the horror film and for postcolonial theory. Mélanie Joseph-Vilain and Judith Misrahi-Barak consider that "in the postcolonial world ghosts ask the fundamental question of heritage: how are history, culture, identity transmitted—or not transmitted—in cultures born from conquest, conflict, and sometimes obliteration?"[7] Following their logic, the pontianak herself figures heritage: she dwells in the most sacred spaces of Malay cultural identity and she insistently speaks about histories of violence and expropriation.

In unpacking the heritage imaginary of the pontianak film, I argue that folkloric horror and the heritage film have much in common. The classic example of British folk horror is *The Wicker Man* (Hardy, 1973), an art-cinematic horror film that uses its Scottish village setting to stage premodern pagan rituals as an uncanny and terrifying discovery of national heritage. One of the ways that horror film bleeds into art cinema is through its ability to imagine folklore as a form of national heritage just as compelling as the literary canon is to the costume drama. Whereas literary heritage films begin from high cultural texts, folkloric horror locates heritage in popular, premodern belief systems that offer potential for subaltern historiographies. Robert Macfarlane has investigated the histories of dissent and violence embedded in eerie representations of the English landscape, and his account of what haunts British modernity speaks in proximity to anticolonial readings of literary heritage.[8] (High and low cultural strands of heritage intertwine in genre mash ups like *Pride and Prejudice and Zombies* [Steers, 2016].) Folkloric horror imagines alternative modes of heritage in various national contexts: we might think of the occult radicalism of *A Field in England* (Wheatley, 2014) or the transgender trolls of *Gräns / Border* (Abbasi, 2018). The ongoing intersection of folkloric horror and art film is exemplified by the rise of auteur-based "new horror" such as Ari Aster's *Midsommar* (2018) or Ana Lily Amirpour's *A Girl Walks Home Alone at Night* (2014). These films mobilize folkloric figures as central facets of their claims on art-cinematic quality and cultural specificity. Moreover, they do so in ways that, like the more conventional heritage film, often place the political resonance of national myths into question.

Gräns queers cherished Swedish folk creatures, and *A Girl Walks Home Alone at Night* uses the vampire to stage an Iranian urban feminism. The Malay *hantu* story similarly insists on national belonging, provides a shared historical basis for a film's narrative, and promises culturally grounded pleasures. And, akin to these other heritage horror films, it entails a disruption of that past in which the nature of the pleasures that we might take in viewing heritage is put into question.

In staging Malay folklore as heritage, pontianak films adapt the cinematic strategies of the heritage film to rewrite hegemonic Malay histories. Since the original debates over British heritage films in the 1980s and 1990s, scholarship has focused on the politics of heritage aesthetics. This debate contains two related issues: whether the genre's use of what I have elsewhere called a pretty mise-en-scène precludes political engagement, and whether its mode of historicity is thereby romanticized or whitewashed.[9] As the term has become separated from its geographical origins, the question also arises of how and if it should be globalized. Alan O'Leary warns that what he calls world heritage cinema offers orientalist spectacles for global audiences.[10] Some Southeast Asian film scholars have also renewed Andrew Higson's claim that heritage films are conservative; May Adadol Ingawanij considers the Thai ghost film *Nang Nak* (Nonzee, 1999) to be a bourgeois heritage film that creates "Thainess as a visual attraction" aimed at Western audiences.[11] These critiques are understandable, given the ease with which representations of Southeast Asian rural landscapes can be arrogated to reactionary national narratives at home and viewed with an orientalist gaze when they circulate internationally. Nonetheless, I continue to resist the idea that the spectacular and nostalgic pleasures of the heritage film are intrinsically reactionary. Whereas O'Leary argues that I find politics in heritage films in order to make up for the otherwise conservative aspects of the genre, I would instead maintain that heritage names those formal mechanisms through which such contestation takes place.

Heritage is always about ownership—of property and of national histories—and the pontianak overthrows stable ideas of both material and cultural inheritance. At the heart of the traditional *kampung*, she emerges as a figure to trouble discourses of tradition and to refute also the modernities that flow from them. This chapter begins by analyzing how the pontianak film has, throughout its history, imagined the *kampung* as a heritage space through setting, mise-en-scène, and narrative. Some films represent traditional performance and spiritual practices such as *mak yong* and *kuda kepang*, drawing on discourses of cultural patrimony to connect the postcolonial present to memories of the Malay past. Others foreground traditional modes of dress and vernacular architecture. After considering the imagery of heritage—its spatial coordinates on screen—I move to an analysis of its historicity. Many recent pontianak

films are set in the past—but rather than evoking precolonial histories, they return over and over to the late-colonial era of the original studio films. We've already seen how *7 Letters* (Khoo et. al., 2015) looks back to the history of the pontianak film as a mode of imagining Singaporean identity, and this chapter will examine several recent films whose stories are similarly set in the years between 1949 and 1965. Films by Shuhaimi Baba, Mamat Khalid, and Glen Goei and Gavin Yap represent a strand of high-profile auteur-based horror that deploys heritage practices in order to revise conventional histories. By revisiting these histories, heritage *hantu* films problematize the association of the *kampung* with conservative Malay identity, offering alternative, feminist accounts of both tradition and modernity. Finally, I turn to the representation of the land itself, in which the cinematic spaces of the *kampung* and its surrounding forest animate the changes in land ownership that characterize decolonization.

Across the chapter, I argue that the ownership of postcolonial Malay spaces and histories cannot be settled and that the pontianak is the force that makes it impossible to do so. In the *kampung*, she creates several interlinked areas of disruption. She troubles the smooth operation of dominant historical narratives, upsetting the way postindependence political discourses have deployed *kampung* traditionalism to uphold racialized modernization. Her acts of feminist haunting also disrupt patriarchal accounts of property ownership and inheritance, extending the feminist argument from chapter 2 to engage the domain of patrilineage. Moreover, by intervening in the heritage film's landscape imaginary, the pontianak troubles our ideas of nature and culture. Heritage is often assumed to be a human history but the pontianak intimates that it might not be entirely so. The nonhuman *hantu* speaks as a force of nonhuman nature, insisting on the ecological consequences of ownership in Malay forests and rural spaces. Heritage might be an anthropocene concept in its assumptions of human rights to the land and its implications in heteropatriarchal systems of inheritance. For the pontianak, this too is a site of feminist uprising. In her violent disturbances to the spaces of Malay heritage, the pontianak's politics extend the scope of feminist intervention, taking in postcolonial history, development, and ecology. Pontianak films return compulsively to the mythology of the *kampung*, but they also ask who owns it.

KAMPUNG MENTALITIES

The *kampung* has engrained meaning in Malay culture: it is freighted with ideas of representing a true Malay domain, and it is thus able to evoke both nostalgic

sentimentality and forms of nationalism that have haunted postcolonial politics. Above all, the *kampung* elicits an affective draw for a population that has largely moved to cities. Harper points out that "a theme of village anthropologies of the 1950s and 1960s ... is the reluctance of Malays to unquestioningly embrace the values of the city and their desire to retain a foothold in village life."[12] A central tenet of neotraditionalism for Kessler is an overinvestment in the idea of the *kampung*, even or especially among people who have little relation to village life in reality.[13] The *kampung* is a culturally and politically resonant space in postcolonial Malaysia and Singapore, conjuring an idyllic way of life whose purity is always already lost. For Raymond Williams, the "myth of the Golden Age" points to a form of historicity in which the traditional continuity and peace of the countryside are imagined as always having just been despoiled by modernity's destructive power, no matter what period one is in.[14] This myth describes well the cultural politics of Malay space. This logic is prominent in *Permata di Perlimbahan / Jewel in the Slum* (Haji Mahadi, 1952), the first film directed by a Malay, in which morality is threatened by the encroaching modernity of night clubs, in contrast to which the heroine sings about nature's beauty while standing outside her bucolic *kampung* house. Timothy Barnard has noted the frequency of studio-era narratives in which the threat to village life by the big city is embodied in tragic love stories, locating the *kampung* as an inevitably vanishing site of moral authority and social harmony.[15]

A crucial aspect of this investment in the *kampung* is its association with spirit belief, viewed as a valuable part of the Malay lifeworld that is also under threat from modernity and urbanization. Thus, in her study of *hantu* storytelling in Malaysia, anthropologist Cheryl Nicholas finds that urban Malays direct her to the *kampungs* to find believers: "'There are no ghosts here,' Makcik Hamidah said in Malay. She explained how hantus do not exist in the city because people in the city do not believe in hantus. 'Kalau you percaya, memang ada' [If you believe then it is,] she explained. . . . 'Orang pekan sudah tak percaya lah . . . susah jugak nak cari hantu' [People from the city stopped believing; (therefore) it is difficult to find hantu]."[16] The *kampung* represents not only a threatened space of cultural authenticity but also a disappearing home for the pontianak. This story of urbanization is legible in the history of the pontianak film. Toh Hun Ping writes that in *Sumpah*, the locals are menaced by supernatural creatures whereas in reality their *kampungs* were soon to be destroyed not by *hantu* but by the forces of modernization.[17] Contemporary pontianak films are made in the wake of this history of development, and they mediate the process, imagining the *kampung* in the age of its disappearance.[18]

The *kampung*'s development as a political site must be understood in relation to its colonial history. As discussed in chapter 3, British colonial policies produced a de facto segregation of Malays, Chinese, and Indians in Malaya and this racial organization of society was heavily determined by land use. Malays had been limited by the British to rice padi cultivation and largely excluded from other forms of commerce or industry. In 1947, according to Charles Hirschman, 92.7 percent of Malays lived in rural areas and by 1967 the percentage was still as high as 82.4 percent.[19] In their attempts to improve the economic position of Malays, UMNO even called for non-Malays to be barred from *kampungs*, a form of ethnonationalist protectionism that was fortunately not taken up.[20] Nonetheless, affective investment in the *kampung* was always economic, political, and above all racial in nature, and this is nowhere more clear than in Mahathir Mohamad's book *The Malay Dilemma*. The thrust of Mahathir's polemic is that modernity had influenced the cities and towns in the variegated forms of Islam, Hinduism, industrialization, British colonialism, and Chinese immigration, but that a combination of what he saw as outdated animist beliefs and the efforts of the British and Chinese had conspired to keep Malays in a backward state in the *kampungs*. "The rest of the world went by, and the tremendous changes of the late nineteenth and twentieth centuries took place without the rural Malays being even spectators."[21] Kahn considers that Mahathir's ideas "reflect a more general movement among 'conservative' Malay nationalists to formulate a developed national narrative of a simple, 'traditional' *kampung* people marginalised by colonialism and foreign immigration."[22] Mahathir's nationalistic argument sees the rural space of the *kampung* as a fantasmatic repository of true Malay identity, at the same time that it speaks of Malays as having been held back by foreigners. While other races gained money and power, Malays were stuck in the *kampung*, close to the land, laboring in impoverished conditions. His claims are ambivalent, and present a broadside against Malay complacency as much as a postcolonial critique. At the same time that the *kampung* stood for Malay nationalist pride, it synecdochally figured the target of an internal critique within Malay nationalism, which looked down on *kampung* dwellers as lazy, primitive, and lacking in the kind of entrepreneurial spirit that might be ascribed to those who had traveled across borders to come to the peninsula. The meaning of the *kampung* is very much at stake in this influential argument, in which it is at once a locus of traditional values and a signifier of outdated ways of life.

This ambivalence is narrativized quite concretely across the pontianak film. The lazy native myth can be seen in the studio films, with comedy characters like the servant Dol in *Sumpah*, who hides dust under a rug instead of sweeping it

up—this kind of physical comedy appeals to stereotypes. Contemporary films continue this vein of humor, but add a Mahathiresque ambiguity in which characters complain about being accused of laziness while also actually being lazy. In *Sesat*, the romantic lead Yamin whines about his mother's nagging but, as his friend points out, he doesn't do any work and is so lacking in dedication to his faith that he can't distinguish between a carpet and a prayer mat. We can discern a more critical account of *kampung* life in *Sumpah*, however, where village people are not lazy but exposed to extreme poverty as a result of colonialism. Comel is homeless and desperate when she arrives in a new village and begs people to give her work. They reply that they have no work to offer, while offscreen we hear a satay seller calling his wares. Sound-image relations create a contrast between Comel's need and the food available for those with money. In the next scene, she collapses, holding her stomach. She tells a passing farmer that she hasn't eaten in days, and he offers to take her home and give her food. His hospitality speaks to tradition, but the emphasis on the basic business of eating in these scenes also foregrounds economic precarity. Such poverty was commonplace in the 1950s: Harper writes that "the basic characteristics of much of the countryside throughout the late colonial period remained isolation, disease and malnutrition."[23] Realist representation of rural poverty, however, was unusual in late-colonial culture. Virginia Hooker discusses the rarity of novels like A. Samad Said's *Salina* (1961), which depicted villagers living in goat sheds and turning to prostitution.[24] As with Italian neorealism or the early films of Satyajit Ray, national authorities frowned upon realist modes of representing social problems.[25] And although the pontianak film is hardly a realist genre, these naturalistic images of rural precarity emerge from the progressive anticolonial beliefs of many working in the studio system, and suggest something distinct from either rose-tinted nostalgia for the *kampung* or elitist accusations of laziness and primitivism. From earliest films, therefore, there is a politics to the construction of the *kampung* as a cinematic space.

If debates over the "*kampung* mentality" register in how pontianak films represent rural space, then these same discourses can also be discerned in how horror films themselves are understood. For conservative commentators, horror films are exemplars of a backward mindset, unsuited to a modern culture. Thus, Mahathir himself has spoken out repeatedly against *filem seram*, claiming that horror films "impede the growth of the Malaysian mind" and counteract the government's attempts "to promote scientific and rational thinking."[26] In Mahathir's modernization strategy for Malaysia, horror films were seen as throwbacks to superstitious *kampung* mentalities. Jamaluddin Aziz and Azlina Asaari gloss Mahathir's comments in relation to "issues of taste, religious values, and nation

building, which in turn reflect inevitable class divisions in Malaysia."[27] This interpretation usefully foregrounds the role of class in constructing the idea of the *kampung* mentality: it is not after all a reflective self-criticism but rather a postcolonial elite looking down on lower-class, less-educated Malays as the architects of their own poverty. Pontianak films become associated with this class hierarchy both for their representation of the *kampung* and *hantu* belief and because the audience for horror films is seen as lacking in cultural capital. Jamaluddin and Azlina also point out that whereas the government has attacked horror as harking back to undesirable aspects of the past, filmmakers defend their work in terms of the positive attributes of tradition.[28] The *kampung* mentality debate of the 1970s is thus reiterated in relation to the pontianak film of the 2000s, where horror can be accused of appealing to primitivism or defended as a culturally authentic representation of traditional practices. The dominant view of the *kampung* is largely conservative, born out of the conjunction of racialized invented tradition, Golden Age nostalgia, and class-based disdain, but the pontianak film's folkloric vision of heritage horror works to disturb and to complicate this history. Rather than rejecting *hantu* belief as primitive, lower class, or anti-Islamic, the pontianak film revels in the spaces and cultural practices of the *kampung*.

THE *KAMPUNG* AS HERITAGE SPACE

The *kampung* is imagined first through its built environment, in large part through its distinctive domestic architecture. Traditional houses are made of local hardwood and built on stilts, with an open verandah to the front, and pontianak films repeatedly foreground these architectural features as a function of their heritage style. In *Pontianak Harum Sundal Malam / Pontianak of the Tuberose* (Shuhaimi, 2004) Marsani's tense visit to Meriam takes place on her ornate wooden verandah, and this architectural style is visually prominent across the genre, from television films like *Pontianak Teng Teng* to art films such as *Lagi Senang Jaga Sekandang Lembu / It's Easier to Raise Cattle* (Eu, 2017). Many films utilize existing locations: *Pontianak Teng Teng* was shot in the northern state of Perlis, and *Sumpah Pontianak* was shot in villages on Singapore's East Coast that were razed long ago.[29] The latter film makes suspenseful use of the structure of the stilt house in a scene in which a lizard *hantu* hides underneath the house before attacking one of its occupants. In its more lighthearted scenes, the social space among the houses forms the setting for children's ball games, and for the satay seller to hawk his wares. In other words, the space of the *kampung* forms a

mise-en-scène of culturally specific activities: in playing *sepak takraw*, eating satay, and encountering *hantu*, Malay heritage *takes place*. We see this combination of vernacular architectural tradition and evocative cultural practices deployed throughout the history of the genre, such that pontianak mise-en-scène is deeply formative of a heritage imaginary.

The visual pleasure of looking at traditional architecture can sometimes form a reactionary nostalgia. *Sesat* is one of the more conservative films in the genre and it locates its central family in an ornately decorated and rather grand house. One interior scene represents the pontianak Rose pouring tea for her host Mak Nor in a huge reception room, the walls of which are composed of wooden panels painted with elaborate red and gold Jawi texts. The richly detailed paneling surrounds Rose with a religious mise-en-scène within which her actions are legible as gestures of piety. The physical structures of the house provide a pedagogy through which to read the actions of the characters who inhabit it. In another scene, cinematic framing deploys architectural space to produce a highly structured composition. A window forms an internal frame, and carved wood on the window frame turns the top of the frame line into a decorative repeat pattern. The lines of the window run parallel to the frame lines, but outside is a gazebo whose roof lines run in diagonals. Within these multiple frames sit Rose and Mak Nor. Rose is receiving romantic advice and the moral universe of this instruction is staged in her containment within layers of Malay architectural lines.

FIGURE 4.2 *Pontianak Sesat dalam Kampung* (Azmi/Astro Ria, 2016) constrains characters within the lines of *kampung* architecture.

Architectural nostalgia is leveraged to more progressive effect in *Misteri Bisikan Pontianak* (M. Subash, 2013), which ties its *kampung* setting to a very different political philosophy. *Misteri* introduces the *kampung* with an establishing shot close to ground level, looking through the stilts of a verandah. Dappled sunlight falling through the leaves of a nearby tree creates an atmosphere that is at once eerie and pretty. Even in this social-justice-themed horror film, the visual space of the *kampung* is aesthetically appealing. Unlike Mak Nor's elegant wooden house, the grandmother's house here does not connote wealth: the roof of her verandah is made of corrugated iron and its floor is bare concrete. Nonetheless, it is shot with a formal precision that creates a kind of beauty, as in a shot in which the horizontal lines of metal roof and wooden railing frame a cat looking diagonally up at a bird cage. Over and over, pontianak films utilize *kampung* houses as visually resonant sites of Malay cultural dwelling.

We can trace the semiotic significance of the *kampung* house through the extent to which its trace remains even in films with urban settings. In *Paku* (P. Rameesh, 2013), the couple lives in a sleek, modern house, but its exterior strongly echoes vernacular style with a dark wood frame and generous verandah. This verandah is the setting for Fahmi's happy flashback to his wife Riana's pregnancy, before she dies and becomes a pontianak. While Riana stays in the traditional house, she is safe, but when the couple visits relatives in a working-class apartment block, disaster strikes. As they leave, the building collapses and Riana is killed by a block of falling concrete. When she returns as a pontianak, Fahmi is at first thrilled to have his beloved wife back, but he becomes increasingly pained by her undead state. Her uncanniness is visualized through domestic architecture. Soon after her return, the couple moves to a characterless condo, where she is visibly out of place. In the end, it is this modern house that destroys her. When the religious uncle pulls out the nail in her neck, a sinkhole opens in the floor and Riana is dragged into it by supernatural forces. She is killed by a house after all, just not the one under which she first died. Instead of haunting a house, this pontianak is haunted by houses, as *Paku* imagines the city as dangerous to women and traditional architecture as the locus of marital safety.

Beyond the built environment of the *kampung*, the pontianak film conjures a heritage imaginary through its staging of Malay cultural practices. I outlined in chapter 1 how the studio-era films drew on pre-Islamic forms such as the *pantun* verse form and the *bersanding* wedding ceremony, as well as on the diverse culinary culture of the market, in order to construct an anticolonial identity. In the context of the late-colonial period, cinematic representation of such precolonial cultural practices was easily legible as a nationalist address, and in that historical moment, perhaps their most radical gesture was the playful rivalry between Hindu

and Muslim food hawkers that ran through the Cathay Keris films. In the post-*dakwah* era, however, representation of Malay heritage is more contested, and instead of making an anticolonial gesture, such images threaten to undo dominant state discourses of cultural and religious identity. Given this difference in political context, it is striking how closely contemporary pontianak films hew to the themes of the earlier films, and how extensively they represent pre-Islamic art forms. In doing so, they distinguish a syncretic and multicultural heritage from the narrow versions of national history proposed by political and religious conservatives. To take a few examples, *Pontianak Harum Sundal Malam 2* (Shuhaimi, 2005) follows *Pontianak Gua Musang / The Pontianak of Musang Cave* (Rao, 1964) in including performers of the martial art *silat*; *PHSM 2* also features practitioners of *kuda kepang*, a Javanese spiritual dance; and the retro comedy *Kala Malam Bulan Mengambang* (Mamat, 2008) features a magical *keris*, the ceremonal Malay dagger after which Cathay Keris studio is named.

The pre-Islamic form most prominently seen in the films is *mak yong*, a dance from the northern states of Malaysia and southern Thailand in which all parts are traditionally performed by women. Pontianaks perform *mak yong* in *Paku Pontianak* (Ismail, 2013) and in both *PHSM* films, as well as in other *hantu* films such as *Badi* (Eyra, 2015). In *Paku Pontianak*, Melati is a young woman with amnesia, who begins to perform *mak yong* instinctively but does not remember how she learned. *Mak yong* is part of her mysterious pontianak past, and her

FIGURE 4.3 The pre-Islamic practice of *kuda kepang* is foregrounded in *Pontianak Harum Sundal Malam 2* (Shuhaimi, 2005).

spectrality becomes visible through her embodied knowledge of this Malay cultural practice. When she dances, the camera's gaze on her body is at first fetishistic, until she turns around and her pontianak form is revealed with long nails and a decomposing face. The two practices—dance and spirit belief—are connected in Melati's body as troublesome modes of Malay heritage that are also beguiling and powerful. In the *PHSM* films, *mak yong* is part of the inheritance that Meriam passes to her daughter Maria, along with the legacy of haunting. *Mak yong*, however, is not simply a quaint folk dance. The practice has become controversial in recent years and is even banned in the state of Kelantan. There, as Patricia Hardwick notes, "PAS officals argue that mak yong has its origin in pre-Islamic belief, encourages the worship of entities besides Allah, and objectifies women."[30] According to Islamist discourse, pre-Islamic cultural practices are *haram* and, as Tan Sooi Beng has pointed out, state funding for such folk traditions was cut in Malaysia after the 1970s.[31] *Kuda kepang* prompted a similar repression: Singapore began to close down its practice with force in the 1980s.[32] Hardwick identifies in the post-*dakwah* period "the systematic omission and destruction of aspects of Malay culture that are deemed to have pre-Islamic origins."[33] The contemporary pontianak films' emphasis on pre-Islamic cultural practices reverses the association of tradition with cultural and political conservatism and rewrites ideas of cultural patrimony in the language of feminist haunting.

HERITAGE FILMS AND REVISIONIST HISTORY

Heritage discourse bespeaks a complex and often ambivalent relationship to history, and in the pontianak film, the *kampung* setting conjures a sense of nostalgic pastness in which ideas of heritage can circulate. But history in the horror film is often the site of originary traumas, of past crimes that return to haunt the present, and this is especially true in postcolonial horror. How does the pontianak film combine its heritage imaginary with the histories of violence that are implied by the genre of postcolonial horror? There are (at least) two histories at stake here: the vague pastness implied by a premodern *kampung* nostalgia and the very specific period of anticolonial activism, separation, and independence. Several films evoke both of these temporalities at once, conjuring the aesthetically appealing visual rhetoric of the *kampung* as premodern idyll at the same time as leveraging nostalgia for the fashions and political memories of the mid-twentieth century. This period is especially fertile for the pontianak film, because of course it is the

moment of the genre's heyday. As with the movie producer's melancholic search for the beautiful actress who played the pontianak in *7 Letters*, the historical pontianak film combines memories of the 1950s with memories of the popular cinema of the time. These memories are never only nostalgic: both *Kala Malam Bulan Mengambang* and *Dendam Pontianak / Revenge of the Pontianak* (Goei and Yap, 2019) are set on the eve of Malaysian independence and both films understand this moment as the site of a trauma that must be investigated. For a cinema of decolonization, the history of independence remains a surprisingly troublesome specter.

The Malaysian horror comedy *Kala Malam Bulan Mengambang* was directed by Mamat Khalid, whose previous film, *Zombi Kampung Pisang* (2007), was Malaysia's first zombie film. It was a huge box office hit and spawned the equally popular *Hantu Kak Limah* (2010–2018) series. Mamat is one of Malaysia's most prominent horror directors, and, like the *Kak Limah* series, *Kala Malam* combines horror with intensely referential comedy. *Kala Malam* stages the 1950s primarily through genre pastiche, with an investigative narrative that frames the supernatural mystery as a film noir. The film is highly stylized, introducing its reporter protagonist Saleh in a canted angle shot, with shadows on his face and jazz music in the background. Noir clichés turn the mid-century modernity of the studio films into a transnational retro style. *Darah Muda*'s mediatic juxtaposition of the old and the new is reiterated when someone asks, "How can there be spirits in this radio era?" and in this way the juxtaposition of premodern *hantu* with the modern world is reinscribed as both a clash of cinematic genres and a clash of historicities. The temporality of the premodern *kampung hantu* pushes up against the retro mode of the postmodern neo-noir pastiche. *Kala Malam* begins with urban noir, but it soon transports its protagonist into the dangerous and beguiling *kampung*. The *hantu* take the form of Putih, a local beauty, and her equally handsome brother Jongkidin, who runs an auto shop that is very much a Malay version of the gas station in *Ossessione* (Visconti, 1943). When they are introduced, Jongkidin leans back sensually on a car's hood, the sleeves of his jumpsuit rolled up and a cigarette hanging languorously from his lips, evaluating Saleh. Putih walks into the frame wearing a loose headscarf and a frangipani flower behind her ear. She, too, eyes Saleh suspiciously. They are the objects of Saleh's erotic gaze, but are also coded as mysterious and possibly dangerous. The scene's bisexual eroticism imbues it with a risky modernity, and the detective / femme fatale attraction is part of the film's noir structure. But the siblings are also premodern *hantu*. Putih is not quite a pontianak but a *jembalang*—a female Earth spirit who is a kind of embodiment of the land on which the *kampung* community is built. Centering an Earth spirit foregrounds the *kampung* as the

FIGURE 4.4 The *hantu* in *Kala Malam Bulan Mengambang* (Mamat, 2008) exude a retro film noir style.

physical ground of the *hantu* story. She is, however, styled to look very much like a pontianak, with long black hair, pale skin, and the symbolic frangipani. Her brother is a were-tiger, and the pair echo in glamorous mid-century style two of the most popular studio-era *hantu*.

Across the film, references to classic Malay cinema abounds, culminating in a spectacular nightclub sequence in which dancers perform "Wo Yao Ni De Ai," a song that was a huge hit in 1957 for Grace Chang.[34] Chang, of course, was a highly popular Chinese musical star who worked for Cathay in Hong Kong, and whose music and films were well known in colonial Malaya. Richard Dyer memorably argues that pastiche "can, at its best, allow us to feel our connection to the affective frameworks, the structures of feeling, past and present, that we inherit and pass on. That is to say, it can enable us to know ourselves affectively as historical beings."[35] Mamat leverages such historical affect in the ambivalence of its nostalgia: the *kampung* is replete with a rich iconography of 1950s studio style, but both its traditional and its modern elements are shot through with corruption. It is revealed that the *kampung* suffers from both political and supernatural wounds: an underground communist cell has been kidnapping and brainwashing people and the *hantu* are killing villagers during each full moon. The communists are depicted as ridiculous, for instance, in their insistence that German should become Malaysia's lingua franca.[36] More significant, though, is the history of the

hantu. In flashback, we discover that in 1939, a female *bomoh* was burned alive by a male rival, and as she died, she placed a curse on the village. Putih and Jongkidin are her children, and in attacking the village, they are continuing her legacy. The *kampung* is under threat externally from communists and the British, but also internally from an inheritance of misogyny that is jealous of female power. As Norman Yusoff puts it, "'ancient' matriarchy is replaced by a patriarchy that seems to signal a transition from the traditional to the modern."[37] The narrative moves toward a revisionist history that is nonetheless deeply ambivalent. The village is freed from political corruption but its anticolonial memory is also comedically anticommunist. Meanwhile, in the conclusion of its noir romance, Saleh takes Putih back to the city with him. Since he doesn't know if she will become murderous during the full moon, he is obliged to lock her up with an excess of padlocks and chains that does not entirely connote feminist emancipation. Nonetheless, there is revisionism in the pontianak leaving the *kampung* and embarking on a different life. In bringing together the city reporter with the *hantu* in a risky romantic relationship, *Kala Malam* also imagines a decoupling of both modernity and tradition from the inheritances of Malay patriarchy.

The project of revisionism is central to Glen Goei and Gavin Yap's *Dendam Pontianak*, a film that exemplifies the confluence of folkloric art horror and prestige heritage film. It boasted a star-studded premiere at the Capitol Theater in Singapore, with Malaysian stars including Nur Fazura Sharifuddin and Remy Ishak in attendance. It also had the highest-grossing opening for a Malay film in several years, outearning horror hits such as *Dukun* (Dain, 2018) and *Hantu Kak Limah*.[38] Box office figures indicate the film's popularity, but we can also frame its distinction in relation to Singaporean public culture. Goei is best known as a theater director: he is associate director of Wild Rice Theater, and his work frequently engages with the complicated inheritances of postcolonial Singapore. Not long after *Dendam Pontianak* premiered, he collaborated with Alfian Sa'at on a play called *Merdeka / 獨立 / சுதந்திரம்* (*Independence*). *Merdeka* proposed a decolonizing counternarrative to the state's bicentennial celebration of the two hundredth anniversary of colonialism in Singapore. Goei is, along with Alfian, one of only a few out gay artists in Singapore, and his work is often characterized by queer modes of performance. In 2017 he starred in drag in *Mama White Snake*, a version of the White Snake legend that combines references to Chinese folklore, British pantomime, and Tsui Hark's cult classic *Green Snake / Ching se* (1993). Goei thus crosses high and low cultural registers, and his reputation as an independent artist is predicated on this ability to move up and down hierarchies of genre and taste. In this context, he functions to position *Dendam Pontianak*

FIGURE 4.5 Traditional Malay wedding costume signifies heritage in *Dendam Pontianak* (Goei and Yap, 2019).

as an auteur film, and one in which audiences might expect the indigenous cultural history of the pontianak to be leveraged both for political purposes and in relation to diverse types of cultural reference.

Dendam Pontianak immediately presents itself as a heritage film: it opens with a spectacular wedding ceremony in a Malay *kampung*. The bride and groom are bedecked in traditional matching red outfits while the period costumes and hairstyles of the guests locate the story in the 1960s. Colors are saturated, depicting the *kampung* with a combination of bright green foliage, warm native hardwood architecture, and rich red and gold textiles. We are placed in a Malay past whose visual appeal is closely tied to its adherence to traditional cultural practices. In other words, the film's form offers us a Golden Age vision of the *kampung* past that is almost immediately interrupted by the haunting presence of a pontianak. Haunting is first indicated by a disturbance in the soundtrack, with a buzzing noise that distorts the voice of the wedding singer. The groom, Khalid, is nervous and appears to know that something is wrong. Soon, the figure appears of a woman in a red *kebaya*, the bright primary color echoing the costuming of the bride and groom. Her spectral appearance indicates that this is not a timeless Golden Age, and that history—in the form of the *kampung*'s secret—is about to be experienced as a disturbing and violent return. On the morning after the wedding, the bride discovers the eviscerated body of one of the guests pinned to a tree. The juxtaposition of marriage with murder in the opening scenes sets in motion the film's generic combination of melodrama, heritage, and horror. As with more conventional costume dramas, *Dendam Pontianak* weaves geopolitical histories through individual stories.

FIGURE 4.6 Heritage is tied to haunting in *Dendam Pontianak* when Mina returns from the dead wearing a traditional *kebaya*.

The film takes place over two time periods, both significant to pontianak and Malay histories. The narrative present of Khalid's wedding to Siti is in 1965, the year of Singapore's expulsion from Malaysia and its national independence. When we flash back to the murder that brought the pontianak into being, we are in 1957, and indeed the day of *merdeka*. We learn in flashback that Khalid has been having a secret relationship with Mina and she is pregnant. In a scene that constitutes the fulcrum of the plot, a heavily pregnant Mina travels to the *kampung* to ask for Khalid's help, arriving exactly as the villagers are gathered in the local *kopitiam*, watching the independence celebrations on a single television. Historicity is pinned to the narrative event, and this television forms another instance of media technology mediating tradition and modernity in the *kampung*.

The television images promise a new birth but Khalid is unwilling to support Mina's child. Instead he and two friends drive her out to the surrounding jungle, and Khalid strangles her. That Mina is murdered on the day of Malaysian independence locates a crime, a violence, and a loss in the moment that should be experienced as joyful. Independence comes at a price, and the pontianak is born alongside Malaysia. What are we to do with these dates? Mina dies in 1957 and reappears in 1965, haunting what looks like a timeless *kampung* space with the discontinuous violence of two political severances. *Dendam* proposes a dual national allegory, in which the pontianak's haunting begins with Malaysia's independence and ends with that of Singapore. It also offers a self-reflexive nod to the history of the classic pontianak films, all of which were released between these years. More than merely a nostalgic reference, however, *Dendam*'s historicity implies that the pontianak emerges in 1957 for a reason. As Steve Pile

puts it, "Vampires jump times and spaces.... The vampire will tell us that colonization and globalization work through pathways and trajectories (as much as territories and periods), producing discontinuous, interrupted, delayed formations."[39] In her pontianak form, Mina speaks about the traumas of decolonization for both countries.

Dendam stages a markedly explicit critique of both (bad) modernity and (bad) tradition through its heritage style. We can trace this style in Khalid's representation. His relationship with Mina is predicated on leaving the *kampung*: he meets her in a dance club that is visualized in a retro 1950s color palette, full of mid-century modern pastels. There are close-ups of a record player, a radio, cigarette smoke, and then a cut back to couples dancing. The scene is evocative of the films of Wong Kar-wai and in particular the dreamy atmosphere of *In the Mood for Love / Faa yeung nin wa* (2000). This sense of mid-century Asian modernity associates Khalid and Mina's relationship with Wong's melancholic postcolonial romance. Khalid tells Mina that he cannot see her any more in a ruined building, overgrown with tree roots in a way that echoes the ending of *In the Mood for Love* at Angkor Wat. After Khalid kills Mina, he no longer frequents dance clubs. Back in the *kampung*, he becomes more traditional, marrying and focusing on at least performing piety. His costuming and styling, however, continue to echo Wong's vision of modern masculine cool. He wears high-waisted trousers and a thin cotton shirt with a white undershirt. This outfit contrasts with the traditional Malay dress of most of the men in his *kampung*: even having returned to the village and committed to a more traditional way of life, both Khalid and his brother (and partner-in-crime) Reza dress as modern men. In one shot, he leans out of a window smoking, his languorous bodily disposition at odds with the constrained movements of piety that I discussed in chapter 2. His dress also contrasts with that of the female characters, who all wear traditional *baju kurung* or *kebayas*. It is the men who make claims to navigate both tradition and modernity, in a way that is not possible for women. The film's narrative works to unravel Khalid's embodied claim on modernity, revealing it to be as false as his lie to Mina that he had to leave her because he had an arranged marriage back in his *kampung*. There, he used Malay tradition to get out of a relationship, wanting the sexual freedom of modernity but not its concomitant claims on equality. Khalid's appearance as a romantic figure in the mode of Tony Leung Chiu-wai's Mr. Wong is also a fantasy. His sharply parted hair and 1960s attire present him as the forward-thinking face of postcolonial Malaysia, but the specter of the past overthrows this attractive fiction, when the pontianak reveals that Khalid's modernity is just as fake as his claim on traditional values.

Mina's revenge uncovers the hypocrisy of the conservative *kampung* ideology, in which a murderer like Khalid is rewarded for maintaining the appearance but not the substance of morality. The attitude that produces Khalid's sexist violence suffuses the community, and the film implies that this is not only a problem of male violence per se but a particular version of Malay identity that is inward-looking and lacking self-critique. Thus, the villagers pick on Khalid's new wife, Siti, blaming her for the pontianak's curse because she is an outsider. When Khalid confesses to the *bomoh*, he is not angry that Khalid took a life, but only that he failed to follow traditional burial protocols. There is no real reckoning with murder as morally wrong, from either the *bomoh* or the other villagers. In the exact place that the village claims moral authority, it lacks compassion. The decision to kill the pontianak comes in a scene that is highly conventional in the genre, in which torch-bearing villagers go to talk to the *penghulu*, or "village chief." The *penghulu*, *bomoh*, and Khalid promise to work together as a community to exorcise Mina. This team coming together is the kind of community response that spectators are typically invited to endorse, but *Dendam* flips expectation by rejecting this vision of Malay patriarchy. As the various representatives of *kampung* authority encircle Mina, she throws them off and, one by one, kills them all. Goei and Yap's pontianak is a heroine who cannot be contained by such hypermasculine postcolonial self-fashioning. There is no dramatic final fight sequence in which the pontianak is vanquished by the forces of the *kampung*; the film refuses to provide that image of male violence. It offers instead a spectacular critique of *kampung* morality and patriarchal control.

Heritage films are defined in part by their tendency to turn history into melodrama. This has often been linked to feminist readings, in which domestic and romantic relationships are leveraged in order to articulate the difficulty of history. *Dendam* turns to melodrama in Mina's final reckonings with Khalid and with her child. When she comes face to face with Khalid—after having dispatched all of the other men—Mina says, "I told you I would never forget you," and this romantic dedication is transformed into words of revenge. In an intimate close-up embrace, she kills him, declaims, "I love you forever," and then eats his entrails. We see her from behind, bent over his body, ass in the air as she chomps on his flesh. An iris into her backside cheekily plays with her bodily pleasure in consuming her former lover. The word *selamanya*, or "forever," is repeated throughout the film, but Mina and Khalid's love is overwritten by death. The love that truly lives on is that for the child who was born the night she died. Mina visits Siti in her pontianak form in order to say a final goodbye to her son, Nik, and to ask Siti to kill her. In a feminist narrative resolution, Mina does not fall victim to men. She gives Siti the nail so that Siti can help her die. As she passes it over, their hands meet in a close-up image of female solidarity. The nail is transformed from

a symbol of sexual violence into a tool with which to disrupt patriarchal narratives. Mina asks Siti to raise Nik differently and to create a new nation with less violence and hatred. Whereas Khalid's selfish violence encodes the hypermasculinity of postcolonial ethnonationalism, Mina sees in Nik the hope for a different regime of Malay identity based on kindness. Here, the pontianak makes a moral claim on the postcolonial nation, embodied in her demand for a new practice of gendering.

Dendam vividly rewrites the pontianak film's gender and heritage politics, but the significance of Singapore in its historical imaginary is more ambivalent. Mina is from Singapore, as we see when Khalid puts her on a bus home after he rejects her. Does Mina-as-Singapore have to be strangled as a condition of Malaysian independence? Is Singapore the film's real protagonist? The narrative present is pointedly 1965, suggesting that a trauma visited on Singapore in 1957 is finally laid to rest when the country separates from Malaysia, though this separation was itself a traumatic moment ("I love you forever"). Mina would have been safe had she remained in Singapore, and it is only by traveling to the *kampung* that she is imperiled. There is a progressive reversal of the fetishization of the *kampung* as a utopian community, and also an implication of the unseen Singapore as a safer place. This geopolitical reading points to the complexity of *Dendam*'s status as a Singaporean pontianak film, with Singaporean directors but a largely Malaysian cast, shot and set in Malaysia. We might also recall that, although the pontianak is very much part of the Singaporean imaginary, the film is made by Chinese-Singaporeans, not by a Malay filmmaker. The same could be said for other high-profile pontianak texts—for instance, Eric Khoo is also Chinese-Singaporean. To a large degree, this situation is a function of the racialized exclusions of the Singaporean film industry, in which it is hard for Malays—and of course especially for Malay women—to make feature films. I would certainly argue against any simple identity politics, and *Dendam* can absolutely be seen as a collaboration in which Singaporean and Malaysian talent together produce a critique of reactionary national identities. Nonetheless, we should not ignore the structures within which the Malay pontianak becomes a Singaporean story, available to all. As well as asking who owns the *kampung*, *Dendam* also poses the question of who owns the pontianak.

IMAGINING INHERITANCE AND OWNERSHIP

Heritage in postcolonial nations is inextricably linked to land ownership. If the very definition of decolonization in the moment of independence is the transfer

of sovereignty from the colonizing nation to the native peoples, then this transfer is one of land ownership as much as it is one of self-determination of peoples. Land ownership has a particular affective history in a postcolonial context, both in the discursive realm of emotional and ideological claims of belonging and as an empirical matter of inheritance, land use, and rights. When we consider the European heritage film in terms of its focus on property—the English aristocratic country house and the picturesque landscape—it is tempting to flip the visual rhetoric of these properties built on the profits of imperial extraction. Higson considers that "the question 'who shall inherit England?' is central to the heritage film," and the question "who shall inherit Malaysia?" is equally important in Malaysian cinema.[40] The reversal is not quite so neat as it first appears, of course. Whereas Higson was complaining that the British heritage film could enable an entirely conservative mode of historical vision, no iconography of land and property in Malaysia can imagine an unbroken line of "natural" ownership. Even in the most traditionalist imagination of the unchanging *kampung*, the experience of colonization imprints land with a politicized significance.

Postcolonial cinema in Malaysia in particular reinscribes land as national territory, creating visions of patrimony and inheritance that often look back to the precolonial and sometimes grapple with colonialism itself. It also engages histories of decolonization, in which development in the shape of urbanization and deforestation has radically transformed the landscape and in which property has become a site of racial, ecological, and transnational contestation. At the same time, land ownership in the Malay world also has a spiritual dimension, in which *hantu* are recognized as the owners—or at least primary occupiers—of land. Before clearing land for a building project, or even before walking across undeveloped nature, animist belief systems demand that one request permission or negotiate terms with the *hantu* who reside there.[41] *Hantu* stories are frequently morality tales about the ethics of land use, with gory punishment for those who misappropriate the land. Postcolonial politics and the cultures of *hantu* belief thus converge in the issue of land ownership, which makes the pontianak film apt for reimagining the real estate of heritage.

This intersection is not intrinsically progressive. The postcolonial inscription of land as Malay is a site in which ethnonationalism converges with both the interests of class elites and patriarchal ideas about property and the structures of kinship. We can see this conservatism in the pontianak film's reiteration of inheritance as a structuring principle of its narratives. The last of the studio-era pontianak films is Ramon Estella's *Pusaka Pontianak*, which translates as "pontianak inheritance." It was also released with the English-language title *The Accursed Inheritance*, suggesting that the *hantu* will interfere in the field of

property and its transfer over time. Made in 1965, *Pusaka* is symptomatic of an anxious conservatism around the future of Malay land and wealth. The film's setup is schematic: a wealthy landowner has died and his relatives gather in his rubber plantation to hear the reading of the will. The will reveals that the family is cursed, and twelve generations ago, an ancestor was a pontianak. The pontianak is due to return in the thirteenth generation. The deceased has set a challenge for his family, in which everyone must remain on the property for four weeks and all who stay will inherit an equal share of the estate. Anyone who leaves or dies will have their inheritance shared among the others. The stage is set for the pontianak to return and terrorize the assembled relatives, who cannot escape without forfeiting their share in the money. In keeping with the shift noted in chapter 1, this pontianak turns out to be fake, part of an elaborate plan on the part of the landowner's widow and her lawyer to cheat the children out of inheriting. As the detective says, "there will never be a pontianak in this twentieth century!" Heritage is transformed into inheritance: the generational and familial transfer of wealth. Instead of representing a real pontianak who might figure a heritage imaginary in terms of the cultural capital of folkloric belief, *Pusaka* stages Malay identity in relation to the literal capital of property. The fake pontianak attempts to divert inheritance to the nefarious second wife, and the thwarting of the plot returns proper ownership to the dead man's children. Rather than creating a disruptive force, here the pontianak is a mechanism put to use on behalf of patriarchy and capital.

Pontianak Menjerit is essentially a modern remake of *Pusaka*, down to the layout of the house at the center of the inheritance plot. Both films center on large country houses that, in contrast to the Malay vernacular stilt houses used elsewhere, exemplify British colonial architecture. In both films, the interior mise-en-scène uses an excessive mode of colonial decor to connote wealth: chandeliers light the rooms and giant antlers and portraits hang on the walls. In *Pusaka*, the colonial qualities of the space are foregrounded with tiger-skin rugs, whereas in *Menjerit* the large and imposing brick exterior is colonial in style. In one scene, a servant asks if Saiful knows the story of the British family who used to live there, and then frightens him with a tale of a murdered husband. In another indication of the proximity of the heritage film to horror, the country house can also be a haunted house. In postcolonial Malaysia, this architectural inheritance of colonialism is out of place, or out of time, and *Menjerit* transforms the history of the house's ownership into a story of colonial haunting. Where *Menjerit* diverts from its source text is in its racialization of the fraudulent heirs. The second wife is Thai, much to the consternation of the existing family. When Ratana first arrives, she speaks in Thai and English and wears traditional

Thai dress. Later, she performs a Thai dance. The issue is raised explicitly when Mazlan complains, "Our father's heirs are from different races." The idea of heirs of different races is a particular problem in a narrative of inheritance because land and property ownership bespeaks national and specifically Malay sovereignty.[42] In the film's climax, Ratana is revealed to be the source of the fake pontianak, and her plan is to kill all thirty-three legitimate heirs and inherit everything. A final intertitle concludes that Ratana and her accomplice were imprisoned and the assets were divided among the dead man's three children. In this updated inheritance plot, the foreign woman is banished and postcolonial property is turned over to the correct, which is to say, male and Malay, ownership.

Although the inheritance of property is a process through which Malay supremacy is imaginatively and materially reproduced, the story of *kampung* land ownership in the postcolonial era is much less unilinear and secure than these haunted house narratives allow. *Kampung* development is characterized by rapid change, such that discourses of timeless traditionalism must always be thought in dialectical relationship to the radical upheavals of modernization. In the decade before Malaysian independence, employment in the rice padi sector fell by 15 percent as commercialization of rice growing led to widespread unemployment.[43] Family smallholdings were replaced by agribusiness and thousands of people moved to the cities as village livelihoods dried up and new forms of wage labor emerged. The traditional *kampung* lifestyle became unsustainable for many, and the nature of the environment—housing, labor conditions, and community structures—was also hugely altered for those who remained. Maila Stivens enumerates shifts in the postcolonial rural economy: "growing commoditisation and mechanisation; the introduction of green revolution technologies like high-yielding varieties of rice; the displacement of village forms of cooperation with more 'rational,' market-driven forms of production; the marginalisation by capital-intensive forms of production like large agricultural machinery; labour shortages; and environmental pollution."[44] The experience of life in the *kampung* was transformed by the developmental processes of decolonization in ways that are belied by the relative stability of its fictional imaginary. As Aihwa Ong describes, the New Economic Policy (NEP) years produced "a growing crisis of the Malay peasantry, which became inseparable from a crisis in Malay cultural identity. *Kampung* notions of kinship, conjugal rights, and gender were increasingly subjected to the operation of state policies."[45] We have already seen how new forms of gender politics and religious doctrine have placed Malay identities under duress. The transformations in land use and ownership of the *kampung* that go under the name of development produce another such site of contestation.

Cinema renders the politics of development visible, and it imagines other lineages of inheritance and historical transmission. To take one example, another of Mamat Khalid's comedy horror films, *Hantu Kak Limah*, features a plan to develop the *kampung*. This development would imperil the livelihood of the main characters and is casually referenced as a quotidian threat. Although contemporary pontianak films represent the *kampung* with a nostalgic view, the genre is disposed to notice the rural environment's transformation and destruction. Indeed, the twenty-first-century return of the pontianak film begins with Shuhaimi Baba's *Pontianak Harum Sundal Malam*, which, along with its sequel, intertwines a feminist fable with a narrative about development capitalism, property, and the pontianak's revenge. *PHSM* asserts land ownership as narratively important right from its semiotically condensed opening, in which the evil Marsani, in addition to enjoying a back massage from his girlfriend and reading a book about a pontianak, signs a contract to sell land to his friend Daniel. This scene introduces Marsani's casual use of women for his own pleasure, his penchant for Malay folklore, and land ownership as the source of his wealth. The pontianak is born when Marsani murders Meriam, but each time she haunts him, she demands the return of her property. She calls him a thief and, in a climactic confrontation, she forces Marsani to confess his guilt and agree to return her inheritance for her descendants.

The film interweaves two historical trajectories: one of inheritance and heritage, and the other of progress and development. Marsani is associated with modernization and rapacious capitalism, and for his family, time is a measure of the transfer of wealth. He is a property developer who turns what was once Kampung Paku Laris into a construction site on which to build a modern housing scheme. His own house is a monstrous hypermodern play on traditional architecture, its hubristic scale reflecting his privatized and commoditized revisioning of the village. By contrast, Meriam is associated with premodern Malay heritage. She is a practitioner of *mak yong*, which, as we have seen, is a dance whose performance indicates the multigenerational transfer of cultural memory. She embodies a Malay tradition and heritage that risk being wiped out by Marsani's aggressive modernization. At the same time, given the controversies over *mak yong*'s preIslamic origins, *PHSM*'s use of this practice figures heritage as a radical claim on religious syncretism and feminist embodiment, at the same time that it links modernity with amoral destruction of both environment and people. The final shots of the film juxtapose these histories of property and persons. First we see Meriam's daughter Maria dancing in front of a modern suburban bungalow, and then we dissolve to an identically composed shot of Meriam as a pontianak in front of the original *kampung* stilt house. As Esther Pereen puts it in her account

of the ghost as a gendered chronotope, "by itself, time is invisible; only in space do its workings become perceptible. The ghost of time, therefore, is conjured in space."[46] Meriam as the pontianak traverses the historical time between the 1950s and the present day, but it is in the transformed space of the *kampung* that the distance between these two historical moments is felt. Where Marsani's historical trajectory has pursued a destructive modernization that wipes out the radical potential of the past, the pontianak demands the ethical restoration of a feminist, syncretic heritage.

For Bliss Cua Lim, the specter disrupts historical time and, in doing so, contains a potential to realign history and produce justice. She writes, "fantastic narratives strain against the clock and calendar, unhinging the unicity of the present by insisting on the survival of the past or the jarring coexistence of other times."[47] Meriam's temporality as a revenant disturbs Marsani's experience of modernity and progress, opening up an otherwise unimaginable space in which a woman might overcome patriarchal violence and retain her property through generations. (This is not only a theoretical question but also a historical one: under Malay *adat* practice, women inherited property equally to men, but the post-*dakwah* shift to syariah law has seen women's rights to inherit land diminished. The film does not refer directly to this situation, but I would argue that its melodramatic story of land appropriated by an unscrupulous man allegorizes this cultural and legal context.) Lim cites Derrida's concept of justice as "being-with-specters," but both she and Pereen are interested in queering the masculinism of Derrida's theory of spectrality.[48] Pereen builds on Spivak's critique that *Specters of Marx* focuses exclusively on the stakes of haunting as the inheritance from fathers to sons (as exemplified in Derrida's central metaphor of *Hamlet*).[49] For Pereen, "The question then becomes what *place* woman could have in a hauntology or spectral theory that would not subsume her to the law of the father; what differently gendered chronotopic *dis-placements* and *dis-temporalities* could she throw up?"[50] The pontianak film centers on a narrative of mother-daughter inheritance that exists because of the pontianak-mother's spectral overcoming of linear historicity. From the beginning of the genre, the woman who becomes a *hantu* returns to find her child—for instance, Comel flying to rescue Maria in *Sumpah*, or Rohani watching over Comel in *Gua Musang*—and that dis-temporality may also lead to dis-placements in the patriarchal ownership of *kampung* real estate. Such redistribution of property occurs in *PHSM 2*, where the temporal delay of maternal haunting succeeds in enacting a revision of history and the production of justice.

PHSM 2 was released just a year after the original and its plot reiterates the same time period as its precursor but from the perspective of the servant, Laila,

who saves Meriam's baby. The sequel focuses on Laila raising the child Maria in another *kampung*, while Marsani is busy modernizing Kampung Paku Laris. This film is structured around two mother-daughter inheritances: in one, Maria is haunted by Meriam, her dead mother, while in the other, Laila's daughter, Bayang, grows up to become the head of her *kampung*. The two girls are raised together, and Laila teaches Bayang to protect Maria. The parallel trajectories of the two daughters are represented through Malay heritage and, in particular, pre-Islamic forms. Maria learns *mak yong* in order to continue her mother's legacy, and when she bends to pick up a dropped fan, Meriam's ghostly hand with long pontianak fingernails reaches in from the edge of the frame and grabs her wrist. When Meriam appears, the villagers flee: the pontianak disrupts the collective space of the *kampung* and exceeds the bodily space of inheritance that Maria's performance offers. In contrast to this feminine dance, Bayang learns the traditional martial art of *silat*, so that she might protect Maria. Her training and strength lead to her becoming the *penghulu*, or "head of the village," and her inheritance is thus the responsibility to save Maria, just as her mother, Laila, did when Maria was born. However, whereas Laila's bravery was that of a loyal servant, Bayang will save Maria through her spiritual strength and as the representative of authority in the *kampung*. Shuhaimi's films consistently imagine traditional spaces with women at their center.

Meriam-as-pontianak possesses Maria's body, in an almost Irigarayan breakdown of mother-daughter boundaries that speaks to Pereen's dis-placements and dis-temporalities. In an attempt to produce justice for Maria, Meriam displaces her in her own body. In the film's climactic fight, Meriam/Maria kidnaps a baby, believing it to be Maria. The child figures an embodied inheritance in the mother-daughter model of hauntology, but Meriam cannot see the connection between the adult child she is possessing and the baby she remembers at her moment of death. She imagines that the baby who was cut out of her womb decades ago would still be an infant. Time is out of joint and Meriam has collapsed temporal as well as bodily boundaries. In order to pacify Meriam, Bayang and the other villagers use *kuda kepang*. In this tradition, practitioners ride wooden horses and, just as the horses become spiritually incarnated during the dance, so the riders take on the personae and powers of the masks they wear. Again, pre-Islamic Malay culture is used in the service of a feminist heritage imaginary. Bayang fights with Meriam in order to save the possessed Maria, but in the end, all three women are on the same side. Bayang tells her, "You are your own child," and when Meriam realizes that she has mistakenly possessed her own daughter, she cries tears of blood. Her realization comes when she sees the ornate gold bangle that Bayang inherited from her mother. Thus, Malay decorative art is the conduit

FIGURE 4.7 In the final scene of *Pontianak Harum Sundal Malam 2* (Shuhaimi, 2006), landscape becomes a liberatory space of inheritance for women.

for recognition, staging heritage both as a visual characteristic of the film's mise-en-scène and as a signifier of feminist generational solidarity.

The resolution of *PHSM 2* brings to fruition what I am conceiving of as a feminist postcolonial hauntology. Meriam and Maria share an impossible screen space, an imagined place in which time is folded so that mother and daughter could see each other. Meriam tells Maria, "my strength is yours to keep," offering another vector of maternal inheritance that is half genetic transmission and half haunting. The two women embrace and Maria wakes as if from a trance to find herself alone in the forest, with her mother gone. As a pontianak, Meriam has finally been put to rest, but in the final scene, the justice for which she returned is delivered. The image fades to black and then to a spectacular landscape view, with a mountain in the distance and a vivid pink sky. Maria visits her mother's grave along with Asmadi, the surviving son of Marsani. The grave is on a hillside, overlooking a tea plantation, so this intimate scene is played out against the background of a beautiful heritage landscape. Asmadi apologizes on behalf of his family for everything they have done to Maria's family. Offering her a box, he returns the things he says are rightfully hers, including the jewelry that Meriam wore to dance *mak yong* in the first film. The gold headpiece, bangles, and earrings are highly decorated, and form a tangible trace of Meriam's memory, and of what UNESCO calls Intangible Cultural Heritage.[51] The more significant

tangible trace, however, is the document that Asmadi smooths out: a deed bestowing on Meriam the land that fills the frame, "from here as far as the eye can see." Asmadi is returning to Maria her true inheritance, which had been stolen by Marsani in 1956. We cut to a close-up of Maria looking out of frame, followed by a long shot that pans almost 180 degrees around the spectacular landscape, across fields, *kampung*, and distant hills. Maria walks into the shot, gazing across the land that she now owns. The film ends with pontianak revenge visualized as the transfer of land ownership. Land transfer as the symbolic moment of decolonization is repeated as feminist liberation and heritage spectacle is tethered to a revised imaginary of Malay inheritance. Instead of conservative traditionalism, the *kampung* in *PHSM 2* becomes a space in which justice can be done for women.

LAND OWNERSHIP AND THE JUNGLE

The pontianak is a figure of justice for women, and her feminism is inseparable from her connection to the land. In troubling inheritance and ownership, she troubles patriarchy as well as the logics of postcolonial land rights. But the land in which the pontianak dwells is not only the *kampung* itself but the jungle that surrounds and sustains it. Looking "as far as the eye can see" asserts a feminist ecology. Arjun Appadurai writes of the relationship of human communities to nonhuman nature that

> neighbourhoods are inherently what they are because they are opposed to something else and derive from other, already produced neighbourhoods. In the practical consciousness of many human communities, this something else is often conceptualised ecologically as forest or wasteland, ocean or desert, swamp or river. Such ecological signs often mark boundaries that simultaneously signal the beginnings of non-human forces and categories or recognizably human but barbarian or demonic forces. Frequently, these contexts, against which neighbourhoods are produced and figured, are at once seen as ecological, social and cosmological terrain.[52]

The *kampung* is exactly this kind of social space. It is defined and bordered by the jungle, and the jungle is a place that belongs to nonhuman and supernatural beings. The intertwined and complex relationship of village to forest is ecologically, socially, and cosmologically constituted: the jungle forms the defining opposition to the civilization of the *kampung*, it provides economic resource and

physical threat, and it also houses the spirits who own the land. The jungle that surrounds the *kampung* is a constant reminder that human ownership of land exists in relationship to a prior and primary *hantu* claim.

In postcolonial Malaysia, the jungle as property is a major site of political contestation. Publicly owned land is often made available for private development, in what Peter Eaton has termed "a tropical forest version of the enclosure of the commons."[53] *PHSM* stages this process as melodrama: we can see Marsani as an allegorical figure, embodying the violent removal of property, and the pontianak as a figure of the land. Indeed, in the series' television sequel, *Anak Pontianak* (Shuhaimi/TV3, 2007–2008), Meriam's great granddaughter Mia is characterized by a special attunement to the forest. In real life, deforestation has radically changed the rural landscape, and the management of this national inheritance is one of the most intractable issues of decolonization. Economic inequality, environmental degradation, indigenous peoples' rights, and globalized capitalism are all at stake in the ownership and use of the jungle. If decolonization describes the process in which colonial structures of power and control are undone, then the jungle is the place in which the stakes are highest and the process the most incomplete. The next chapter will address the aesthetic forms of the jungle in more detail but for now it forms a crucial part of the story of heritage and land ownership, since the pontianak's claim to the forest becomes a way in which environmental politics can be cinematically articulated to a history of anticolonial struggle.

In the same period in which Malays experienced the transformation of *kampung* life through urbanization, they also saw a dramatic loss of the surrounding jungle. According to one study, 60 percent of peninsular Malaysian forest cover was lost during the twentieth century.[54] Deforestation has accelerated even more in the last fifty years. Since 1980, Malaysia has lost 20 percent and Indonesia 30 percent of their remaining forest.[55] S. Robert Aiken and Colin H. Leigh characterize deforestation as "a frontal attack on the lowland forests of the [Malay] Archipelago, where vast areas have been cleared for plantation and subsistence agriculture or felled to supply the international trade in tropical hardwoods. The original, near-continuous vegetation cover is now much fragmented, and in some places—for example, in Peninsular Malaysia—only isolated patches of lowland primary forest remain."[56] These radical transformations of the jungle in the postcolonial period have their roots in the British attitude to the land, which interpreted customary usage as availability, and moreover considered the transformation of land into commodity as their paternalistic duty. Bagoes Wiryomartono claims that before the British, there was no concept of land ownership as property or wealth. Malaya's colonial rulers introduced a

system of land tenure that overthrew the forest as a commonly held resource and instead took some forest under state protection and for the rest gave land titles to individuals and companies.[57] As well as bringing land into capitalist circulation, colonial rule in Malaya racialized the forest. Conflict over forest rights was created between state imperatives toward forest management and the various claims of Orang Asli groups, Malays, and foreign-owned industries. Racialization is expressed, for instance, in noncompliance with restrictions on logging, and in a widespread Malay-centric culture of corruption and clientelism.[58] Peluso and Vandergeest describe the production of what they term "political forests," concluding that "these laws also racialized access to forest products and land in ways that left powerful postcolonial legacies."[59] Deforestation as an ecological process can be tracked to the development of global industries in hardwood, rubber, and palm oil, but it also becomes a vector for postcolonial struggles over land rights and for environmental protection on a global scale.

In the postcolonial period, ownership of the forest is contested not only in the legal realm of rights but also as an urgent political question of inheritance. As environmental activism develops, the Malay rainforest becomes a symbol of the environment as global patrimony. For Jeyamalar Kathirithamby-Wells, "the chainsawing of majestic Malaysian dipterocarps became as effective a visual symbol of the ecological holocaust as the burning forests of the Amazon," and in 1986, Friends of the Earth and Sahabat Alam Malaysia (SAM) organized in Penang the first international conference on rainforest destruction.[60] Environmental activism makes universalist claims in which the Malay rainforest must be protected for the sake of the world, and this heritage claim was at first rejected by the Malaysian state. In 1983, Prime Minister Mahathir offered a postcolonial critique of Western ecopolitics, saying:

> It is very easy for conservationists living in countries that had waxed rich on the rapacious exploitations of the world's resources in the past to condemn the systematic elimination of these forests. But for Malaysia which is faced with all kinds of restrictions to the export of manufactured goods, there is no choice but to exploit natural wealth like timber.... The world will not pay us to preserve the forests. And so a choice has to be made—deforest and develop economically or remain poor so that the rich can glory in the beauty of the Malaysian rainforest with their majestic trees.[61]

Mahathir argued that since Western consumption had contributed the most to environmental degradation, those countries should bear the cost of forest conservation. This position illustrates the impossibility of decolonizing the forest

when the legacy of colonial rule is a globalized capitalist system within which countries like Malaysia see no economic option but to continue to destroy them. By 2019, Mahathir had necessarily changed his rhetoric, claiming that Malaysia had developed without damaging its environment. Speaking to a UN event on sustainable development and environmental stewardship, he said, "We obtained these socio-economic achievements while managing and sustaining [Malaysia's] resources."[62] Despite the critique of those who see scientific discourses of conservation as rooted in colonial thought, the scale of environmental crisis has forced Mahathir, along with other regional leaders, at least to acknowledge the global importance of the forest.[63]

Kathirithamby-Wells describes the postcolonial history of deforestation as "driving a wedge between nature and culture."[64] The memory of a smoothly symbiotic relationship between *kampung* and jungle may be another aspect of Golden Age nostalgia, but it is undeniable that there have now developed significant social, political, and ecological disjunctures. The pontianak speaks both to the memory and to its disruption. She is both nature and culture, a figure whose affiliation with the concept of nature in the forms of forest, death, and the maternal body is materialized in the cultural forms of image, sound, and language. She is therefore uniquely attuned to the materiality of the forest and the affective dimensions of its ownership and destruction. The pontianak film dwells on the border between *kampung* and jungle. The jungle is the domain of *hantu*, and yet part of what makes the pontianak powerful is her ability to come into the *kampung* and merge undetected with human communities. In many films—for instance, *Ponti Anak Remaja* (Nizam/Astro Ria, 2009) and *Paku Pontianak*—the protagonists encounter the pontianak in the jungle and bring her to the *kampung*. It is widely believed that the pontianak cannot exist without the jungle. It is for this reason, according to local legend, that so few pontianak films are made in Singapore, since there are no longer any remaining jungles in which she might live. This idea is narrativized in several films. The plot of *Ponti Anak Remaja*, for instance, involves the need to find a source of special jungle flowers, without which the pontianak cannot survive in human society. In *Pontianak Bidan Gayah* (Rahman, 2003), one character explains that there cannot be a pontianak in their village because "nowadays there is no more forest. Everywhere has already become urban, with electricity and bright lights." The pontianak needs the jungle to survive, but in many films, that jungle has been cut down and its wilderness transformed into the ordered monoculture of the plantation. In *Hantu Bungkus vs Pontianak* (Rahman, 2015), the setting is an oil palm plantation; in *Teng Teng*, it is a rubber plantation; and in *Dendam*, the central scene in which Mina is murdered takes place in a banana plantation.

Space, like time, is out of joint and the contemporary pontianak film makes visible the postcolonial disinheritance of Malay land.

The pontianak film to engage most explicitly with land ownership and the jungle is not Malaysian but Indonesian: *Pontien: Pontianak Untold Story* (Agung, 2016) demonstrates the meeting of deforestation politics with pontianak histories across the Malay archipelago. *Pontien* tells the story of an environmental activist, Arta, whose brother has gone missing while fighting against a palm oil company. She travels to the *kampung* in which he was last seen to investigate, and finds that, despite being zoned for state protection, the forest there is being cleared for palm oil. The film visualizes this transformation with an unusual series of drone shots, which are angled from almost directly overhead, looking down on the landscape. The effect of this downward gaze is disconcerting. Instead of the spectacular landscape view that we associate with a heritage imaginary, the sequences document space cartographically. We move from the city of Pontianak to the serried rows of oil palm plantations, where an aerial perspective emphasizes their status as manufactured landscapes. *Pontien* cannot see the landscape as a beautiful inheritance in the way that *PHSM 2* does. On ground level, Arta finds that local people do not seem to care—they tell her that if the village floods, they will find new work at the plantation. Environmental protection is regarded as a discourse of the neocolonial outsider. Arta meets with the owner of the palm oil business, a Mafia-like figure who wears sunglasses and is surrounded by young women in cocktail dresses. He tries to buy her off, but she angrily refuses his check, shouting, "Your plantation shouldn't be here.... One palm tree that you plant takes up to thirty liters of water per day.... Do you think this land has no owner?" Her anger at the plantation owner's obvious villainy is articulated not only in terms of her missing brother, or the plantation's excess water use, but also in terms of a prior sense of land ownership.

Anna Lowenhaupt Tsing discusses deforestation in Borneo, where *Pontien* is set, arguing that, "in Kalimantan, privatization took a particular form: the intertwined growth of legal and illegal resource extraction. Together, big and small operators advanced privatization through military and political force, displacing earlier residents' resource rights."[65] This move away from customary rights and toward an enclosed, privatized, and criminally exploited space produces the linkage that Arta voices between environmental and postcolonial discourses of nature and land. These connections are reflected in the scholarship on deforestation. Wicke et al. assess the unsustainability of palm oil production in Southeast Asia, finding that shared regional consequences include "loss of biodiversity, emission of greenhouse gases (GHG) from carbon stock changes in biomass and soil, ... forest fires and related respiratory diseases, and land tenure and human

FIGURE 4.8 Drone photography views landscape not as heritage spectacle in *Pontien: Pontianak Untold Story* (Agung, 2016).

rights conflicts."[66] What *Pontien* includes that the social scientists do not, of course, is the ownership of the forest by *hantu*. The local people may not be motivated by protecting the jungle, but the *hantu* are. In a newspaper interview, the film's director, Agung Trihatmodjo, speaks about the fact that much of *Pontien* was shot far from its diegetic location, because there is no longer any jungle around Pontianak. He says, "Our forests are gone now. The simple logic is that when the forest is ruined, never mind people, ghosts get angry."[67]

In *Pontien*, the ghosts who haunt Arta are the pontianaks who are the original owners and guardians of the land. Arta's boss at the NGO where she works tells her that she should focus on the environmental issue and not concern herself with the history of the area, but he will be proved wrong. Environmental destruction cannot be understood without history and the film returns us to Lim's view of the specter as disturbing history in order to produce justice. According to folklore, the city of Pontianak was so called because of the many *hantu* who lived there. The city was founded in 1771 by Sultan Syarif Abdul Rahman Alkadri, who is reputed to have fought the pontianaks to make the land safe for humans. In the film, Arta begins to experience episodes in which she is transported to the past, first to a sea battle in which the sultan attacks the island, and then to the jungle where the ship's cannon fires at indigenous figures. These episodes are immersive and frightening—cutting to close-ups of Arta almost drowning

as the ship's cannon fire explodes above her—but they are not immediately horrific. Historical epic changes to uncanny horror when she wakes up in the jungle, her breathing closely miked, and turns around to encounter a pontianak.

According to local mythology, the sultan made claim to the land by firing a cannon into the jungle, deciding to build his palace wherever it landed. This claim on ownership is notably not colonial (although the cannon is a foreign technology of military dominance), but this early assertion of Malay rights did nonetheless displace the land's original *hantu* owners. The film parallels this historical struggle with the contemporary one against the palm oil developers. Environmental trauma brings the pontianak back to the descendants of the sultan. As Niar tells Arta, "Every place has its own story. Every inch of this land has its owner." Another local character adds, "That's right, all have their own rights. We don't know if the land that we stand on is owned by some other creatures." As descendants of the sultan, Arta's hosts see themselves as inheritors of Malay tradition, and yet they are also imagined on the side of power, willing to sign off on exploitation of the land. It is Arta, the outsider and environmental activist, who is haunted by the pontianaks, who truly own the land. Toward the end of the film, smoke enters her ears and eyes, and her face changes into a *hantu* image of decomposition. Arta is possessed by pontianaks, and ultimately, she does their work by killing the plantation owner. Deforestation is the most consequential heritage politics of the postcolonial era, and the pontianaks' land ownership offers a way of imagining resistance.

This chapter began with a baleful incursion of modern media technology into the natural space of the *kampung*. The anxiety that this scene embodies about rural space, historical change, and the fate of Malay cultures in the wake of modernization echoes across the approaches to heritage and inheritance that I have analyzed here. In focusing on the *kampung*, it becomes clear how the heritage imaginary of the pontianak film echoes and responds to the heritage film's fascination with property, from the stately home to the picturesque landscape. It understands that this cinematic form can be a model for thinking postcolonial inheritances, and that it is complexly imbricated in fantasies of and resistances to imperialism. The pontianak film resonates with Malay nationalist visions of sole ownership of the state and its land, but it also imagines rural spaces as sites of feminist and ecological resistance. It evokes the ambivalences of heritage culture in its historicity, visualizing the *kampung* past at once as a Malay Golden Age and as a time of oppression and violence. Moreover, in revisiting the histories of colonialism and independence, the pontianak film engages in a project of revisionism that implicates the present in the exploitative systems of the past. Issues of patriarchal violence, social hierarchy, unchecked rural development,

racial inequality, and ecological destruction are all located within the parameters of Malay inheritance. In sum, the heritage imaginary of the pontianak film is a troubling presence, as heritage must inevitably be as a concept in postcolonial cinemas. No answer to the question "who owns the *kampung*?" can be easy and the films addressed here articulate the way popular cinema returns over and again to the difficulty of decolonizing both cinematic and national spaces. In delineating the space of the *kampung*, we have traveled beyond its limits and into the jungle, and the next chapter will examine the jungle itself, its representation, and its cinematic forms.

CHAPTER 5

ANIMISM AS FORM

A Pontianak Theory of the Forest

At the heart of the pontianak's allure is her animist origin, which dates from some of the earliest cultures of the Malay archipelago. We have seen in previous chapters how colonial discourse in Singapore and Malaya—including some elements of the film industry—viewed animism as a form of superstition that should be discouraged in favor of Islam and modern rationalism. We have also seen how the concept of animism as a precolonial and pre-Islamic system of thought works to pose the pontianak variously as an anticolonial force that might disrupt the patriarchal, racist, and capitalist logics of postcolonial societies, or, viewed from the perspective of power, as a dangerous remnant of forbidden beliefs and a threat to hegemonic order. Underpinning this discursive conflict is the meaning of animism in general and its significance in the Malay context in particular. Animism is a troubled concept, having been invented by colonial scholars to describe a belief system that they interpreted—and often misinterpreted—through a Western Christian lens. It was first used by Edward Tylor in 1871 to describe a form of "the doctrine of souls and other spiritual beings," which he associated with so-called primitive cultures.[1] Tylor outlines many qualities that come to define animism:

> Animism, the doctrine of spiritual beings, at once develops with and reacts upon mythic personification, in that early state of the human mind.... An idea of pervading life and will in nature far outside modern limits, a belief in personal souls animating even what we call inanimate bodies, a theory of transmigration of souls as well in life as after death, a sense of crowds of spiritual beings sometimes flitting through the air, but sometimes also inhabiting trees and rocks and waterfalls, and so lending their own personality to such material object—all

these thoughts work in mythology with such manifold coincidence as to make it hard indeed to unravel their separate action.[2]

The pontianak is such a mythic personification, but other elements of Tylor's description are equally relevant to Malay beliefs, including the sense of spiritual personhood in trees and rocks.

In the twentieth century, animism was identified strongly with this attribution of subjectivity to nonhuman nature, as in James Frazer's claim that "to the savage the world in general is animate, and trees and plants are no exception to the rule. He thinks that they have souls like his own, and he treats them accordingly."[3] These visions of animism depend on a racist hierarchy in which non-Europeans were seen as less advanced and unable to understand the difference between subjects and objects. Its colonialist foundations have prompted some scholars to reject the term as fatally flawed, since at best, "animism" represents an imprecise translation of indigenous worldviews and at worst an example of epistemological violence. Anselm Franke argues, however, that it is important to retain the term because it describes both a set of practices and the modern relationship to them.[4] This both/and approach is invaluable in describing the circulation of animist ideas in Malay popular cultures, where they do not constitute a pure belief system but rather form a syncretic and historically referential pathway through anticolonial aesthetics. Animism refers as much to the modern adoptions and appropriations of precolonial worldviews, and to the critical lens that postcolonial thought brings to their history, as to any authentic precolonial philosophy. This chapter will argue that both through and against its colonial history, animism is a disruptive quality in Malay culture.

Franke exemplifies the recent turn of scholars across the humanities to new theories of animism as part of an attempt to reconfigure critical theory away from the inheritances of the modern: these approaches encompass radical perspectives on anthropology, as well as scholarship on media theory, indigeneity, and posthumanism. Drawing on theorists like Bruno Latour, media scholarship has rewritten animism as an ontology for the digital age.[5] Such reconfigurations of animism remind us that an investigation of regionally specific cultural histories can open onto universal questions. And yet, as important as it is to think of indigenous worldviews as philosophical concepts, this chapter will insist on the critical value of reading animism in relation to its Malay cultural, historical, and geopolitical specificity. Rather than abstracting animism as a universalizing foil to the problems of modernity, I trace its aesthetic and political resonance within Malaysian and Singaporean visual cultures. In doing so, I aim to read animism in a way that is politically located without being limited to the local.

Malaysian writer Burhan Baki points out that Western philosophers often think with ghosts—he cites Hegel, Marx, Freud, and Derrida—while still being seen as rational, whereas Asian cultures cannot escape the colonial logic in which they are viewed as primitive and irrational for their spirit belief.[6] How, he asks, can Malays develop a progressive identity without falling into a colonialist rejection of the cultural work of *hantu*?

> For chide me not for resisting an analysis that in some ways only re-establishes our oldest thinking about East/West, Pre/Post-Enlightenment, and Mythological/Scientific relations, with all the power structures attending them. And besides, "changing sides" might not be so easy without some sort of painfully violent break on the cultural, political and ideological level. . . . It could very well be that our beliefs in hantu, makhluk, halus and orang bunian, with our rather meticulous typologies and taxonomies of them, is ultimately indissociable from any culture that is Malay or "Asian" in origin.[7]

For Burhan, animism is necessary to the project of decolonizing Malay thought and culture. In alignment with this idea, I propose a pontianak theory of spectrality, in which both colonial and postcolonial epistemologies are subject to haunting.

Animism as critical methodology offers a way to locate Malay cinemas as central rather than peripheral to questions of film theory and world cinema. In the pontianak film, theorizing animism enables a reframing of how aesthetics and politics might intersect in postcolonial cinemas. The pontianak is a figure of disturbance, appearing in moments of geopolitical upheaval and, as we have seen, promising to overthrow normativities of gender, race, and national belonging. If the popularity of the pontianak in film, television, art, and fiction alerts us to the continuing circulation of animist figures, this chapter makes the case that animism functions in cinema not only through folkloric characters but also in the construction of the diegesis. *Hantu* and other supernatural creatures are not only animist characters but elements in an animist world. The pontianak is indelibly linked to the *kampung* and the jungle, and it is the audiovisual construction of this entire mise-en-scène that conjures an animist aesthetic. Malay animism provides a worldview and a theory of located knowledge whose influence on culture is legible in aesthetic terms: in the relationship between human and nonhuman nature, between figure and ground, in the representation of landscape, in perspective and point of view, and in the imaginative constitution of space and place. The pontianak film thus has a unique ability to negotiate Malay identities not simply because the pontianak is a traditional figure but more substantially in its staging of animism as cinematic form.

There is a long history in film theory of thinking of cinema as animate. Jean Epstein, for example, writes that "on screen, nature is never inanimate. Objects take on airs. Trees gesticulate.... Every prop becomes a character."[8] Sergei Eisenstein writes of Disney cartoons that "the very idea, if you will, of the animated cartoon is like a direct embodiment of the method of animism."[9] Classical film theory already imagined the cinema as animate in terms of its capacity to distribute life across the mise-en-scène, and in particular its propensity to see the natural world and nonhuman objects as imbued with spirit and vitality. What happens if we texture film theoretical animacy with the perspectives of indigenous animism—how might that juxtaposition help us draw out the cinematic screen as an animate field? Tim Ingold describes the animist world in a way that resonates with film theory:

> Animacy, then, is not a property of persons imaginatively projected onto the things with which they perceive themselves to be surrounded. Rather... it is the dynamic, transformative potential of the entire field of relations within which beings of all kinds, more or less person-like or thing-like, continually and reciprocally bring one another into existence. The animacy of the lifeworld, in short, is not the result of an infusion of spirit into substance, or of agency into materiality, but is rather ontologically prior to their differentiation.[10]

This sense of a dynamic field of relations within which meaning and life are constantly being created evokes the cinematic field as animate. Indeed, in describing animist thought as a constant process of world-making, Ingold cites Paul Klee's claim that art "does not reproduce the visible but makes visible."[11] Cinema, too, renders the world visible and we can see cinematic world-making as a process akin to animism. Thinking cinema with the pontianak enables us to ground that world-making culturally and historically while insisting on its contribution to film theory. Malay horror films become a bountiful case study of cinema's animacy, and a way into thinking about the value of animist cultures for theorizing world cinema. Malay animism provides a way of understanding not only the cosmology of a film but also its form of visuality. Animism, I argue, becomes a tool for reading films and a method of postcolonial film theory.

Returning to the jungle and its ownership as questions of visuality, this chapter investigates cultures of decolonization in relation to the Malay landscape and its nonhuman inhabitants. It proposes an anticolonial aesthetics in which nonhuman nature is granted revised forms of agency and value. To propose animism as form is to ask how we might represent an environment as animate. What does it mean to take animism as an embedded part of a lifeworld or epistemology and

to think it in relation to cinematicity? We have seen the sheer range of pontianak texts across genres and media, but it is in popular visions of animism that the deep tendrils of its influence can be most vividly experienced. Animism in popular horror film discloses a rich and complex cultural logic. It is found in the transformation of precolonial spirit belief into the generic pleasures of the *hantu* film, but equally in the ways that *hantu* films represent the forest and the nonhuman world. As a way of conceptualizing a relationship to nonhuman nature, animism insists that an environmental vision is central to postcolonial politics in Southeast Asia. In analyzing animism in the pontianak film, this chapter brings together a series of theoretical interests: new theories of animism, film scholarship on the forest, ecological theory, and anticolonial aesthetics. As with the frameworks of gender and race, animism provides at once a way of approaching the films' cultural embeddedness and a lens through which to understand the pontianak film as a mode of world cinema.

NEW ANIMISMS

The emergence of a new wave of scholarship on animism in the mid-twentieth century marks the beginning of a theoretical current that has transformed animism into a key concept with which critical theory has reckoned with modernity and its inheritances. This intellectual history forms a significant context for understanding the animism of the pontianak film, firstly because it locates animism within histories of colonial thought and secondly because it uses geographically specific ways of conceiving the world to pose universal questions of subjectivity. It is therefore useful to consider the new animist theorists and the extent to which they are (and are not) helpful to this project. The original shift was in anthropology: Irving Hallowell studied the Canadian Ojibwe, who believe that "the world is full of people, only some of whom are human."[12] Graham Harvey glosses Hallowell as pioneering a worldview approach, in which animist beliefs allow us to see as partial the priority given to humans in modernist worldviews, and through which we might understand animism less as a belief about the animacy of nonhumans and more as an alternative conceptualization of the world.[13] Two main strands of animist theory emerged: structural and phenomenological. Structural animism, closely associated with the work of Philippe Descola and Eduardo Viveiros de Castro, humanizes nature by seeing plants and animals as part of the social world. In Viveiros de Castro's perspectivism, each type of nonhuman person has their own perspective on the object

world, which might be radically different from one another.[14] For him, we think it strange to propose a jaguar or a tree as having subjectivity because we cannot imagine the form of those perspectives. He proposes that, "if Western multiculturalism is relativism as public policy, then Amerindian perspectivist shamanism is multinaturalism as cosmic politics."[15] Phenomenological animism focuses less on structures of agency and more on ways of perceiving the world. Nurit Bird-David examines indigenous cultures in which direct engagement with the world produces a different experience than modern detachment. She argues that animism is not a religious belief but a relational epistemology.[16] For her, we misunderstand animacy when we see nonhuman persons as spirits. She writes, "We do not personify other entities and then socialize with them but personify them as, when, and because we socialize with them."[17] In this theory, it is not that people consider a tree to be a person and thus wish to communicate with it, but rather that they engage with the tree (for instance, by harvesting its sap) and, through that relationality, they consider it to be a person. In each of these models, animism becomes a way of theorizing the relationship of human to nonhuman nature.

The relevance of these accounts of animism to the pontianak is evident: Malay spirit belief participates in the network of indigenous worldviews studied by new animists.[18] Malays in the pre-Islamic era constructed what Kaj Århem sees as characteristic of all animisms, "a world inhabited by human and non-human persons in intersubjective and inter-agentive communication with one another."[19] Where animism proposes a different model of relating to the nonhuman world, it opens up the potential to understand the forest differently, and later in this chapter, I will explore how a recognition of the forest as animate might change both cinematic representation and the postcolonial politics of land ownership. The influence of the new animism has moved far beyond the anthropological study of indigenous belief systems, however, and in the humanities, it becomes a more sweeping counter to modernity. As Århem puts it:

> Animism has come to stand for an alternative, non-modern ontology, a counterpoint to naturalism—the hegemonic cosmology of modernity.... As opposed to naturalism, which assumes a foundational dichotomy between objective nature and subjective culture, animism posits an intersubjective and personalized universe in which the Cartesian split between person and thing is dissolved and rendered spurious. In the animist cosmos, animals and plants, beings and things, may all appear as intentional subjects and persons, capable of will, intention and agency.[20]

The Western theorist most associated with this move is again Latour, who posits that every colonial empire has claimed that its primitive predecessor confused categories that they, the moderns, could properly separate. For Latour, modern societies in fact never did properly separate nature/culture, subject/object, and science/fantasy, and they accused primitive societies of the precise category errors by which they themselves were constituted.[21] Latour also points out that today, scientists agree that things have agency, and that it thus makes no sense to reject animism on empirical grounds.[22] Latour is not so much interested in the actual practices of animism as in the way it illuminates the failures of modernity. As Franke puts it, "Animism was thus progressively inscribed in a set of imaginary oppositions that enforced and legitimized Western imperial modernity, constituting a spatial-geographic 'outside,' and a primitive, evolutionary 'past.'"[23] Latour's animism thereby provides a critique of colonial modernity in conversation with the lively debates on the problem of Western modernities in the postcolonial world.[24] Indeed, Peter Bräunlein has argued that "ghosts, spirits and spectres are well suited to reflect on 'alternative' or 'multiple modernities.'"[25] In this reading, as for Burhan, the Malay *hantu* might figure not only a premodern past but a nonmodern future.

Theorists have also addressed animism as a quality of media, with both cultural and philosophical approaches. The cultural approach is exemplified by scholarship on Apichatpong Weerasethakul, whose films draw on Thai animism.[26] From the were-tiger in *Tropical Malady / Sud pralad* (2004) to the haunting relative in *Uncle Boonmee Who Can Recall His Past Lives / Loong Boonmee raleuk chat* (2010), Apichatpong's films fill the Southeast Asian jungle with animate spirits. Nathalie Boehler links the decentering of humans within Apichatpong's framing to animist cosmology, and reads his jungles as liminal spaces in which human and spirit worlds can meet.[27] There is a political dimension to Apichatpong's rendering of animism, for it subverts the official religious discourse of Buddhism in Thailand, in the same way that Malay animism disconcerts state Islam.[28] Since Apichatpong's films often include a subtle but nonetheless bold political subtext, Boehler and others have seen animist spirits as part of his resistance to state oppression, especially in the jungle areas of Thailand's north.[29] Such political animism is common in postcolonial nations, as Harry Garuba influentially argues in his discussion of "animist realism" in world literature.

Animism, according to Garuba, "has often provided avenues of agency for the dispossessed in colonial and postcolonial Africa."[30] Yet he does not consider animism to be fully explicable either as a residual element of culture in Raymond Williams's terms or as a cultural nationalism that turns to the past for political

reasons. Rather, "it is, at a much deeper level, a manifestation of an *animist unconscious*, which operates through a process that involves what I describe as a *continual re-enchantment of the world*."[31] In this position, Garuba brings animist theory close to theories of enchantment such as those of Jane Bennett and Simon During, which propose a post-Weberian reenchantment of the world.[32] Some accounts of animist enchantment intersect with secular modernity: Bliss Cua Lim considers that "the spectral alerts us to the contiguity—rather than the subsuming—of diverse ways of inhabiting the world. One worlding admits to the active force of the supernatural; the other moves in the realm of instrumental rationality. To critique homogenous time is to insist that people dwell in more than one world and one time. Thus, instead of considering enchantment solely as a function of capitalist contradiction, I would rather say that diverse modes of being are intermingling."[33] Lim's understanding of animism is, like my own, syncretic. Garuba, though, aligns more with the postsecular turn in his insistence that we take animism seriously as belief and causal agent in the world. In his claim that "animist logic . . . destabilizes the hierarchy of science over magic and the secularist narrative of modernity by reabsorbing historical time into the matrices of myth and magic," Garuba sees animism as a thoroughly antimodern cultural form.[34]

This antimodernity becomes central to the more philosophically oriented approach to animism, which abstracts the concept far from the specifics of any embedded belief system. The idea of words and networks as animate, for instance, turns animism into a universalizing metaphor. According to Grant Bollmer and Katherine Guinness:

> By way of multiple, often circuitous routes, digital media evoke the animistic with their oft-troubling effects of seemingly autonomous images and data. The agency of these objects resonates with the varied theoretical positions of object-oriented ontology, speculative realism, or new materialism, where "premodern" doctrines of vitalism and superstition provide means to do away with subject/object binaries, a separation of nature and culture, and other "modern" principles, accounting for impersonal forces and actions beyond the anthropocentrism of Western culture.[35]

Animism thus performs multiple functions for contemporary media theory—it is antimodern, ontological, antianthropocentric, and posthuman. Franke picks up on the thread of vitalism in these theories, proposing that we reverse colonial animism by applying it to the West, using it to think about the distinction between life and nonlife through the gothic, the uncanny, and the spectral.[36] His interest

in how art can reanimate dead things is reminiscent of film theory from André Bazin onward, but in a sense, this familiarity is the problem: from a film-theoretical perspective, this conceptualization of animism doesn't add much to existing models.[37] These strands of thought intersect in one of the only articles to consider Malaysian horror film from an animist perspective. Bogna Konior's reading of *Histeria* (Lee, 2008) deploys a range of ontologies, from relational to predatory animisms, to analyze the film's narrative, but her analyses are more compelling when they turn to theories of cinematic life, such as those of Siegfried Kracauer.[38] Because she is interested in philosophical approaches to animism, Konior insists that animism operates as "a theoretical framework rather than a cultural trace," making a case that Southeast Asian cinema should not be relegated to what she dismisses as area studies approaches.[39] Although I agree with her completely that Malaysian cinema should be a nonperipheral object of film-philosophical inquiry, I resist the idea that historical and culturally oriented analysis is merely or problematically ethnographic. But whereas Bollmer, Guinness, or Franke do not need to worry that their application of animism to Euro-American new media and gallery art might be dismissed as peripheral, Konior's insistence on theoretical abstraction is symptomatic of the tightrope walked by postcolonial scholars of animism: how to center non-Western thought without being read as "ethnographic."

The new animism has been incredibly generative of radical thought around indigeneity, ecology, and alternatives to colonial modernity. In the end, however, I find that both the anthropological and critical theory visions of animism are susceptible to similar problems: both tend to reify and romanticize animist belief. Ingold's claim that the experience of astonishment is unavailable in scientific thought and Bird-David's argument that indigenous people observe a tree over time whereas scientists could only create knowledge by cutting it down both seem to be based on entirely false premises.[40] These anthropological constructions of rationality as bad object are very close to Abram Lewis's description of "the impetus of anthro-decentrizing critique as a critique of the politics of secularism."[41] For Lewis, animism is called upon to counter "the secularizing hermeneutics of demystification privileged by symptomatic criticism."[42] Here is where I part company with the new animism, and embrace its bad objects. Damon Young makes a compelling argument for the urgent need of a hermeneutics of suspicion in the contemporary era, in light of which I find the antirationality of these animist theorists to be politically retrograde.[43] The previous chapters' analyses of the pontianak's political force demonstrate the figure's value for a hermeneutics of suspicion. Instead of understanding animism as a source of pure knowledge about the world, this chapter will focus on the circulation of

animism in Malay culture, interrogating the theoretical implications of its located history. Rather than viewing animism as a universal theory of which Malay films are merely one example, I want to draw out the implications of Malay animism for theorizing world cinema. I begin from animism as a central and sustaining aspect of Malay culture, a set of practices, narratives, aesthetics, beliefs, and worldviews that constitute neither a premodern truth about the Malay people nor the foundation for an antimodern philosophy based on such essentialism. Animism *does* have a vibrant role to play in the culture of decolonization, but I contend that it does so through the complex and messy aesthetic and political syncretisms of our age, rather than in a tout court reversal of modernity.

MALAY SYNCRETISMS

There is no historical record of Malay animism that predates its syncretism. Anthony Milner writes of fifth- and sixth-century inscriptions discovered in Kedah that, "apart from their use of Indian concepts and vocabulary, the repeated use of such a key term as curse (sumpah)—a Malay word—suggests a desire to deploy supernatural powers that goes back well before the period of Indianization."[44] Animism (and in particular the discourse of magical curses that opens the first pontianak film) is one of the earliest and indeed one of the only documented facts about early Malay cultures. But even here, animism is combined with Buddhist and Hindu ideas and Malay words are folded into Sanskrit. Animism has existed in relation to other belief systems for at least as long as the historical record, and this combinative ability is crucial to its continuing prominence in popular culture. From the Indian traders who brought Brahmanism, Mahayana Buddhism, and Tantrism in the fourth century AD, through the Buddhist Srivijaya empire that influenced Malaya from the eighth to the twelfth centuries, to the Arab Muslim traders who transformed the region in the fifteenth century, the Malay archipelago has been a place in which many belief systems have mixed.[45] Moreover, it is not only that trade and conquest brought different religions to the region, but that these ideas were deeply integrated into existing beliefs. Mohd. Taib Osman points out, for instance, that the forms of Islam that first became popular in Malaya, namely, Sufism and Shi'ite sects, were open to syncretism with local beliefs.[46] The major Western scholars of Malay belief agree on the complexity of this history: Richard Winstedt finds the fusion of pagan, Hindu, and Muslim elements difficult to map, while Skeat speaks of the "singularly mixed character"

of Malay belief, such that "these various elements of their folklore are . . . now so thoroughly mixed up together that it is often almost impossible to disentangle them."[47]

This view of syncretism as impossibly tangled connotes a certain colonial disdain. We can hear the condescension in R. J. Wilkinson's description of "the curious readiness of the laity to accept several irreconcilable faiths at the same time. . . . It is not surprising that the religion of the Straits-born Chinese should have been sarcastically defined as 'a belief in the Virgin Mary, the Prophet Muhammad and all the ghosts in Singapore.' "[48] But if syncretism was viewed by the British as a strange anomaly, it was available to Malay nationalist discourse as a source of cultural strength. In 1962, for instance, Syed Hussein bin Ali gave a public lecture in Kuala Lumpur on the value of the Malay language, in which he says:

> From the history of the Malayo-Polynesian region, which includes Malaya, Indonesia, and the Philippines, it was found that the people inhabiting this area had been remarkably assimilative and syncretic in their cultural life. The Hindu, Buddhist, Islamic and Western Civilizations had respectively contributed to the cultural accumulation of this region. Due to this assimilative and syncretic trend of the Malayo-Polynesian people, there developed from within them a language which contained all the complementary traits of a flexible and syncretic culture.[49]

Here we see syncretism used much more broadly than its common religious usage to conjure a process of cultural enfolding and accretion, in which a transnational openness to difference leads to a utopian visioning of Malaysia. Such a progressive account of syncretism is echoed in contemporary cultural criticism. Artist Ismail Zain proposes Malaysian art as "syncretistic," bringing together influences from cave paintings, Western art, Zen painting, pop culture, craft traditions, and more.[50] Simon Soon argues that for Ismail, seeing the world in syncretistic terms enables both a different way of seeing and a critical undoing of colonial modernity.[51] Malay attitudes to syncretism thus index the extent to which national identity is imagined as open or closed, multicultural or ethnically pure.

Most contention around animism in the postcolonial era focuses on religion: chapter 3 discussed the tension between animism and Islam, which contemporary films continue to manage carefully. Unlike the syncretic modes of Islamic practice in fifteenth-century Melaka, post-*dakwah* Islam in Malaysia understands animist belief as fundamentally incompatible with its tenets. Religious leaders would like to see the total abandonment of non-Islamic beliefs, but, as S. Husin

Ali puts it, "even though it is clearly against Islam, the traditional belief system continues to exist, as it is deeply rooted and difficult to eradicate."[52] As much as conservative Islam would like to eradicate animism, the reality of Malay culture is much more accommodating. The way in which pontianak films carefully balance Islamic and animist worldviews is indicative of a historically rooted grafting. Taib describes the way that a villager might turn to Islam for moral guidance, but if he had a bad harvest, he would address the fish spirits, and Nathan Porath notes the linguistic hierarchy in which Islam is a religion (*agama*) whereas animism is merely a belief (*percayaan*).[53] J. N. McHugh characterizes the structure differently, arguing that Islam and Hinduism overlay an animist foundation, which still defines the Malay moral landscape.[54] More recent anthropologists find a similar tension between religious orthodoxy and traditional worldviews. Cheryl Nicholas recounts meeting people who say they do not believe in *hantu* because it is against Islam and then talk about family members who have been possessed by *hantu*.[55] Zwemer describes the practice of translating Malay *hantu* into Arab *jinn* in order to fold them into Islam. (He considers this doubly syncretic, since *jinn* themselves are pre-Islamic spirits from Arabia, which were once themselves syncretically folded into Islam.)[56] Thus, Malay Muslims find various ways to reconcile apparently incompatible beliefs within a worldview that is, with varying degrees of comfort, syncretic.

Many pontianak texts focus on the tension between Islam and animism as competing belief systems, but we should not ignore the third term in Taib's three point system of animism-Islam-rationalism. The late-colonial pontianak films frequently staged modern scientific knowledge as a way of understanding the existence of *hantu*, although science is presented very much as a risky endeavor. *Anak Pontianak / Son of the Pontianak* (Estella, 1958) and *Gergasi / The Giant* (Ghosh, 1958) both feature mad scientists, in whose test tube and flask-filled laboratories dangerous knowledge is created. Moreover, their scientific experiments produce *animist* knowledge: Dr. Sulong in *Anak Pontianak* creates a *polong* to do his bidding, and Dr. Samsi in *Gergasi* creates the eponymous ogre. In these early films, scientific knowledge is suspicious, and it always ends up playing a negative role: either creating monsters in an overweening, *Frankenstein* narrative or shoring up the cynicism of those who wrongly insist that *hantu* do not really exist. To restore peace, some combination of animist and religious knowledge is required. In *Gergasi*, the village head recites Muslim prayers to counter the ogre, though it is the animist pontianak Manis who finally vanquishes him. Just as in Taib's assessment of Malay culture more generally, these films play on "the negotiation of tensions between these three factors."[57]

It is perhaps unsurprising that horror texts would emphasize animism and religion over science, and that they might deploy scientific rationality either as a wrongheaded denial that spirits exist or as a dangerous discourse that could lead to the creation of monsters. But in at least one contemporary version of the pontianak, syncretism focuses on the relationship between animism and science. *Ponti Anak Remaja* (Nizam/Astro Ria, 2009) is a telefilm that keeps its distance from both religion and the horror genre. It is instead a teen romantic comedy, in which a group of students find a pontianak in the jungle and bring her back to their university, where they pretend she is an exchange student from Singapore. The film opens in 1963, in what looks like a conventional scene of a man alone in the jungle at night, but it quickly becomes apparent that he is not a villager straying outside the *kampung* but a scientist conducting research. He is searching for a flower that only blooms at night, and when he finds it and attempts to take a sample, a pontianak appears in a flash and throws him back. In this precredit sequence, notably set—as are *Kala Malam Bulan Mengambang* (Mamat, 2008) and *Dendam Pontianak / Revenge of the Pontianak* (Goei and Yap, 2019), among others—in the immediate postcolonial years, the pontianak appears to protect the forest from the predatory investigations of science. The credit sequence that follows, however, tells a different story. Animated DNA sequences and human blood cells spin across the frame, interspersed with vintage scientific illustrations of trees, flowers, and human physiology. Knowledge about the internal structures of human and nonhuman nature is combined, prefiguring the film's attempt to splice animist accounts of the world with rationalist ones. Harry Garuba writes of animist realism that "the rational and scientific are appropriated and transformed into the mystical and magical."[58] *Ponti Anak Remaja* makes precisely the opposite move, instead transforming the mystical into science.

The main narrative takes place in the present day, with a group of teens who are about to fail their biology class and need to find an extra credit project to save their grade. They decide to continue the project of their disabled grandfather, who turns out to be the pre-credit scientist, now physically incapacitated as a result of his dangerous research. The teens read grandpa's notebook, which includes both directions to the mysterious flower and a diagram illustrating how to nail a pontianak. They enter the forest and find the flower. When they cut it, just as in the 1960s, the pontianak appears. But whereas the 1960s forest was full of saturated colors, graphically silhouetted trees, and dramatically top-lit pink flowers, the 2000s mise-en-scène is flatly naturalistic and the pontianak is clumsy and powerless. The visual richness of the 1960s forest has been depleted, and with it the abilities of the pontianak. The friends manage to nail her, and the pontianak

FIGURE 5.1 In *Ponti Anak Remaja* (Nizam Zakaria/Astro Ria, 2009), the supernatural is diagrammed into science.

tells the teens that because of human intervention, there is only one of these special plants left. Human exploitation of the jungle has led to the flower being almost extinct, and, because the pontianak needs the flower to survive, it is thus an existential threat to spirit life too. The film's main narrative problem is easily read as a reference to deforestation and to the human destruction of both the plants and communities who live in the jungle. If science is first aligned with the destruction of the forest, *Remaja* sets up this historical problem in order to imagine that science can also be its solution.

The pontianak—renamed Ponti—enters the university and turns out to be intellectually brilliant. Unlike her slacker human friends, she is excited by the bookstore and the biotech building, and wants nothing more than to learn. The film provides a rational explanation for her abilities, which is that the nail penetrated her cerebellum and turned her into a genius. The folkloric belief that the pontianak can be subdued by nailing the back of her neck is reconfigured as a materialist explanation about brain chemistry. Science combines with animism both in the brilliant *hantu* and in the trajectory of the flower that sustains her. The teens experiment on the flower and, like their grandpa, discover that it has (apparently) supernatural properties.[59] The students discover what was missing in grandpa's formula to propagate the plant, enabling the pontianak to survive and the flower to be harvested for further research. They also use flower serum to cure grandpa's muteness, enabling him to speak once more. He reveals

that he is Ponti's father, and that she is half pontianak, half human. She decides to stay in the human world and take care of him, but rather than presenting this choice as one of Islamic values over animism (as *Pontianak Sesat dalam Kampung* [Azmi/Astro Ria, 2016] does), *Remaja* aligns familial ties with science and the betterment of the environment. Pontianak and human are part of one family and the scientific world of the university and the animist world of the forest must join forces. In the film's conclusion, the university decides to invest in studying the biomedical potential of the flower. This storyline accords with the way that scholars of animism are finding validation in contemporary plant science. Matthew Hall notes that "a substantial body of pioneering research in the plant sciences ... demonstrates a remarkable convergence with indigenous animist knowledge of plant ontology.... Such convergence prompts a discussion of animist-based models for a human-plant ethics."[60] The idea that plants might be "active, responsive, autonomous and intelligent organisms" combines botanical science with animist thought, and *Remaja* deploys this nonreligious—and strikingly not misogynist—version of syncretism to reimagine the human relationship to the diverse spirits and beings of the forest.

ANIMIST SPACES

If Malay animism is promiscuously syncretic with regard to epistemologies, it remains closely grounded in the Malay concept of space and place. Bagoes Wiryomartono writes that the Malay word for space, *tempat*, "is not only for human beings and things, but it includes also the invisible, the inaudible, and the inexhaustible. Tempat is inclusive for the known and the unknown as well as for the material and spiritual world."[61] The world is conceptualized as a space containing many different kinds of being, and thus human subjectivity can be seen as a particular way of being in the world, among other kinds of life. Animism conceives a relationship to nonhuman nature through the idea that spirits exist in what Md Salleh Yaspar terms "both natural and supernatural objects and beings."[62] He explains that the Malay universe is "both non-differentiated and interrelated," such that, "in this universe of Peninsular Malaysian folk-tales and folk dramas, the modes of existence of the various objects and beings are not always completely differentiated, instead they are often considered as similar to that of man."[63] People can communicate with natural objects and supernatural beings, and, indeed, such relationships are central to social harmony. Taib lays out the social logic that animism constructs, writing that "the concept of the

natural surroundings in the pre-Islamic days which have survived to this day was such that every mountain, hill or river had its guardian spirit, and man, in founding a village or cultivating the crops on land, had to come to terms with his surroundings, which in effect meant maintaining a balanced and harmonious relationship with his spirit neighbours."[64] It is not only that spirits can be found in natural objects such as trees and rivers, but that the relationships forged with these beings have consequences for human social relations. Both the nonhuman environment and supernatural beings are forms of legitimation discourse, in reference to which—and in communication with whom—harmonious social relations can be established and maintained.

Malay animism therefore does consider nonhuman nature to contain spirit or life, although not entirely in the way that colonial observers imagined. Walter Skeat, who wrote the first colonial account of Malay folk beliefs, focused on the anthropomorphic qualities of animism, in which animals and things have a consciousness and soul in the same sense that humans do. He points to the frequency with which humans turn into animals and vice versa as illustration that all forms of life share the same kind of self-awareness for Malays.[65] When we attend more closely, however, we find that what animates the Malay world is a life force called *semangat*, which is not the same as human consciousness. Jeanne Cuisinier calls *semangat* belief a "culte de la vie," and Salleh writes that, "in the Malay folk tales, objects such as rocks, rings and plants have to be treated with care, for semangat is believed to live in them."[66] That all kinds of beings have *semangat* does not mean that they are all equally sentient: Malay animism is nothing if not taxonomic. Salleh points out the separation in which animals can move, plants can grow, and objects can only decay.[67] The concept of *semangat* can explain how the pontianak is undead in a somewhat different way than a European vampire: a person might return from the dead if their own *semangat* is restored, but their body could also be taken over—possessed or vampirized—by an external spirit.[68] The *semangat* of a *hantu* is not different in kind from the *semangat* of a person, a tree, or a tiger. James Fox understands this system in terms of an "immanence of life," in which "there is a plurality of beings and, at the same time, a recognition of the oneness of the individual with the whole in the community of life."[69] This system is not democratic, and does not consider objects like rocks or trees to be persons in the same way that humans with self-awareness are persons. Nonetheless, Fox's concept of immanence does direct our attention to animacy as a *field*, and a field that we can understand in terms of cinematic mise-en-scène.

That animacy is a quality found in everything contained within the space (or *tempat*) of the Malay world has consequences both for how we think about the pontianak's relationship to the jungle and for how we read that relationship

FIGURE 5.2 *Lagi Senang Jaga Sekandang Lembu* (Eu, 2017) foregrounds the pontianak's intimacy with nonhuman nature.

on-screen. Writers on Malay traditional culture frequently emphasize the need for people to form good relationships with places such as rivers and forests, because those places also contain spirits. Writing in the 1920s, Samuel Zwemer observes that "should a man wish to mine or set up a house, he must begin by propitiating the spirits of the turned-up soil; should he desire to fish, he will address the spirits of the sea and even the fish themselves; should he contemplate planting, he begins by acknowledging that rice has a living essence of its own which he is bound to treat with respect. In short, he considers that all nature is teeming with life and that his own soul is walking in the midst of invisible foes."[70] Amran bin Kasimir discusses this intimacy with the nonhuman in specific relationship to trees. Many trees contain spirits, and people must behave with particular respect toward trees or risk being cursed.[71] In *Pontianak vs Orang Minyak* (Afdlin, 2012), the pontianaks live inside trees, and in *Lagi Senang Jaga Sekandang Lembu / It's Easier to Raise Cattle* (Eu, 2017), the cool pontianak friend hangs out in a tree. Malay animism is above all a theory of located knowledge, in which this forest or these rocks contain animate spirits.

Moreover, the relationships of humans to the nonhuman environment can become meaningful through the meeting of spirits. Anne Yvonne Guillou considers the ontology of powerful spaces as "animist agents" that depend on the bringing together of spirits of different kinds. According to her, powerful spaces can be created from "an extensive group of beings (including humans and spirits), objects and events, natural elements (springs, trees, rocks, termite mounts, animals)...and finally, special ritual constructions via theater...dance and singing."[72] In this description, we see how the mise-en-scène of the forest, the pontianak, and the performance of pre-Islamic art forms such as *kuda kepang* and *mak yong* might contribute, in films like *Pontianak Harum Sundal Malam 2 / Pontianak of the Tuberose 2* (Shuhaimi, 2005), to the creation of a powerful animist field. Instead of focusing solely on the pontianak as an animist figure, we begin to see the entire diegetic world of the pontianak film as staging animism.

Viewing the animist world as a cinematic screen crowded with life enables us to think about the pontianak as a cinematic form, not figure but ground, or rather figure as part of a ground expanded to include an entire visible and invisible world. The pontianak is not human, and her figuration is therefore not so different from the other elements of the animate field. Her nonhuman status opens the visual field in ways that are not limited by individual point of view or character. Like the jaguar's (or perhaps in this context the tiger's), her perspective is not that of a human, but rather represents a visible density of animist spirit. Malay animism complicates the binary of figure and ground, asking us to pay attention to mise-en-scène as an entire animate field. We return to the Malay jungle, now thinking of it not only as the object of ownership and development, but also as an aesthetic terrain. Dispersed across the mise-en-scène of the pontianak film, the formal registrations of precolonial ways of understanding the forest transform the animist worldview into an anticolonial aesthetic.

FOLIAGE AND HISTORIES OF DECORATIVE ART

The most direct way to think about animism as form is to consider the pontianak films' representation of jungle foliage. Sequences in which leaves and branches dominate the frame are so common in pontianak films as to be a genre marker. The opening sequence of the "Cinema" section of *7 Letters* (Khoo, 2015), for instance, unfolds as the pontianak character walks through a dense jungle toward the camera, singing. As the shot begins, she is in the distance, centered but tiny

within the frame, dwarfed by giant palm leaves to her left and a dense field of small branches and lianas to her right. As she walks, she leans close to a tree, and the sequence ends with her sitting on a fallen tree trunk, surrounded by stalks and hanging leaves. Throughout, there is no horizon or sky visible, so the dense tapestry of undergrowth forms the entire context within which her performance is staged. Khoo's use of jungle foliage as the setting for an emotional song sequence refers to a proliferation of such scenes in the studio-era films, which often place either the pontianak or her daughter in a forest clearing. A clear precursor can be seen in *Pontianak Gua Musang / The Pontianak of Musang Cave* (Rao, 1964), in an early scene in which the soon-to-become pontianak Rohani sings about her hopes for the future. The sequence also begins with her sitting on a branch, with palm fronds and grasses spiking around her. Her dress has a foliate pattern, adding to the impression that she is part of the scenery. We cut to a longer shot, in which dark tree trunks and large leaves crowd the foreground and Rohani is but a small figure. As she walks toward the camera, her face is framed by leaves. Aside from a tiny patch of visible sky in the corner of the frame, the entire field of vision comprises the relationship of Rohani's figure to foliage.

The linkage of forest scenes with song sequences indicates the extent to which foliage is used in Singapore studio film to express emotion. Eisenstein called landscape "the freest element of film, the least burdened with servile, narrative tasks, and the most flexible in conveying moods, emotional states, and spiritual experiences," and we can certainly see the jungle as a kind of emotional landscape in Malay cinema.[73] The classic palace epic *Hang Jebat* (Hussein, 1961), for instance, has a scene in which the tragic heroine sings among the trees. In *Sri Menanti / Moon Over Malaya* (Majumdar, 1958), a melodrama of doomed interracial love, foliage indicates visually the impossible relationship between Fatimah, who is Malay, and Wong, who is Chinese. Fatimah looks out of her bedroom window in what could become a shared romantic gaze with Wong. She does not see him, however, and in an optical point-of-view shot, we see that she is looking only at leaves. An almost identical shot occurs when she hears Wong playing his flute: her gaze falls beyond the limits of the *kampung* and into the forest. Leaves here suggest possibility and the freedoms of nature, as well as a romantic longing for the figure who is not in the frame. If the forest provides a space of cinematic affect across Malay cinema, its animist form becomes significantly more prominent in the pontianak film. The jungle is the pontianak's home and foliage the mise-en-scène for her most deeply felt losses. In *Gua Musang*, Comel returns unknowingly to Rohani's favorite clearing to sing a ballad to the mother she has never met. Amran tells her that he doesn't know if her mother is alive or dead, or where her grave would be, were she dead. Without a

FIGURE 5.3 The opening of "Cinema" (Khoo, 2015) echoes the forest compositions of studio films.

grave, Rohani is uncannily disconnected from the land and the mother-daughter connection emerges in a supernatural fashion, through the shared space of the forest. Contemporary films elaborate on this discourse. In *Dendam Pontianak*, Mina returns to the jungle to die, surrounded by lush green leaves. And in *Langsuir* (Osman, 2018), the lovesick *hantu* Suri addresses the jungle directly, pleading, "dearest leaves, please hear my longing for him." For the pontianak, foliage is never mere background but an extension of animist figuration into the living tapestry of the trees around her.

Across major historical shifts in mode of production and style, the pontianak film associates its central *hantu* with foliage. In the earliest existing film, *Sumpah Pontianak* (Rao, 1958), Comel is captured by villagers and tied to a tree. We see her in close-up, surrounded by leaves as she insists on her innocence. *Gergasi* opens in the jungle, as Rahman encounters the pontianak Manis leaning on a branch, singing seductively with leaves and branches behind her head. When we cut to a close-up, mottled light from the leaves plays across her face, using foliage to create light and shadow effects even when the trees themselves are not visible. When Rahman confronts her, Manis moves behind the tree and comes out the other side as a monstrous pontianak. The tree obscures her transformation, becoming a space of both animist and cinematic magic. Foliage is equally central to *Pontianak* (Sutton, 1975), where, in keeping with the film's *giallo* style, representation of the jungle is more graphically expressive. In one scene, the pontianak's

FIGURE 5.4 *Pontianak Gua Musang* (Rao, 1964) surrounds Rohani completely with forest foliage.

daughter Melati hears an echoing voice calling her. She goes into the forest behind her house, where the pontianak appears. When Melati turns and sees the white apparition, they first share a two-shot, and then the pontianak vanishes, leaving Melati gazing into dark green foliage. In a jump cut, we shift to a slightly different shot of Melati and the pontianak, in which the two women are in the same relation to each other within the frame, but the forest is different. Now, the pontianak is overshadowed by a huge banana leaf, and when she again disappears, Melati is left in what looks like a conversation with a plant. These shots cannot be joined into any coherent narrative space, but their cinematic excess echoes the film's staging of the jungle as lush, overgrown, and epistemologically tangled. Contemporary films frequently make explicit the pontianak's animist connection to the forest. In *Paku Pontianak* (Ismail, 2013), Melati is drawn to powerful animist spaces. After Melati vanishes on a trip to a lake, we cut to a close-up of a white orchid surrounded by shiny deep green leaves. Suraya finds Melati in the forest, looking intently at these flowers. In long shot, the two women appear tiny within deep jungle space, and are framed internally

FIGURE 5.5 *Paku Pontianak* (Ismail, 2013) illustrates the dense visuality of the jungle.

by branches, rocks, and hanging fronds that threaten to obscure their view altogether.

What these histories of pontianak foliage share is a representational commitment to the dense visuality of the Malay jungle. José Moure calls the forest in cinema "a visual experience: a tangled and overflowing visual field."[74] Although he is not writing specifically about Southeast Asian cinema, his account is apt for the Malay jungle. Ecologists Robert Aiken and Colin Leigh describe the latter in terms of its extreme species diversity—the Malesian forests of Malaysia and Indonesia contain 10 percent of all the identified plant species on the planet— and its richly layered structure.[75] In addition to abundant trees, they write, "lianas and epiphytes add to the architectural complexity and visual experience."[76] This idea of the forest as both akin to a built environment and, in the words of both the ecologists and the film scholar, a *visual experience* underlines that it functions not merely as a green background to human activities, but as a particularly rich and affective kind of cinematic space. Moure theorizes the cinematic qualities of the forest, arguing that, "in opposition to the desert which would be the place of emptiness par excellence, the forest is the place of over-fullness, of an excess of visibility that the camera finds hard to tame."[77] Pontianak films consistently prioritize foliage within the frame, locating human and *hantu* figures in relation to the forest rather than the other way around. The absence of negative space in a frame filled with tangled layers of vegetation creates an animist field of immanent life, in which the clear separation of human figures from their

environment is undermined by the profusion and visual overload of the plant elements.

Such overfullness begins as a material quality, in which the jungle as profilmic space influences the aesthetic terms of its own representation. Michelangelo Antonioni writes on the challenges of filming in the forest, "At a few metres from the actor to the lens, so many branches, leaves, lianas, roots are interposed between them that the person risks not being visible."[78] We can see this effect in many pontianak films: in *Pontianak*, for example, when Melati and Aziz enter the jungle, giant palm fronds hang directly in front of the camera. Lighting is another problem. Director of photography Paul Onorato describes a shoot in the Malaysian jungle in which "tropical undergrowth allows almost no light to penetrate to the ground" and lighting units "would have been useless against the dense foliage."[79] These practical challenges lead to various solutions. The studio-era films combine studio-shot scenes, in which female actors are classically lit against picturesque foliate backdrops, with daytime location shooting in which the disorder of the jungle produces a more decomposed patterning within the frame. Recent films shot digitally are more flexible with lighting: the scene described earlier from *Paku Pontianak* uses natural light for a maximal effect of entangled foliage, whereas part of *Dendam Pontianak*'s heritage style is a nostalgic reproduction of the artificial backlighting typical of jungles shot on film. The ease with which digitally shot films move into the jungle emphasizes the aesthetic effect of overabundance. Antonioni considers that "the more frightening the forest is, the less it is photogenic. The interlacing of the vegetation is so dense that the trees are fused into one another, without nuance, all lost in an unrelieved amalgam."[80] Overfullness of the image leads to a loss of separation, in which the multiplicity of vegetal forms becomes visually indistinguishable. For Antonioni, this frightening aspect of the forest is a problem, but in the pontianak film, the blending of figure and ground is central to the construction of the cinematic screen as an animist field.

To see the jungle as a foliate field without visible negative space is to imagine it as decorative pattern within what is otherwise a realist landscape. What is the relationship of animist ideas to decorative art forms? For one thing, the early Malay cultures who practiced animism also produced largely decorative art. Any turn to the decorative can be understood as a reference to the visual imagination of precolonial cultures. Decorative art, moreover, is centrally engaged in representing nonhuman nature. Precolonial art in the Malay Peninsula was focused on practices such as ornamental woodcarving, examples of which can be seen in *kampung* architecture in *Pontianak Sesat dalam Kampung*. This mode of aesthetic practice takes flora and fauna as central motifs to be stylized and abstracted. One

FIGURE 5.6 Decorative foliate patterns in the frontispiece of the *Hikayat Abdullah bin Abdul Kadir Munsyi* (Singapore: Mission Press, 1849, image copyright © the British Library Board).

study in the ornamental design of everyday objects finds that traditional Malay woodcarving includes a "fusion of figurative shapes and vegetal motifs" and that "flowers, fruits, and plants were used widely."[81] Ivor Evans organizes Malay decorative patterns into categories of geometric, plants and flowers, and animals.[82] Geometric patterns are derived from Islamic art, but the popularity of plant and animal pattern demonstrates the continuation of animist influence and the importance of specifically decorative visions of the world. Sarena Abdullah analyzes the inheritance of the Malay decorative tradition in hand-drawn manuscripts, and argues that although decoration was influenced by Arabic and Islamic abstraction, it also reflected "local taste, which was based on floral motifs, materials and colours."[83] She goes on to describe "floral and foliate sketches" in one nineteenth-century manuscript and "decorative foliate patterns" in early lithography of an influential text, the *Hikayat Abdullah*.[84] From the earliest histories of aesthetic practice in Malaya, foliage was a central representational and decorative form, and one that distinguishes a Malay aesthetic.

In the postcolonial period, the inheritance of Malay decorative art necessarily circulates in the wake of the intervening history of colonial modernity. Of particular concern is the relationship between the colonial perspectives that came

to dominate both cinematic vision and aesthetic modernity and the traditional and anticolonial voices that have countered this visual hegemony. Film theory has elaborated the way that cinematic visuality emerges from the intertwined histories of colonialism and aesthetic modernity.[85] Both these histories resonate in Malaysia and Singapore, but we must consider the specific logics of modernity in the Southeast Asian colonial context and how Malay artists and intellectuals engaged with and often resisted European modes of representation. Scholarship on visual modernity in Malaya has primarily addressed the emergence of modern forms of landscape painting, which is to say, predominantly the representation of forested spaces. W. J. T. Mitchell famously proposes that "landscape is a particular historical formation associated with European imperialism," and Malaysian art historians have traced the local development of these colonial forms of looking.[86] Zakaria Ali stipulates that landscape painting began in Malaya after the arrival in the nineteenth century of English painters such as William Westall and Robert Smith. He analyzes Smith's *Convalescent Bungalow* (1820) in terms of colonial visuality, in which the hilly Penang landscape is laid out for the spectator, using light and shade to produce a picturesque view in which the titular British house symbolizes progress and brings an organizing principle of ownership to the Romantically wild landscape.[87] In this analysis, modern visuality is an unavoidably colonial model, and any postcolonial use of the visual aesthetics of modernity is necessarily an engagement with that legacy, or at least takes place in a world in which modernity cannot be imagined away. As with accounts of the colonial foundation of cinematic vision, Zakaria points out how hard it is to represent the Malay landscape outside of colonial modes of seeing.

Despite the unavoidable influence of colonial vision, Malaysian art historians have insisted that visual modernity does not belong wholly to Europeans. Sarena argues that a sense of modern visuality emerged in Malaya earlier than conventional histories claim, predating the British introduction of European modern art. She looks to popular culture, arguing that "decorative elements and other early forms of visual culture like drawings, illustrations, photographs, as well as pictures in printed media have never been examined as factors in the development of modern art in Malaya."[88] In other words, art history had previously only considered painting influenced by European models as relevant. By considering popular culture and decorative art, we trace a different history of modernity and the Malay landscape. In the 1920s, Malay intellectuals debated whether or not image-making was acceptable in Islam. The Kaum Muda, or Young Thinkers, argued in favor of the image, arguing in particular that photography and film could provide "a vehicle for modernisation."[89] Soon cites an editorial in the *Al-Ikhwan* journal called "Gambar atau Lukisan," which translates as "Image or Painting,"

but which implies a conflict between the modern image—including photography and cinema—and artistic traditions. For Soon, "what is implied here is a belief that pictorial representation brought with it a sense of historical consciousness, which doubly served as an engine for human progress."[90] From a cinematic perspective, these debates echo those of classical film theory, asking similar questions to Béla Balázs or Kracauer on the differences between painting and photography, as well as those of Walter Benjamin on mechanical reproduction and the experience of progress. Both Zakaria and Soon question how Malay artists could wrest aesthetic modernity out of the hands of the colonizer. Within the bounds of realist landscape painting, it is hard to escape colonial visuality, and artists like Mas Pirngardie, whose paintings were European-influenced, were often dismissed as self-orientalizing. The contradictions of colonial modernity are writ large on these landscapes, as indeed they are in late-colonial cinema. Soon concludes that "decolonisation is the project of creating a new position for the modern subject outside of Europe, in all its complexities."[91] The pontianak film is equally part of this project.

If colonial-era art sought to grapple with the landscape image as a vector of progress and modernity, some contemporary artists return to the animist forms of Malay decorative traditions as a way to decolonize aesthetics. Yee I-Lann, whose pontianak-themed exhibition *Like the Banana Tree at the Gate* I examined in chapter 2, is also strongly invested in the forest and in indigenous cultural forms. *Ghost in the Banana Tree* (2016) comprises a series of 238 photographs of banana trees in urban locations. Some of the images can be read as landscapes in a conventional way: taken from a distance, with buildings and trees framed to create perspectival views. Others locate the banana trees in close-up, filling the frame almost entirely with foliage. Still others are legible spatially but resist any sense of mastery by locating the banana plants as dominant in the frame, where they cut off lines of perspective and obscure other objects. Installed in a grid, the photographs hold in tension geometric structure with an organic impression of tessellated foliage. The multiplicity of trees suggests a forest, but the images remain separate. The order (and disorder) of the human built environment overlays but cannot destroy the patterns of nonhuman nature. Of course, the banana tree is the traditional home of the pontianak, so although no spirits are visible in this work, their presence is strongly implied. Yee also works with traditional decorative art forms, as in her project *TanahAirKu* (2018), in which she works with indigenous Sabahan weavers to make patterned bamboo *tikar* mats. This project brings everyday decorative objects, made out of forest materials, into the museum in a way that decolonizes Malaysian art though its emphasis on indigenous craftspeople, trees, and histories of decorative pattern.

Singaporean artist Zarina Muhammad places contemporary animism at the center of her practice, exploring cultures of Southeast Asian magic and spirit belief in relation to the political inheritances of postcoloniality. Her installation *Pragmatic Prayers for the Kala at the Threshold* from 2018 uses the *penunggu*, the threshold spirit of a place, as a way to combine pre- and postcolonial spaces in Singapore. It maps the Austronesian cosmology of an upper, middle, and lower world onto three locations in the city, tracing the urban development of Singapore's coastline through the material histories of colonial labor. This piece speaks to the syncretic nature of animist culture, with the figure of Kala pointing both to the long-standing Hindu influence on Javanese animism and to the more recently imported cultures of the Indian workers whose labor built Singapore's grand British villas. It is also syncretic in the sense of combining animist worldviews with a pointed political critique, such that animist belief does not preclude a hermeneutic of suspicion. Zarina excavates colonial histories while at the same time renewing the potential of animism to imagine new modes of being in postcolonial Singapore. In *Conversations with the Malayan Banyan, the Queen and the Many Names of Other Guiding Spirits of Place* (2019) and *Pokoknya* (2020), Zarina collaborated with sound artist Tini Aliman and with a range of indigenous plants, including a banyan named Ara. This description is intentional, as Zarina views the plants as living beings with whom she creates art. The plants were chosen in part for their connection to mythological figures: the banyan is widely believed to harbor spirits and the artists also included a banana tree for its close association with the pontianak. The installation uses biodata sonification to translate the plants' responses to stimulus into sounds audible to humans. Here, Zarina and her collaborators create a way of listening to nonhuman nature, which mediates animist belief in the *semangat* of trees. *Pokoknya* also included a performance by a gamelan ensemble, so that trees perform both in their original form and in the shape of wood from which the instruments are made. The way in which Malay visual culture imagines trees is never neutral, and the work of Yee and Zarina demonstrates how a resistance to the landscape view of indigenous flora can intertwine with decorative art forms and animist belief systems in an aesthetic of decolonization.

These interlinking histories of animism, colonialism, art history, and modernity provide us with a way of theorizing foliage as political form, and of historicizing the cinematic representation of the jungle. The pontianak films are part of a culture of decolonization in which residual elements of colonial visuality sustain in dialogic tension with the cultural forces of anticolonialism. To a significant degree, colonial ways of thinking and being are still in effect. We have seen how ethnonationalism repurposes colonial racial ideology in Malaysia for the benefit

of Malay elites and in Singapore for Chinese ones, a powerful example of where the work of decolonization has still to be done. One way of thinking the role of cinematic form in these processes is to consider whether landscape is being viewed in an essentially colonial way. Realist modes of landscape representation can be turned toward Malay ethnonationalism by romanticizing the ethnically exclusive mythology of the *kampung*. It is thus not coincidental that more conservative films like *Sesat* are also those featuring the most conventional beauty shots of the landscape around the *kampung*. By contrast, anticolonial ways of seeing attempt to break away from these racialized forms. In chapter 4, we began to see how the heritage imaginary works to resignify picturesque landscapes. The final shots of *PHSM 2* transform the distanced view across a hilly landscape to insist on a feminist perspective. Just as artists like Yee and Zarina draw on precolonial art forms, the decorative patterns of jungle foliage in the pontianak film, I argue, enable a staging of the animist world that counters colonial visuality at the level of cinematic form. In the pontianak film, foliage speaks not only to a nationally resonant landscape but also to a precolonial mode of sensing the world. As with *hantu* stories, animist aesthetics resist Western forms and create syncretic Malay languages of cinema.

POINT OF VIEW IN THE FOREST

Foliage pushes the screen toward decorative flatness, or rather to an architectural entanglement that mobilizes depth but deemphasizes figure/ground hierarchy. This aesthetic of the forest nevertheless takes place within the perspectival space of popular narrative. Thus, animist form also works within the dynamic space of cinema, deploying what I call an environmental point of view in its construction of narrative space. Consider again the distanced colonial perspective of *Convalescent Bungalow*. Jacques Aumont and others have traced the influence of painting on cinematic landscapes, and colonial landscape painting forms a significant part of this story of aesthetic influence.[92] At the same time, postcolonial film scholars have delineated cinema's implication in structures of colonial vision, in which the world, in Timothy Mitchell's words, was "rendered up to the [European] individual according to the way in which, and to the extent to which, it could be set up before him or her as an exhibit."[93] In the Western landscape view, as in the cinematic apparatus, point of view is structured as that of the male colonist, or at least certainly a human. We can see traces of this mode of looking at the environment in the pontianak film. Its fetishization of vernacular

architecture is partially analogous to the class vision of the European picturesque, in which the peasant's shack can appear quaint only to those upper classes who need not live in such lowly conditions. The wooden stilt house by the jungle can create a similarly reactionary picturesque effect. This perspective exemplifies the transformation of colonial hierarchies into postcolonial ones, in which the Malay elite could romanticize the *kampung* while maintaining a secure distance from the poverty of rural communities. But the colonial account of point of view depends fundamentally on a conception of the relationship of land to people that is in conflict with an animist worldview. Fowler and Helfield write of landscape in cinema that "the milieu includes both the rural space within which or in relation to which the action takes place, as well as the rural inhabitants whose lives and daily activities give this space its meaning and value."[94] Malay animism would not see human inhabitants as giving meaning and value to the land, nor would it distinguish between human and nonhuman nature. One of the ways that the pontianak film counters the colonial apparatus, then, is by introducing a nonhuman point of view that works to decolonize landscape.

Many pontianak films construct images that are coded as optical point-of-view shots but are unclaimed, never connected to any character's vision or knowledge. One of the ways we recognize an optical point-of-view shot is that there is something between the camera and the human object of the gaze, partially blocking our vision. In the pontianak film, foliage intervenes between camera and object, in the way described as a problem by Antonioni. Conventionally, such a "bad" viewpoint is motivated by the location in space—often concealed—of the diegetic onlooker. But in the pontianak film, these looks remain untethered from any human character. The leaves that block our view signify something other than the concealment of a human character *by* nature: instead, they indicate that the origin of the point of view is nature itself. In *Pontianak Teng Teng* (Khan/TV3, 2014), a strikingly odd shot renders the film's central group of friends almost invisible by the proliferation of branches closer to the camera. The same effect occurs when the wise woman, Mak Isa, walks through the forest followed by a small animal: the spectator is placed behind a tree, following both creatures through the leaves that swirl away from its trunk. In *Pontianak Masih Beraya di Kampung Batu* (Ang/Astro Ria, 2012), multiple scenes view characters from a distance, partially blocked by leaves. In the syntax of horror, these shots would usually be motivated by a concealed character point of view and would thereby produce suspense about the identity and intent of a human observer. Here, I argue that this formal mechanism instead conjures the animate environment as the origin of its perspective, creating suspense by implying that the forest, like the pontianak, might be watching the humans within its space.[95]

FIGURE 5.7 Jungle point of view in *Pontianak Masih Beraya di Kampung Batu* (Ang, 2012).

The most extensive usage of this environmental point of view is in *Paku Pontianak*, where it is introduced through another generic indicator of optical point of view, the apparently embodied camera movement. In this film, horror is dispersed across the mise-en-scène through shots in which the camera moves, close to the ground, in a way that conventionally indicates the perspective of a frightening presence (aka "psychocam"). There is a creepy sense of someone watching the action but these shots are not attached to a specific character's eye. We never cut to a reverse shot and the spectator must revise their assumptions about what constitutes a person who might possess a point of view. The jungle is watching, and these shots locate the jungle itself as a subject and perspectival origin of located knowledge. The pontianak protagonist Melati does not know that she is a *hantu*, but she was murdered in the jungle and the environment around her does know who she is. *Paku Pontianak* uses high-angle and overhead shots in a disjunctive and unmotivated way. We look down on the family eating dinner, and on Melati alone in her room. Nonhuman nature is watching Melati, and this disembodied viewpoint becomes communicative in a scene in which Melati looks up and is inspired by the air above her to start a *mak yong* dance, without understanding how she knows it. This knowing environment surrounds the *kampung* like a dome, so that the perspective looking at Melati and her husband, Adam, can come from ground level, from within the trees, or from overhead. The jungle knows things about Melati and its nonhuman point of view is more accurate than that

of Adam, who is consistently misguided. When the couple returns home, Adam expects to find Melati walking behind him, but when he turns around, she has vanished. He finds her inside, already asleep. Later, he ventures outside to find her on a child's swing in the garden. She looks normal, but in the next shot, she has become a frightening pontianak. He turns away, only to find pretty Melati behind him. *Paku Pontianak* turns the animist idea that human perspective is less full than that of nonhuman nature into a series of horror effects, but alongside the jump scares it develops an account of plant perspective.

The environmental point of view in *Paku Pontianak* and other films can be thought in relation to what Greg Uhlin terms plant thinking in cinema. For Uhlin, "the specificity and expressivity of plants remains relatively unexplored [in cinematic ecocriticism], unless abstracted to the level of landscape."[96] Uhlin's project usefully rejects the idea of plants as primarily the source of landscape images, preferring to compare the way plants think without consciousness or identity to theories of cinematic thought. Plants grow toward the light and communicate with other plants without having what we would consider a sense of self-awareness or individuality. He argues that cinema does not replicate human modes of thought but that it could have more in common with the nonconsciousness, nonsingularity of being, and heterotemporality of plant life.[97] It doesn't seem likely that Uhlin himself would view the pontianak film as exemplary of his vision of vegetal cinema, however, as he is focused on experimental film and modernist art cinema. (His examples include Andrei Tarkovsky and John Smith.) He insists that "vegetal filmmaking is not concerned with the thematic or symbolic use of plants in cinema. What it aims at, instead, is the incorporation of the perspectives of plant-thinking as a structural mechanism in the production of images."[98] One could easily dismiss the pontianak films as a thematic use of the vegetal, in which forests signify merely as dark and frightening places, or deploy animism for a culturally specific setting. But Uhlin's separation of landscape/thematic use and vegetal/cinematic thought does not hold so securely in the Southeast Asian context, where an animist perspective always already understands the forest as animate. Just as plant science aligns with animist belief in its conception of plants as communicative, connected entities, so the Malay horror film conceives of its vegetative environment as thinking, despite not being at all formally experimental. In Viveiros de Castro's language, the animate forest has its own perspective.[99] *Paku Pontianak* envisions its jungle as alive with *semangat*, such that any plant can form a knowing subject of the look, even though this subjectivity is not individuated. Any position within the space of the jungle can stand in synecdochally for the environment as a whole, and that environment produces a way of looking

and thinking. Plant thinking is simultaneously a narrative trope and a form of cinematicity.

FORESTS FULL OF ANIMALS AND SPIRITS

The animate field of mise-en-scène contains not only humans and plants but also animals and other nonhuman persons. Graham Harvey theorizes animism in terms of a "larger-than-human social cosmos," which nicely captures the mutuality of nonhuman animist life.[100] Salleh describes this cosmos in specific terms of Malay animism, in which all kinds of person are

> co-inhabitants of one common part of the universe, the dunia. Within this dunia, man as a creature dominates the central part which is called negeri or the populated regions, like the towns and villages, while the plants and animals occupy the jungles and the waters which are unpopulated.... Man, for instance, is free to trudge the jungle or sail the sea if he so wishes, although he has to be mindful of the fact that he is actually in the territories of other living souls.[101]

This shared space is reminiscent of Arjun Appadurai's description of the line between civilization and wilderness, but Salleh evokes something other than a fearful boundary. The jungle is dangerous for him not only in a practical, tigery way, but also because it is not the domain of humans but the home of other living things. And these other lives are manifold. In much the same way that the Malay jungle is uniquely complex in its flora, it is strikingly diverse in its animal life. Aiken and Leigh note that there are 203 recorded species of mammal in Peninsular Malaysia, and 460 species of bird.[102] "A characteristic feature of the Malaysian fauna," they continue, "is that many species often coexist in relatively small areas."[103] As with the dense richness of jungle foliage, animal life forms a complex architecture in which species coexist through space, time, and resource partitioning, which is to say that they live in different vertical layers of the forest, are active at different times, and eat different things.[104] To understand the forest as animate is to recognize the extent to which it is saturated with life. It is not surprising that indigenous belief systems have created an equally abundant pantheon of spirits. The pontianak exists in a space replete with other nonhuman creatures, whose presence opens up another way that films decenter human agency.

The density of animals and *hantu* in the pontianak film contributes to the fuzziness of figure/ground relations. Their diegetic worlds are populated by thinking animals and animal spirits, as well as (apparently) natural animals. There is no simple binary in which only humans can be active characters, and it becomes difficult to taxonomize what kind of animacy one should impute to any given creature. *Hantu* and animals should not be considered so much as well-known characters who appear in cameo roles in the films but rather as part of the warp and weft of their animate world. The studio-era films include a talking mouse deer (*Anak Pontianak*), a tiger that might be real or a were-tiger (*Pontianak Gua Musang*), a werewolf, a *polong* (like a golem), and a snake spirit (also *Anak*), and, in *Sumpah Pontianak*, a whole array of spirits, including an *hantu raya* (great ghost), a wild man (*orang hutan*), and a giant lizard creature. The lost film *Dendam Pontianak / The Pontianak's Vengeance* (Rao, 1957) reportedly featured a *hantu nenek*, or grandmother of the forest, as well as the *tuju-tuju*, a flying egg with a spear.[105] Although the recent films are less profligate with their creaturely representation, we still encounter Earth spirits (*jembalang*), shroud ghosts (*pocong*), and fairies (*orang bunian*), as well as cats, mice, owls, and other everyday creatures. The *Pontianak* from 1975 includes a scene in which one of character swallows a live mouse, only to have the mouse shout for help from inside his stomach. Animals that seem normal can turn out to have the powers of self-awareness, thought, and speech. Across the pontianak film, animals and spirits are part of the same animate universe as the jungle, and can be understood as part of the genre's aesthetic.

One culturally resonant example of animal aesthetics is the appearance in *Anak Pontianak* of Sang Kancil, the talking mouse deer. Sang Kancil is a well-known figure in Malay folktales, in which stories revolve around this tiny but wily creature outwitting larger predators such as tigers and crocodiles. The mouse deer is native to Southeast Asia, and is much loved in Malaysia and Singapore. It is the smallest hoofed animal in the world, no larger than a domestic cat, and its intelligence is thus pitted against its lack of physical defenses. Sang Kancil is well known from children's fables but it has also been used as a political allegory in which the less-powerful states of Southeast Asia can outwit the larger political forces of China or the West.[106] Its appearance in *Anak Pontianak* plays with these conventions, while embedding the mouse deer within the animate space of the forest. The pontianak's friend Mat goes into the jungle to learn secret knowledge that might help her. The establishing shot of Mat in the jungle is almost entirely comprised of foliage, the old man tiny within the frame. We cut to a shot of a large white bird: decomposition of space here works to inscribe animals as well as plants into this nonhuman mise-en-scène. Mat hears a voice,

whose source cannot be seen, telling him to cross the river. He looks up, motivating a cut to a smaller bird on a branch. Is the bird talking to him? he asks. The voice replies that it has never heard a bird speak. Mat turns to a tree and asks the same question, only to receive the same reply. Eventually, Mat turns around and sees that the speaker is a mouse deer. The deer tricks him into falling into deep water, and then laughs and tells him that he doesn't need to cross the river because he, the mouse deer, can tell him the secret that will save the *kampung*. The scene is an elaborate way to impart a small piece of information, and its value is not in how it serves the narrative but in how it creates an animate world.

Indeed, the mouse deer's ability to indicate a larger animate environment centers the figure's extratextual life. Shaw Brothers used the fact that they were filming with a real mouse deer as the basis for a series of "news" stories. *Berita Harian* reported that the studio had purchased three mouse deer, but one played dead and then escaped while unsupervised.[107] *The Straits Times* ramped up the fiction with a report that the escaped deer was valuable to the studio because they had trained it to move its lips, and *Movie News* went further still, insisting that the mousedeer "really speaks in Malay."[108] Shaw offered a reward for the return of the creature and a group of teenagers found it. In these stories, we can see animism operating across an expanded cultural field: from the fictional narratives of the films through supposedly factual articles about their production and out to the experiences and beliefs of those potential audience members who might catch a mouse deer or read a media story about one. Animism works to create a public sphere, and we can note that the status of actual belief is not entirely important. Do readers of *Movie News* genuinely believe in the talking mouse deer? Even if the stories are likely taken with a pinch of salt by most readers, what circulates with these publicity stories is the liveliness of the cultural narrative of the intelligent mouse deer and, with it, the experience of living in an animate world.

The other most popular animal spirit in pontianak films and beyond is the *harimau jadian*, or were-tiger (literally, "imitation tiger"). The were-tiger features prominently in *Gua Musang* and more recently appears in *Kala Malam Bulan Mengambang* and in the television series *Keluarga Pontimau* (Norhanisham and Bhatia / TV3, 2015–2016). (The name combines the words *pontianak* and *tiger* in an *Addams Family*–style gothic sitcom about a marriage between different *hantu*.) In the studio era, were-tigers starred in several horror films such as *Hantu Rimau* (Rao, 1960), *Sitora* (P. Ramlee, 1964), and *Harimau Jadian* (M. Amin, 1972). Like the mouse deer, the were-tiger has a long history in Malay folklore. The first documentary references are found in fifteenth-century Melaka, where the Portuguese authorities were involved in catching and excommunicating them.[109] In the 1800s, Abdullah bin Abdul Kadir wrote that he no longer believed in were-tigers

because both Islam and the white men rejected the idea as superstition.[110] At the end of the nineteenth century, though, Hugh Clifford could still observe that "the worst and most rapacious of the man-eaters are themselves human beings, who have been driven to temporarily assume the form of an animal, by the aid of Black Art, in order to satisfy their overpowering lust for blood."[111] We can see in the history of the were-tiger a syncretic interplay among indigenous belief, Islam, colonialism, and modernity that is shared by the cultures of the pontianak. These syncretisms are visible across the cinematic representation of the were-tiger.

The status of the imitation tiger is always in some doubt. Patrick Newman narrates the various beliefs of Malays and Orang Asli around whether were-tigers were humans who could transform themselves into tigers or the spirits of tigers who entered into humans.[112] *Gua Musang* continues this ambivalence, as the villagers debate whether the tiger that is attacking the *kampung* is a real animal or a shape-shifting *hantu*. This uncertainty fuels the atmosphere of suspicion in which the innocent Comel is suspected by the villagers of being a pontianak, as we are never sure whether events have natural or supernatural causes. When we eventually see the tiger, the images of the animal's beauty and danger are forcefully real. These shots—clearly filmed separately from the space of the actors—nonetheless effectively mobilize the indexical qualities of the profilmic tiger to evoke a sense of both natural and supernatural awe. In the film's denouement, Halimah is killed by the tiger in a sequence that combines plant, animal, and spirit life as we cut from a shot of the tiger to one of the long grasses rustling as she is pulled out of view. In its tiger images, *Gua Musang* evocatively stages the power of an animate universe. And of course the were-tiger speaks to a real threat: in the 1940s, a person in the state of Terengganu was more likely to be eaten by a tiger than killed in an automobile accident.[113] The tiger population of the Malay Peninsula has dropped from three thousand in the 1950s to a mere two hundred today, and there are urgent fears of extinction.[114] But in the heyday of the studio era, the were-tiger narrated a corporeal presence in terms that complicate the status of the tiger as animal, spirit, or human in essence.

Imbuing animals with *semangat*, or "souls," is a central feature of Malay animism, and in cinematic terms, *semangat* can be visualized through point of view. We can see the ongoing significance of animist film form as a way of narrating postcoloniality in the conjuring of animal point of view in recent Singaporean moving-image culture. Ho Tzu Nyen's experimental video *2 or 3 Tigers* (2015) depicts the fateful encounter between colonial administrator George Coleman and a tiger, previously depicted in the lithograph *Interrupted Road Surveying in Singapore* (1865). In reality, Coleman was killed by the tiger, but in the video, their relationship becomes more complex. The two-screen animation deploys

FIGURE 5.8 The corporeal presence of the were-tiger in *Pontianak Gua Musang* (Rao, 1964).

an uncanny doubling as man turns into tiger and vice versa, with both figures singing a hypnotic song of shared experience. The singing tiger creates an uncanny animacy, and the refrain "we're tigers—were-tigers," along with the movement of the figures endlessly leaping or falling toward each other, weaves an animist imaginary in which tigers might reflect more successfully than colonists on the nature of the tiger-human relationship. If Ho's video exemplifies the critical impulses of postcolonial animism, a very different version of animal point of view emerges in Singapore's Bicentennial Experience, a multimedia exhibition mounted in 2019 to celebrate the two hundredth anniversary of the founding of modern Singapore. Central to the experience is an animated film that narrates the arrival of the British through the optical point of view of animals. We see the ships sail in from the point of view of an eagle flying over the bay, and the signing of treaties and development of trade through the vision of a mouse, a cat, and a dragonfly. It's striking that these are not all indigenous animals, and in the case of the cat and mouse, they could even have traveled to Singapore by boat themselves. Why did the film not choose iconic local animals

like the tiger, mouse deer, or tapir? Moreover, it is easy to conclude that animality is evoked to avoid including the perspective of the human inhabitants of the island, evading a visualization of such an encounter as conflict or displacement. The Bicentennial Experience folds colonial fantasy into its postcolonial history, and instead of combining human and nonhuman inhabitants of the forest, it counterposes Malay animals with European people. From experimental video to the most mainstream of state fictions, animal animacy remains an irresistible form for understanding Southeast Asian colonial history.

ANIMISM AS POSTCOLONIAL ECOLOGY

This chapter has investigated how animist form enables the pontianak film to conjure anticolonial aesthetics through its envisioning of nonhuman nature. An intrinsic part of this aesthetic is the dual role of the forest to signify an enduring precolonial culture and, simultaneously, an environmental politics that has become urgent in twenty-first-century Malaysia and Singapore. The forest has often been leveraged as a political space in cinema: for example, Paul Mitchell argues that the "cine del bosque" in Spain uses the forest to explore "conflicts between modernity and primitivism, social inclusion or marginalization, and political compliance or subversion," and Patrícia Vieira writes about the Amazonian jungle's challenge to political order.[115] We can see refractions of such textual politics in Malay cinemas, where the forest similarly evokes the conflicted historical relationships of human societies to nonhuman nature. In late-colonial studio cinema, representing the jungle was part of the push toward Malay representation, along with the work of Maria Menado, Abdul Razak, and others in telling Malay stories. In the postcolonial era, animist form elaborates an aesthetics of decolonization centering on reimagining national spaces and reckoning with the threat of environmental destruction. The forest is overdetermined as a site of Malay patrimony and its representation speaks to the centrality of the nonhuman environment in imagining Malay (and Malaysian and Singaporean) worlds. At the same time that the forest provides a semiotics of animist inheritance, the actual forests are undergoing an unprecedented period of destruction. Chapter 4 outlined the history of deforestation in peninsular Malaysia and Jeyamalar Kathirithamby-Wells identifies in the present an "escalating environmental degradation at the heart of development in the tropics."[116] Saiful Arif Abdullah and Adnan Hezri provide a damning list of the environmental impacts of deforestation, including a loss of "wildlife diversity, richness,

and abundance, . . . conflicts between humans and wildlife, . . . surface erosion and landslides, . . . [and] transmission or spread of vector-borne diseases."[117] All aspects of the animate field are being transformed, and this ecological transformation cannot be isolated from the discursive history of the forest.

The forest itself is a discursive construction. Nancy Lee Peluso and Peter Vandergeest use the term *political forest* to characterize the Foucauldian genealogy within which, they argue, we should abandon the idea of the forest as a natural thing and understand it as constituted discursively and in relation to state power.[118] They point out that the forest was never pristine and separate from human activity, since local people engaged in planting, burning, hunting, and harvesting products like cinnamon and resins from the trees. They conclude that "what explorers, scientists, and eventually government officials came to call 'forests' in Southeast Asia were thus products of human activities in the long and short term—collection, production, protection, and cultivation."[119] Lye Tuck-Po reflects on the cultural consequences of state production of forests, pointing out that the process of drawing boundaries to demarcate conservation areas works to present the rest of the country as both modern and ripe for development, while the special areas are cordoned off as marginal to the modern nation. For her, when forests are demarcated as traditional spaces, they become "sites of wilderness and nostalgia."[120] This separation is a problem, since it simultaneously justifies rampant development in the nonprotected areas and turns the forests into fossilized heritage sites. We can see how the political history of forest ownership and changing land use is materially linked to the discursive landscape in which the forest is contested culturally. The meaning of the forest as a site of tradition is as politically overdetermined as that of the *kampung*. As with the discourse of heritage examined in the last chapter, forest nostalgia is easily bent to conservative use. Zainal Kling calls for Malay culture to resist globalization, using the tree as a nativist metaphor when he writes that "the center of our literature and knowledge must grow and flourish in our own earth, as a banyan tree wants to be fertile in its own air and earth."[121] This invocation of the banyan tree as an ethnonationalist symbol is the ideological opposite to Zarina Muhammad's queer feminist collaboration with her banyan tree, or to Amanda Nell Eu's feminist vision of a young pontianak's freedom in climbing a tree in *Lagi Senang*. The stakes of nature as metaphor can be high.

Moreover, in the context of animist theories that draw primarily from the worldviews of indigenous cultures, it is critical to recall the exclusion of the Malay Peninsula's indigenous peoples (comprising several ethnic groups gathered under the moniker Orang Asli) from any land rights to the forest. In the reorganizations of forested land that followed on independence, Orang Asli were allocated

to designated areas or so-called "aboriginal reserves," in which they could not own land and existed with minimal protections as "tenants at will," precisely because that land was reserved by the state.[122] Those Orang Asli living outside of reserves had no protections at all. The status of Orang Asli illustrates how the racialization of Malaysian citizenship has implications for the political discourse of the forest. Ethnic Malays were determined to be *bumiputera*, or indigenous (literally, sons of the soil), whereas Orang Asli in the peninsula were— incredibly—excluded from the category of indigenous people and had no rights to own land. Instead, they were given the legal status of "wards" of their respective state governments.[123] Orang Asli were given the right to live in forests and use them in certain ways that others could not, but they were excluded from any rights to the land, which could be owned only by Malays.[124] This exclusion from *bumiputera* status is also a cultural marginalization. Orang Asli are infrequently represented in Malaysian cinema but *Gua Musang* gives Orang Asli characters a small but significant role. The people who find the baby Comel after her mother has been murdered are Orang Sakai, and it's according to their beliefs that Comel was sent floating down the river. When Comel encounters an old Orang Sakai man—identifiable by his traditional headband and necklace—he is the only person who can confirm her identity and save her life.[125] The forests of Gua Musang continue to be a site in which indigeneity is discursively and materially felt. The rift between Orang Asli as traditional inhabitants of the land and Malays as its legal owners has reached a crisis point in contemporary Gua Musang, where indigenous Malaysians have built blockades to protest the destruction of the jungle for durian plantations.[126] In Gua Musang, Kuala Langat, and other sites across Malaysia, Orang Asli groups are linking land rights with urgent environmental activism.[127]

Pontianak films brush the fantasmatic qualities of animism against the real life destruction of the Malaysian environment in a way that enables us to see forest aesthetics as postcolonial ecology. Film scholars have increasingly viewed the postcolonial and the ecocritical as connected, in part because, as James Boucher argues, it is the colonial ideology that formerly colonized areas and people are of less intrinsic value that has enabled their continued environmental exploitation.[128] David Martin-Jones revises the idea of political cinema with critiques of colonial modernity in mind, finding that "the underside of colonial modernity is far more inclusive of the histories of the Earth than definitions of political cinema as a cinema of resistance may typically acknowledge."[129] His revised corpus of postcolonial ecocinema is more centered on art cinema than on popular genres, but his description of the field's narrativity resonates with the way I understand the animist work of the pontianak. He writes that "the list of such disappeared pasts is

increasingly both human and nonhuman, and includes: animals, extinct species, spirits, mythological creatures, slaves, indigenous peoples, women, the disappeared and murdered, the poor, even the farmed landscapes and mined depths of the Earth itself.... Current debates surrounding ecology give a different meaning to what is resisted in and by a cinema of resistance."[130] By conjuring not only the pontianak herself but the animist field of trees, animals, and spirits in which she lives, *hantu* films counter neocolonial epistemologies and ways of framing the world. The pontianak in "Nobody" (Khoo/HBO Asia, 2018), for instance, attacks exploitative labor and development in Singapore, and in *Dendam Pontianak* she demonstrates the lie of independence without gender equality. If animism is, as Linda Hogan insists, a form of decolonization of the mind, then the pontianak film's animist aesthetic gestures to the continued need for such a process in the face of the environmental failures of the postcolonial state.[131]

Animism as form makes the forest *do* things, giving it point of view, agency, and meaning. In both Singaporean and Malaysian film, the pontianak constitutes a central term through which the environment is represented—and represented, moreover, as a living entity. The pontianak brings together the *kampung* and the forest, and she demands that we view the forest within an anticolonial visuality. To return to animist theory, Tim Ingold describes the animist world as a "domain of entanglement," and "rather like the vines and creepers of a dense patch of tropical forest."[132] Persons are not separate, but are like a network of tree roots, all intertwined. He continues, "This tangle is the texture of the world. In the animic ontology, beings do not simply occupy the world, they inhabit it, and in so doing—in threading their own paths through the meshwork—they contribute to its ever-evolving weave."[133] By thinking the pontianak film in terms of animism as a cultural logic, I have argued that we can locate an aesthetics and politics of decolonization across the weave of its visual forms. It is a mode of folkloric visuality that responds to the contemporary—the world of late colonialism, independence, and decolonization. Its world of *hantu*, plants, and animals, of nonhuman as well as human creatures, asks us to imagine a crowded *dunia*. This world of humans, animals, spirits, and trees is one that we must all find a way to live in together. It conjures the promise and violent challenges of the postcolonial, globalized era. To return to Burhan Baki's insistence that we think with *hantu*, the pontianak proposes a mode of cinematic world-making in which the relationship of humans to the nonhuman environment must be constantly remade in a complex domain of entanglement.

NOTES

INTRODUCTION

1. Avery F. Gordon, *Ghostly Matters: Haunting and the Sociological Imagination* (Minneapolis: University of Minnesota Press, 1997), 8.
2. Manuel Godinho de Erédia, *Malaca, l'Inde méridionale et le Cathay: Manuscrit original autographe de Godinho de Eredia, appartenant à la Bibliothèque Royale de Bruxelles*, trans. M. Léon Janssen (1618; Brussels: Librairie Européene C. Muquardt, 1882), 42, my translation.
3. Colonial anthropology was often based on such misunderstandings, and as a result there is a slippage among terms. Moreover, Malay beliefs and folklore varied regionally. Thus we find the *pontianak* and the *langsuir* often conflated, or combined with the *penanggalan*, or even mixed up with completely unrelated spirits.
4. Stu Burns, "Vampire and Empire: Dracula and the Imperial Gaze," *eTropic* 16, no. 1 (2017): 12.
5. Kirk Michael Endicott, *An Analysis of Malay Magic* (Oxford: Clarendon, 1970), 61.
6. Richard Winstedt, *The Malay Magician: Being Shaman, Saiva and Sufi* (London: Routledge, 1951), 24–25.
7. R. J. Wilkinson, *Malay Beliefs* (London: Luzac, 1906), 23.
8. J. N. McHugh, *Hantu Hantu: An Account of Ghost Belief in Modern Malaya* (Singapore: Donald Moore, 1955), 79.
9. Mohd. Taib Osman, *Malay Folk Beliefs: An Integration of Disparate Elements* (Kuala Lumpur: Dewan Bahasa dan Pustaka, 1989), 89.
10. Anonymous, "Malaya Has Its Own Terror," *Singapore Standard*, October 13, 1957, 9.
11. Andrew Hock Soon Ng, "A Cultural History of Pontianak Films," in *New Malaysian Essays*, vol. 2, ed. Amir Muhammad (Petaling Jaya: Matahari, 2009), 217.
12. Adrian Yuen Beng Lee, "The Villainous Pontianak?: Examining Gender, Culture, and Power in Malaysian Horror Films," *Pertanika Journal* 24, no. 4 (2016): 1434.
13. Nicolette Yeo, *Old Wives' Tales: Fascinating Tales, Beliefs and Superstitions of Singapore and Malaysia* (Singapore: Times Editions, 2004), 16.
14. Burns, "Vampire and Empire," 9.
15. Bram Stoker, *Dracula* (1878; New York: Oxford University Press, 2011), 222, my italics.
16. Bram Stoker, *Bram Stoker's Notes for Dracula: A Facsimile Edition*, annotated and transcribed by Robert Eighteen-Bisang and Elizabeth Miller (Jefferson, NC: McFarland, 2008), 284.

17. Isabella Bird, *The Golden Chersonese and the Way Thither* (London: John Murray, 1883), 353–355, my italics.
18. Steve Pile, "Perpetual Returns: Vampires and the Ever Colonised City," in *Postcolonial Urbanism: Southeast Asian Cities and Global Processes*, ed. Ryan Bishop, John Phillips, and Wei Wei Yeo (New York: Routledge, 2003), 280.
19. Burns, "Vampire and Empire," 9.
20. Ken Gelder, *Reading the Vampire* (London: Routledge, 1994), 12.
21. Patrick Brantlinger, *Rule of Darkness: British Literature and Imperialism, 1830–1914* (Ithaca: Cornell University Press, 1988), 625.
22. Stephen D. Arata, "The Occidental Tourist: 'Dracula' and the Anxiety of Reverse Colonization," *Victorian Studies* 33, no. 4 (Summer 1990): 623.
23. Anonymous, "Malay Belle Back to Blood-Sucking Tricks," *Straits Times*, August 30, 1957, 10.
24. Amir Muhammad, *120 Malay Movies* (Petaling Jaya: Matahari, 2010), 14.
25. Meheli Sen, *Haunting Bollywood: Gender, Genre, and the Supernatural in Hindi Commercial Cinema* (Austin: University of Texas Press, 2017); Sangita Gopal, *Conjugations: Marriage and Form in New Bollywood Cinema* (Chicago: University of Chicago Press, 2011), 91–123.
26. For an account of the film's use of the supernatural, see Naminata Diabate, "Re-Imagining West African Women's Sexuality: Bekolo's *Les Saignantes* and the Mevoungou," in *Development, Modernism and Modernity in Africa*, ed. Augustine Agwuele (New York: Routledge, 2013), 166–181.
27. I am grateful to Cüneyt Çakırlar for his insight into the Turkish horror film. See also Zeynep Sahintürk, "The Djinn in the Machine: Technology and Islam in Turkish Horror Film," in *Digital Horror: Haunted Technologies, Network Panic and the Found Footage Phenomenon*, ed. Linnie Blake and Xavier Aldana Reyes (London: I. B. Tauris, 2016), 95–106.
28. Joan Hawkins, *Cutting Edge: Art-Horror and the Horrific Avant-Garde* (Minneapolis: University of Minnesota Press, 2000).
29. Adam Lowenstein, *Shocking Representation: Historical Trauma, National Cinema, and the Modern Horror Film* (New York: Columbia University Press, 2005).
30. William Paul, *Laughing Screaming: Modern Hollywood Horror and Comedy* (New York: Columbia University Press, 1994).
31. See chapters 2 and 3 for elaboration of this issue.
32. For instance, per television listings in the *Straits Times*, *Pontianak Gua Musang* screened in the "Malay Movie" slot of Singapore's Channel 3 in November 30, 1984, in the "Mutiara Kelasik" slot on RTM 1 on June 15, 1989, and on the KTO channel on October 20, 2011.
33. Hasleen Bachik, "Cathay Tidak Putus-Putus Didatangi Peminat Pontianak," *Berita Harian*, May 2, 1997, 6.
34. Ahmad Rabiul Zulkifli, "Man Dresses as 'Pontianak' to Make People Comply with MCO," *New Straits Times*, March 31, 2020.
35. A. Richards, "Stephen Meets a Vampire and Vows No More Lifts for Pretty Women," *Singapore Free Press*, July 16, 1960, 3.
36. Letters to the Editor, *Singapore Free Press*, July 21 and 27, 1960, 6.
37. Anonymous, "Pontianak!," *Singapore Free Press*, December 22, 1960, 12.
38. True Sakti Girl, "Scary Real Pontianak Ghost Captured in Malaysia," YouTube, uploaded April 7, 2019, www.youtube.com/watch?v=sU5OIAI5dJE&t=1s.
39. Catherine Lim, *They Do Return . . . But Gently Lead Them Back* (Singapore: Times, 1992); Ralph Modder, *Curse of the Pontianak* (Singapore: Horizon, 2004); Pugalenthi, *Pontianak Nightmares* (Singapore: Asuras, 2000); Rahmad bin Badri, *Ghostly Tales from Singapore* (Singapore: Wellington Educational, 1993); Andrew Lim, *Paranormal Singapore: Tales from the Kopitiam* (Singapore: Monsoon, 2008); Russell Lee, *True Singapore Ghost Stories 5* (Singapore: Angsana, 1996).

40. Carole Faucher, "As the Wind Blows and the Dew Came Down: Ghost Stories and Collective Memory in Singapore," in *Beyond Description: Singapore Space Historicity*, ed. Ryan Bishop, John Phillips, and Wei-Wei Yeo (London: Routledge, 2004), 190–203.
41. Ralph Modder, "Moon Princess," in *Curse of the Pontianak*, 1–22.
42. Alfian Sa'at, *Malay Sketches* (New York: Gaudy Boy, 2018), 97.
43. Alfian, 96.
44. Yee I-Lann, quoted in Boo Su-Lyn, "How a Malaysian Artist Brought a 'Pontianak' to New York," *Malay Mail*, June 22, 2016.
45. Ng Yi-Sheng, "A History of Singapore Horror," *BiblioAsia*, July 3, 2017, www.nlb.gov.sg/biblioasia/2017/07/03/a-history-of-singapore-horror/.
46. Tan Bee Thiam, conversation with author, August 21, 2017.
47. Sandra Ponzanesi and Marguerite Waller, eds., *Postcolonial Cinema Studies* (London: Routledge, 2012), 9.
48. Ken Gelder, "Global/Postcolonial Horror: An Introduction," *Postcolonial Studies* 3, no. 1 (2000): 35.
49. Luise White, *Speaking with Vampires: Rumor and History in Colonial Africa* (Berkeley: University of California Press, 2000), 5.
50. White, 5.
51. Aihwa Ong, "The Production of Possession: Spirits and the Multinational Corporation in Malaysia," *American Ethnologist* 15, no. 1 (February 1988): 28.
52. Ong, 33.
53. Gordon, *Ghostly Matters*, 18–19.
54. Gelder, "Global/Postcolonial Horror," 35. On postcolonial zombies, see, for example, Kyle Bishop, "The Sub-Subaltern Monster: Imperialist Hegemony and the Cinematic Voodoo Zombie," *Journal of American Culture* 31, no. 2 (2008): 141–152; Edna Aizenberg, "I Walked with a Zombie: The Pleasures and Perils of Postcolonial Hybridity," *World Literature Today* 73, no. 3 (1999): 461–466; and Jean Comaroff and John Comaroff, "Alien-Nation: Zombies, Immigrants, and Millennial Capitalism," *South Atlantic Quarterly*, February 2002, 17–28.
55. Bliss Cua Lim, "Spectral Times: The Ghost Film as Historical Allegory," *positions* 9, no. 2 (2001): 287.
56. Bliss Cua Lim, *Translating Time: Cinema, the Fantastic, and Temporal Critique* (Durham: Duke University Press, 2009), 2.
57. Lim, 20.
58. Lim, "Spectral Times," 289; Jacques Derrida, *Specters of Marx: The State of Debt, the Work of Mourning and the New International*, trans. Peggy Kamuf (New York: Routledge, 1994).
59. María del Pilar Blanco and Esther Peeren, eds., *The Spectralities Reader: Ghosts and Haunting in Contemporary Cultural Theory* (London: Bloomsbury, 2013), 11–16.
60. Murray Leeder, ed., *Cinematic Ghosts: Haunting and Spectrality from Silent Cinema to the Digital Era* (London: Bloomsbury, 2015), 3.
61. Leeder, 9.
62. Arnika Fuhrmann, "*Nang Nak*—Ghost Wife: Desire, Embodiment, and Buddhist Melancholia in a Contemporary Thai Ghost Film," *Discourse* 31, no. 3 (2009): 226–227. The historical context in Thailand is not European colonialism, but Fuhrmann addresses a similar formation of female ghostly figures who engage national histories.
63. Arnika Fuhrmann, *Ghostly Desires: Queer Sexuality and Vernacular Buddhism in Contemporary Thai Cinema* (Durham: Duke University Press, 2016), 5. See also Adam Knee, "Thailand Haunted: The Power of the Past in Contemporary Thai Horror Film," in *Horror International*, ed. Steven Jay Schneider and Tony Williams (Detroit: Wayne State University Press, 2005), 141–159.
64. Priya Jaikumar, *Where Histories Reside: India as Filmed Space* (Durham: Duke University Press, 2019), 8, 30.

65. Jaikumar, 29.
66. Paul Wells, *The Horror Genre: From Beelzebub to Blair Witch* (New York: Wallflower, 2000), 1.
67. Angela M. Smith, *Hideous Progeny: Disability, Eugenics, and Classic Horror Cinema* (New York: Columbia University Press, 2012), 2.
68. Dudley Andrew, "Time Zones and Jetlag: The Flows and Phases of World Cinema," in *World Cinemas, Transnational Perspectives*, ed. Nataša Ďurovičová and Kathleen Newman (New York: Routledge, 2010), 59–89.
69. David Martin-Jones, *Cinema Against Doublethink: Encounters with the Lost Pasts of World History* (London: Routledge, 2019).
70. Peter Limbrick, *Arab Modernism as World Cinema: The Films of Moumen Smihi* (Oakland: University of California Press, 2020), 3.
71. Jennifer Fay, *Inhospitable World: Cinema in the Time of the Anthropocene* (New York: Oxford University Press, 2018).
72. Fay, 4.
73. See, for example, Schneider and Williams, *Horror International*.
74. John Edgar Browning and Caroline Joan (Kay) Picart, "Introduction: Documenting Dracula and Global Identities in Film, Literature, and Anime," in *Draculas, Vampires, and Other Undead Forms: Essays on Gender, Race, and Culture*, ed. John Edgar Browning and Caroline Joan (Kay) Picart (Lanham, MD: Scarecrow, 2009), x.
75. Christopher Frayling, *Vampyres: Lord Byron to Count Dracula* (London: Faber, 1991), 4.
76. Stephen Teo, *The Asian Cinema Experience: Styles, Spaces, Theory* (New York: Routledge, 2013), 94.
77. Teo, 92; Jinhee Choi and Mitsuyo Wada-Marciano, "Introduction," in *Horror to the Extreme: Changing Boundaries in Asian Cinema* (Hong Kong: Hong Kong University Press, 2009), 1.
78. Dana Och and Kirsten Strayer, eds., *Transnational Horror Across Visual Media* (London: Routledge, 2014), 2.
79. Jennifer Feeley, "Transnational Specters and Regional Spectators: Flexible Citizenship in New Chinese Horror Cinema," *Journal of Chinese Cinemas* 6, no. 1 (2012): 51–52.
80. Pieter Aquilia, "Westernising Southeast Asian Cinema: Coproductions for Transnational Markets," *Continuum: Journal of Media and Cultural Studies* 20, no. 5 (2006): 433.
81. Aquilia, 436.
82. Lim, *Translating Time*, 36.
83. Rob Stone, Paul Cooke, Stephanie Dennison, and Alex Marlow-Mann, eds., *The Routledge Companion to World Cinema* (London: Routledge, 2017), 1–2.
84. Anna Lowenhaupt Tsing, *Friction: An Ethnography of Global Connection* (Princeton: Princeton University Press, 2005), 5.
85. Tsing, 3.
86. William van der Heide, *Malaysian Cinema, Asian Film: Border Crossings and National Cultures* (Amsterdam: Amsterdam University Press, 2002), 105–106.
87. See, for example, Chua Beng Huat, "Singapore Cinema: Eric Khoo and Jack Neo—Critique from the Margins and the Mainstream," *Inter-Asia Cultural Studies* 4, no. 1 (2003): 117–125; Olivia Khoo, "Slang Images: On the Foreignness of Contemporary Singaporean Films," *Inter-Asia Cultural Studies* 7, no. 1 (2006): 81–98; Raphael Millet, *Singapore Cinema* (Singapore: Editions Didier Millet, 2007); Liew Kai Khiun and Stephen Teo, eds., *Singapore Cinema: New Perspectives* (New York: Routledge, 2017); Edna Lim, *Celluloid Singapore: Cinema, Performance and the National* (Edinburgh: Edinburgh University Press, 2018).
88. Heide, *Malaysian Cinema*, 144.
89. Abi, *Filem Melayu: Dahulu dan Sekarang* (Shah Alam: Marwilis, 1987).
90. Jamil Sulong, Hamzah Hussein, and Abul Malik Mokhtar, *Daftar Filem Melayu* (Selangor: FINAS, 1993), 10–11.

91. Ernest Renan, *Qu'est-ce qu'une nation?*, trans. Ethan Rundell (Paris: Presses-Pocket, 1992).
92. Mohamad Hatta Azad Khan, "The Malay Cinema (1948–1989) Early History and Development" (PhD diss., University of New South Wales, 1994).
93. Badrul Redzuan Abu Hassan, "Constructing the Cinema-of-Intent: Revisiting Hatta Azan Khan's 'True Picture,'" *Asian Social Science* 8, no. 5 (2012): 55–64.
94. Adil Johan, *Cosmopolitan Intimacies: Malay Film Music of the Independence Era* (Singapore: NUS Press, 2017), 6.
95. Adil, 20.
96. Gerald Sim, "Historicizing Singapore Cinema: Questions of Colonial Influence and Spatiality," *Inter-Asia Cultural Studies* 12, no. 3 (2011): 358.
97. Kenneth Paul Tan, "Pontianaks, Ghosts and the Possessed: Female Monstrosity and National Anxiety in Singapore Cinema," *Asian Studies Review* 34, no. 2 (2010): 151–170; Alicia Izharuddin, "The Laugh of the Pontianak: Darkness and Feminism in Malay Folk Horror," *Feminist Media Studies* 20, no. 7 (2020): 999–1012; Lee, "The Villainous Pontianak?," 1431–1444.
98. Jac S. M. Kee, "Boundary Monsters in a Time of Magic," in *New Malaysian Essays 2*, ed. Amir Muhammad (Petaling Jaya: Mata Hari, 2009), 273–274.
99. Kee, 272.
100. Sophia Siddique Harvey, "Mapping Spectral Tropicality in *The Maid* and *Return to Pontianak*," *Singapore Journal of Tropical Geography* 29 (2008): 25.
101. Siddique Harvey, 26.
102. Gaik Cheng Khoo, *Reclaiming Adat: Contemporary Malaysian Film and Literature* (Vancouver: University of British Columbia Press, 2006).
103. Azlina Asaari and Jamaluddin Aziz, "Perkembangan Filem Seram di Malaysia: Satu Tinjauan Literatur," *e-Bangi: Journal of Social Sciences and Humanities* 12, no. 2 (2017): 30–45.
104. Jamaluddin Aziz and Azlina Asaari, "*Saka* and the Abject: Masculine Dominance, the Mother and Contemporary Malay Horror Film," *AJWS* 20, no. 1 (2014): 72; Mohd. Amirul Akhbar Mohd. Zulkifli, Amelia Yuliana Abd Wahab, and Hani Zulaikha, "The Potential of Malaysia's Horror Movies in Creating Critical Minds: A Never Ending Philosophical Anecdote," *Proceedings of 2012 2nd International Conference on Humanities, Historical, and Social Sciences* (2012): 175–176.
105. Ponzanesi and Waller, *Postcolonial Cinema*, 1.
106. Kuan-Hsing Chen, *Asia as Method: Toward Deimperialization* (Durham: Duke University Press, 2010), 2.
107. Rebecca Weaver-Hightower and Peter Hulme, eds., *Postcolonial Film: History, Empire, Resistance* (New York: Routledge, 2014), 3.
108. Stuart Hall, "New Ethnicities," in *Stuart Hall: Critical Dialogues in Cultural Studies*, ed. David Morley and Kuan-Hsing Chen (New York: Routledge, 1996), 441–449.

1. POPULAR HORROR AND THE ANTICOLONIAL IMAGINARY

1. Timothy Barnard, "Vampires, Heroes and Jesters: A History of Cathay Keris," in *The 26th Hong Kong International Film Festival, The Cathay Story*, ed. Wong Ain-ling and Sam Ho (Hong Kong: Hong Kong Film Archive, 2002), 130.
2. Barnard, 130.
3. Anonymous, "Brief Battle in Cinema Foyer," *Singapore Standard*, May 3, 1957, 1.
4. Advertisement for *Pontianak*, *Singapore Standard*, May 10, 1957, 3.
5. Barnard, "Vampires," 140n9.

6. Ng Yi-Sheng, "A History of Singapore Horror," *BiblioAsia*, www.nlb.gov.sg/biblioasia/2017/07/03/a-history-of-singapore-horror/.
7. Albert Odell, "Singapore Film History," reel 5, Oral History Interviews, Singapore National Archives.
8. Advertisements for films, *Singapore Standard*, February 8, 1958, 9.
9. Hamzah Hussin, *Memoir Hamzah Hussin: Dari Cathay Keris ke Studio Merdeka* (Bangi: Penerbit Universiti Kebangsaan Malaysia, 1998), 41.
10. Laksamanan Krishnan, in the documentary *Kachang Puteh to Popcorn: A History of Singapore Film* (Lamb, 1999).
11. Advertisement for *Pontianak*, *Singapore Standard*, July 25, 1958, 7; advertisement for *Pontianak* in Xing Zhou Ri Bao (星洲日报), July 12, 1958, 4; Anonymous, "Chinese Films by Cathay in Singapore," *Straits Times*, June 20, 1959, 7.
12. Hamzah, *Memoir*, 41.
13. Philip Cheah, "Singapore: Starting Over," in *Being and Becoming: The Cinemas of Asia*, ed. Aruna Vasudev, Latika Padgonkar and Rashmi Doraiswamy (Delhi: Macmillan, 2002), 380.
14. Mohd. Zamberi A. Malek and Aami Jarr, *Malaysian Films: The Beginning* (Kuala Lumpur: Perbadanan Kemajian Filem Nasional Malaysia / FINAS, 2005), 74.
15. Lim Kay Tong, *Cathay: 55 Years of Cinema* (Singapore: Landmark, 1991), 116.
16. William van der Heide, *Malaysian Cinema, Asian Film: Border Crossings and National Cultures* (Amsterdam: Amsterdam University Press, 2002), 21.
17. Hamzah Hussin quoted in Heide, 105.
18. Ainon binti Haji Kuntom, *Malay Film Industry in Singapore and Malaysia* (Penang: Universiti Sains Malaysia, 1973), 9; Mohamad Hatta Azad Khan, "The Malay Cinema (1948–1989) Early History and Development" (PhD diss., University of New South Wales, 1994), 136.
19. Jamil Sulong, *Kaca Permata: Memoir Seorang Pengarah* (Kuala Lumpur: Dewan Bahasa dan Pustaka, 1990), 35.
20. Jan Uhde and Yvonne Ng Uhde, "The Exotic Pontianaks," in *Fear Without Frontiers: Horror Cinema Across the Globe*, ed. Steven Jay Schneider (Godalming: Fab, 2003), 129.
21. Jan van der Puttten, "Bangsawan: The Coming of a Malay Popular Theatrical Form," *Indonesia and the Malay World* 42, no. 123 (2014): 268–285.
22. Tan Sooi Beng, "From Popular to 'Traditional' Theater: The Dynamics of Change in Bangsawan of Malaysia," *Ethnomusicology* 33, no. 2 (1989): 229–274. See also her *Bangsawan: A Social and Stylistic History of Popular Malay Opera* (Oxford: Oxford University Press, 1993).
23. Hassan Muthalib and Wong Tuck Cheong, "Malaysia: Gentle Winds of Change," in Vasudev, Padgonkar and Doraiswamy, *Being and Becoming*, 48.
24. Sharifah Zinjuaher H. M. Ariffin and Hang Tuah Arshad, *Sejarah Filem Melayu* (Kuala Lumpur: Sri Sharifah, 1980), 9–10.
25. Jamil, *Kaca Permata*, 58.
26. Hanita Mohd. Mohktar-Ritchie, "Negotiating Melodrama and the Malay Woman: Female Representation and the Melodramatic Mode in Malaysian-Malay Films from the Early 1990s–2009" (PhD diss., University of Glasgow, 2011), 58.
27. Timothy White, "Pontianaks and the Issue of Verisimilitude in Singaporean Cinema," unpublished paper, Department of English Language and Literature, National University of Singapore (2002), 4.
28. Jamil, *Kaca Permata*, 57.
29. White, "Verisimilitude," 6.
30. Jamil bin Sulong, "Bangsawan's Influence in Malay Films," in *Cerita Filem Malaysia* (Hulu Klang: Perbadanan Kemajuan Filem Nasional, 1989), 57.
31. Jamil, "Bangsawan's Influence," 59.
32. Mohktar-Ritchie, "Melodrama," 57–58.

1. POPULAR HORROR AND THE ANTICOLONIAL IMAGINARY 243

33. Norman Yusoff, "Contemporary Malaysian Cinema: Genre, Gender and Temporality" (PhD diss., University of Sydney, 2013), 97–98; Uhde and Uhde, "Exotic" 129.
34. Hatta Azad Khan, "The Malay Cinema," 114.
35. Zamberi and Aami, *Malaysian Films*, 160–162, Hatta Azad Khan, "The Malay Cinema," 116.
36. Jamil, "Bangsawan's Influence," 58.
37. "Dari segi persembahannya pula, memang sudah dari mula filem-filem Melayu diarahkan oleh orang-orang India, maka cara persembahannya mempunyai ciri-ciri India di mana jalan ceritanya disulamkan dengan para pelakon menari dan menyayi dalam berbagai keadaan sedih, gembira dan sebagainya." Abi, *Filem Melayu: Dahulu dan Sekarang* (Shah Alam: Marwilis, 1987), 12.
38. Mokhtar-Ritchie, "Melodrama," 54; Ravi Vasudevan, "The Melodramatic Mode and the Commercial Hindi Cinema: Notes on Film History, Narrative and Performance in the 1950s," *Screen* 30, no. 3 (Summer 1989): 39.
39. Shahrom Mohd. Dom, "Struktur Filem Melayu: Nota Perbandingan Konsep dan Satu Pendekatan," paper presented at Forum of 4th Malaysian Film Festival, 1984, 5. Quoted in Zamberi and Aami, *Beginning*, 170.
40. Hatta Azad Khan, "The Malay Cinema," 124, Zamberi and Aami, *Malaysian Films*, 172.
41. Zamberi and Aami, *Malaysian Films*, 174.
42. Rolando B. Tolentino, "Niche Globality: Philippine Media Texts to the World," in *Popular Culture Co-Productions and Collaborations in East and Southeast Asia*, ed. Rolando Tolentino, Nissim Otmazgin, and Eyal Ben-Ari (Singapore: NUS Press, 2013), 154.
43. Hatta Azad Khan, "The Malay Cinema," 117.
44. Hatta Azad Khan, 118.
45. Quoted Zamberi and Aami, *Malaysian Films*, 164.
46. Hatta Azad Khan, "The Malay Cinema," 128–129.
47. "Tambahan pula, pengarah-pengarah filem pada masa itu banyak yang diimport. Antara dari India, Manila, Hong Kong dan ada juga dari England. Mereka itu semuanya mempunyai asas kerja-kerja pengarahan. Kerana itulah peluang orang Melayu untuk menjadi pengarah filem Melayu terlalu sedikit." Salleh Ghani, *Filem Melayu: Dari Jalan Ampas ke Ulu Klang* (Kuala Lumpur: Variapop, 1989), 14.
48. Sharifah Zinjuaher and Hang Tuah, *Sejarah*, 25.
49. Salleh, *Filem Melayu*, 14.
50. Sharifah Zinjuaher and Hang Tuah, *Sejarah*, 25.
51. Hatta Azad Khan, "The Malay Cinema," 118.
52. "Jadi untuk apa perlunya jawatan Direktor itu jika ia tidak mengetahui bahasa dan dialog filemnya?" Sharifah Zinjuaher and Hang Tuah, *Sejarah*, 25.
53. "Penolong pengarah juga bertanggungjawab menjaga segala adat resam orang Melayu, kiranya ada babak-babak yang menyentuh adat istiadat orang Melayu dalam filem itu." Salleh, *Filem Melayu*, 14.
54. Salleh, 15.
55. Hatta Azad Khan, "The Malay Cinema," 119.
56. Hassan and Wong, "Malaysia," 49; Salleh, *Filem Melayu*, 15.
57. Anonymous, "S. Sudarmadji Menolong Ramon," *Majallah Filem*, October 1964, 2.
58. Anonymous, "'Pontianak Gua Musang' Filem Yang Mempunyai Keistimewaan," *Berita Harian*, October 3, 1964, 7.
59. Suhari, "Pontianak Gua Musang Ta' Tentu Chorak Cherita-nya," *Berita Harian*, December 5, 1964, 7.
60. Hassan Abdul Muthalib, "The End of Empire: The Films of the Malayan Film Unit in 1950s British Malaya," in *Film and the End of Empire*, ed. Lee Grieveson and Colin MacCabe (London: BFI/Palgrave, 2011), 182.

61. Virginia Matheson Hooker, *Writing a New Society: Social Change Through the Novel in Malay* (Leiden: KITLV, 2000), 182.
62. T. N. Harper, *The End of Empire and the Making of Malaya* (Cambridge: Cambridge University Press, 1999), 290.
63. Harper, 290.
64. Abdullah Hussein, *P. Ramlee: Kisah Hidup Seniman Agung*, 147, quoted in Hatta Azad Khan, "The Malay Cinema," 131.
65. Hatta Azad Khan, "The Malay Cinema," 134.
66. Lim, *Cathay*, 130.
67. Hatta Azad Khan, "The Malay Cinema," 122.
68. Zamberi and Aami, *Malaysian Films*, 188.
69. Lim, *Cathay*, 135.
70. Susan Barrie, "A Hag to Beauty Then Kampong Vampire," *Straits Times*, May 3, 1957, 8.
71. Anonymous, "Now It's the Curse," *Singapore Standard*, April 18, 1958, 13.
72. Zieman, "A Role She Will Always Be Remembered For," *The Star*, August 19, 2007.
73. Zieman, "Role."
74. Allan Koay, "Famed Foe, the Pontianak," *The Star*, August 5, 2005.
75. Anonymous, "Maria Menado in Mata Hari," *Movie News*, issue number missing, 1958, 17.
76. Raphaël Millet, *Singapore Cinema* (Singapore: Editions Didier Millet, 2006), 44–45; Bervin Cheong, "Fabulous Fifties: Celebrating Malaysia's Classic Style Icons," *The Star*, August 30, 2014.
77. Doug Lackersteen, "Lion of Malaya to Be Filmed Soon," *Straits Times*, November 23, 1958, 1.
78. Anonymous, "Film Queen Maria Gets the Sack," *Singapore Standard*, December 3, 1958, 1.
79. Anonymous, "Maria on Contract for Film in RI," *Straits Times*, January 9, 1959, 7; Suresh Kohli, "Singapore (1960)," *The Hindu*, May 22, 2011.
80. Lim, *Cathay*, 120.
81. Anonymous, "Bunga Tanjong," *Mastika Filem*, December 1962, 22.
82. Hanisah Selamat, "Produser Wanita Jangan Takut Bersaing—Maria Menado," *Berita Harian*, January 7, 2019.
83. Uhde and Udhe, "Exotic," 128.
84. Zieman, "Role."
85. Zieman, "Role."
86. Quoted in Hooker, *Writing*, 188, original in "Surat dari Pengarang," *Mastika*, December 1953.
87. Timothy Barnard and Jan van der Putten, "Malay Cosmopolitan Activism in Post-War Singapore," in *Paths Not Taken: Political Pluralism in Post-War Singapore*, ed. Michael Barr and Carl Trocki (Singapore: NUS Press, 2008), 133.
88. Harper, *Empire*, 282.
89. Hooker, *Writing*, 182.
90. Virginia Matheson, "Usman, Awang, Keris Mas and Hazmah: Individual Expressions of Social Commitment in Malay Literature," *Review of Indonesian and Malaysian Affairs* 21, no. 1 (1987), 108.
91. Timothy Barnard, "Sedih Sampai Buta: Blindness, Modernity, and Tradition in the Malay Films of the 1950s and 60s," *KITLV Journal* 161, no. 4 (2005): 436.
92. Harper, *Empire*, 285; Barnard and Putten, "Malay Cosmopolitan," 78.
93. Hooker, *Writing*, 184.
94. Barnard and Putten, "Malay Cosmopolitan," 144.
95. Hooker, *Writing*, 185–186.
96. Harper, *Empire*, 295.
97. "Semangat kebangsaan di-negara-negara Asia dan Afrika pada asas-nya berupa sikap hendak mempertahankan diri daripada pengaroh Barat." Editorial, "Mencari Keperibadian Sendiri," *Penulis* 1, no. 1 (January 1964): 3.

1. POPULAR HORROR AND THE ANTICOLONIAL IMAGINARY ❦ 245

98. "Perkara yang kedua ia-lah tentang hubongan kita dengan Barat dalam bidang kebudayaan dan kesusasteraan. Terang pada pandangan mata kasar kita bahawa pada kebiasaan-nya kita menerima anasir-anasir yang terburuk sa-kali daripada kebudayaan Barat." Editorial, "Mencari," 4.
99. "Hasil-hasil kebudayaan yang mereka expot, sama ada melalui wayang gambar, piring hitam atau pun buku, penoh denagan natijah dan isi yang boleh meruntohkan akhlak dan ethika bangsa kita." Editorial, "Mencari," 4.
100. Aihwa Ong, "The Production of Possession: Spirits and the Multinational Corporation in Malaysia," *American Ethnologist* 15, no. 1 (February 1988): 28–42.
101. Suhaimi Haji Muhammad, "Kebenaran," *Mastika*, January 1959, 10.
102. Some *Penulis* writers took a more nuanced view. Taib argues for the need to set aside emotive labels like "modern," "ancient," "classic," and "decadent" in thinking about contemporary Malay literature and culture. He argues that "we consider all literary and artistic outcomes as fulfilling the will, the sense of taste and the basics expression of one's style and society in one instant." ("Kita anggap semua hasil sastera dan kesuasteraan sebagai memenuhi kehendak, daya rasa dan dasar2 pemikiran satu2 corak dan golongan masyarakat pada satu2 ketika.") Mohd. Taib Osman, "Kesusasteraan Melayu dengan Corak Masyarakat dan Budayanya," *Penulis* 3, no. 1 (January 1969): 79.
103. Hooker, *Writing*, 367.
104. Partha Chatterjee, *The Nation and Its Fragments: Colonial and Postcolonial Histories* (Princeton: Princeton University Press, 1993), 6.
105. Chatterjee, 6.
106. Harper, *Empire*, 229.
107. Charles Hirschman, *Ethnic and Social Stratification in Peninsular Malaysia* (Washington, DC: American Sociological Association, 1965), 7.
108. Khoo Kay Kim, "The Emergence of Plural Communities in the Malay Peninsula Before 1874," in *Multiethnic Malaysia, Past, Present and Future*, ed. Lim Teck Ghee, Alberto Gomes, and Azly Rahman (Petaling Jaya: MiDAS, 2009), 12–14.
109. Khoo, 16–17.
110. Khoo, 20.
111. Hirschman, *Stratification*, 11.
112. J. S. Furnivall, *Colonial Policy and Practice: A Comparative Study of Burma and Netherlands India* (New York: NYU Press, 1965), 304–305.
113. Daniel P. S. Goh and Philip Holden, "Introduction: Postcoloniality, Race and Multiculturalism," in *Race and Multiculturalism in Malaysia and Singapore*, ed. Daniel P. S. Goh, Matilda Gabrielpillai, Philip Holden, and Gaik Cheng Khoo (New York: Routledge, 2009), 4.
114. Khoo, "Emergence," 11, 29.
115. Mohd. Taib Osman, *Malay Folk Beliefs: An Integration of Disparate Elements* (Kuala Lumpur: Dewan Bahasa dan Pustaka, 1989), 45.
116. Hassan and Wong, "Malaysia," 48 and 186.
117. Hatta Azad Khan, "The Malay Cinema," 305.
118. Joel S. Kahn, *Other Malays: Nationalism and Cosmopolitanism in the Modern Malay World* (Singapore: NUS Press and NIAS Press, 2006), 117.
119. Amir Muhammad, *120 Malay Movies* (Petaling Jaya: Matahari, 2010), 21–22.
120. Amir, *Movies*, 27; Zamberi and Aami, *Malaysian Films*, ix.
121. Hatta Azad Khan, *Other Malays*, 116.
122. See, for example, Mohd. Taib Osman, "Pantun, Syair dan Sajak: dari Segi Pandangan Diakronis dan Sinkronis," *Penulis* 2, no. 1 (1968): 17. Taib points out that "pantun is a people's poetic tradition (oral) and is still fertile in kampungs, in rural areas that have yet to experience the city's rapid urbanization." ("pantun adalah tradisi puisi rakyat [lisan] dan masih hidup subur dikampung-kampung, iaitu dalam golongan luar bandar yang belum merasai arus hidup yang pesat dikota-kota.")

123. Barrie, "Hag," 8.
124. Eric Hobsbawm and Terence Ranger, eds., *The Invention of Tradition* (Cambridge: Cambridge University Press, 1983).
125. Clive S. Kessler, "Archaism and Modernity: Contemporary Malay Political Culture," in *Fragmented Vision: Culture and Politics in Contemporary Malaysia*, ed. Joel S. Kahn and Francis Loh Kok Wah (Sydney: Allen and Unwin, 1992), 135.
126. Theodore C. Bestor, *Neighborhood Tokyo* (Stanford: Stanford University Press, 1989), 2.
127. Kessler, "Archaism," 141.
128. Anthony Milner, *The Malays* (London: Wiley-Blackwell, 2011), 76, 103, 241.
129. Anthony Reid, "Understanding *Melayu* (Malay) as a Source of Diverse Modern Identities," in *Contesting Malayness: Malay Identity Across Boundaries*, ed. Timothy Barnard (Singapore: Singapore University Press, 2004), 10.
130. Reid, 10.
131. Reid, 15–16.
132. Reid, 16.
133. Anonymous, "First News of Shaw's Latest Horror Film, Four Malayan Demons Meet in Anak Pontianak," *Movie News* 10, no. 7 (January 1958): 22.
134. Anonymous, 22.
135. Advertisement for *Anak Pontianak*, *Straits Times*, February 10, 1958, 5.
136. There are narrative hints that the tiger might have been a supernatural were-tiger, so there is some possibility of a supernatural ending, albeit not a pontianak.
137. Anonymous, "Pontianak Gua Musang," *Berita Filem* 46 (September 1964): 3.
138. Anonymous, "Seram," *Berita Filem* 48 (November 1964): 44–45.
139. Anonymous, "Pontianak Gua Musang," *Filem Malaysia*, August 1964, 20.
140. Uhde and Uhde, "Exotic," 131.
141. Andrew Ng, "Sisterhood of Terror: The Monstrous Feminine of Southeast Asian Horror Cinema," in *A Companion to the Horror Film*, ed. Harry Benshoff (London: Wiley, 2014), 450.
142. Amir, *Movies*, 329.
143. Amir, 329.
144. Hassan, "Empire," 187.
145. Hamzah, *Memoir*, 39.
146. "Sekali lagi usaha Tom Hodge untuk 'mendidik' pemikiran orang Melayu melalui filem dengan 'memodenkan' kepercayaan karut mereka gagal." Hamzah, 39.
147. "Penonton pada tahun enam puluhan tidak gemar bila nilai budaya dipermainkan." Hamzah, 39.
148. For further discussion of political pedagogy in popular cinema, see Jennifer Fay, *Theaters of Occupation: Hollywood and the Re-Education of Postwar Germany* (Minneapolis: University of Minnesota Press, 2008); and Ian Aitken and Camille Deprez, eds., *The Colonial Documentary Film in South and South-East Asia* (Edinburgh: Edinburgh University Press, 2017). For a Malay-specific analysis, see Nadine Chan, "A Cinema Under the Palms: The Unruly Lives of Colonial Educational Films in British Malaya" (PhD diss., University of Southern California, 2015).
149. Anonymous, "Pontianak Kembali," *Berita Filem* 38 (January 1964): 10.
150. Anonymous, 10.
151. See William R. Roff, *The Origins of Malay Nationalism* (New Haven: Yale University Press, 1967), 139–148.
152. Anonymous, "Pontianak Kembali," *Berita Filem* 30 (May 1963): 48.
153. Anonymous, "Pontianak Kembali," *Berita Filem* 38 (January 1964): 9.
154. Anonymous, "Pontianak Kembali," *Berita Filem* 26 (January 1963): 48.
155. Anonymous, "Pontianak Kembali," *Mastika* 10 (April 1963): 15.
156. "Kembali," 15.

157. Anonymous, "Pusaka Pontianak," *Berita Filem* 48 (November 1964): 16.
158. Anonymous, "Pusaka Pontianak," *Majallah Filem* 55 (October 1964): 6.
159. Wak Cantuk, "Cerita Hantu," *Berita Harian*, October 9, 2011, 8.

2. TROUBLING GENDER WITH THE PONTIANAK

1. Walter William Skeat, *Malay Magic: An Introduction to the Folklore and Popular Religion of the Malay Peninsula* (New York: Macmillan, 1900), 325.
2. Skeat, 326.
3. Tania De Rozario, "Death Wears a Dress," presentation at the Urban Weird Conference (University of Hertfordshire, 2018).
4. Kenneth Paul Tan, "Pontianaks, Ghosts and the Possessed: Female Monstrosity and National Anxiety in Singapore Cinema," *Asian Studies Review* 34, no. 2 (2010): 151.
5. Andrew Hock Soon Ng, "Death and the Maiden: The Pontianak as Excess in Malay Popular Culture," in *Draculas, Vampires, and Other Undead Forms: Essays on Gender, Race, and Culture*, ed. John Edgar Browning and Caroline Joan (Kay) Picart (Lanham, MD: Scarecrow, 2009), 173.
6. Adrian Yuen Beng Lee, "The Villainous Pontianak?: Examining Gender, Culture, and Power in Malaysian Horror Films," *Pertanika Journal* 24, no. 4 (2016): 1432.
7. Jamaluddin bin Aziz and Azlina binti Asaari, "Saka and the Abject: Masculine Dominance, the Mother and Contemporary Malay Horror Film," *Asian Journal of Women's Studies* 20, no. 1 (2014): 74.
8. Carol Clover, *Men, Women, and Chainsaws: Gender in the Modern Horror Film* (Princeton: Princeton University Press, 1992); Barbara Creed, *The Monstrous-Feminine: Film, Feminism, Psychoanalysis* (New York: Routledge, 1993).
9. Alicia Izharuddin, "Pain and Pleasure of the Look: the Female Gaze in Malaysian Horror Film," *Asian Cinema* 26, no. 2 (2015): 135.
10. Tom Barnes, "Women Caned in Malaysia for Attempting to Have Lesbian Sex," *Independent*, September 3, 2018; www.sistersinislam.org.my/; www.facebook.com/feministmalaysia/.
11. J. N. McHugh, *Hantu Hantu: An Account of Ghost Belief in Modern Malaya* (Singapore: Donald Moore, 1955), 80.
12. Ralph Modder, *Curse of the Pontianak* (Singapore: Horizon, 2004), 23–38.
13. Ng, "Death and the Maiden," 171; Elaine Showalter, *Sexual Anarchy: Gender and Culture at the Fin de Siècle* (London: Penguin, 1990), 181.
14. Carol A. Senf, "Dracula: The Unseen Face in the Mirror," *Journal of Narrative Technique* 9, no. 3 (Fall 1979): 167.
15. Lee, "The Villainous Pontianak?," 1434. We can also note here the transition from nails as in fingernails to nails as in hammer and nails. It's a slippage that only works in English, suggesting a colonial-era linguistic movement.
16. Cheryl L. Nicholas, "Speaking About Ghosts / Cerita Hantu Melaya" (PhD diss., University of Oklahoma, 2004), 23.
17. Angela M. Smith, *Hideous Progeny: Disability, Eugenics, and Classic Horror Cinema* (New York: Columbia University Press, 2012), 3.
18. Alicia, "Pain and Pleasure," 140; Stephen Teo, *The Asian Cinema Experience: Styles, Spaces, Theory* (New York: Routledge, 2013), 107.
19. Alicia Izharuddin, "The Laugh of the Pontianak: Darkness and Feminism in Malay Folk Horror," *Feminist Media Studies* 20, no. 7 (2020): 1001.
20. Tan, "Pontianaks, Ghosts and the Possessed," 151.

21. Ng, "Death and the Maiden," 170.
22. Andrew Ng Hock Soon, "Sisterhood of Terror: The Monstrous Feminine of Southeast Asian Horror Cinema," in *A Companion to the Horror Film*, ed. Harry M. Benshoff (New York: Wiley Blackwell, 2013), "Sisterhood of Terror," 450.
23. Nicolette Yeo, *Old Wives' Tales: Fascinating Tales, Beliefs and Superstitions of Singapore and Malaysia* (Singapore: Times, 2004), 15. See, for example, "Pregnant," in *Pontianak: True Stories*, ed. Pugalenthi, Sr. (Singapore: Asuras, 1996), 58–62; and "Maternity Woes" in *True Singapore Ghost Stories 5*, ed. Russell Lee (Singapore: Angsana, 1996), 64–67.
24. William van der Heide, *Malaysian Cinema, Asian Film: Border Crossings and National Cultures* (Amsterdam: Amsterdam University Press, 2002), 162, argues that we can consider melodrama to be an encompassing style across Malay and Malaysian cinema.
25. Nino Taziz, *From the Written Stone: an Anthology of Malaysian Folklore* (Kuala Lumpur: Utusan, 2006), 35–38.
26. Ralph Modder and Aeishah Ahmed, *Myths and Legends of Malaysia and Singapore* (Singapore: Horizon, 2009), 105.
27. Gaik Cheng Khoo, *Reclaiming Adat: Contemporary Malaysian Film and Literature* (Vancouver: UBC Press, 2006), 5.
28. Khoo, 4–5.
29. Khoo, 231.
30. Khoo, 16.
31. Raja Rohana Raja Mamat, *The Role and Status of Women in Malaysia: Social and Legal Perspectives* (Kuala Lumpur: Dewan Bahasa dan Pustaka, 1991), 19.
32. Maila Stivens, "Becoming Modern in Malaysia: Women at the End of the Twentieth Century," in *Women in Asia: Tradition, Modernity and Globalisation*, ed. Louise Edwards and Mina Roces (St. Leonards: Allen and Unwin, 2000), 26.
33. Stivens, 26.
34. Stivens, 17.
35. Aihwa Ong, "State Versus Islam: Malay Families, Women's Bodies, and the Body Politic in Malaysia," in *Bewitching Women, Pious Men: Gender and Body Politics in Southeast Asia*, ed. Aihwa Ong and Michael G. Peletz (Berkeley: University of California Press, 1995), 161–164.
36. Alicia, "Pain and Pleasure of the Look," 139.
37. Khoo, *Reclaiming Adat*, 5, *124;* Rosalind Galt, "The Prettiness of Italian Cinema," in *Popular Italian Cinema*, ed. Sergio Rigoletto and Louis Bayman (Basingstoke, UK: Palgrave, 2013), 52–68.
38. This history of censorship will be addressed in more detail in chapter 3.
39. Shuhaimi Baba quoted in Faridul Anwar Farinordin, "Pontianak Returns with a Vengeance," *New Straits Times*, May 1, 2004.
40. Krzysztof Gonerski, "A Closer Look on Malaysian Thrillers and Horrors," trans. Klaudia Januszewska, *Five Flavours*, February 9, 2018.
41. Discussion thread on "New Thai Horror" on *The Fortean Times*, http://forum.forteantimes.com/index.php?threads/new-thai-horror.15694.
42. Norman Yusoff, "Contemporary Malaysian Cinema: Genre, Gender and Temporality" (PhD diss., University of Sydney, 2013), 109.
43. Alicia, "Pain and Pleasure," 136.
44. Ng, "Death and the Maiden," 167.
45. Amanda Nell Eu, interview with author.
46. Michael Dove, *The Banana Tree at the Gate: A History of Marginal Peoples and Global Markets in Borneo* (New Haven: Yale University Press, 2011), 35.
47. Boo Su-Lyn, "How a Malaysian Artist Brought a 'Pontianak' to New York," *Malay Mail*, June 22, 2016.

48. Boo, "Artist."
49. C. A. Xuan Mai Ardia, "Legends, Ghosts and Feminism: Malaysian Artist Yee I-Lann at Tyler Rollins Fine Art," *Art Radar*, October 6, 2016.
50. Amanda Nell Eu, interview with author.
51. Nosa Normanda, interview with author. Nosa's family comes from West Kalimantan, where Indonesian-Chinese communities have a long history. By including a Chinese pontianak, Nosa attends to regional specificity in a way that is ignored by the usual racial separations of the genre.
52. Nosa Normanda, interview with author. See also Intan Paramaditha, *Apple and Knife* (London: Harvill Secker, 2018).
53. Rhona J. Berenstein, *Attack of the Leading Ladies* (New York: Columbia University Press, 2018), 38.
54. For an example of debate over the relationship of softness and queerness, see Au Yeong How, "Iqram: Tidak Semua Lelaki Lembut Itu Gay," *MStar*, June 18, 2009.
55. Bliss Cua Lim, "Spectral Times: The Ghost Film as Historical Allegory," *positions* 9, no. 1 (2001): 289.
56. Bliss Cua Lim, "Queer Aswang Transmedia: Folklore as Camp," *Kritika Kultura* 24 (2015): 181.
57. See, for instance, Robin Wood's classic analysis of the horror film in terms of the return of the repressed in "An Introduction to the American Horror Film," in *American Nightmare: Essays on the Horror Film*, ed. Andrew Britton, Richard Lippe, Tony Williams, and Robin Wood (Toronto: Festival of Festivals, 1979); Harry M. Benshoff, *Monsters in the Closet: Homosexuality and the Horror Film* (Manchester: Manchester University Press, 1997); Michael Saunders, *Imps of the Perverse: Gay Monsters in Film* (Westport, CT: Praeger, 1998); and Noreen Giffney and Myra J. Hird, eds., *Queering the Non/Human* (Aldershot, UK: Ashgate, 2008).
58. Jamaluddin and Azlina, "Saka and the Abject," 73.
59. Ong, "State Versus Islam," 187.
60. Nicola Smith, "Malaysia's PM Rejects Same-Sex Marriage," *Telegraph*, October 26, 2018; Boo Su-Lyn, "LGBT Activists' Portraits Removed from George Town Festival Exhibition," *Malay Mail*, August 8, 2018; Ella Braidwood, "Police Raid Malaysian Gay Bar to 'Stop the Spread of LGBT Culture in Society,'" *Pink News*, August 18, 2018, www.pinknews.co.uk/2018/08/18/police-raid-malaysian-gay-bar-to-stop-the-spread-of-lgbt-culture-in-society/.
61. Thilaga Sulathireth, quoted in Hannah Ellis-Peterson, "Malaysia Accused of 'State-Sponsored Homophobia' After LGBT Crackdown," *Guardian*, August 22, 2018.

3. RACE, RELIGION, AND MALAY IDENTITIES

1. Anthony Milner, *The Malays* (London: Wiley-Blackwell, 2011). He points out the many examples of groups who have considered themselves Malay without adhering to one or more of these stipulations, as well as groups who adhere to them without considering themselves to be Malay (1–5).
2. Charles Hirschman, "The Making of Race in Colonial Malaya: Political Economy and Racial Ideology," *Sociological Forum* 1, no. 2 (Spring 1986): 330.
3. Robert W. Hefner, ed., *The Politics of Multiculturalism: Pluralism and Citizenship in Malaysia, Singapore, and Indonesia* (Honolulu: University of Hawai'i Press, 2001), 42.
4. Hefner, 4.
5. Ariffin Omar, *Bangsa Melayu: Malay Concepts of Democracy and Community, 1954–1950* (Kuala Lumpur: Oxford University Press, 1993), 194.
6. Maznah Mohamad and Syed Muhd Khairudin Aljunied, eds., *Melayu: The Politics, Poetics and Paradoxes of Malayness* (Singapore: NUS Press, 2011), x–xi.

7. Daniel P. S. Goh and Philip Holden, "Introduction: Postcoloniality, Race and Multiculturalism," in *Race and Multiculturalism in Malaysia and Singapore*, ed. Daniel P. S. Goh, Matilda Gabrielpillai, Philip Holden, and Gaik Cheng Khoo (New York: Routledge, 2009), 2.
8. Goh and Holden, 1.
9. Sharmani P. Gabriel, "The Meaning of Race in Malaysia: Colonial, Post-Colonial and Possible New Conjunctures," *Ethnicities* 15, no. 6 (2015): 783.
10. Michael D. Barr and Zlatko Skrbiš, *Constructing Singapore: Elitism, Ethnicity, and the Nation Building Project* (Copenhagen: NIAS Press, 2008), 50.
11. Lian Kwen Fee and Narayanan Ganapathy, "The Politics of Racialization and Malay Identity," in *Multiculturalism, Migration and the Politics of Identity in Singapore*, ed. K. F. Lian (Singapore: Springer, 2016), 106.
12. Sheila Nair, "The Limits of Protest and Prospects for Political Reform in Malaysia," *Critical Asian Studies* 39, no. 3 (2007): 88–89.
13. Ooi Kee Beng, "Beyond Ethnocentrism: Malaysia and the Affirmation of Hybridisation," in *Multiethnic Malaysia, Past, Present and Future*, ed. Lim Teck Ghee, Alberto Gomes, and Azly Rahman (Petaling Jaya: MiDAS, 2009), 456–457.
14. Judith Nagata, "Boundaries of Malayness: 'We Have Made Malaysia: Now It Is Time to (Re)Make the Malays but Who Interprets the History?,'" in Maznah and Syed Muhd Khairudin, *Melayu*, 23.
15. Mahathir Mohamad, *The Malay Dilemma* (Singapore: Marshall Cavendish, 2008), 162–163.
16. John Locke, *Second Treatise of Government and a Letter Concerning Toleration* (Oxford: Oxford University Press, 2016), 14–26.
17. Aníbal Quijano, "Coloniality and Modernity/Rationality," *Cultural Studies* 21, no. 2 (2007): 168–178; Judith Butler and Athena Athanasiou, *Dispossession: The Performative in the Political* (London: Polity, 2013), 7–9.
18. Ruaslina Idrus, "Malays and Orang Asli: Contesting Indigeneity," in Maznah and Syed Muhd Khairudin, *Melayu*, 101–123.
19. Nair, "The Limits of Protest," 84; Syed Hussein Alatas, *The Myth of the Lazy Native: A Study of the Image of the Malays, Filipinos and Javanese from the 16th to the 20th Century and Its Function in the Ideology of Colonial Capitalism* (London: Frank Cass, 1977).
20. "Masalah watak tertawan disebabkan oleh . . . tersebarnya pengaruh budaya Barat . . . sebagai kuasa imperialis yang terbesar dalam sejarah dunia." Syed Hussein Alatas, "Watak Tertawan di Negara Membangun," in *Pascakolonialisme dalam Pemikiran Melayu*, ed. Mohamad Daud Mohamad and Zabidah Yahya (Kuala Lumpur: Dewan Bahasa dan Pustaka, 2005), 1–2.
21. Geoffrey Wade, "The Origins and Evolution of Ethnocracy in Malaysia," *Working Paper Series*, no. 112 (Asia Research Institute, NUS, 2009), 9.
22. Chua Beng-Huat, *Culture, Multiracialism, and National Identity in Singapore* (Singapore: NUS Press, 1995), 169.
23. Maznah Mohamad, "Like a Shady Tree Swept by the Windstorm: Malays in Dissent," in Maznah and Syed Muhd Khairudin, *Melayu*, 36.
24. Stuart Hall, "New Ethnicities," in *Race, Culture and Difference*, ed. J. Donald and A. Rattansi (London: Sage, 1992), 252–259.
25. Richard Dyer, *White: Essays on Race and Culture* (London: Routledge, 1997), 13–14.
26. Kristin Thompson, "The Concept of Cinematic Excess," *Cine-Tracts* 1/2 (1977): 54–64. Melanesia can in part be included within the Malay world, although not all accounts would consider it to be so.
27. Andrew Ng Hock Soon, "A Cultural History of the Pontianak Films," in *New Malaysian Essays 2*, ed. Amir Muhammad (Petaling Jaya: Mata Hari, 2009), 232.
28. Sophia Siddique Harvey, "Mapping Spectral Tropicality in *The Maid* and *Return to Pontianak*," *Singapore Journal of Tropical Geography* 29 (2008): 30.

3. RACE, RELIGION, AND MALAY IDENTITIES

29. Kenneth Paul Tan, "Pontianaks, Ghosts and the Possessed: Female Monstrosity and National Anxiety in Singapore Cinema," *Asian Studies Review* 34, no. 2 (2010): 159.
30. Tan, 159.
31. Zen Cho, *Spirits Abroad* (Kuala Lumpur: Fixi, 2015).
32. Zen Cho, author website, https://zencho.org/frequently-asked-questions/.
33. See, among many examples, Robin Wood, "Introduction to the American Horror Film," in *American Nightmare: Essays on the Horror Film* (Toronto: Festival of Festivals, 1979), 7–28; and Christopher Sharrett, "The Horror Film as Social Allegory (and How It Comes Undone)," in *A Companion to the Horror Film*, ed. Harry M. Benshoff (New York: Wiley, 2017), 56–89.
34. Gaik Cheng Khoo, "Introduction: Theorizing Different Forms of Belonging in a Cosmopolitan Malaysia," in *Malaysia's New Ethnoscapes and Ways of Belonging*, ed. Gaik Cheng Khoo and Julian C. H. Lee (London: Routledge, 2016), 2.
35. The word *sesuai* translates as "suitable" but it does a lot of ideological work in Malay, connoting that which is culturally normative and acceptable.
36. Sumit K. Mandal, "Transethnic Solidarities, Racialisation and Social Equality," in *The State of Malaysia: Ethnicity, Equity and Reform*, ed. Edmund Terence Gomez (London: Routledge, 2004), 49.
37. Amir Muhammad, "The Malay/sian Dilemma," in *Generation: A Collection of Contemporary Malaysian Ideas*, ed. Amir Muhammad, Kam Raslan, and Sheryll Stothard (Kuala Lumpur: Hikayat, 1998), 103.
38. Khoo, "Introduction," 2, 4.
39. Olivia Khoo, "Slang Images: On the Foreignness of Contemporary Singaporean Films," *Inter-Asia Cultural Studies* 7, no. 1 (2006): 81–98.
40. Gerald Sim, "Historicizing Singapore Cinema: Questions of Colonial Influence and Spatiality," *Inter-Asia Cultural Studies* 12, no. 3 (2011): 358–370; see also Sim, *Postcolonial Hangups in Southeast Asian Cinema: Poetics of Space, Sound, and Stability* (Amsterdam: Amsterdam University Press, 2020), 53–96.
41. Nagata, "Boundaries of Malayness," 26.
42. Nagata, 20.
43. Ahmad Fauzi Abdul Hamid, "Malay Racialism and the Sufi Alternative," in Maznah and Syed Muhd Khairudin, *Melayu*, 86.
44. I will discuss animism and syncretism in more detail in chapter 5.
45. Walter William Skeat, *Malay Magic: An Introduction to the Folklore and Popular Religion of the Malay Peninsula* (New York: Macmillan, 1900), 327.
46. Andrew Ng, "Sisterhood of Terror: The Monstrous Feminine of Southeast Asian Horror Cinema," in *A Companion to the Horror Film*, ed. Harry M. Benshoff (London: Wiley Blackwell, 2017), 442.
47. Amir Muhammad, *120 Malay Movies* (Petaling Jaya: Matahari, 2010), 24.
48. Muhamad Ali, *Islam and Colonialism: Becoming Modern in Indonesia and Malaya* (Edinburgh: Edinburgh University Press, 2016), 34, 43.
49. Hamzah Hussin, *Memoir Hamzah Hussin: Dari Cathay Keris ke Studio Merdeka* (Bangi: Penerbit Universiti Kebangsaan Malaysia, 1998), 42.
50. Anonymous, "Players Herald Shooting of New Film," *Sunday Standard*, June 2, 1957, 3.
51. Anonymous, "Wily, 'Talking' Mousedeer Is $500 Windfall to Singapore Youth," *Straits Times* December 18, 1957, 7.
52. Jason P. Abbott and Sophie Gregorios-Pippas, "Islamization in Malaysia: Processes and Dynamics," *Contemporary Politics* 16, no. 2 (2010): 136.
53. For discussion of these various social changes, see Abbott and Gregorios-Pippas, 135–136; and Azmi Aziz and A. B. Shamsul, "The Religious, the Plural, the Secular and the Modern: A Brief Critical Survey on Islam in Malaysia," *Inter-Asia Cultural Studies* 5, no. 3 (2004): 353–354.

54. Azmi and Shamsul, "The Religious," 354.
55. Abbott and Gregorios-Pippas, "Islamization in Malaysia," 137.
56. Kua Kia Soong, "Racial Conflict in Malaysia: Against the Official History," *Race and Class* 49, no. 3 (2007): 43.
57. See, for example, Kua, "Racial Conflict," 35; Khoo Kay Jin, "The Grand Vision: Mahathir and Modernisation," in *Fragmented Vision: Culture and Politics in Contemporary Malaysia*, ed. Joel S. Kahn and Francis Loh Kok Wah (Sydney: Allen and Unwin, 1992), 49; and Judith Nagata, "Religious Ideology and Social Change: The Islamic Revival in Malaysia," *Pacific Affairs* 53, no. 3 (1980): 407.
58. Zainah Anwar, *Islamic Revivalism in Malaysia: Dakwah Among the Students* (Petaling Jaya: Pelanduk, 1987), 10.
59. Zainah, 4–5.
60. Joseph Chinyong Liow, "Political Islam in Malaysia: Problematising Discourse and Practice in the UMNO-PAS 'Islamisation Race,'" *Commonwealth and Comparative Politics* 42, no. 2 (2004): 184.
61. Farish A. Noor, "Blood, Sweat and Jihad: The Radicalization of the Political Discourse of the Pan-Malaysian Islamic Party from 1982 Onwards," *Contemporary Southeast Asia* 25, no. 2 (2003): 203.
62. Michael D. Barr and Anantha Raman Govindasamy, "The Islamisation of Malaysia: Religious Nationalism in the Service of Ethnonationalism," *Australian Journal of International Affairs* 64, no. 3 (2010): 299.
63. Barr and Govindasamy, 294.
64. Aihwa Ong, "State Versus Islam: Malay Families, Women's Bodies, and the Body Politic in Malaysia," in *Bewitching Women, Pious Men: Gender and Body Politics in Southeast Asia*, ed. Aihwa Ong and Michael G. Peletz (Berkeley: University of California Press, 1995), 177.
65. Dahlia Martin, "Gender, Malayness, and the Ummah: Cultural Consumption and Malay Muslim Identity," *Asian Studies Review* 38, no. 3 (2014): 404.
66. A suggestive study by Iman Research in 2019 on Malaysian youths who support violent extremism found that "the main drivers behind violent extremism in Malaysia are our national politics that is tinged with racial undertones." There is a direct line from the ethnonationalism of the immediate postcolonial era to the religious extremism of the present day, and histories of colonialism and racism are central to interpreting such studies. Dina Zaman, "An Inconvenient Truth?," *The Star* March 17, 2019.
67. Ameer Ali, "Islamic Revivalism in Harmony and Conflict," *Asian Survey* 24, no. 3 (1984): 299; Mohamad Abu Bakar, "External Influences on Contemporary Islamic Resurgence in Malaysia," *Contemporary Southeast Asia* 13, no. 2 (1991): 222, 225; Nagata, "Religious Ideology," 413; Farish, "Blood, Sweat and Jihad," 204.
68. Zainah, *Islamic Revivalism*, 24; Greg Fealy, "Islamisation and Politics in Southeast Asia: The Contrasting Cases of Malaysia and Indonesia," in *Islam in World Politics*, ed. Nelly Lahoud and Anthony H. Johns (New York: Routledge, 2005), 159; and Abu Bakar, "External Influences," 222.
69. See, for example, Andreas Ufen, "Political Finance and Corruption in Southeast Asia: Causes and Challenges," in *The Changing Face of Corruption in the Asia Pacific: Current Perspectives and Future Challenges*, ed. Marie de la Rama and Chris Rowley (Amsterdam: Elsevier, 2017), 23–33.
70. Anonymous, "Wahabbism Has No Place Here," *The Star*, August 28, 2016; Tavleen Tarrant and Joseph Sipalan, "Worries About Malaysia's 'Arabisation' Grow as Saudi Ties Strengthen," *Reuters*, December 21, 2017, www.reuters.com/article/us-malaysia-politics-religion-analysis/worries-about-malaysias-arabisation-grow-as-saudi-ties-strengthen-idUSKBN1EF1O3.
71. Marina Mahathir, quoted in Tarrant and Sipalan, 2017.
72. Ahmad Farouk Musa, quoted in Abdar Rahman Koya, "'Wahhabisation' Greater Threat Than Arabisation, Says IRF Chief," *Free Malaysia Today*, December 1, 2017, www.freemalaysiatoday.com/category/nation/2017/12/01/wahhabisation-greater-threat-than-arabisation-says-irf-chief/.

73. Fuziah Kartini Hassan Basri and Raja Ahmad Alauddin, "The Search for a Malaysian Cinema: Between U-Wei, Shuhaimi, Yusof and LPFM," *Asian Cinema* (Winter 1995): 71–72.
74. Ng, "Sisterhood of Terror," 450.
75. Azlina Asaari and Jamaluddin Aziz, "Perkembangan Filem Seram di Malaysia: Satu Tinjauan Literatur," *e-Bangi: Journal of Social Sciences and Humanities* 12, no. 2 (2017): 40.
76. Ian Stewart, "Sex, Violence, and Horror Banned on TV," *South China Morning Post*, February 7, 1995. See also Lee Yuen Beng and Mustafa Kamal Anuar, "Kebangkitan Semula Filem Seram di Malaysia: Liberalisasi atau Komersialisasi?," in *Antologi Esei Komunikasi: Teori, Isu dan Amalan*, ed. Azman Azwan Azmawati, Mahyuddin Ahmad, Mustafa Kamal Anuar, and Wang Lay Kim (Pulau Pinang: Penerbit Universiti Sains Malaysia, 2015), 142n2.
77. Azlina and Jamaluddin, "Perkembangan," 40.
78. Zieman, "Classics Among 22 on List of Banned Films," *The Star*, April 13, 2003.
79. Masami Mustaza, "UMNO Wing Gives Moviemakers the Creeps," *Malay Mail*, October 15, 2009; Julia Zappei, "Horror Films Rise from the Dead in Malaysia," *Asia One*, March 21, 2012, www.asiaone.com/print/News/Latest%2BNews/Showbiz/Story/A1Story20120321-334769.html.
80. Hassan Muthalib and Wong Tuck Cheong, "Malaysia: Gentle Winds of Change," in *Being and Becoming: The Cinemas of Asia*, ed. Aruna Vasudev, Latika Padgonkar, and Rashmi Doraiswamy (Delhi: Macmillan, 2002), 321.
81. Wan Amizah Wan Mahmud, Chang Peng Kee, and Jalamuddin Aziz, "Film Censorship in Malaysia: Sanctions of Religious, Cultural, and Moral Values," *Jurnal Komunikasi* 25 (2009): 47.
82. Gordon Kho, "Horror Movies Making a Killing," *The Star*, September 4, 2018.
83. Osman quoted in Kho, "Horror Movies."
84. "Syaitan itu memberikan janji-janji kepada mereka dan membangkitkan angan-angan kosong pada mereka, padahal syaitan itu tidak menjanjikan kepada mereka selain dari tipuan belaka." *Qur'an*, Surat An-Nisa 120, https://tafsirq.com/4-an-nisa/ayat-120.
85. Farish, "Blood, Sweat, and Jihad," 213.
86. Timothy P. Daniels, "Introduction: Performance, Popular Culture, and Piety in Malaysia and Indonesia," in *Performance, Popular Culture, and Piety in Muslim Southeast Asia*, ed. Timothy P. Daniels (New York: Palgrave, 2013), 8–9.
87. Timothy P. Daniels, "'Islamic' TV Dramas, Malay Youth, and Pious Visions for Malaysia," in Daniels, *Performance*, 107–108, 118.
88. We can contrast this effect to the classical films, which were willing to depict Malay villains. For instance, in *Pontianak Gua Musang*, the murderous Halimah is the only person to wear a headscarf, and her habit of recovering her head is used as a way of indicating her duplicity and false modesty.
89. It is noteworthy that the makers of *Konpaku* consider it to be transgressive for managing to depict an interracial romance at all, even if the female lead turns out to be an evil demon. www.konpakuthemovie.com/.
90. Karin van Nieuwkirk, *Muslim Rap, Halal Soaps, and Revolutionary Theater* (Austin: University of Texas Press, 2011), 1–5.
91. Ong, "State Versus Islam," 177.
92. Zaidi Mohamad, "Emma Maembong Jadi Pontianak Bertudung," *Berita Harian*, March 13, 2016.
93. Anonymous, "Emma Berubah Wajah Jadi 'Puntianak Sesat,'" *Berita Harian*, March 17, 2016.
94. Jac S. M. Kee, "Boundary Monsters in a Time of Magic," in *New Malaysian Essays 2*, ed. Amir Muhammad (Petaling Jaya: Mata Hari, 2009), 267.
95. Kee, 266.
96. Zurairi Ar, "'Fans Tell Me I'm Going to Hell': Emma Maembong Laments Online Bullying After Unveiling," *Malay Mail*, February 9, 2019.
97. Nieuwkirk, *Muslim Rap*, 21, discusses how pious productions emphasize restricted bodily movements for women in order to avoid improper excess or sensuality. Rose's attempt to avoid signs of

pontianak bodily expressivity emphasizes this problem in combining gestural theology with pontianak cinematic agency.

98. Zainah Anwar, "What Islam, Whose Islam? Sisters in Islam and the Struggle for Women's Rights," in *The Politics of Multiculturalism: Pluralism and Citizenship in Malaysia, Singapore, and Indonesia*, ed. Robert W. Hefner (Honolulu: University of Hawai'i Press, 2001), 234.
99. *Pontianak Beraya di Kampung Batu* screened on September 2, 2011, during the first week of Hari Raya, and the sequel screened on August 28, 2012, ten days after Ramadan.
100. Dina Zaman, quoted in Maznah, "Like a Shady Tree," 52.
101. Sim, *Postcolonial Hangups*, 25–28.

4. WHO OWNS THE *KAMPUNG*?

1. Lye Tuck-Po, "Forest People, Conservation Boundaries, and the Problem of 'Modernity' in Malaysia," in *Tribal Communities in the Malay World: Historical, Cultural and Social Perspectives*, ed. Geoffrey Benjamin and Cynthia Chou (Singapore: Institute of Southeast Asian Studies, 2002), 160–161.
2. Timothy Barnard, "Sedih Sampai Buta: Blindness, Modernity and Tradition in Malay Films of the 1950s and 1960s," *KITLV Journal, Royal Netherlands Institute of Southeast Asian and Caribbean Studies* 161, no. 4 (2005): 434.
3. Priya Jaikumar, *Where Histories Reside: India as Filmed Space* (Durham: Duke University Press, 2019), 28.
4. Anonymous, "Now It's the Curse," *Singapore Standard*, April 18, 1958, 13.
5. Claire Monk, "The British Heritage-Film Debate Revisited," in *British Historical Cinema*, ed. Claire Monk and Amy Sargeant (London: Routledge, 2002), 183.
6. Andrew Higson, "The Heritage Film and British Cinema," in *Dissolving Views: Key Writings on British Cinema*, ed. Andrew Higson (London: Cassell, 1996), 233.
7. Mélanie Joseph-Vilain and Judith Misrahi-Barak, "Introduction," in *Postcolonial Ghosts / Fantômes Post-Coloniaux* (Montpellier: Presses Universitaires de la Méditerranée, 2009), 18.
8. Robert Macfarlane, "The Eeriness of the English Countryside," *Guardian*, April 10, 2015.
9. Rosalind Galt, *Pretty: Film and the Decorative Image* (New York: Columbia University Press, 2010).
10. Alan O'Leary, "Towards World Heritage Cinema (Starting from the Negative)," in *Screening European Heritage*, ed. Paul Cooke and Rob Stone (London: Palgrave, 2016), 76.
11. May Adadol Ingawanij, "*Nang Nak*: Thai Bourgeois Heritage Film," *Inter-Asia Cultural Studies* 8, no. 2 (2007): 180.
12. T. N. Harper, *The End of Empire and the Making of Malaya* (Cambridge: Cambridge University Press, 1999), 257.
13. Clive Kessler, *Islam and Politics in a Malay State: Kelantan, 1838–1969* (Ithaca: Cornell University Press, 1978), 146.
14. Raymond Williams, *The Country and the City* (Oxford: Oxford University Press, 1975), 14.
15. Barnard, "Sedih," 434.
16. Cheryl L. Nicholas, *Speaking About Ghosts / Cerita Hantu Melayu* (PhD diss., University of Oklahoma, 2004), 157–158.
17. Toh Hun Ping, "*Curse of Pontianak/Sumpah Pontianak*," in *World Film Locations: Singapore*, ed. Lorenzo Codelli (London: Intellect, 2014), 24.
18. Many stories feature pontianaks as revenants of what used to exist in a location. For example, in "Yio Chu Kang Pontianak," a housewife in a block of flats sees a head and feet floating outside her eleventh floor window when she is pregnant. It transpires that *kampung* graveyards were disturbed

4. WHO OWNS THE *KAMPUNG*? 255

to build the apartment block, and this is why there are so many ghosts. The pontianak represents the haunting of a person but also of a place. Russell Lee, *The Almost Complete Collection of True Singapore Ghost Stories 5* (Singapore: Angsana, 1996), 151–152.

19. Charles Hirschman, *Ethnic and Social Stratification in Peninsular Malaysia* (Washington, DC: American Sociological Association, 1965), 13.
20. Harper, *End of Empire*, 262.
21. Mahathir Mohamad, *The Malay Dilemma* (Singapore: Marshall Cavendish, 2010), np.
22. Joel S. Kahn, *Other Malays: Nationalism and Cosmopolitanism in the Modern Malay World* (Singapore: Singapore University Press and NIAS Press, 2006), 109.
23. Harper, *End of Empire*, 229.
24. Virginia Matheson Hooker, *Writing a New Society: Social Change Through the Novel in Malay* (Leiden: KITLV, 2000), 221, 237–241; Samad Said, *Salina*, trans. Harry Aveling (Kuala Lumpur: Dewan Bahasa dan Pustaka, 1975).
25. Giulio Andreotti famously accused Vittorio De Sica of "washing dirty linen in public" and "slandering Italy abroad." Quoted in Mira Liehm, *Passion and Defiance: Italian Film from 1942 to the Present* (Berkeley: University of California Press, 1986), 91. Film star and politician Nargis similarly accused Satyajit Ray of selling images of Indian poverty to the West. See Neepa Majumdar, "*Pather Panchali*: From Neorealism to Melodrama," in *Film Analysis*, ed. Jeffrey Geiger and R. L. Rutsky (New York: Norton, 2005), 514.
26. Mahathir Mohamad quoted in Azlina Asaari and Jamaluddin Aziz, "*Saka* and the Abject: Masculine Dominance, the Mother and Contemporary Malay Horror Films," *AJWS* 20, no. 1 (2014): 72. See also Anonymous, "Filem Seram: Persatuan Penerbit Mahu Jumpa Mahathir," *Perak Today*, October 13, 2011.
27. Azlina and Jamaluddin, "*Saka*," 73.
28. Azlina and Jamaluddin, 73.
29. Singapore Film Locations Archive, https://sgfilmlocations.com/2014/12/26/sumpah-pontianak-the-curse-of-pontianak-1958/.
30. Patricia A. Hardwick, "Embodying the Divine and the Body Politic: Mak Yong Performance in Rural Kelantan, Malaysia," in *Performance, Popular Culture, and Piety in Muslim Southeast Asia*, ed. Timothy P. Daniels (New York: Palgrave, 2013), 77.
31. Tan Sooi Beng, "From Popular to 'Traditional' Theater: The Dynamics of Change in Bangsawan of Malaysia," *Ethnomusicology* 33, no. 2 (1989): 287.
32. Ronnie Pinsler, "Kuda kepang horse trance dancers at Malay wedding, Tiong Bahru. Dancers entranced by horse spirits are subdued to stop their trance state by being wrestled to the ground," photograph, National Archives of Singapore, 01/04/1981, media image number 19990007460-078.
33. Hardwick, "Divine," 77.
34. The song has found another popular iteration in the soundtrack to *Crazy Rich Asians* (Chu, 2018), a Singaporean romcom that deploys a glossier mode of national fantasy.
35. Richard Dyer, *Pastiche* (London: Routledge, 2007), 180.
36. Norman Yusoff, *Contemporary Malaysian Cinema: Genre, Gender, and Temporality* (PhD diss., University of Sydney, 2013), 222f, describes this scene as a contemporary political dig at those globalizers who prefer English, another far-off European language, as an appropriate lingua franca for Malaysia.
37. Yusoff, 223.
38. Tahir Alhamzah, "*Dendam Pontianak* Rakes in RM 1.3 mil After 1 Week in Cinemas," *New Straits Times*, September 19, 2019.
39. Steve Pile, "Perpetual Returns: Vampires and the Ever Colonised City," in *Postcolonial Urbanism: Southeast Asian Cities and Global Processes*, ed. Ryan Bishop, John Phillips, and Wei Wei Yeo (New York: Routledge, 2003), 266–267.

40. Higson, "Heritage," 239.
41. Local legend has it that the UKM campus looks unfinished because, when it was built, the planners made a deal with the *hantu* of the jungle on the future site of the university. The *hantu* agreed that the university could have the land for forty years, counting from when the construction was complete, so the builders left the buildings deliberately a little unfinished so that the countdown would not begin. This tale is an evocative illustration of how *hantu* are always caught up in property relations and land rights, and how *hantu* stories provide a rationale for the often disappointing appearance of modernity.
42. It is generally forbidden for non-Muslims to inherit from Muslims in Malaysia. See Wan Zulkifli Wan Hassan et al., "The Practice of Interfaith Inheritance Distribution in Malaysia: An Analysis of its Fatwa," *Middle-East Journal of Scientific Research* 22, no. 3 (2014): 464–469; on land ownership limited to Malays, see Voon Phin-Keong, "Rural Land Ownership and Development in the Malay Reservations of Peninsular Malaysia," *South East Asian Studies* 14, no. 4 (1977): 496–512.
43. Harper, *End of Empire*, 242.
44. Maila Stivens, "Becoming Modern in Malaysia: Women at the End of the Twentieth Century," in *Women in Asia: Tradition, Modernity and Globalisation*, ed. Louise Edwards and Mina Roces (St. Leonards: Allen and Unwin, 2000), 30.
45. Aihwa Ong, "State Versus Islam: Malay Families, Women's Bodies, and the Body Politic in Malaysia," in *Bewitching Women, Pious Men: Gender and Body Politics in Southeast Asia*, ed. Aihwa Ong and Michael G. Peletz (Berkeley: University of California Press, 1995), 168.
46. Esther Pereen, "The Ghost as a Gendered Chronotope," in *Ghosts, Stories, Histories: Ghost Stories and Alternative Histories*, ed. Sladja Blazan (Cambridge: Cambridge Scholars, 2007), 82.
47. Bliss Cua Lim, *Translating Time: Cinema, the Fantastic, and Temporal Critique* (Durham: Duke University Press, 2009), 11.
48. Bliss Cua Lim, "Spectral Times: The Ghost Film as Historical Allegory," *positions* 9, no. 1 (2001): 289, quoting Jacques Derrida, *Specters of Marx: The State of Debt, the Work of Mourning and the New International*, trans. Peggy Kamuf (New York: Routledge, 1994), xix.
49. Derrida, *Specters of Marx*, 3–48; Gayatri Chakravorty Spivak, "Ghostwriting," *Diacritics* 25, no. 2 (1995): 64–84.
50. Pereen, "Chronotope," 92, italics in original.
51. "Mak Yong Theatre," UNESCO Intangible Cultural Heritage website, https://ich.unesco.org/en/RL/mak-yong-theatre-00167.
52. Arjun Appadurai, *Modernity at Large: Cultural Dimensions of Globalization* (Minneapolis: University of Minnesota Press, 1996), 183.
53. Peter Eaton, *Land Tenure, Conservation and Development in Southeast Asia* (London: Routledge, 2005), 40.
54. Jeyamalar Kathirithamby-Wells, *Nature and Nation: Forests and Development in Peninsular Malaysia* (Honolulu: University of Hawai'i Press, 2005), xxix.
55. Birka Wicke, Richard Sikkema, Veronika Dornburg, and André Faaij, "Exploring Land Use Changes and the Role of Palm Oil Production in Indonesia and Malaysia," *Land Use Policy* 28 (2011): 204.
56. S. Robert Aiken and Colin H. Leigh, eds., *Vanishing Rain Forests: The Ecological Transition in Malaysia* (Oxford: Clarendon, 1992), 19.
57. Bagoes Wiryomartono, "Urbanism, Place, and Culture in the Malay World: The Politics of Domain from Pre-Colonial to Post-Colonial Era," *City, Culture and Society* 4 (2014): 218; see also Aiken and Leigh, *Vanishing*, 50.
58. Kathirithamby-Wells, *Nature and Nation*, xxxi.
59. Nancy Lee Peluso and Peter Vandergeest, "Genealogies of the Political Forest and Customary Rights in Indonesia, Malaysia, and Thailand," *Journal of Asian Studies* 60, no. 3 (2001): 791–792.

60. Kathirithamby-Wells, *Nature and Nation*, 366.
61. Mahathir Mohamad quoted in Raj Kumar, *The Forest Resources of Malaysia: Their Economics and Development* (Oxford: Oxford University Press, 1986), 79, original, www.pmo.gov.my/ucapan/?m=p&p=mahathir&id=53.
62. Anonymous, "At UN, Mahathir Says Malaysia Climbed World Ladder Without Ravaging Environment," *Today*, September 7, 2019.
63. See, for example, Lye, "Forest People," 160–184.
64. Kathirithamby-Wells, *Nature and Nation*, xxix.
65. Anna Lowenhaupt Tsing, *Friction: An Ethnography of Global Connection* (Princeton: Princeton University Press, 2005), 21.
66. Wicke et al., "Land Use," 193. And, although some factors differ between Indonesia and Malaysia, or between Borneo and the Malaysian Peninsula, the overall causes and effects of deforestation are the same.
67. "Hutan kita sekarang ini sudah hilang. Logika sederhananya adalah, ketika hutan rusak jangankan manusia hantu juga marah." Sahirul Hakim, "Kuntilanak di Filem Pontien," *Tribun Pontianak*, March 14, 2015.

5. ANIMISM AS FORM

1. Edward B. Tylor, *Primitive Culture: Researches Into the Development of Mythology, Philosophy, Religion, Language, Art, and Custom*, vol. 1 (London: John Murray, 1903), 23. Graham Harvey insists that Tylor sees animism as the basis for all religious belief, rather than as a distinct mode of belief unique to primitive peoples. Graham Harvey, *Animism: Respecting the Living World* (New York: Columbia University Press, 2006), 6.
2. Tylor, *Primitive Culture*, 287.
3. James Frazer, *The Golden Bough: A Study in Magic and Religion* (1922; New York: Cosimo Classics, 2009), 111.
4. Anselm Franke, "Much Trouble in the Transportation of Souls, or; the Sudden Disorganization of Boundaries," in *Animism*, vol. 1 (Antwerp: Sternberg, 2006), 12.
5. Bruno Latour, *We Have Never Been Modern* (Cambridge, MA: Harvard University Press, 2012).
6. Burhan (Burhanuddin) Baki, "Yes, We Must Move On: Theoretical Notes on Various Things Malaysian," in *New Malaysian Essays*, vol. 1, ed. Amir Muhammad (Kuala Lumpur: Matahari, 2008), 107.
7. Burhan, 106.
8. Jean Epstein, "The Cinema Seen from Etna," trans. Stuart Liebman, in *Jean Epstein: Critical Essays and New Translations*, ed. Sarah Keller and Jason Paul (Amsterdam: Amsterdam University Press, 2012), 289, 290.
9. Sergei M. Eisenstein, *Eisenstein on Disney*, ed. Jay Leyda, trans. Alan Upchurch (London: Methuen, 1988), 44.
10. Tim Ingold, "Rethinking the Animate, Re-Animating Thought," *Ethnos* 71, no. 1 (2006): 9; Nurit Bird-David, "'Animism' Revisited: Personhood, Environment, and Relational Epistemology," *Current Anthropology* 10, no. S1 (1991): 10.
11. Quoted in Ingold, "Rethinking the Animate," 12, original Paul Klee, *Notebooks*, vol. 1, *The Thinking Eye* (London: Lund Humphries, 1961), 76.
12. Irving Hallowell cited in Harvey, *Animism*, 18.
13. Harvey, 18.

14. Philippe Descola, "Societies of Nature and the Nature of Society," in *Conceptualizing Society*, ed. Adam Kuper (New York: Routledge, 1992), 107–126; Eduardo Viveiros de Castro, "Cosmological Deixis and Amerindian Perspectivism," *Journal of the Royal Anthropological Institute* 4, no. 3 (1998): 469–488.
15. Viveiros de Castro, "Cosmological Deixis," 472.
16. Bird-David, "'Animism' Revisited," 68.
17. Bird-David, 77.
18. The inclusion of Malay culture as "indigenous" erases the distinction between Malay and Orang Asli cultures and political histories, which we will consider later.
19. Kaj Århem, "Southeast Asian Animism in Context," in *Animism in Southeast Asia*, ed. Kaj Århem and Guido Sprenger (London: Routledge, 2016), 51.
20. Århem, 22.
21. Latour, *Modern*, 39.
22. Bruno Latour and Anselm Franke, "Angels Without Wings, a Conversation Between Bruno Latour and Anselm Franke," in Franke, *Animism*, 1:86–96, 88.
23. Franke, "Much Trouble," 17.
24. See, for example, S. N. Eistenstadt, "Multiple Modernities," *Dedalus* 129, no. 1 (2000): 1–29; Dilip Parameshwar Gaonkar, ed., *Alternative Modernities* (Durham: Duke University Press, 2001).
25. Peter J. Bräunlen, "Spirits in and of Southeast Asia's Modernity," in *Dynamics of Religion in Southeast Asia: Magic and Modernity*, ed. Volker Gottowik (Amsterdam: Amsterdam University Press, 2014), 35.
26. See, for example, May Adadol Ingawanij, "Animism and the Performative Realist Cinema of Apichatpong Weerasethakul," in *Screening Nature: Cinema Beyond the Human*, ed. Anat Pick and Guinevere Narraway (Oxford: Berghahn, 2013), 91–109; and Mitsuyo Wada-Marciano, "Showing the Unknowable: *Uncle Boonmee Who Can Recall His Past Lives*," in *Cinematic Ghosts: Haunting and Spectrality from Silent Cinema to the Digital Era*, ed. Murray Leeder (London: Bloomsbury, 2015), 271–289.
27. Nathalie Boehler, "The Jungle as Border Zone: The Aesthetics of Nature in the Work of Apichatpong Weerasethakul," *ASEAS—Austrian Journal of South-East Asian Studies* 4, no. 2 (2011): 301.
28. On Apichatpong's queering of Buddhism, see Arnika Fuhrmann, *Ghostly Desires: Queer Sexuality and Vernacular Buddhism in Contemporary Thai Cinema* (Durham: Duke University Press, 2016), 122–159.
29. Boehler, "The Jungle as Border Zone," 302.
30. Harry Garuba, "Explorations in Animist Materialism: Notes on Reading/Writing African Literature, Culture, and Society," *Public Culture* 15, no. 2 (2003): 285.
31. Garuba, 265, italics in original.
32. Jane Bennett, *The Enchantment of Modern Life: Crossings, Attachments, and Ethics* (Princeton: Princeton University Press, 2002); Simon During, *Modern Enchantments: The Cultural Power of Secular Magic* (Cambridge, MA: Harvard University Press, 2002).
33. Bliss Cua Lim, *Translating Time: Cinema, the Fantastic, and Temporal Critique* (Durham: Duke University Press, 2009), 137.
34. Garuba, "Animist Materialism," 270.
35. Grant Bollmer and Katherine Guinness, "'Do You Really Want to Live Forever?': Animism, Death, and the Trouble of Digital Images," *Cultural Studies Review* 24, no. 2 (2018): 79–96.
36. Franke, "Much Trouble," 23–34.
37. See, for example, André Bazin, *What Is Cinema*, vol. 1, trans. Hugh Gray (Berkeley: University of California Press, 1967); Thomas Elsaesser, "Myth as the Phantasmagoria of History: H. J. Syberberg, Cinema, and Representation," *New German Critique*, nos. 24/25 (1981–1982):

5. ANIMISM AS FORM 259

108–154; Tom Gunning, "To Scan a Ghost: The Ontology of Mediated Vision," *Grey Room* 26 (2007): 94–127.
38. Bogna M. Konior, "Contemporary Malaysian Horror: Relational Politics of Animism and James Lee's *Histeria*," *Plaridel* 12, no. 2 (August 2015): 83–109.
39. Konior, 83.
40. Ingold, "Rethinking the Animate," 9; Bird-David, "'Animism' Revisited," 77.
41. Abram J. Lewis, "Trans Animisms," *Angelaki* 22, no. 2 (2017): 206.
42. Lewis, "Trans Animisms," 206.
43. Damon Young, "Ironies of Web 2.0," in *How to Be Now*, ed. Josh Kotin, Sarah Chihaya, and Kinohi Nishikawa, *Post-45* 2 (2019): np.
44. Anthony Milner, *The Malays* (London: Wiley-Blackwell, 2011), 28.
45. Kirk Michael Endicott, *An Analysis of Malay Magic* (Oxford: Clarendon, 1970), 3.
46. Mohd. Taib Osman, *Malay Folk Beliefs: An Integration of Disparate Elements* (Kuala Lumpur: Dewan Bahasa dan Pustaka, 1989), 152–155.
47. Richard Winstedt, *The Malay Magician: Being Shaman, Saiva and Sufi* (London: Routledge, 1951), 4; Walter William Skeat, *Malay Magic: An Introduction to the Folklore and Popular Religion of the Malay Peninsula* (New York: Macmillan, 1900), xii–xiii.
48. R. J. Wilkinson, *Malay Beliefs* (London: Luzac, 1906), 1.
49. Syed Hussein bin Ali, *Malay as the National Language* (Kuala Lumpur: Dewan Bahasa dan Pustaka, 1962), 2.
50. Ismail Zain, *Seni dan Imajan: Suatu Pandangan Umum terhadap Imajan dan Makna Kontektuilnya* (Kuala Lumpur: Muzium Seni Negara Malaysia, 1980), np.
51. Simon Soon, "Malay: The Hikmat [Inner Workings] of Seni [Art]: Gambar [Picture], Lukis [to Paint or Draw], Moden/Moderen [Modern], Sezaman [of This Age], Baru [New], Kontemporer/Kontemporari [Contemporary], Kagunan [Beneficial Refinement], Imajan [Imagery]," *Southeast of Now: Directions in Contemporary and Modern Art in Asia* 2, no. 2 (2018): 149.
52. Taib, *Malay Folk Beliefs*, 114: "Walaupun nyata bertertangan dengan Islam, sistem kepercayaan tradisional terus wujud, sebab ianya kuat berakar umbi dan susah hendak dihapuskan begitu saja." Syed Husin Ali, *Masyarakat dan Pimpinan Kampung di Malaysia* (Kuala Lumpur: Fajar Bakti, 1977), 94.
53. Taib, *Malay Folk Beliefs*, 54; Nathan Porath, "Maya (Image) in Indigenous Riau World-View: A Forgotten Concept of Malayan Animist Thought and Ritual Practice," *Journal of the Malaysian Branch of the Royal Asiatic Society (JMBRAS)* 88, pt. 2, no. 309 (2015): 4.
54. J. N. McHugh, *Hantu Hantu: An Account of Ghost Belief in Modern Malaya* (Singapore: Donald Moore, 1955), 21–22.
55. Cheryl L. Nicholas, "Speaking About Ghosts / Cerita Hantu Melayu" (PhD diss., University of Oklahoma, 2004), 180.
56. Samuel M. Zwemer, *The Influence of Animism on Islam: An Account of Popular Superstitions* (New York: Macmillan, 1920), 126.
57. Taib, *Malay Folk Beliefs*, 71.
58. Garuba, "Animist Materialism," 267.
59. They first use it to make a love serum, which the film first plays as comedy and then reverses course to present as unethical. When Farid first uses the potion to make the Mean Girl Sofia like him, we are encouraged to understand her newfound attraction as humorous. But when the other girls learn what Farid has done, they angrily accuse him of forcing her affections. In a surprisingly feminist turn, what might have been played entirely as comedy is condemned as coercive. Having foreclosed on the patriarchal misuse of the flower to control women, *Remaja* turns toward the potential of scientific inquiry to work in the service of animist nature.

60. Matthew Hall, "Talk Among the Trees: Animist Plant Ontologies and Ethics," in *The Handbook of Contemporary Animism*, ed. Graham Harvey (Durham: Acumen, 2013), 385.
61. Bagoes Wiryomartono, "Urbanism, Place, and Culture in the Malay World: The Politics of Domain from Pre-Colonial to Post-Colonial Era," *City, Culture and Society* 4 (2014): 219.
62. Md Salleh Yaspar, "The World-View of Peninsular Malaysian Folk-Tales and Folk Dramas," in *Malaysian World-View*, ed. Mohd. Taib Osman (Singapore: Institute of Southeast Asian Studies, 1985), 254.
63. Salleh, 256.
64. Taib, "The Traditional Malay Socio-Political World-View," in Taib, *Malaysian World-View*, 56.
65. Skeat, *Malay Magic*, 29–30.
66. Salleh, "World-View," 270; Jeanne Cuisiner, *Semangat: L'ame et son culte en Indochine et Indonésie* (Paris: Gallimard, 1951).
67. Salleh, "World-View," 270.
68. Cheryl Nicholas discusses the potential for reanimation and the need to guard both *semangat* and bodies closely: Nicholas, *Speaking About Ghosts*, 64.
69. James Fox, "Southeast Asian Religions: Insular Cultures," in *The Encyclopaedia of Religion*, vol. 13 (New York: MacMillan, 1987), 524.
70. Zwemer, *The Influence of Animism*, 13–14.
71. Amran bin Kasimir, "Religion and Social Change Amongst the Indigenous People of the Malay Peninsula" (PhD diss., Aberdeen University, 1983), vi and 42.
72. Anne Yvonne Guillou, "Potent Places and Animism in Southeast Asia," *Asia Pacific Journal of Anthropology* 18, no. 5 (2017): 391, 395.
73. S. M. Eisenstein, *Nonindifferent Nature: Film and the Structure of Things*, trans. Herbert Marshall (Cambridge: Cambridge University Press, 1987), 217.
74. José Moure, "L'appel de la forêt chez quelques cinéastes contemporains: Une expérience sensible," in *La Forêt Sonore: De l'esthétique à l'écologie*, ed. Jean Mottet (Ceyzérieu: Éditions Champ Vallon, 2017), 179.
75. S. Robert Aiken and Colin H. Leigh, eds., *Vanishing Rain Forests: The Ecological Transition in Malaysia* (Oxford: Clarendon, 1992), 30.
76. Aiken and Leigh, 24.
77. "À l'opposé du désert que serait le lieu du vide par excellence, la forêt serait le lieu du trop-plein, d'un excès de visible que l'objectif de la caméra aurait du mal à domestiquer." Moure, "L'appel de la forêt," 179.
78. "À quelques mètres de distance de l'acteur, entre ce dernier et l'objectif, s'interposent tant de branches, tant de feuilles, lianes, racines que le personnage risque de ne pas être visible." Michelangelo Antonioni, quoted in Moure, 180.
79. Paul Onorato, "Beach and Jungle Filming in Malaysia," *American Cinematographer* 59, no. 6 (June 1978): 599.
80. "Plus la forêt est effrayante et moins elle est photogénique. L'entrelacs de la végétation est si épais que les verts sont fondues l'un dans l'autre, sans nuances, tout se périt en un amalgame dénué de relief." Antonioni quoted in Moure, "L'appel de la forêt," 180.
81. Zulkfli bin Md Yusoff, Dzul Haimi bin Md Zain, and Hamidon bin Saniman, "The Ornamental Design of Traditional Malay Utensils *(Kukuran)* in Peninsula Malaysia," *SHS Web of Conferences* 23, no. 01004 (2016): 4, 5.
82. Ivor H. N. Evans, "Some Malay Patterns and Designs," *Journal of the Federated Malay States Museum* 12 (1929): 163–167.
83. Sarena Abdullah, "Expanding the Historical Narrative of Early Visual Modernity in Malaya," *Wacana Seni: Journal of Arts Discourse* 17 (2018): 48.
84. Sarena, 48, 56.

85. See, for example, Fatimah Tobing Rony, *The Third Eye: Race, Cinema, and the Ethnographic Spectacle* (Durham: Duke University Press, 1996); Ella Shohat and Robert Stam, *Unthinking Eurocentrism: Multiculturalism and the Media* (London: Routledge, 1994).
86. W. J. T. Mitchell, "Imperial Landscape," in *Landscape and Power*, ed. W. J. T. Mitchell (Chicago: University of Chicago Press, 1994), 5.
87. Zakaria Ali, "Renungan ke atas Catan Landskap Malaysia," *Wacana Seni: Journal of Arts Discourse* 1 (2002): 1.
88. Sarena, "Expanding," 42.
89. Soon, "Malay," 120.
90. Soon, 125.
91. Soon, 147.
92. Jacques Aumont, "The Variable Eye, or The Mobilization of the Gaze," trans. Charles O'Brien and Sally Shafto, in *The Image in Dispute: Art and Cinema in the Age of Photography*, ed. Dudley Andrew (Austin: University of Texas Press, 1997), 231–253; see also Catherine Fowler and Gillian Helfield, "Introduction," in *Representing the Rural: Space, Place and Identity in Films About the Land*, ed. Catherine Fowler and Gillian Helfield (Detroit: Wayne State University Press, 2006), 8–9.
93. Timothy Mitchell, *Colonizing Egypt* (Berkeley: University of California Press, 1988), 13.
94. Fowler and Helfield, *Representing the Rural*, 6.
95. We can find similar camerawork in other *hantu* films. In *Harimau Jadian*, for example, the camera often views the protagonist through leaves and grass, at plant—or indeed tiger—level.
96. Graig Uhlin, "Plant-Thinking with Film: Reed, Branch, Flower," in *The Green Thread: Dialogues with the Vegetal World*, ed. Patrícia Vieira, Monica Gagliano, and John Ryan (Lanham, MD: Lexington, 2016), 201.
97. Uhlin, 205–206.
98. Uhlin, 215.
99. Viveiros de Castro, "Cosmological Deixis," 469–488.
100. Graham Harvey, "Animist Realism in Indigenous Novels and Other Literature," in Harvey, *The Handbook of Contemporary Animism*, 461.
101. Salleh, "World-View," 271.
102. Aiken and Leigh, *Vanishing Rain Forests*, 35–36.
103. Aiken and Leigh, 37.
104. Aiken and Leigh, 37–38.
105. Anonymous, "Revenge of Pontianak," *Sunday Standard*, August 18, 1957, 9.
106. See, for example, Joseph Chinyong Liow and Michael Leifer, eds., *Dictionary of the Modern Politics of Southeast Asia* (New York: Routledge, 2014), 1. The introduction to this overview of regional politics compares the states of SEA to a mouse deer in their "deftness and dexterity" in navigating the politics of the Cold War. A recent example can be found in Singapore's finance minister Heng Swee Keat comparing the nation to a mouse deer in his 2019 budget statement. Goh Yan Han, "Singapore Budget 2019: Who Is Sang Kancil, the Mouse Deer Singapore Is Likened to by Heng Swee Keat?," *Straits Times*, February 18, 2019.
107. Anonymous, "Sang Kanchil Pedaya Ahli2 Buat Film," *Berita Harian*, December 14, 1957, 2.
108. Anonymous, "Wily, 'Talking' Mousedeer Is $500 Windfall to Singapore Youth," *Straits Times*, December 18, 1957, 7; Anonymous, "First News of Shaw's Latest Horror Film, Four Malayan Demons Meet in *Anak Pontianak*," *Movie News*, January 1958, 22.
109. Peter Boomgaard, *Frontiers of Fear: Tigers and People in the Malay World, 1600–1950* (New Haven, CT: Yale University Press, 2001), 186.
110. Boomgaard, 187.
111. Hugh Clifford, quoted in Patrick Newman, *Tracking the Weretiger: Supernatural Man-Eaters of India, China and Southeast Asia* (London: McFarland, 2012), 114.

112. Newman, 190.
113. T. N. Harper, *The End of Empire and the Making of Malaya* (Cambridge: Cambridge University Press, 1999), 230.
114. Aiken and Leigh, *Vanishing Rain Forests*, 96; World Wildlife Fund, "The Malayan Tiger Is Officially Critically Endangered," July 28, 2015, www.wwf.org.my/?19945/The-Malayan-tiger-isofficially-Critically-Endangered.
115. Paul Mitchell, "The Representation of the Forest in Koldo Serra's *Bosque de sombras* (2006)," *Catalan Journal of Communication and Cultural Studies* 7, no. 1 (2015): 89–90; Patrícia Vieira, "Laws of the Jungle: The Politics of Contestation in Cinema About the Amazon," in Patrícia Vieira, Monica Gagliano, and John Ryan, *The Green Thread*, 13.
116. Jeyamalar Kathirithamby-Wells, *Nature and Nation: Forests and Development in Peninsular Malaysia* (Honolulu: University of Hawai'i Press, 2005), xxx.
117. Saiful Arif Abdullah and Adnan A. Hezri, "From Forest Landscape to Agricultural Landscape in the Developing Tropical Country of Malaysia: Pattern, Process, and Their Significance on Policy," *Environmental Management* 42 (2008): 910–913.
118. Nancy Lee Peluso and Peter Vandergeest, "Genealogies of the Political Forest and Customary Rights in Indonesia, Malaysia, and Thailand," *Journal of Asian Studies* 60, no. 3 (2001): 766.
119. Peluso and Vendergeest, 766–767.
120. Lye Tuck-Po, "Forest People, Conservation Boundaries, and the Problem of 'Modernity' in Malaysia," in *Tribal Communities in the Malay World: Historical, Cultural and Social Perspectives*, ed. Geoffrey Benjamin and Cynthia Chou (Singapore: Institute of Southeast Asian Studies, 2002), 162.
121. "Pusat sastera dan ilmu kita mesti tumbuh dan berkembang di bumi sendiri, seperti pohon jejawi serta beringin subur dalam udara dan buminya." Zainal Kling, "Situasi Pascakolonialisme," in *Pascakolonialisme dalam Pemikiran Melayu*, ed. Mohamad Daud Mohamad and Zabidah Yahya (Kuala Lumpur: Dewan Bahasa dan Pustaka, 2005), 34.
122. Aiken and Leigh, *Vanishing Rain Forests*, 100.
123. Ong Puay Liu, "Identity Matters: Ethnic Perceptions and Concerns," in *Multiethnic Malaysia, Past, Present and Future*, ed. Lim Teck Ghee, Alberto Gomes, and Azly Rahman (Petaling Jaya: MiDAS, 2009), 466.
124. Peluso and Vandergeest, "Genealogies," 796, provide concrete examples of how this process deprived Orang Asli of property rights, such as fruit holdings being expropriated by the state and auctioned off to Malay landowners.
125. Anonymous, "Pontianak Gua Musang," *Mastika Filem*, September 1964, 37.
126. Sharifah Mahsinah Abdullah, "800 Orang Asli Set Up Blockades Against Logging, Durian Plantation Near Gua Musang," *New Straits Times*, February 16, 2018.
127. Yasmin Ramlan, "Orang Asli Deliver Protest Note to MB Over Kuala Langat Forest," *Malaysiakini*, February 26, 2020, www.malaysiakini.com/news/512278.
128. James Boucher, "Radical Animism and the Geontological: An Ecocritical Reading of Patrick Chamoiseau's *Le vieil homme esclave et le molosse*," *Alternative Francophone* 2, no. 3 (2019): 49.
129. David Martin-Jones, *Cinema Against Doublethink: Encounters with the Lost Pasts of World History* (London: Routledge, 2019), 23.
130. Martin-Jones, 23.
131. Linda Hogan, "We Call It Tradition," in Harvey, *The Handbook of Contemporary Animism*, 17–26.
132. Ingold, "Rethinking the Animate," 14, 13.
133. Ingold, 14.

BIBLIOGRAPHY

Abbott, Jason P., and Sophie Gregorios-Pippas. "Islamization in Malaysia: Processes and Dynamics." *Contemporary Politics* 16, no. 2 (2010): 135–151.
Abdar Rahman Koya. "'Wahhabisation' Greater Threat Than Arabisation, Says IRF Chief." *Free Malaysia Today*, December 1, 2017.
Abi aka Ahmad bin Idris. *Filem Melayu: Dahulu dan Sekarang*. Shah Alam: Marwilis. 1987.
Adil Johan, *Cosmopolitan Intimacies: Malay Film Music of the Independence Era*. Singapore: NUS Press, 2017.
Ahmad Fauzi Abdul Hamid. "Malay Racialism and the Sufi Alternative." In Maznah and Khairudin, *Melayu*, 68–100.
Ahmad Rabiul Zulkifli. "Man Dresses as 'Pontianak' to Make People Comply with MCO." *New Straits Times*, March 31, 2020.
Aiken, S. Robert, and Colin H. Leigh, eds. *Vanishing Rain Forests: the Ecological Transition in Malaysia*. Oxford: Clarendon, 1992.
Ainon binti Haji Kuntom. *Malay Film Industry in Singapore and Malaysia*. Penang: Universiti Sains Malaysia, 1973.
Aitken, Ian, and Camille Deprez, eds. *The Colonial Documentary Film in South and South-East Asia*. Edinburgh: Edinburgh University Press, 2017.
Aizenberg, Edna. "I Walked with a Zombie: The Pleasures and Perils of Postcolonial Hybridity." *World Literature Today* 73, no. 3 (999): 461–466.
Alfian Sa'at. *Malay Sketches*. New York: Gaudy Boy, 2018.
Alicia Izharuddin. "The Laugh of the Pontianak: Darkness and Feminism in Malay Folk Horror." *Feminist Media Studies* 20, no. 7 (2020): 999–1012.
——. "Pain and Pleasure of the Look: The Female Gaze in Malaysian Horror Film." *Asian Cinema* 26, no. 2 (2015): 135–152.
Ameer Ali. "Islamic Revivalism in Harmony and Conflict." *Asian Survey* 24, no. 3 (1984): 296–313.
Amir Muhammad. *120 Malay Movies*. Petaling Jaya: Matahari, 2010.
——, ed. *New Malaysian Essays*. Vol. 1. Petaling Jaya: Matahari, 2008.
Amir Muhammad, Kam Raslan, and Sheryll Stothard, eds. *Generation: A Collection of Contemporary Malaysian Ideas*. Kuala Lumpur: Hikayat, 1998.
Amran bin Kasimir. "Religion and Social Change Amongst the Indigenous People of the Malay Peninsula." PhD diss., Aberdeen University, 1983.

Andrew, Dudley. "Time Zones and Jetlag: The Flows and Phases of World Cinema." In *World Cinemas, Transnational Perspectives*, ed. Nataša Durovičová and Kathleen Newman, 59–89. New York: Routledge, 2010.

Anonymous. "At UN, Mahathir Says Malaysia Climbed World Ladder Without Ravaging Environment." *Today Online*, September 27, 2019.

———. "Brief Battle in Cinema Foyer." *Singapore Standard*, May 3, 1957.

———. "*Bunga Tanjong*." *Mastika Filem*, December 1962.

———. "Chinese Films by Cathay in Singapore." *Straits Times*, June 20, 1959.

———. "Emma Berubah Wajah Jadi 'Puntianak Sesat.'" *Berita Harian*, March 17, 2016.

———. "Filem Seram: Persatuan Penerbit Mahu Jumpa Mahathir." *Perak Today*, October 13, 2011.

———. "Film Queen Maria Gets the Sack." *Singapore Standard*, December 3, 1958.

———. "First News of Shaw's Latest Horror Film, Four Malayan Demons Meet in *Anak Pontianak*." *Movie News*, January 1958.

———. "Malaya Has Its Own Terror." *Singapore Standard*, October 13, 1957.

———. "Malay Belle Back to Blood-Sucking Tricks." *Straits Times*, August 30, 1957.

———. "Maria Menado in Mata Hari." *Movie News*, issue number missing, 1958.

———. "Maria on Contract for Film in RI." *Straits Times*, January 9, 1959.

———. "Now It's the Curse." *Singapore Standard*, April 18, 1958.

———. "Players Herald Shooting of New Film." *Sunday Standard*, June 2, 1957.

———. "Pontianak!" *Singapore Free Press*, December 22, 1960.

———. "*Pontianak Gua Musang*." *Berita Filem* 46 (September 1964).

———. "*Pontianak Gua Musang*." *Filem Malaysia*, August 1964.

———. "*Pontianak Gua Musang*." *Mastika Filem*, September 1964.

———. "*Pontianak Gua Musang* Filem Yang Mempunyai Keistimewaan." *Berita Harian*, October 3, 1964.

———. "*Pontianak Kembali*." *Berita Filem* 26 (January 1963).

———. "*Pontianak Kembali*." *Berita Filem* 30 (May 1963).

———. "*Pontianak Kembali*." *Berita Filem* 38 (January 1964).

———. "*Pontianak Kembali*." *Mastika* 10 (April 1963).

———. "*Pusaka Pontianak*." *Majallah Filem* 55 (October 1964).

———. "*Pusaka Pontianak*." *Berita Filem* 48 (November 1964).

———. "Revenge of Pontianak." *Sunday Standard*, August 18, 1957.

———. "S. Sudarmadji Menolong Ramon." *Majallah Filem*, October 1964.

———. "Sang Kanchil Pedaya Ahli2 Buat Film." *Berita Harian*, December 14, 1957.

———. "Seram." *Berita Filem* 48 (November 1964).

———. "Wahabbism Has No Place Here." *The Star*, August 28, 2016.

———. "Wily, 'Talking' Mousedeer Is $500 Windfall to Singapore Youth." *Straits Times*, December 18, 1957.

Appadurai, Arjun. *Modernity at Large: Cultural Dimensions of Globalization*. Minneapolis: University of Minnesota Press, 1996.

Aquilia, Pieter. "Westernising Southeast Asian Cinema: Coproductions for Transnational Markets." *Continuum: Journal of Media and Cultural Studies* 20, no. 5 (2006): 433–445.

Arata, Stephen D. "The Occidental Tourist: 'Dracula' and the Anxiety of Reverse Colonization." *Victorian Studies* 33, no. 4 (1990): 621–645.

Århem, Kaj. "Southeast Asian Animism in Context." In *Animism in Southeast Asia*, edited by Århem and Guido Sprenger, 3–30. London: Routledge, 2016.

Ariffin Omar. *Bangsa Melayu: Malay Concepts of Democracy and Community, 1954–1950*. Kuala Lumpur: Oxford University Press, 1993.

Au Yeong How. "Iqram: Tidak Semua Lelaki Lembut Itu Gay." *MStar*, June 18, 2009.

Aumont, Jacques. "The Variable Eye, or The Mobilization of the Gaze." Translated by Charles O'Brien and Sally Shafto. In *The Image in Dispute: Art and Cinema in the Age of Photography*, edited by Dudley Andrew, 231–253. Austin: University of Texas Press, 1997.

Azlina Asaari and Jamaluddin Aziz. "Perkembangan Filem Seram di Malaysia: Satu Tinjauan Literatur." *e-Bangi: Journal of Social Sciences and Humanities* 12, no. 2 (2017): 30–45.

Azmi Aziz and A. B. Shamsul. "The Religious, the Plural, the Secular and the Modern: A Brief Critical Survey on Islam in Malaysia." *Inter-Asia Cultural Studies* 5, no. 3 (2004): 341–356.

Badrul Redzuan Abu Hassan. "Constructing the Cinema-of-Intent: Revisiting Hatta Azad Khan's 'True Picture.'" *Asian Social Science* 8, no. 5 (2012): 55–64.

Bagoes Wiryomartono. "Urbanism, Place, and Culture in the Malay World: The Politics of Domain from Pre-Colonial to Post-Colonial Era." *City, Culture and Society* 4 (2014): 217–227.

Barnard, Timothy. "Sedih Sampai Buta: Blindness, Modernity, and Tradition in the Malay Films of the 1950s and 60s." *KITLV Journal* 161, no. 4 (2005): 433–453.

——. "Vampires, Heroes and Jesters: A History of Cathay Keris." In *The 26th Hong Kong International Film Festival, the Cathay Story*, edited by Wong Ain-ling and Sam Ho, 124–142. Hong Kong: Hong Kong Film Archive, 2002.

Barnard, Timothy P., and Jan van der Putten. "Malay Cosmopolitan Activism in Post-War Singapore." In *Paths Not Taken: Political Pluralism in Post-War Singapore*, edited by Michael Bar and Carl Trocki, 132–153. Singapore: NUS Press, 2008.

Barnes, Tom. "Women Caned in Malaysia for Attempting to Have Lesbian Sex." *Independent*, September 3, 2018.

Barr, Michael D., and Anantha Raman Govindasamy. "The Islamisation of Malaysia: Religious Nationalism in the Service of Ethnonationalism." *Australian Journal of International Affairs* 64, no. 3 (2010): 293–311.

Barr, Michael D., and Zlatko Skrbiš. *Constructing Singapore: Elitism, Ethnicity, and the Nation Building Project*. Copenhagen: NIAS Press, 2008.

Barrie, Susan. "A Hag to Beauty Then Kampong Vampire." *Straits Times*, May 3, 1957.

Bazin, André. *What Is Cinema*. Vol. 1. Translated by Hugh Gray. Berkeley: University of California Press, 1967.

Bennett, Jane. *The Enchantment of Modern Life: Crossings, Attachments, and Ethics*. Princeton: Princeton University Press, 2002.

Benshoff, Harry M. *Monsters in the Closet: Homosexuality and the Horror Film*. Manchester: Manchester University Press, 1997.

Berenstein, Rhona J. *Attack of the Leading Ladies*. New York: Columbia University Press, 2018.

Bestor, Theodore C. *Neighborhood Tokyo*. Stanford: Stanford University Press, 1989.

Bird, Isabella. *The Golden Chersonese and the Way Thither*. London: John Murray, 1883.

Bird-David, Nurit. "'Animism' Revisited: Personhood, Environment, and Relational Epistemology." *Current Anthropology* 10, no. S1 (1991): 67–91.

Bishop, Kyle. "The Sub-Subaltern Monster: Imperialist Hegemony and the Cinematic Voodoo Zombie." *Journal of American Culture* 31, no. 2 (2008): 141–152.

Blanco, María del Pilar, and Esther Pereen, eds. *The Spectralities Reader: Ghosts and Haunting in Contemporary Cultural Theory*. London: Bloomsbury, 2013.

Boehler, Nathalie. "The Jungle as Border Zone: The Aesthetics of Nature in the Work of Apichatpong Weerasethakul." *ASEAS—Austrian Journal of South-East Asian Studies* 4, no. 2 (2011): 290–304.

Bollmer, Grant, and Katherine Guinness. "'Do You Really Want to Live Forever?': Animism, Death, and the Trouble of Digital Images." *Cultural Studies Review* 24, no. 2 (2018): 79–96.

Boo Su-Lyn. "How a Malaysian Artist Brought a 'Pontianak' to New York." *Malay Mail*, June 22, 2016.

——. "LGBT Activists' Portraits Removed from George Town Festival Exhibition." *Malay Mail*, August 8, 2018.

Boomgaard, Peter. *Frontiers of Fear: Tigers and People in the Malay World, 1600–1950*. New Haven, CT: Yale University Press, 2001.

Boucher, James. "Radical Animism and the Geontological: An Ecocritical Reading of Patrick Chamoiseau's *Le vieil homme esclave et le molosse*." *Alternative Francophone* 2, no. 3 (2019): 42–60.

Braidwood, Ella. "Police Raid Malaysian Gay Bar to 'Stop the Spread of LGBT Culture in Society.'" *Pink News*, August 18, 2018.

Brantlinger, Patrick. *Rule of Darkness: British Literature and Imperialism, 1830–1914*. Ithaca, NY: Cornell University Press, 1988.

Bräunlen, Peter J. "Spirits in and of Southeast Asia's Modernity." In *Dynamics of Religion in Southeast Asia: Magic and Modernity*, edited by Volker Gottowik, 33–54. Amsterdam: Amsterdam University Press, 2014.

Browning, John Edgar, and Caroline Joan (Kay) Picart, eds. *Draculas, Vampires, and Other Undead Forms: Essays on Gender, Race, and Culture*. Lanham, MD: Scarecrow, 2009.

———. "Introduction: Documenting Dracula and Global Identities in Film, Literature, and Anime." In Browning and Picart, *Draculas, Vampires, and Other Undead Forms*, ix–xxii.

Burhan (Burhanuddin) Baki. "Yes, We Must Move On: Theoretical Notes on Various Things Malaysian." In *New Malaysian Essays*, vol. 1, edited by Amir Muhammad, 83–124. Kuala Lumpur: Matahari, 2008.

Burns, Stu. "Vampire and Empire: Dracula and the Imperial Gaze." *eTropic* 16, no. 1 (2017): 5–17.

Butler, Judith, and Athena Athanasiou. *Dispossession: The Performative in the Political*. London: Polity, 2013.

Chan, Nadine. "A Cinema Under the Palms: The Unruly Lives of Colonial Educational Films in British Malaya." PhD diss., University of Southern California, 2015.

Chatterjee, Partha. *The Nation and Its Fragments: Colonial and Postcolonial Histories*. Princeton: Princeton University Press, 1993.

Chen Kuan-Hsing. *Asia as Method: Toward Deimperialization*. Durham: Duke University Press, 2010.

Cheong, Bervin. "Fabulous Fifties: Celebrating Malaysia's Classic Style Icons." *Star2.com*, August 30, 2014.

Cho, Zen. *Spirits Abroad*. Kuala Lumpur: Buku Fixi, 2015.

Choi, Jinhee, and Mitsuyo Wada-Marciano, eds. *Horror to the Extreme: Changing Boundaries in Asian Cinema*. Hong Kong: Hong Kong University Press, 2009.

Chua Beng Huat. *Culture, Multiracialism, and National Identity in Singapore*. Singapore: NUS Press, 1995.

———. "Singapore Cinema: Eric Khoo and Jack Neo—Critique from the Margins and the Mainstream." *Inter-Asia Cultural Studies* 4, no. 1 (2003): 117–125.

Clover, Carol. *Men, Women, and Chainsaws: Gender in the Modern Horror Film*. Princeton: Princeton University Press, 1992.

Comaroff, Jean, and John Comaroff. "Alien-Nation: Zombies, Immigrants, and Millennial Capitalism." *South Atlantic Quarterly* (February 2002): 17–28.

Creed, Barbara. *The Monstrous-Feminine: Film, Feminism, Psychoanalysis*. New York: Routledge, 1993.

Cuisinier, Jeanne. *Semangat: l'ame et son culte en Indochine et Indonésie*. Paris: Gallimard, 1951.

Daniels, Timothy P. "'Islamic' TV Dramas, Malay Youth, and Pious Visions for Malaysia." In Daniels, *Performance, Popular Culture, and Piety*, 105–133.

———, ed. *Performance, Popular Culture, and Piety in Muslim Southeast Asia*. New York: Palgrave, 2013.

Derrida, Jacques. *Specters of Marx: The State of Debt, the Work of Mourning and the New International*. Translated by Peggy Kamuf. New York: Routledge, 1994.

Descola, Philippe. "Societies of Nature and the Nature of Society." In *Conceptualizing Society*, edited by Adam Kuper, 107–126. New York: Routledge, 1992.

Diabate, Naminata. "Re-Imagining West African Women's Sexuality: Bekolo's *Les Saignantes* and the Mevoungou." In *Development, Modernism and Modernity in Africa*, edited by Augustine Agwuele, 166–181. New York: Routledge, 2013.

Dina Zaman. "An Inconvenient Truth?" *The Star*, March 17, 2019.

Dove, Michael R. *The Banana Tree at the Gate: A History of Marginal Peoples and Global Markets in Borneo*. New Haven: Yale University Press, 2011.

During, Simon. *Modern Enchantments: The Cultural Power of Secular Magic*. Cambridge, MA: Harvard University Press, 2002.

Dyer, Richard. *Pastiche*. London: Routledge, 2007.
———. *White: Essays on Race and Culture*. London: Routledge, 1997.
Eaton, Peter. *Land Tenure, Conservation and Development in Southeast Asia*. London: Routledge, 2005.
Editorial. "Mencari Keperibadian Sendiri." *Penulis* 1, no. 1 (January 1964): 3.
Eisenstein, Sergei M. *Eisenstein on Disney*. Edited by Jay Leyda. Translated by Alan Upchurch. London: Methuen, 1988.
———. *Nonindifferent Nature: Film and the Structure of Things*. Translated by Herbert Marshall. Cambridge: Cambridge University Press, 1987.
Eistenstadt, S. N. "Multiple Modernities." *Dedalus* 129, no. 1 (2000): 1–29.
Ellis-Peterson, Hannah. "Malaysia Accused of 'State-Sponsored Homophobia' After LGBT Crackdown." *Guardian*, August 22, 2018.
Elsaesser, Thomas. "Myth as the Phantasmagoria of History: H. J. Syberberg, Cinema, and Representation." *New German Critique*, nos. 24/25 (1981–1982): 108–154.
Endicott, Kirk Michael. *An Analysis of Malay Magic*. Oxford: Clarendon, 1970.
Epstein, Jean. "The Cinema Seen from Etna." Translated by Stuart Liebman. In *Jean Epstein: Critical Essays and New Translations*, edited by Sarah Keller and Jason Paul, 287–310. Amsterdam: Amsterdam University Press, 2012.
Evans, Ivor H. N. "Some Malay Patterns and Designs." *Journal of the Federated Malay States Museum* 12 (1929): 163–167.
Faridul Anwar Farinordin. "Pontianak Returns with a Vengeance." *New Straits Times*, May 1, 2004.
Farish A. Noor. "Blood, Sweat and Jihad: the Radicalization of the Political Discourse of the Pan-Malaysian Islamic Party from 1982 Onwards." *Contemporary Southeast Asia* 25, no. 2 (2003): 200–232.
Faucher, Carole. "As the Wind Blows and the Dew Came Down: Ghost Stories and Collective Memory in Singapore." In *Beyond Description: Singapore Space Historicity*, edited by Ryan Bishop, John Phillips, and Wei-Wei Yeo, 190–203. London: Routledge, 2004.
Fay, Jennifer. *Inhospitable World: Cinema in the Time of the Anthropocene*. New York: Oxford University Press, 2018.
———. *Theaters of Occupation: Hollywood and the Re-Education of Postwar Germany*. Minneapolis: University of Minnesota Press, 2008.
Fealy, Greg. "Islamisation and Politics in Southeast Asia: The Contrasting Cases of Malaysia and Indonesia." In *Islam in World Politics*, edited by Nelly Lahoud and Anthony H. Johns, 152–169. New York: Routledge, 2005.
Feeley, Jennifer. "Transnational Specters and Regional Spectators: Flexible Citizenship in New Chinese Horror Cinema." *Journal of Chinese Cinemas* 6, no. 1 (2012): 41–64.
Fowler, Catherine, and Gillian Helfield, eds. *Representing the Rural: Space, Place and Identity in Films About the Land*. Detroit: Wayne State University Press, 2006.
Fox, James. "Southeast Asian Religions: Insular Cultures." In *The Encyclopedia of Religion*, vol. 13, edited by M. Eliade, 520–530. New York: Macmillan, 1987.
Franke, Anselm, ed. *Animism*. Vol. 1. Antwerp: Sternberg, 2006.
———. "Much Trouble in the Transportation of Souls, or The Sudden Disorganization of Boundaries." In Franke, *Animism*, 1:11–53.
Frayling, Christopher. *Vampyres: Lord Byron to Count Dracula*. London: Faber, 1991.
Frazer, James. *The Golden Bough: A Study in Magic and Religion*. 1922; New York: Cosimo Classics, 2009.
Furhmann, Arnika. *Ghostly Desires: Queer Sexuality and Vernacular Buddhism in Contemporary Thai Cinema*. Durham: Duke University Press, 2016.
———. "*Nang Nak*—Ghost Wife: Desire, Embodiment, and Buddhist Melancholia in a Contemporary Thai Ghost Film." *Discourse* 31, no. 3 (2009): 220–247.
Furnivall, J. S. *Colonial Policy and Practice: A Comparative Study of Burma and Netherlands India*. Cambridge: Cambridge University Press, 1948.

Fuziah Kartini Hassan Basri and Raja Ahmad Alauddin. "The Search for a Malaysian Cinema: Between U-Wei, Shuhaimi, Yusof and LPFM." *Asian Cinema* (Winter 1995): 58–73.

Gabriel, Sharmani P. "The Meaning of Race in Malaysia: Colonial, Post-Colonial and Possible New Conjunctures." *Ethnicities* 15, no. 6 (2015): 782–809.

Galt, Rosalind. "The Prettiness of Italian Cinema." In *Popular Italian Cinema*, edited by Sergio Rigoletto and Louis Bayman, 52–68. Basingstoke, UK: Palgrave, 2013.

———. *Pretty: Film and the Decorative Image*. New York: Columbia University Press, 2010.

Gaonkar, Dilip Parameshwar, ed. *Alternative Modernities*. Durham: Duke University Press, 2001.

Garuba, Harry. "Explorations in Animist Materialism: Notes on Reading/Writing African Literature, Culture, and Society." *Public Culture* 15, no. 2 (2003): 261–285.

Gelder, Ken. "Global/Postcolonial Horror: An Introduction." *Postcolonial Studies* 3, no. 1 (2000): 35–38.

———. *Reading the Vampire*. London: Routledge, 1994.

Giffney, Noreen, and Myra J. Hird, eds. *Queering the Non/Human*. Aldershot, UK: Ashgate, 2008.

Godinho de Erédia, Manuel. *Malaca, l'Inde méridionale et le Cathay: Manuscrit original autographe de Godinho de Eredia, appartenant à la Bibliothèque Royale de Bruxelles*. Translated by M. Léon Janssen. 1618; Brussels: Librairie Européene C. Muquardt, 1882.

Goh, Daniel P. S., Matilda Gabrielpillai, Philip Holden, and Gaik Cheng Khoo, eds. *Race and Multiculturalism in Malaysia and Singapore*. New York: Routledge, 2009.

Goh Yan Han. "Singapore Budget 2019: Who Is Sang Kancil, the Mouse Deer Singapore Is Likened to by Heng Swee Keat?" *Straits Times*, February 18, 2019.

Gonerski, Krzysztof. "A Closer Look on Malaysian Thrillers and Horrors." Translated by Klaudia Januszewska. *Five Flavours*, February 9, 2018.

Gopal, Sangita. *Conjugations: Marriage and Form in New Bollywood Cinema*. Chicago: University of Chicago Press, 2011.

Gordon, Avery F. *Ghostly Matters: Haunting and the Sociological Imagination*. Minneapolis: University of Minnesota Press, 1997.

Guillou, Anne Yvonne. "Potent Places and Animism in Southeast Asia." *Asia Pacific Journal of Anthropology* 18, no. 5 (2017): 389–399.

Gunning, Tom. "To Scan a Ghost: The Ontology of Mediated Vision." *Grey Room* 26 (2007): 94–127.

Hall, Stuart. "New Ethnicities." In *Race, Culture and Difference*, edited by J. Donald and A. Rattansi, 252–259. London: Sage, 1992.

Hamzah Hussin. *Memoir Hamzah Hussin: Dari Cathay Keris ke Studio Merdeka*. Bangi: Penerbit Universiti Kebangsaan Malaysia, 1998.

Hanisah Selamat. "Produser Wanita Jangan Takut Bersaing—Maria Menado." *Berita Harian*, January 7, 2019.

Hardwick, Patricia A. "Embodying the Divine and the Body Politic: Mak Yong Performance in Rural Kelantan, Malaysia." In Daniels, *Performance, Popular Culture, and Piety*, 77–103.

Harper, T. N. *The End of Empire and the Making of Malaya*. Cambridge: Cambridge University Press, 1999.

Harvey, Graham. *Animism: Respecting the Living World*. New York: Columbia University Press, 2006.

———. "Animist Realism in Indigenous Novels and Other Literature." In Harvey, *The Handbook of Contemporary Animism*, 454–467.

———, ed. *The Handbook of Contemporary Animism*. Durham: Acumen, 2013.

Harvey, Sophia Siddique. "Mapping Spectral Tropicality in *The Maid* and *Return to Pontianak*." *Singapore Journal of Tropical Geography* 29 (2008): 24–33.

Hasleen Bachik. "Cathay Tidak Putus-Putus Didatangi Peminat Pontianak." *Berita Harian*, May 2, 1997.

Hassan Abdul Muthalib. "The End of Empire: the Films of the Malayan Film Unit in 1950s British Malaya." In *Film and the End of Empire*, edited by Lee Grieveson and Colin MacCabe, 287–323. London: BFI/Palgrave, 2011.

Hassan Muthalib and Wong Tuck Cheong. "Malaysia: Gentle Winds of Change." In Vasudev, Padgonkar, and Doraiswamy, *Being and Becoming*, 301–328.

Hawkins, Joan. *Cutting Edge: Art-Horror and the Horrific Avant-Garde*. Minneapolis: University of Minnesota Press, 2000.

Hefner, Robert W., ed. *The Politics of Multiculturalism: Pluralism and Citizenship in Malaysia, Singapore, and Indonesia*. Honolulu: University of Hawai'i Press, 2001.

Heide, William van der. *Malaysian Cinema, Asian Film: Border Crossings and National Cultures*. Amsterdam: Amsterdam University Press, 2002.

Higson, Andrew. "The Heritage Film and British Cinema." In *Dissolving Views: Key Writings on British Cinema*, edited by Andrew Higson, 232–248. London: Cassell, 1996.

Hirschman, Charles. *Ethnic and Social Stratification in Peninsular Malaysia*. Washington, DC: American Sociological Association, 1965.

———. "The Making of Race in Colonial Malaya: Political Economy and Racial Ideology." *Sociological Forum* 1, no. 2 (Spring 1986): 330–361.

Hobsbawm, Eric, and Terence Ranger, eds. *The Invention of Tradition*. Cambridge: Cambridge University Press, 1983.

Hogan, Linda. "We Call It Tradition." In Harvey, *The Handbook of Contemporary Animism*, 17–26.

Hooker, Virginia Matheson. *Writing a New Society: Social Change Through the Novel in Malay*. Leiden: KITLV Press, 2000.

Ingawanij, May Adadol. "Animism and the Performative Realist Cinema of Apichatpong Weerasethakul." In *Screening Nature: Cinema Beyond the Human*, edited by Anat Pick and Guinevere Narraway, 91–109. Oxford: Berghahn, 2013.

———. "Nang Nak: Thai Bourgeois Heritage Cinema." *Inter-Asia Cultural Studies* 8, no. 2 (2007): 180–193.

Ingold, Tim. "Rethinking the Animate, Re-Animating Thought." *Ethnos* 71, no. 1 (2006): 9–20.

Intan Paramaditha. *Apple and Knife*. London: Harvill Secker, 2018.

Ismail Zain. *Seni dan Imajan: Suatu Pandangan Umum terhadap Imajan dan Makna Kontektuilnya*. Kuala Lumpur: Muzium Seni Negara Malaysia, 1980.

Jaikumar, Priya. *Where Histories Reside: India as Filmed Space*. Durham: Duke University Press, 2019.

Jamaluddin bin Aziz and Azlina binti Asaari. "Saka and the Abject: Masculine Dominance, the Mother and Contemporary Malay Horror Film." *Asian Journal of Women's Studies* 20, no. 1 (2014): 71–92.

Jamil Sulong. "Bangsawan's Influence in Malay Films." In *Cerita Filem Malaysia*, 56–60. Hulu Klang: Perbadanan Kemajuan Filem Nasional, 1989.

———. *Kaca Permata: Memoir Seorang Pengarah*. Kuala Lumpur: Dewan Bahasa dan Pustaka, 1990.

Jamil Sulong, Hamzah Hussein, and Abul Malik Mokhtar. *Daftar Filem Melayu*. Selangor: FINAS, 1993.

Joseph-Vilain, Mélanie, and Judith Misrahi-Barak, eds. *Postcolonial Ghosts / Fantômes Post-Coloniaux*. Montpellier: Presses Universitaires de la Méditerranée, 2009.

Kahn, Joel S. *Other Malays: Nationalism and Cosmopolitanism in the Modern Malay World*. Singapore: Singapore University Press and NIAS Press, 2006.

Kahn, Joel S., and Francis Loh Kok Wah, eds. *Fragmented Vision: Culture and Politics in Contemporary Malaysia*. Sydney: Allen and Unwin, 1992.

Kathirithamby-Wells, Jeyamalar. *Nature and Nation: Forests and Development in Peninsular Malaysia*. Honolulu: University of Hawai'i Press, 2005.

Kee, Jac S. M. "Boundary Monsters in a Time of Magic." In *New Malaysian Essays 2*, edited by Amir Muhammad, 245–280. Petaling Jaya: Mata Hari, 2009.

Kessler, Clive. *Islam and Politics in a Malay State: Kelantan, 1838–1969*. Ithaca: Cornell University Press, 1978.

Kho, Gordon. "Horror Movies Making a Killing." *The Star*, September 4, 2018.

Khoo, Gaik Cheng. "Introduction: Theorizing Different Forms of Belonging in a Cosmopolitan Malaysia." In *Malaysia's New Ethnoscapes and Ways of Belonging*, edited by Gaik Cheng Khoo and Julian C. H. Lee, 1–16. London: Routledge, 2016.

———. *Reclaiming Adat: Contemporary Malaysian Film and Literature*. Vancouver: UBC Press, 2006.

Khoo Kay Kim. "The Emergence of Plural Communities in the Malay Peninsula Before 1874." In Lim, Gomes, and Azly, *Multiethnic Malaysia, Past, Present and Future*, 11–32.

Khoo, Olivia. "Slang Images: On the Foreignness of Contemporary Singaporean Films." *Inter-Asia Cultural Studies* 7, no. 1 (2006): 81–98.

Knee, Adam. "Thailand Haunted: The Power of the Past in Contemporary Thai Horror Film." In *Horror International*, edited by Steven Jay Schneider and Tony Williams, 141–159. Detroit: Wayne State University Press, 2005.

Koay, Allan. "Famed Foe, the Pontianak." *The Star*, August 5, 2005.

Kohli, Suresh. "Singapore (1960)." *The Hindu*, May 22, 2011.

Konior, Bogna M. "Contemporary Malaysian Horror: Relational Politics of Animism and James Lee's *Histeria*." *Plaridel* 12, no. 2 (August 2015): 83–109.

Kua Kia Soong. "Racial Conflict in Malaysia: Against the Official History." *Race and Class* 49, no. 3 (2007): 33–53.

Kumar, Raj. *The Forest Resources of Malaysia: Their Economics and Development*. Oxford: Oxford University Press, 1986.

Lackersteen, Doug. "Lion of Malaya to Be Filmed Soon." *Straits Times*, November 23, 1958.

Latour, Bruno. *We Have Never Been Modern*. Cambridge, MA: Harvard University Press, 2012.

Latour, Bruno, and Anselm Franke. "Angels Without Wings, a Conversation Between Bruno Latour and Anselm Franke." In Franke, *Animism*, 1:86–96.

Lee, Adrian Yuen Beng. "The Villainous Pontianak? Examining Gender, Culture, and Power in Malaysian Horror Films." *Pertanika Journal* 24, no. 4 (2016): 1431–1444.

Lee, Russell. *The Almost Complete Collection of True Singapore Ghost Stories 5*. Singapore: Angsana, 1996.

Lee Yuen Beng and Mustafa Kamal Anuar. "Kebangkitan Semula Filem Seram di Malaysia: Liberalisasi atau Komersialisasi?" In *Antologi Esei Komunikasi: Teori, Isu dan Amalan*, edited by Azman Azwan Azmawati et al., 142–155. Pulau Pinang: Penerbit Universiti Sains Malaysia, 2015.

Leeder, Murray, ed. *Cinematic Ghosts: Haunting and Spectrality from Silent Cinema to the Digital Era*. London: Bloomsbury, 2015.

Lewis, Abram J. "Trans Animisms." *Angelaki* 22, no. 2 (2017): 203–215.

Lian Kwen Fee and Narayanan Ganapathy. "The Politics of Racialization and Malay Identity." In *Multiculturalism, Migration and the Politics of Identity in Singapore*, edited by K. F. Lian, 99–112. Singapore: Springer, 2016.

Liehm, Mira. *Passion and Defiance: Italian Film from 1942 to the Present*. Berkeley: University of California Press, 1986.

Liew Kai Khiun and Stephen Teo, eds. *Singapore Cinema: New Perspectives*. New York: Routledge, 2017.

Lim, Andrew. *Paranormal Singapore: Tales from the Kopitiam*. Singapore: Monsoon, 2008.

Lim, Bliss Cua. "Queer Aswang Transmedia: Folklore as Camp." *Kritika Kultura* 24 (2015): 178–225.

———. "Spectral Times: The Ghost Film as Historical Allegory." *positions* 9, no. 1 (2001): 287–329.

———. *Translating Time: Cinema, the Fantastic, and Temporal Critique*. Durham: Duke University Press, 2009.

Lim, Catherine. *They Do Return . . . But Gently Lead Them Back*. Singapore: Times, 1992.

Lim, Edna. *Celluloid Singapore: Cinema, Performance and the National*. Edinburgh: Edinburgh University Press, 2018.

Lim Kay Tong. *Cathay: 55 Years of Cinema*. Singapore: Landmark, 1991.

Lim Teck Ghee, Alberto Gomes, and Azly Rahman, eds. *Multiethnic Malaysia, Past, Present and Future*. Petaling Jaya: MiDAS, 2009.

Limbrick, Peter. *Arab Modernism as World Cinema: The Films of Moumen Smihi*. Oakland: University of California Press, 2020.

Liow, Joseph Chinyong. "Political Islam in Malaysia: Problematising Discourse and Practice in the UMNO-PAS 'Islamisation Race.'" *Commonwealth and Comparative Politics* 42, no. 2 (2004): 184–205.

Liow, Joseph Chinyong, and Michael Leifer, eds. *Dictionary of the Modern Politics of Southeast Asia*. New York: Routledge, 2014.

Locke, John. *Second Treatise of Government and a Letter Concerning Toleration*. Oxford: Oxford University Press, 2016.

Lowenstein, Adam. *Shocking Representation: Historical Trauma, National Cinema, and the Modern Horror Film*. New York: Columbia University Press, 2005.

Lye Tuck-Po. "Forest People, Conservation Boundaries, and the Problem of 'Modernity' in Malaysia." In *Tribal Communities in the Malay World: Historical, Cultural and Social Perspectives*, edited by Geoffrey Benjamin and Cynthia Chou, 160–184. Singapore: Institute of Southeast Asian Studies, 2002.

Macfarlane, Robert. "The Eeriness of the English Countryside." *Guardian*, April 10, 2015.

Mahathir Mohamad. *The Malay Dilemma*. Singapore: Times, 1970.

Majumdar, Neepa. "*Pather Panchali*: from Neorealism to Melodrama." In *Film Analysis*, edited by Jeffrey Geiger and R. L. Rutsky, 510–527. New York: Norton, 2005.

Mandal, Sumit K. "Transethnic Solidarities, Racialisation and Social Equality." In *The State of Malaysia: Ethnicity, Equity and Reform*, edited by Edmund Terence Gomez, 49–78. London: Routledge, 2004.

Martin, Dahlia. "Gender, Malayness, and the Ummah: Cultural Consumption and Malay Muslim Identity." *Asian Studies Review* 38, no. 3 (2014): 403–421.

Martin-Jones, David. *Cinema Against Doublethink: Encounters with the Lost Pasts of World History*. London: Routledge, 2019.

Masami Mustaza. "UMNO Wing Gives Moviemakers the Creeps." *Malay Mail*, October 15, 2009.

Matheson, Virginia. "Usman, Awang, Keris Mas and Hazmah: Individual Expressions of Social Commitment in Malay Literature." *Review of Indonesian and Malaysian Affairs* 21, no. 1 (1987): 108–131.

Maznah Mohamad. "Like a Shady Tree Swept by the Windstorm: Malays in Dissent." In Maznah and Khairudin, *Melayu*, 34–67.

Maznah Mohamad and Syed Muhd Khairudin Aljunied, eds. *Melayu: The Politics, Poetics and Paradoxes of Malayness*. Singapore: NUS Press, 2011.

McHugh, J. N. *Hantu Hantu: An Account of Ghost Belief in Modern Malaya*. Singapore: Donald Moore, 1955.

Md Salleh Yaspar. "The World-View of Peninsular Malaysian Folk-Tales and Folk Dramas." In Taib, *Malaysian World-View*, 252–275.

Millet, Raphaël. *Singapore Cinema*. Singapore: Editions Didier Millet, 2006.

Milner, Anthony. *The Malays*. London: Wiley-Blackwell, 2011.

Mitchell, Paul. "The Representation of the Forest in Koldo Serra's *Bosque de sombras* (2006)." *Catalan Journal of Communication and Cultural Studies* 7, no. 1 (2015): 89–97.

Mitchell, Timothy. *Colonizing Egypt*. Berkeley: University of California Press, 1988.

Mitchell, W. J. T., ed. *Landscape and Power*. Chicago: University of Chicago Press, 1994.

Modder, Ralph. *Curse of the Pontianak*. Singapore: Horizon, 2004.

Modder, Ralph, and Aeishah Ahmed. *Myths and Legends of Malaysia and Singapore*. Singapore: Horizon, 2009.

Mohamad Abu Bakar. "External Influences on Contemporary Islamic Resurgence in Malaysia." *Contemporary Southeast Asia* 13, no. 2 (1991): 220–228.

Mohamad Daud Mohamad and Zabidah Yahya, eds. *Pascakolonialisme dalam Pemikiran Melayu*. Kuala Lumpur: Dewan Bahasa dan Pustaka, 2005.

Mohamad Hatta Azad Khan. "The Malay Cinema (1948–1989) Early History and Development." PhD diss., University of New South Wales, 1994.

Mohd. Amirul Akhbar Mohd. Zulkifli, Amelia Yuliana Abd Wahab, and Hani Zulaikha. "The Potential of Malaysia's Horror Movies in Creating Critical Minds: A Never Ending Philosophical Anecdote." *Proceedings of 2012 2nd International Conference on Humanities, Historical, and Social Sciences* (2012): 175–176.

Mohd. Taib Osman. "Kesusasteraan Melayu dengan Corak Masyarakat dan Budayanya." *Penulis* 3, no. 1 (January 1969): 74–80.
———. *Malay Folk Beliefs: An Integration of Disparate Elements*. Kuala Lumpur: Percetakan Dewan Bahasa dan Pustaka, 1989.
———, ed. *Malaysian World-View*. Singapore: Institute of Southeast Asian Studies, 1985.
———. "Pantun, Syair dan Sajak: Dari Segi Pandangan Diakronis dan Sinkronis." *Penulis* 2, no. 1 (1968): 17–27.
———. "The Traditional Malay Socio-Political World-View." In Taib, *Malaysian World-View*, 46–75.
Mohd. Zamberi A. Malek and Aami Jarr. *Malaysian Films: The Beginning*. Kuala Lumpur: Perbadanan Kemajian Filem Nasional Malaysia/FINAS, 2005.
Mokhtar-Ritchie, Hanita Mohd. "Negotiating Melodrama and the Malay Woman: Female Representation and the Melodramatic Mode in Malaysian-Malay Films from the Early 1990s-2009." PhD diss., University of Glasgow, 2011.
Monk, Claire. "The British Heritage-Film Debate Revisited." In *British Historical Cinema: The History, Heritage and Costume Film*, edited by Claire Monk and Amy Sargeant, 176–198. London: Routledge, 2002.
Moure, José. "L'appel de la forêt chez quelques cinéastes contemporains: Une expérience sensible." In *La Forêt Sonore: De l'esthétique à l'écologie*, edited by Jean Mottet, 179–189. Ceyzérieu: Éditions Champ Vallon, 2017.
Muhamad Ali. *Islam and Colonialism: Becoming Modern in Indonesia and Malaya*. Edinburgh: Edinburgh University Press, 2016.
Nagata, Judith. "Boundaries of Malayness: 'We Have Made Malaysia: Now It Is Time to (Re)Make the Malays but Who Interprets the History?'" In Maznah and Khairudin, *Melayu*, 3–33.
———. "Religious Ideology and Social Change: The Islamic Revival in Malaysia." *Pacific Affairs* 53, no. 3 (1980): 405–439.
Nair, Sheila. "The Limits of Protest and Prospects for Political Reform in Malaysia." *Critical Asian Studies* 39, no. 3 (2007): 339–368.
Newman, Patrick. *Tracking the Weretiger: Supernatural Man-Eaters of India, China and Southeast Asia*. London: McFarland, 2012.
Ng, Andrew Hock Soon. "A Cultural History of Pontianak Films." In *New Malaysian Essays*, vol. 2, edited by Amir Muhammad, 215–232. Petaling Jaya: Matahari, 2009.
———. "Death and the Maiden: The Pontianak as Excess in Malay Popular Culture." In Browning and Picart, *Draculas, Vampires, and Other Undead Forms*, 167–186.
———. "Sisterhood of Terror: The Monstrous Feminine of Southeast Asian Horror Cinema." In *A Companion to the Horror Film*, edited by Harry M. Benshoff, 442–459. London: Wiley Blackwell, 2017.
Ng Yi-Sheng. "A History of Singapore Horror." BiblioAsia. www.nlb.gov.sg/biblioasia/2017/07/03/a-history-of-singapore-horror/.
Nicholas, Cheryl L. "Speaking About Ghosts / Cerita Hantu Melayu." PhD diss., University of Oklahoma, 2004.
Nieuwkirk, Karin van. *Muslim Rap, Halal Soaps, and Revolutionary Theater*. Austin: University of Texas Press, 2011.
Och, Dana, and Kirsten Strayer, eds. *Transnational Horror Across Visual Media*. London: Routledge, 2014.
Odell, Albert. Singapore National Archives Oral History Interviews. www.nas.gov.sg/archivesonline/oral_history_interviews/interview/002640.
O'Leary, Alan. "Towards World Heritage Cinema (Starting from the Negative)." In *Screening European Heritage*, edited by Paul Cooke and Rob Stone, 63–84. London: Palgrave, 2016.
Ong, Aihwa. "The Production of Possession: Spirits and the Multinational Corporation in Malaysia." *American Ethnologist* 15, no. 1 (February 1988): 28–42.

———. "State Versus Islam: Malay Families, Women's Bodies, and the Body Politic in Malaysia." In *Bewitching Women, Pious Men: Gender and Body Politics in Southeast Asia*, edited by Aihwa Ong and Michael G. Peletz, 159–194. Berkeley: University of California Press, 1995.

Ong Puay Liu. "Identity Matters: Ethnic Perceptions and Concerns." In Lim, Gomes, and Azly, *Multiethnic Malaysia, Past, Present and Future*, 463–481.

Onorato, Paul. "Beach and Jungle Filming in Malaysia." *American Cinematographer* 59, no. 6 (June 1978): 582–596.

Ooi Kee Beng. "Beyond Ethnocentrism: Malaysia and the Affirmation of Hybridisation." In Lim, Gomes, and Azly, *Multiethnic Malaysia, Past, Present and Future*, 447–462.

Paul, William. *Laughing Screaming: Modern Hollywood Horror and Comedy*. New York: Columbia University Press, 1994.

Peluso, Nancy Lee, and Peter Vandergeest. "Genealogies of the Political Forest and Customary Rights in Indonesia, Malaysia, and Thailand." *Journal of Asian Studies* 60, no. 3 (2001): 761–812.

Pereen, Esther. "The Ghost as a Gendered Chronotope." In *Ghosts, Stories, Histories: Ghost Stories and Alternative Histories*, edited by Sladja Blazan, 81–96. Cambridge: Cambridge Scholars, 2007.

Pile, Steve. "Perpetual Returns: Vampires and the Ever Colonised City." In *Postcolonial Urbanism: Southeast Asian Cities and Global Processes*, edited by Ryan Bishop, John Phillips, and Wei Wei Yeo, 265–286. New York: Routledge, 2003.

Ponzanesi, Sandra, and Marguerite Waller, eds. *Postcolonial Cinema Studies*. London: Routledge, 2012.

Porath, Nathan. "Maya (Image) in Indigenous Riau World-View: A Forgotten Concept of Malayan Animist Thought and Ritual Practice." *Journal of the Malaysian Branch of the Royal Asiatic Society (JMBRAS)* 88, no. 309 (2015): 3–23.

Pugalenthii. *Pontianak Nightmares*. Singapore: Asuras, 2000.

Pugalenthi, Sr. *Pontianak: True Stories*. Singapore: Asuras, 1996.

Putten, Jan van der. "Bangsawan: The Coming of a Malay Popular Theatrical Form." *Indonesia and the Malay World* 42, no. 123 (2014): 268–285.

Quijano, Aníbal. "Coloniality and Modernity/Rationality." *Cultural Studies* 21, no. 2 (2007): 168–178.

Rahmad bin Badri. *Ghostly Tales from Singapore*. Singapore: Wellington Educational, 1993.

Raja Rohana Raja Mamat. *The Role and Status of Malay Women in Malaysia: Social and Legal Perspectives*. Kuala Lumpur: Dewan Bahasa dan Pustaka Malaysia, 1991.

Reid, Anthony. "Understanding *Melayu* (Malay) as a Source of Diverse Modern Identities." In *Contesting Malayness: Malay Identity Across Boundaries*, edited by Timothy Barnard, 1–24. Singapore: Singapore University Press, 2004.

Renan, Ernest. *Qu'est-ce qu'une nation?* Translated by Ethan Rundell. Paris: Presses-Pocket, 1992.

Richards, A. "Stephen Meets a Vampire and Vows No More Lifts for Pretty Women." *Singapore Free Press*, July 16, 1960.

Roff, William R. *The Origins of Malay Nationalism*. New Haven: Yale University Press, 1967.

Rony, Farimah Tobing. *The Third Eye: Race, Cinema, and the Ethnographic Spectacle*. Durham: Duke University Press, 1996.

Ruaslina Idrus. "Malays and Orang Asli: Contesting Indigeneity." In Maznah and Khairudin, *Melayu*, 101–123.

Sahintürk, Zeynep. "The Djinn in the Machine: Technology and Islam in Turkish Horror Film." In *Digital Horror: Haunted Technologies, Network Panic and the Found Footage Phenomenon*, edited by Linnie Blake and Xavier Aldana Reyes, 95–106. London: I. B. Tauris, 2016.

Sahirul Hakim. "Kuntilanak di Filem Pontien." *Tribun Pontianak*, March 14, 2015.

Saiful Arif Abdullah and Adnan A. Hezri. "From Forest Landscape to Agricultural Landscape in the Developing Tropical Country of Malaysia: Pattern, Process, and their Significance on Policy." *Environmental Manangement* 42 (2008): 907–917.

Salleh Ghani. *Filem Melayu: Dari Jalan Ampas ke Ulu Klang*. Kuala Lumpur: Variapop, 1989.

Samad Said. *Salina*. Translated by Harry Aveling. Kuala Lumpur: Dewan Bahasa dan Pustaka, 1975.
Sarena Abdullah. "Expanding the Historical Narrative of Early Visual Modernity in Malaya." *Wacana Seni: Journal of Arts Discourse* 17 (2018): 41–75.
Saunders, Michael. *Imps of the Perverse: Gay Monsters in Film*. Westport, CT: Praeger, 1998.
Sen, Meheli. *Haunting Bollywood: Gender, Genre, and the Supernatural in Hindi Commercial Cinema*. Austin: University of Texas Press, 2017.
Senf, Carol A. "Dracula: The Unseen Face in the Mirror." *Journal of Narrative Technique* 9, no. 3 (Fall 1979): 160–170.
Shahrom Mohd. Dom. "Struktur Filem Melayu: Nota Perbandingan Konsep dan Satu Pendekatan." Paper presented at Forum of 4th Malaysian Film Festival, 1984.
Sharifah Mahsinah Abdullah. "800 Orang Asli Set Up Blockades Against Logging, Durian Plantation Near Gua Musang." *New Straits Times*, February 16, 2018.
Sharifah Zinjuaher H. M. Ariffin and Hang Tuah Arshad. *Sejarah Filem Melayu*. Kuala Lumpur: Sri Sharifah, 1980.
Sharrett, Christopher. "The Horror Film as Social Allegory (and How It Comes Undone)." In *A Companion to the Horror Film*, edited by Harry M. Benshoff, 56–89. New York: Wiley, 2017.
Shohat, Ella, and Robert Stam. *Unthinking Eurocentrism: Multiculturalism and the Media*. London: Routledge, 1994.
Showalter, Elaine. *Sexual Anarchy: Gender and Culture at the Fin de Siècle*. London: Penguin, 1990.
Sim, Gerald. "Historicizing Singapore Cinema: Questions of Colonial Influence and Spatiality." *Inter-Asia Cultural Studies* 12, no. 3 (2011): 358–370.
———. *Postcolonial Hangups in Southeast Asian Cinema: Poetics of Space, Sound, and Stability*. Amsterdam: Amsterdam University Press, 2020.
Skeat, Walter William. *Malay Magic: An Introduction to the Folklore and Popular Religion of the Malay Peninsula*. New York: Macmillan, 1900.
Smith, Angela M. *Hideous Progeny: Disability, Eugenics, and Classic Horror Cinema*. New York: Columbia University Press, 2012.
Smith, Nicola. "Malaysia's PM Rejects Same-Sex Marriage." *Telegraph*, October 26, 2018.
Soon, Simon. "Malay: The Hikmat [Inner Workings] of Seni [Art]: Gambar [Picture], Lukis [to Paint or Draw], Moden/Moderen [Modern], Sezaman [of this Age], Baru [New], Kontemporer/Kontemporari [Contemporary], Kagunan [Beneficial Refinement], Imajan [Imagery]." *Southeast of Now: Directions in Contemporary and Modern Art in Asia* 2, no. 2 (2018): 119–166.
Spivak, Gayatri Chakravorty. "Ghostwriting." *Diacritics* 25, no. 2 (1995): 64–84.
Stewart, Ian. "Sex, Violence, and Horror Banned on TV." *South China Morning Post*, February 7, 1995.
Stivens, Maila. "Becoming Modern in Malaysia: Women at the End of the Twentieth Century." In *Women in Asia: Tradition, Modernity and Globalisation*, edited by Louise Edwards and Mina Roces, 16–38. St. Leonards: Allen and Unwin, 2000.
Stoker, Bram. *Bram Stoker's Notes for Dracula: A Facsimile Edition*. Annotated and transcribed by Robert Eighteen-Bisang and Elizabeth Miller. Jefferson, NC: McFarland, 2008.
———. *Dracula*. 1878; New York: Oxford University Press, 2011.
Stone, Rob, Paul Cooke, Stephanie Dennison, and Alex Marlow-Mann, eds. *The Routledge Companion to World Cinema*. London: Routledge, 2017.
Suhaimi Haji Muhammad. "Kebenaran." *Mastika*, January 1959.
Suhari. "Pontianak Gua Musang Ta' Tentu Chorak Cherita-nya." *Berita Harian*, December 5, 1964.
Syed Husin Ali. *Masyarakat dan Pimpinan Kampung di Malaysia*. Kuala Lumpur: Fajar Bakti, 1977.
Syed Hussein Alatas. *The Myth of the Lazy Native: A Study of the Image of the Malays, Filipinos and Javanese from the 16th to the 20th Century and Its Function in the Ideology of Colonial Capitalism*. London: Frank Cass, 1977.
———. "Watak Tertawan di Negara Membangun." In Daud and Zabidah, *Pascakolonialisme dalam Pemikiran Melayu*, 1–11.

Syed Hussein bin Ali. *Malay as the National Language*. Kuala Lumpur: Dewan Bahasa dan Pustaka, 1962.

Tahir Alhamzah. "*Dendam Pontianak* Rakes in RM 1.3 mil After 1 Week in Cinemas." *New Straits Times*, September 19, 2019.

Tan, Kenneth Paul. "Pontianaks, Ghosts and the Possessed: Female Monstrosity and National Anxiety in Singapore Cinema." *Asian Studies Review* 34, no. 2 (2010): 151–170.

Tan, Sandi. *The Black Isle*. New York: Grand Central, 2012.

Tan Sooi Beng. *Bangsawan: A Social and Stylistic History of Popular Malay Opera*. Oxford: Oxford University Press, 1993.

———. "From Popular to 'Traditional' Theater: The Dynamics of Change in Bangsawan of Malaysia." *Ethnomusicology* 33, no. 2 (1989): 229–274.

Tarrant, Tavleen, and Joseph Sipalan. "Worries About Malaysia's 'Arabisation' Grow as Saudi Ties Strengthen." *Reuters*, December 21, 2017.

Taziz, Nino. *From the Written Stone: An Anthology of Malaysian Folklore*. Kuala Lumpur: Utusan, 2006.

Teo, Sharlene. *Ponti*. London: Picador, 2018.

Teo, Stephen. *The Asian Cinema Experience: Styles, Spaces, Theory*. New York: Routledge, 2013.

Thompson, Kristin. "The Concept of Cinematic Excess." *Cine-Tracts* 1, no. 2 (1977): 54–64.

Toh Hun Ping. "*Curse of Pontianak/Sumpah Pontianak*." In *World Film Locations: Singapore*, edited by Lorenzo Codelli, 24–25. London: Intellect, 2014.

Tolentino, Rolando. "Niche Globality: Philippine Media Texts to the World." In *Popular Culture Co-Productions and Collaborations in East and Southeast Asia*, edited by Nissim Otmazgin and Eyal Ben-Ari, 150–168. Singapore: NUS Press, 2013.

Tsing, Anna Lowenhaupt. *Friction: An Ethnography of Global Connection*. Princeton: Princeton University Press, 2005.

Tylor, Edward B. *Primitive Culture: Researches Into the Development of Mythology, Philosophy, Religion, Language, Art, and Custom*. Vol. 1. London: John Murray, 1903.

Ufen, Andreas. "Political Finance and Corruption in Southeast Asia: Causes and Challenges." In *The Changing Face of Corruption in the Asia Pacific: Current Perspectives and Future Challenges*, edited by Marie de la Rama and Chris Rowley, 23–33. Amsterdam: Elsevier, 2017.

Uhde, Jan, and Yvonne Ng Uhde. "The Exotic Pontianaks." In *Fear Without Frontiers: Horror Cinema Across the Globe*, edited by Steven Jay Schneider, 125–134. Godalming: Fab, 2003.

Uhlin, Graig. "Plant-Thinking with Film: Reed, Branch, Flower." In Vieira, Gagliano, and Ryan, *The Green Thread*, 201–217.

Vasudev, Aruna, Latika Padgonkar, and Rashmi Doraiswamy, eds. *Being and Becoming: The Cinemas of Asia*. Delhi: Macmillan, 2002.

Vasudevan, Ravi. "The Melodramatic Mode and the Commercial Hindi Cinema: Notes on Film History, Narrative and Performance in the 1950s." *Screen* 30, no. 3 (1989): 29–50.

Vieira, Patrícia. "Laws of the Jungle: The Politics of Contestation in Cinema About the Amazon." In Vieira, Gagliano, and Ryan, *The Green Thread*, 129–145.

Vieira, Patrícia, Monica Gagliano, and John Ryan, eds. *The Green Thread: Dialogues with the Vegatal World*. Lanham, MD: Lexington, 2016.

Viveiros de Castro, Eduardo. "Cosmological Deixis and Amerindian Perspectivism." *Journal of the Royal Anthropological Institute* 4, no. 3 (1998): 469–488.

Voon Phin-Keong. "Rural Land Ownership and Development in the Malay Reservations of Peninsular Malaysia." *South East Asian Studies* 14, no. 4 (1977): 496–512.

Wada-Marciano, Mitsuyo. "Showing the Unknowable: *Uncle Boonmee Who Can Recall His Past Lives*." In Leeder, *Cinematic Ghosts*, 271–289.

Wade, Geoffrey. "The Origins and Evolution of Ethnocracy in Malaysia." *Working Paper Series*, no. 112. Asia Research Institute, NUS, 2009.

Wak Cantuk. "Cerita Hantu." *Berita Harian*, October 9, 2011.

Wan Amizah Wan Mahmud, Chang Peng Kee, and Jalamuddin Aziz. "Film Censorship in Malaysia: Sanctions of Religious, Cultural, and Moral Values." *Jurnal Komunikasi* 25 (2009): 42–49.

Wan Zulkifli Wan Hassan et al. "The Practice of Interfaith Inheritance Distribution in Malaysia: An Analysis of Its Fatwa." *Middle-East Journal of Scientific Research* 22, no. 3 (2014): 464–469.

Weaver-Hightower, Rebecca, and Peter Hulme, eds. *Postcolonial Film: History, Empire, Resistance*. New York: Routledge, 2014.

Wells, Paul. *The Horror Genre: From Beelzebub to Blair Witch*. New York: Wallflower, 2000.

White, Luise. *Speaking with Vampires: Rumor and History in Colonial Africa*. Berkeley: University of California Press, 2000.

White, Timothy. "Pontianaks and the Issue of Verisimilitude in Singaporean Cinema." Unpublished paper, Department of English Language and Literature, National University of Singapore (2002), np.

Wicke, Birka, Richard Sikkema, Veronika Dornburg, and André Faaij. "Exploring Land Use Changes and the Role of Palm Oil Production in Indonesia and Malaysia." *Land Use Policy* 28 (2011): 193–206.

Wilkinson, R. J. *Malay Beliefs*. London: Luzac, 1906.

Williams, Raymond. *The Country and the City*. Oxford: Oxford University Press, 1975.

Winstedt, Richard. *The Malay Magician: Being Shaman, Saiva and Sufi*. London: Routledge, 1951.

Wood, Robin. "An Introduction to the American Horror Film." In *American Nightmare: Essays on the Horror Film*, edited by Andrew Britton, Richard Lippe, Tony Williams, and Robin Wood, 7–28. Toronto: Festival of Festivals, 1979.

Xuan Mai Ardia, C. A. "Legends, Ghosts and Feminism: Malaysian Artist Yee I-Lann at Tyler Rollins Fine Art." *Art Radar*, October 6, 2016.

Yasmin Ramlan. "Orang Asli Deliver Protest Note to MB Over Kuala Langat Forest." *Malaysiakini*, February 26, 2020.

Yeo, Nicolette. *Old Wives' Tales: Fascinating Tales, Beliefs and Superstitions of Singapore and Malaysia*. Singapore: Times, 2004.

Young, Damon. "Ironies of Web 2.0." *Post-45* 2 (2019): np.

Yusoff, Norman. "Contemporary Malaysian Cinema: Genre, Gender and Temporality." PhD diss., University of Sydney, 2013.

Zaidi Mohamad. "Emma Maembong Jadi Pontianak Bertudung." *Berita Harian*, March 13, 2016.

Zainah Anwar. *Islamic Revivalism in Malaysia: Dakwah Among the Students*. Petaling Jaya: Pelanduk, 1987.

——. "What Islam, Whose Islam? Sisters in Islam and the Struggle for Women's Rights." In Hefner, *The Politics of Multiculturalism*, 227–252.

Zainal Kling. "Situasi Pascakolonialisme." In Daud and Zabidah, *Pascakolonialisme dalam Pemikiran Melayu*, 12–36.

Zakaria Ali. "Renungan ke atas Catan Landskap Malaysia." *Wacana Seni: Journal of Arts Discourse* 1 (2002): 1–12.

Zappei, Julia. "Horror Films Rise from the Dead in Malaysia." *Asia One*, March 21, 2012.

Zieman. "Classics Among 22 on List of Banned Films." *The Star*, April 13, 2003.

——. "A Role She Will Always Be Remembered For." *The Star*, August 19, 2007.

Zulkfli bin Md Yusoff, Dzul Haimi bin Md Zain, and Hamidon bin Saniman. "The Ornamental Design of Traditional Malay Utensils *(Kukuran)* in Peninsula Malaysia." *SHS Web of Conferences* 23, no. 01004 (2016): 1–8.

Zurairi Ar. "'Fans Tell Me I'm Going To Hell': Emma Maembong Laments Online Bullying After Unveiling." *Malay Mail*, February 9, 2019.

Zwemer, Samuel M. *The Influence of Animism on Islam: An Account of Popular Superstitions*. New York: Macmillan, 1920.

INDEX

Aami Jarr, 42, 46, 51
Abbott, Jason P., 144–45
Abdul Rahman, 47
Abdul Razak, 44, 52, 54, 72, 233
Abi (Ahmad bin Idris), 30, 45
A. B. Shamsul, 145
Abul Malik Mokhtar, 30
Adam (S. Roomai Noor, 1956), 51
adat (Malay laws and customs), 33, 48–49, 97–98, 102, 117, 122, 186
Adil Johan, 31–32
Adnan Hezri, 233–34
adulteries, 84–86, 88, 97. *See also* sexualities
Agung Trihatmodjo, 194
Ahmad Farouk Musa, 147
Ahmad Fauzi Abdul Hamid, 142, 146
Aiken, S. Robert, 190, 218, 228
Alfian Sa'at, 18–20, 125, 176
Alicia Izharuddin, 32–33, 82, 94, 99, 102
Amin, M., 51
Amir Muhammad, 9–11, 64, 75, 135, 143
Amirpour, Lily, 163
Amran bin Kasimir, 213
Anak Pontianak (Shuhaimi/TV3, 2007–2008), 14, 190
Anak Pontianak / Son of the Pontianak (Estella, 1958): advertisement, *41*; animism, 208, 229–30; gender, 69–71; *hantu*, 73; identities, 51; Malay Film Productions, 3; Malay folklore, 72; maternities, 96; modernities, 162; race, 69–71; transnationalism, 46

Andrew, Dudley, 25
animism, 197–236; Abdul, 52; animals and spirits, 37, 197–98, 228–33, 261n106; anticolonialism, 197–98, 200–1, 214; Britain, 76, 232–33; Cathay Keris studios, 52; colonialism, 198, 201, 223, 231; decolonization, 199, 200, 206, 223, 233, 236; decorative arts, 219–20, 223–24; definitions of, 197–98, 200; environmental destruction, 201, 233–36; film theories, 200–1, 203–6; foliage, 37, 214–44; geopolitics, 198; *hantu* beliefs, 202, 203; horror films, 25, 30, 72, 200–201, 205; Islam, 37, 76–77, 142–44, 148–49, 152, 155, 197, 203, 206, 207–8, 211, 230–31; jungles, 34–35, 202, 203, 218–19, 225–28, 233; land ownership, 202; Mahathir, 167; Malay culture, 117–18, 198, 205–6, 208, 213; Malay folklore, 211–12, 229–30; modernities, 1, 76, 77–78, 201–6, 223, 231; monstrosities, 208–9; nationalism, 203–4; new animisms, 201–6; plant science, 211; politics, 203–4, 223, 229, 261n106; pontianak films, 37, 199, 201, 208–11, 213–19, 224–36, 259n59; pontianaks, 1, 5, 8, 37, 142–43, 152, 197–99, 202, 212–14, 216, 217, 222–23; postcolonialism, 34, 197–201, 205, 233–36; race, 198; rationalism, 208–9; religion, 206–11, 257n1; Salleh, 228; Singapore, 198; Southeast Asia, 143, 201, 205, 229, 233; spaces of, 211–14; Thailand, 203; Western culture, 197–98, 201–5; world cinema, 200, 206

anticolonialism, 57–61; *adat* (Malay laws and customs), 97–98; animism, 197–98, 200–201, 214; ethnonationalism, 62; feminism, 118; Islam, 143, 146; Malay culture, 57–59, 63, 171; Malaysia, 50, 118; Maria, 53, 54–55; nationalism, 60–61, 171–72; pontianak films, 9–11, 35, 41, 50, 68–69, 72, 76, 82, 99, 173–74, 223, 233; pontianaks, 1, 16, 98, 109, 190, 197, 236; pontianak short stories, 18; Singapore, 50, 57; world cinema, 24–26
Antonioni, Michelangelo, 219, 225
Apichatpong Weerasethakul, 104, 157, 203
Appadurai, Arjun, 189, 228
Aquilia, Pieter, 27
Arata, Stephen, 8
Århem, Kaj, 202
ASAS 50 (Angkatan Sasterawan 50), 58–59
As Boas Maneiras/Good Manners (Rojas, Dutra, 2014), 13
Aster, Ari, 163
aswang (Filipino ghost), 22, 28, 117
Athanasiou, Athena, 126
Aumont, Jacques, 224
Azlina Asaari, 33–34, 81, 147, 168–69
Azmi Aziz, 145

Babadook, The (Kent, 2014), 13
Badrul Redzuan Abu Hassan, 31
Bagoes Wiryomartono, 190, 211
bangsa Melayu (Malay race or nation), 68–69, 97. *See also* race
bangsawan (Malay opera), 43–44, 45, 64
Baring-Gould, Sabine, 6
Barnard, Timothy, 57–58, 59, 166
Barr, Michael D., 125, 146
Basker, K. M., 45, 51
Bazin, André, 204–5
beauty, 55, 79, *85*, 89, 91, 92–93, 109
Bekolo, Jean-Pierre, 11
Benjamin, Walter, 22, 222
Bennett, Jane, 204
Berenstein, Rhona, 111
Berita Filem, 51, 73–74, 76–77
Berita Harian, 49, 78, 230
Bester, Theodore, 67
Bhabha, Homi, 21
Big Durian, The (Amir, 2003), 135
Bird, Isabella, 6–8
Bird-David, Nurit, 202, 205

Black Isle, The (Tan), 19
"Blame" (De Rozario), 80
Blanco, María del Pilar, 23
Boehler, Nathalie, 203
Bollmer, Grant, 204
Boucher, James, 235
Brantlinger, Patrick, 6, 8
Bräunlein, Peter, 203
Britain: animism, 76, 232–33; geopolitics, 50; heritage films, 163–64, 182; land ownership, 190; Malaya, 38, 50, 58, 62–63, 67–68, 123, 167; race, 62–63, 167; Singapore, 50, 232–33; Wells, 8. *See also* colonialism
Browning, John Edgar, 26
Bunga Tanjong/Cape of Flowers (Estella, 1963), 56
Burhan Baki, 199, 203, 236
Burhanuddin Al-Helmy, 123–24
Burns, Stu, 2, 6, 8
Butler, Judith, 126

Carter, Angela, 13
Cathay Classic Film Festival, 13–14
Cathay Keris studios: animism, 52; Chang, 175; Ho, 57; Hodge, 75; Maria, 56; multiethnicities, 64; nationalism, 171–72; pontianak films, 2–3, 9–10, 39, 73, 75, 84, 121; transnationalism, 42, 44–46, 51. *See also individual films*
Cathay Theatre, 13–14, 39
censorship, 4–5, 59, 101–2, 117, 147–48, 149–50
Chakrabarty, Dipesh, 22, 24
Chang, Grace, 175
Chatterjee, Partha, 60–61
Chen, Kuan-Hsing, 34
childbirth. *See* maternities
Cho, Zen, 130–31
Choi, Jinhee, 27
Chua Beng-Huat, 127
"Cinema" (Khoo, 2015), 119–22, 214–15, *216*. *See also 7 Letters* (Khoo, Boo, Neo, Tong, Rajagopal, Tan, P.P., Tan, R., 2015)
Cixous, Hélène, 94
Clifford, Hugh, 231
Clover, Carol, 81
colonialism: animism, 198, 201, 223, 231; decorative arts, 220–24; environmental destruction, 235; *hantu* beliefs, 8–9; horror films, 25; identities, 123; *kampung* (rural Malay village), 167, 168; land ownership, 182, 190–91;

Malaya, 38, 221; Malaysia, 35, 38, 67–68, 223–24; modernities, 143, 221–22, 223, 235; pontianak films, 29, 38, 41, 52, 75, 76, 223, 224–25; pontianaks, 2, 9; pontianak short stories, 18; race, 42, 47, 49, 123–27, 167, 223–24, 252n66; sexualities, 88; Singapore, 32, 35, 41–42, 130, 176; Southeast Asia, 8–9, 29, 221; traditionalism, 67, 160; transnationalism, 41–52; vampires, 8–9, 21–22, 29, 178–79; world cinema, 25. *See also* anticolonialism; decolonization; postcolonialism

Company of Wolves, The (Jordan, 1984), 13
Convalescent Bungalow (Smith, 1820) (art), 221, 224
Conversations with the Malayan Banyan, the Queen and the Many Names of Other Guiding Spirits of Place (Zarina, 2019) (art), 223
Creed, Barbara, 81, 94
Cuisinier, Jeanne, 212

Dang Anom (Hussein, 1962), 51, 64
Daniels, Timothy P., 150
Darah Muda/Young in Heart (Jamil Sulong, 1963), 159
decolonization: animism, 199, 200, 206, 223, 233, 236; decorative arts, 222; Dussel, 25; environmental destruction, 190–92; horror films, 25; identities, 140; jungles, 190; land ownership, 165, 189; Malay culture, 67; Malaysia, 9, 21, 23, 40, 140; modernities, 160; pontianak films, 1, 5, 9, 11, 21, 34, 39, 40–41, 50, 52, 65, 67, 99, 118, 158, 223, 225; pontianaks, 21–23, 33, 37, 40–41, 95; race, 50, 131; Singapore, 9, 21, 23, 40, 223–24. *See also* anticolonialism
decorative arts, 219–24
deforestation. *See* environmental destruction
deformities. *See* monstrosities; monstrous-feminine, the
Dendam Pontianak/Revenge of the Pontianak (Goei and Yap, 2019), 12, 176–81
Dendam Pontianak/The Pontianak's Vengeance (Rao, 1957): animism, 209, 229; *bangsawan* (Malay opera), 44; Cathay Keris studios, 2–3, 9–10; gender, 112–13, 236; Ho, 57; identities, 66; Islam, 144; jungles, 136, 192, 216, 219; *kampung* (rural Malay village), 160–61, 162; *merdeka* (independence), 9–10; multiethnicities, 40; publicity shot, *43*; queerness, 112–13

De Rozario, Tania, 80, 82
Derrida, Jacques, 23, 115, 186, 199
Descola, Philippe, 201
Dina Zaman, 157
disabilities, 24–25
Dove, Michael, 109
Dracula (Stoker), 6, 91. *See also* vampires
During, Simon, 204
Dussel, Enrique, 25
Dyer, Richard, 128, 175

Eaton, Peter, 190
Eighteen-Bisang, Robert, 6
Eisenstein, Sergei, 200, 215
Endicott, Kirk, 2
environmental destruction: colonialism, 235; decolonization, 190–92; *hantu* beliefs, 194–95; heritage, 195; inheritance, 190, 195–96; jungles, 190–92, 233–35; *kampung* (rural Malay village), 36–37, 75, 184; Malaysia, 37, 190–92, 233–35; modernities, 185; politics, 34, 195; pontianak films, 37, 185, 193–96, 209–10, 235–36; pontianaks, 5, 95, 190, 192, 194–95, 209–10; postcolonialism, 38, 184, 191–92; Singapore, 233; Southeast Asia, 233–34; Tsing, 28–29; Western culture, 191
Epstein, Jean, 200
Essay of Hauntings: Dance of the Fragrant Flowers, An (Yee, 2016) (art), 109
Estella, Ramon, 40, 46, 49, 52, 182. *See also individual films*
ethnonationalism: anticolonialism, 62; identities, 67; Islam, 146; jungles, 234; *ketuanan Melayu* (Malay supremacy), 61–62; land ownership, 182; Malaysia, 61, 67–68; pontianak films, 35, 65, 67–69, 117–18, 181; pontianaks, 71; race, 64, 68, 123–27, 223–24; religion, 252n66; Western culture, 61. *See also* nationalism
Eu, Amanda Nell, 12–13, 101, 104, 106–7, 109, 234
Evans, Ivor, 220

family relations, 151. *See also* maternities
Fantasi (Aziz, 1992), 147–48
Farish Noor, 146
Faucher, Carole, 17
Fay, Jennifer, 25–26
Feeley, Jennifer, 27

female agencies: Fuhrmann, 23; Maria, 54, 56; nail mythologies, 92; Ng, 81; patriarchies, 81; pontianak films, 5, 101, 116–17; pontianaks, 19, 33, 70–71, 76, 80, 81, 87, 99, 109

femininities: Islam, 153–54; the monstrous-feminine, 81, 94; nail mythologies, 92; pontianaks, 5, 32–33, 36, 69–70, 81–83, 95–96, 100, 109, 121. *See also* gender

feminism: *adat* (Malay laws and customs), 98; anticolonialism, 118; gender, 34–35, 94–109; heritage films, 180; Maria, 54–55; modernities, 34, 165; nail mythologies, 90, 92; pontianak films, 4–5, 12–13, 32–36, 81, 83, 89, 100–109, 130, 165, 173, 180–81, 185–86, 187–89, 195, 224, 234; pontianaks, 1, 19, 35–36, 80–83, 94–109, 130, 165, 189; pontianak short stories, 18–19; postcolonialism, 38, 83, 94–100, 188; rape, 89; religion, 82–83; traditionalism, 165

feminist film theories, 35, 81

Filem Malaysia, 74

filem seram. *See* horror films; *individual films*

film theories and studies, 22–29, 35, 81, 200–201, 203–6, 221, 222

Folklore (Khoo/HBO Asia, 2018), 14, 135–42, 162

forests. *See* jungles

Fowler, Catherine, 225

Fox, James, 212

Franke, Anselm, 198, 203, 204–5

Frayling, Christopher, 26

Frazer, James, 198

Fuhrmann, Arnika, 23, 28, 239n62

Furnivall, J. S., 63

Gabriel, Sharmani P., 124–25

Ganapathy, Narayanan, 125

Garuba, Harry, 203–4, 209

Gelder, Ken, 8, 21

Gelora Hidup (Rao, 1954), 48–49

gender, 79–118; *adat* (Malay laws and customs), 33; feminism, 34–35, 94–109; inheritance, 186–87; Islam, 99, 151–52, 154; land ownership, 186; Maria, 54; misogyny, 83–89; modernities, 34, 36, 49; nail mythologies, 90–94; pontianak films, 13, 36, 69–71, 83, 99–100, 112–18, 236; pontianaks, 1, 19, 33, 81–83, 87–88, 112, 199; pontianak short stories, 18–19; postcolonialism, 38, 83, 95; queerness, 34–35, 109–18; rationalism, 152; revenge, 83–89; transgender representation, 112–18. *See also* femininities; masculinities

gender politics: identities, 118, 184; Malaysia, 99; *Malay Sketches* (Alfian), 18–19; nail mythologies, 90; pontianak films, 35, 86, 102, 118, 181; pontianaks, 81, 82, 94–100; postcolonialism, 99, 118

gender violence: pontianak films, 87–89, 97, 102, 104, 115, 140–41, 178, 180; pontianaks, 1, 82–83, 101, 180. *See also* nail mythologies; rape

geopolitics: animism, 198; Britain, 50; horror films, 94; the monstrous-feminine, 94; pontianak films, 38, 81, 177, 181; pontianaks, 23, 199; postcolonialism, 31; race, 158

Gerard, Emily, 6

Gergasi/The Giant (Ghosh, 1958): animism, 143–44, 208; identities, 66; Islam, 143–44, 148; jungles, 216; *kampung* (rural Malay village), 71–72; Malay Film Productions, 3; modernities, 162; multiethnicities, 69; nail mythologies, 91–92; rationalism, 73; sexualities, 95; theater influence, 44

Ghost in the Banana Tree (Yee, 2016) (art), 222

ghosts, 1, 17, 22–23, 95, 115, 185–86, 199. *See also hantu* beliefs

Girl Walks Home Alone at Night, A (Amirpour, 2014), 163–64

Godinho de Erédia, Manuel, 1–2

Goei, Glen, 12, 112–13, 165, 176–77, 180

Goh, Daniel P. S., 63, 124

Golden Chersonese and the Way Thither, The (Bird), 6–7

Gopal, Sangita, 11

Gordon, Avery, 1, 22, 95, 139

Govindasamy, Anantha Raman, 146

Gräns/Border (Abbasi, 2018), 163–64

Gregorios-Pippas, Sophie, 144–45

Guillou, Anne Yvonne, 214

Guinness, Katherine, 204

Haji Mahadi, 47, 51

Hall, Matthew, 211

Hall, Stuart, 38, 128

Hallowell, Irving, 201

Hamzah Hussin, 30, 42, 58–59, 75–76, 78, 144

Hang Jebat (Hussein, 1961), 51, 64, 215

Hang Tuah (Majumdar, 1956), 30, 45

Hang Tuah Arshad, 44, 47, 128

INDEX

hantu beliefs: animism, 202, 203; Bird on, 7–8; colonialism, 8–9; environmental destruction, 194–95; figurines of, 3; identities, 199; Islam, 142–44, 208; jungles, 192, 194–95; *kampung* (rural Malay village), 166; land ownership, 37, 182–83, 190, 256n41; McHugh, 2, 88; modernities, 21–22, 162; pontianak films, 39, 69, 71–78, 133, 169, 195, 229; pontianaks, 1–2, 91; postcolonialism, 22; Southeast Asia, 22, 30; vampires, 5, 7–8; Western culture, 199

Hantu Bungkus vs Pontianak (Abdul Rahman, 2015), 192

Hantu Jerangkung (Basker, 1957), 51

Hantu Kak Limah series (Mamat, 2010–2018), 148, 174, 176, 185

Hantu Rimau (Rao, 1960), 230

Hardwick, Patricia, 173

Harimau Jadian (M. Amin, 1972), 230

Harper, T. N., 51, 58, 59, 62, 166, 168

Harvey, Graham, 201, 228, 257n1

Harvey, Sophia Siddique, 33, 130

Hassan Muthalib, 44, 49, 63, 148

Hawkins, Joan, 12

Hefner, Robert W., 123

Heide, William van der, 29–30, 42

Helfield, Gillian, 225

Herder, Johann Gottfried, 68

heritage, 169–73; environmental destruction, 195; horror films, 163–64, 165, 183; inheritance, 163; jungles, 190–91, 234; *kampung* (rural Malay village), 36, 164, 169–73; land ownership, 159, 181–82; landscape images, 224; Malay culture, 171–73; Malay folklore, 164; politics, 164, 195; pontianak films, 169–73, 185, 195–96; pontianaks, 163, 165; postcolonialism, 163, 195

heritage films, 162–65, 169, 173–81, 182, 183

Hertogh, Huberdina Maria, 53–54

Higson, Andrew, 163, 164, 182

Hikayat Abdullah bin Abdul Kadir Munsyi (manuscript), 220

Hindi films, 11, 45–46

Hirschman, Charles, 62–63, 123, 167

Histeria (J. Lee, 2008), 205

historicities, 164–65, 173–81

Ho Tzu Nyen, 231–32

Ho Ah Loke, *10*, 30, 57, 75

Hobsbawn, Eric, 67

Hodge, Tom, 75–76, 102

Hogan, Linda, 236

Holden, Philip, 63, 124

Hooker, Virginia, 50, 58–59, 60, 168

horror films, 11–15; animism, 25, 30, 72, 200–201, 205; censorship, 4–5, 101–2, 147–48; colonialism/decolonization, 25; deformities, 93; disabilities, 24–25; geopolitics, 94; heritage, 163–64, 165, 183; identities, 51; Islam, 101–2, 147–48; *kampung* (rural Malay village), 162; Malay culture, 25, 51; Malaysia, 27, 33–34, 102, 148, 205; misogyny, 95; modernities, 78, 161–62, 168; patriarchies, 94; pontianaks, 11–15; postcolonialism, 21–22, 173; rationalism, 117; Southeast Asia, 8, 27; traditionalism, 169; transnationalism, 12, 26–27; vampires, 163–64; vegetal films, 227; Western culture, 24–27; world cinema, 26–27. *See also individual films*

House of Aunts (Cho), 130–31

Hulme, Peter, 37–38

Hussein Hanif, 51, 52

Ila (artist), 20

independence, 9–11, 35, 40, 50, 125, 174, 178, 181

Indian films, 24

Ingawanij, May Adadol, 164

Ingold, Tim, 200, 205, 236

inheritance: environmental destruction, 190, 195–96; gender, 186–87; heritage, 163; Islam, 256n42; *kampung* (rural Malay village), 181–89, 195; land ownership, 165, 191, 256n42; patriarchies, 195–96; pontianak films, 149, 182–89, 193; pontianaks, 164, 187, 189; race, 195–96

Intan Paramaditha, 111

Islam, 142–58; *adat* (Malay laws and customs), 33, 48; animism, 37, 76–77, 142–44, 148–49, 152, 155, 197, 203, 206, 207–8, 211, 230–31; anticolonialism, 143, 146; decorative arts, 220, 221–22; femininities, 153–54; gender, 99, 151–52, 154; *hantu* beliefs, 142–44, 208; horror films, 101–2, 147–48; identities, 146, 148, 157; inheritance, 256n42; *kampung* (rural Malay village), 151–52; land ownership, 186; Malaya, 143; Malay culture, 66–67, 76, 118, 142, 147–48, 150, 157, 173, 208; Malaysia, 36, 97, 122, 144–50, 207–8; Maria, 53–54; modernities, 143, 145; multiethnicities, 146; nail mythologies, 154; nationalism, 150–51; pontianak films, 105–6, 117–18, 143–44,

Islam (*continued*)
 147–58, 208, 211; pontianaks, 5, 36, 37, 71, 82, 94, 121–22, 142–58; race, 142, 145, 146, 150–52; *Siccin* (Mestçi, 2014), 11; transgender representation, 115; women's roles, 99
Islamic Renaissance Front (IRF), 147
Ismail Zain, 207

Jaikumar, Priya, 24, 25, 160
Jamaluddin Aziz, 33–34, 81, 147–48, 168–69
Jamil Sulong, 30, 44, 45, 51, 57, 58, 159
Jordan, Neil, 13
Joseph-Vilain, Mélanie, 163
jungles, 189–96; animism, 34–35, 202, 203, 218–19, 225–28, 233; environmental destruction, 190–92, 233–35; ethnonationalism, 234; foliage, 214–24; *hantu* beliefs, 192, 194–95; heritage, 190–91, 234; *kampung* (rural Malay village), 189–90; land ownership, 189–96; Malaysia, 190, 218, 233, 235; politics, 191, 233, 234–35; pontianak films, 37, 136, 192–93, 209–10, 212–19, 224–28, 235–36; pontianaks, 3–4, 192, 199, 212–17, 222–23, 236; race, 235; Southeast Asia, 234
Ju-On/The Grudge (Shimizu, 2002), 26–27

Kahn, Joel S., 167
Kala Malam Bulan Mengambang (Mamat, 2008), 172, 174–76, 209, 230
kampung (rural Malay village), 159–96; architecture, 169–73; colonialism, 167, 168; environmental destruction, 36–37, 75, 184; *hantu* beliefs, 166; heritage, 36, 164, 169–73; identities, 165, 167; inheritance, 181–89, 195; Islam, 151–52; jungles, 189–90; land ownership, 159–60, 165, 184, 189–96; landscape images, 224; Malay culture, 165–66, 170–71, 184; Malaysia, 160; mentalities, 165–69; modernities, 60, 74–75, 76, 159–62, 166–67, 178, 184–85; nationalism, 165–67; *pantuns* (Malay oral tradition), 66, 245n122; politics, 165–66, 167, 168; pontianak films, 37, 64–66, 69, 71–72, 73, 160–73, 174–77, 180, 185, 189, 224–25; pontianaks, 3–4, 151–52, 162, 165–66, 192, 199, 236, 254n18; postcolonialism, 165–66, 184; race, 128, 167; revisionist history, 173–81; Singapore, 37, 74–75, 160; traditionalism, 160, 165, 178; women's roles, 99
Kathirithamby-Wells, Jeyamalar, 191, 192, 233

Kee, Jac S. M., 33, 152
Keluarga Pontimau (Norhanisham and Bhatia/TV3, 2015–2016), 14, 230
Keris Mas, 58, 59
Kessler, Clive, 67, 160, 166
ketuanan Melayu (Malay supremacy), 61–62, 63
Khoo, Eric, 119–21, 135–37, 139, 144, 162, 181, 215
Khoo, Gaik Cheng, 33, 97–98, 101, 102, 117, 133, 135
Khoo, Olivia, 138
Khoo Kay Kim, 62–63
Klee, Paul, 200
Konior, Bogna, 205
Konpaku (Remi, 2019), 151, 253n89
Kracauer, Siegfried, 205
Krishnan, Laksamanan, 40, 45, 47, 51
Kuntilanak (Rizal, 2018), 14
"Kuntilanak" (Sulaiman), 18
Kwaidan (Kobayashi, 1964), 26–27

Lagi Senang Jaga Sekandang Lembu/It's Easier to Raise Cattle (Eu, 2017), 12–13, 101, 104–7, 169, 213, 234
Laila Majnun (Rajhans, 1933), 42, 43–44
Lancang Kuning (Amin, 1962), 51
land ownership, 181–96; *adat* (Malay laws and customs), 186; animism, 202; colonialism, 182, 190–91; decolonization, 165, 189; ethnonationalism, 182; gender, 186; *hantu* beliefs, 37, 182–83, 190, 256n41; heritage, 159, 181–82; inheritance, 165, 191, 256n42; Islam, 186; jungles, 189–96; *kampung* (rural Malay village), 159–60, 165, 184, 189–96; Malaysia, 190; Orang Asli (indigenous peoples), 191, 234–35; patriarchies, 165, 182, 183, 186; politics, 34, 190–91; pontianak films, 37, 182–89, 195; pontianaks, 21, 189, 190, 195; postcolonialism, 159, 181–82, 189–91; race, 126–27, 167, 191
landscape images, 221–25, 227
langsuir (birth spirit), 2, 3, 237n3
Langsuir (Osman, 2018), 91, 148, 150, 216
Latour, Bruno, 198, 203
Lee, Adrian Yuen Beng, 6, 32–33, 81, 91
Lee, James, 131, 135, 205
Lee, Russell, 16–17
Leeder, Murray, 23
Leigh, Colin H., 190, 218, 228

Lewis, Abram, 205
Leyden, John, 68
Lian Kwen Fee, 125
Like the Banana Tree at the Gate: A Leaf in the Storm (Yee, 2016) (art), 101, 107–9, 222
Lim, Bliss Cua, 22–23, 27–28, 115, 117, 186, 194, 204
Lim, Catherine, 16–17
Limbrick, Peter, 25
Lim Kay Tong, 51
Liow, Joseph Chinyong, 145–46
Liv Rianty binte Noor Hishamudin, 96
Locke, John, 126
Loke Wan Tho, 51–52
Lowenstein, Adam, 12
Lye Tuck-Po, 160, 234

Macfarlane, Robert, 163
Maembong, Emma, 152–53
Maghrebi films, 25
Mahathir Mohamad, 97, 118, 126–27, 147, 148, 167–69, 191–92
Mahsuri (Rao, 1958), 48
Maid, The (Tong, 2005), 27, 94
Majallah Filem, 49, 51, 68–69, 77–78
Majumdar, Phani, 45
Malaya: Britain, 38, 50, 58, 62–63, 67–68, 123, 167; colonialism, 38, 221; decorative arts, 220–21; independence, 35; Islam, 143; modernities, 221–22; multiethnicities, 62–63; politics, 50–51, 53, 58, 62; pontianak films, 35; pontianaks, 2, 9, 121; race, 39–42, 62, 67–68, 123; religion, 206; transnationalism, 46; vampires, 6
Malay culture: Abdul, 52; *adat* (Malay laws and customs), 33, 117; animism, 117–18, 198, 205–6, 208, 213; anticolonialism, 57–59, 63, 171; decolonization, 67; heritage, 171–73; horror films, 25, 51; identities, 61–72, 122–23, 184; Islam, 66–67, 76, 118, 142, 147–48, 150, 157, 173, 208; *kampung* (rural Malay village), 165–66, 170–71, 184; Maria, 52, 56; maternities, 84; modernities, 61, 67, 97, 160, 195; monstrosities, 21; nationalism, 50, 61–62, 76; New Economic Policy (NEP), 184; politics, 67; pontianak films, 9–11, 40, 52, 64–65, 66–67, 75–76, 118, 172–73; pontianaks, 1, 5, 9, 15–20, 23–24, 27–28, 35, 78, 81, 122, 142–43, 163, 176–77, 192; queerness, 116; race, 122; religion, 207; Taib, 245n102; traditionalism, 67–68, 160; transnationalism, 32, 46, 48, 51; vampires, 26; Western culture, 59–61, 99, 206–7; Zainal, 234. *See also hantu* beliefs
Malay Dilemma, The (Mahathir), 126–27, 167
Malay Film Productions, 3, 30. *See also* Shaw Brothers
Malay folklore: animism, 211–12, 229–30; Cathay Keris studios, 51; heritage, 164; Maria, 56; pontianak films, 52, 72, 97; pontianaks, 1–2, 5–8, 27–28, 33, 71, 122, 237n3; Skeat, 2, 7, 79–80, 206–7, 212
Malaysia: *adat* (Malay laws and customs), 33, 97; animals, 228, 231; anticolonialism, 50, 118; censorship, 4–5, 117; colonialism, 35, 38, 67–68, 223–24; decolonization, 9, 21, 23, 40, 140; decorative arts, 219–24; environmental destruction, 37, 190–92, 233–35; ethnonationalism, 61, 67–68; films of, 29–32; gender politics, 99; horror films, 27, 33–34, 102, 148, 205; identities, 97, 122–24, 127, 132–34, 140, 142–43, 146, 157–58, 199, 207; independence, 9, 50, 125, 174, 178, 181; Islam, 36, 97, 122, 144–50, 207–8; jungles, 190, 218, 233, 235; *kampung* (rural Malay village), 160; land ownership, 182, 190; maternities, 99; modernities, 74–75, 97–99, 124, 145, 168–69, 221; multiethnicities, 62–63, 146; nationalism, 31–32, 42, 59, 67–68, 168–69; politics, 50–51, 61, 124–25, 233, 252n66; pontianak films, 4, 5, 11, 13, 29–34, 140; pontianaks, 2, 5, 8, 9, 15, 122, 143, 181; postcolonialism, 31–32, 34, 35, 83, 98–99, 124, 165–66; queerness, 118; race, 34, 36, 38, 42, 63, 97, 122–27, 135, 147, 223–24, 235, 252n66; religion, 34, 36, 122, 142, 146–47, 206–11, 252n66; Singapore, 35, 50–51, 178; transnationalism, 62, 207; women's roles, 98–99
Malaysian Films: The Beginning (FINAS), 64
Malay Sketches (Alfian), 18
male violence. *See* gender violence
Mamat Khalid, 165, 174–75, 185
Mandal, Sumit, 135
Maria Menado, 4, *10*, 39, 47, 52–57, 72, 233
Maria Menado Productions, 56
Martin, Dahlia, 146
Martin-Jones, David, 25, 235–36

masculinities, 13, 89, 113–15, 128, 180–81
Mastika Filem, 48, 57, 59, 60, 68
Mata Hari/The Rape of Malaya (Estella, 1958), 54–55
maternities: Malay culture, 84; Malaysia, 99; pontianak films, 96, 109–11, 186–88, 215–16; pontianaks, 1–2, 6–8, 28, 54, 79–80, 84–86, 96. *See also langsuir* (birth spirit)
Mat Tiga Suku/Crazy Mat (Mat Sentol, 1964), 30
Maznah Mohamad, 124, 127
McHugh, J. N., 2, 88, 208
Md Salleh Yaspar, 211
merdeka (independence), 9–10, 59, 82. *See also* independence
Merdeka (Independence) (play), 176
Merdeka Studios, 30, 75
Midsommar (Aster, 2018), 163–64
Miller, Elizabeth, 6
Milner, Anthony, 67, 122, 206, 249n1
misogyny, 32–33, 36, 79–89, 90, 95, 102
Misrahi-Barak, Judith, 163
Misteri Bisikan Pontianak (M. Subash, 2013), 115–18, 171
Mitchell, Paul, 233
Mitchell, Timothy, 224
Mitchell, W. J. T., 221
modernities: animism, 1, 76, 77–78, 201–6, 223, 231; ASAS 50 (Angkatan Sasterawan 50), 58; colonialism, 143, 221–22, 223, 235; decolonization, 160; decorative arts, 220–24; environmental destruction, 185; feminism, 34, 165; gender, 34, 36, 49; *hantu* beliefs, 21–22, 162; horror films, 78, 161–62, 168; identities, 97; Islam, 143, 145; *kampung* (rural Malay village), 60, 74–75, 76, 159–62, 166–67, 178, 184–85; land ownership, 126; Malaya, 221–22; Malay culture, 61, 67, 97, 160, 195; Malaysia, 74–75, 97–99, 124, 145, 168–69, 221; politics, 160; pontianak films, 5, 37, 58, 72–78, 138–40, 143–44, 164–66, 174, 176, 179, 185–86; pontianaks, 5, 19, 21–22, 26, 32, 33, 72–73, 82, 94, 143, 164; pontianak short stories, 18–19; postcolonialism, 1; queerness, 34; race, 165; religion, 76; sexualities, 34, 48–49; Singapore, 124, 138–40, 221; Southeast Asia, 124, 143; traditionalism, 159–60, 176–79; Western culture, 60–61, 143; world cinema, 25–26
Mohamad Hatta Azad Khan, 31, 44, 46–49, 64–65

Mohd. Taib Osman, 2, 63, 206, 208, 211–12, 245n102, 245n122
Mohd. Zamberi Malek, 42, 46, 51
Mokhtar-Ritchie, Hanita, 44, 45
Monk, Claire, 163
monstrosities, 21, *85*, 92–93, 111–12, 113–14, 208–9
monstrous-feminine, the, 81, 94
Moure, José, 218
mouse-deer, 229–30
Movie News, 72, 230
Muhamad Ali, 143
multiethnicities: Cathay Keris studios, 64; identities, 123–24; Islam, 146; Malaysia, 62–63, 146; Mandal, 135; politics, 123–27; pontianak films, 5, 40, 69–70, 121, 130, 140; pontianaks, 19–20; pontianak short stories, 17; Southeast Asia, 124. *See also* transnationalism
Myth of the Lazy Native, The (Syed Hussein) (study), 127

Nagata, Judith, 126, 142
nail mythologies, 3, 6, 79, 87, 90–94, 154, 210
Nair, Sheila, 125, 127
Nang Nak (Nonzee, 1999), 28, 164
National Film Censorship Board (LPFM), 147–48
nationalism: animism, 203–4; anticolonialism, 60–61, 171–72; Cathay Keris studios, 171–72; Islam, 150–51; *kampung* (rural Malay village), 165–67; Malay culture, 50, 61–62, 76; Malaysia, 31–32, 42, 59, 67–68, 168–69; Maria, 56; politics, 61–62, 165–66; pontianak films, 32–33, 64–65, 68, 75, 118, 171–72, 195; pontianaks, 5, 40–41, 75, 82, 199; race, 61–62, 151; Singapore, 42. *See also* ethnonationalism
New Economic Policy (NEP), 99, 125, 184
Newman, Patrick, 231
Ng, Andrew Hock-Soon, 6, 75, 81, 91, 102, 143, 147
Ng Yi-Sheng, 20, 39
Nicholas, Cheryl, 91, 166, 208
Nieuwkirk, Karin van, 151
"Nobody" (Khoo/HBO Asia, 2018), 236
Nosa Normanda, 109–11, 112–13, 249n51

Och, Dana, 27
O'Leary, Alan, 164
Ong, Aihwa, 21–22, 60, 99, 118, 146, 151–52, 184

Onorato, Paul, 219
Ooi Kee Beng, 125–26
Orang Asli (indigenous peoples), 69, 126, 191, 231, 234–35
orang minyak (oily man), 11, 114. *See also Pontianak vs Orang Minyak* (Afdlin, 2012)
Orang Minyak/Oily Man (Krishnan, 1958), 78, 161–62
Osman Ali, 148. *See also Langsuir* (Osman, 2018)

Paku (Rameesh, 2013), 148–49, 171
Paku Kuntilanak/Nail Demon (Findo, 2009), 87–88, 89, 90, 95–96, 113–14
Paku Pontianak (Ismail, 2013): animism, 217–18, 226–28; beauty, 89; family relations/women's roles, 100, 151; Islam, 149, 150, 151; jungles, 192, 217–18, 219, 226–28; Malay culture, 172–73; nail mythologies, 90, 93; sexualities, 96
Pan Islamic Malaysian Party (PAS), 145–46
patriarchies: female agencies, 81; horror films, 94; inheritance, 195–96; land ownership, 165, 182, 183, 186; Maria, 56–57; nail mythologies, 91, 92–93; pontianak films, 70, 75, 87–88, 92–94, 103, 115, 117, 154, 173, 176, 180–81, 259n59; pontianaks, 18, 19, 32, 35–36, 79–83, 109, 165, 189, 197
Paul, William, 13
Peeping Tom (Powell, 1960), 12
Peluso, Nancy Lee, 191, 234
penanggalan (birth vampires), 2, *3*, 7, 20, 237n3
Penarek Beca/The Trishaw Man (P. Ramlee, 1955), 30, 51
Penghidupan/Life (Krishnan, 1951), 47, 53
Penulis (journal), 59–61, 245n102
Pereen, Esther, 23, 185–86, 187
Permata di Perlimbahan/Jewel in the Slum (Haji Mahadi, 1952), 51, 166
PHSM. *See Pontianak Harum Sundal Malam/Pontianak of the Tuberose* (Shuhaimi, 2004)
Picart, Kay, 26
Pile, Steve, 8, 178–79
plant sciences, 211, 227
Pokoknya (Zarina, 2020) (art), 223
politics: animism, 203–4, 223, 229, 261n106; ASAS 50 (Angkatan Sasterawan 50), 58; environmental destruction, 34, 195; fantastic films, 23; heritage, 164, 195; identities, 123–24; jungles, 191, 233, 234–35; *kampung* (rural Malay village), 165–66, 167, 168; land ownership, 34, 190–91; Malaya, 50–51, 53, 58, 62; Malay culture, 67; Malaysia, 50–51, 61, 124–25, 233, 252n66; modernities, 160; multiethnicities, 123–27; nationalism, 61–62, 165–66; pontianak films, 5, 9–11, 13, 38, 41; pontianaks, 20, 165, 176–78, 190, 205; pontianak short stories, 18; postcolonialism, 38, 94–100; race, 34–35, 38, 62, 124–27; Singapore, 50–51, 124–25, 233; transnationalism, 49; world cinema, 25. *See also* gender politics; geopolitics
Pompuan, Pontianak dan . . . (Asmat/SSTV, 2004), 114
Ponti (Teo), 19
Pontianak (Nosa, 2017), 109–11
Pontianak (Raihan, 2005), 88
Pontianak (Rao, 1957), 2–3, 9, 39–41, 44, 47, 54, 57, 66
Pontianak (Sutton, 1975): animism, 229; identities, 129; Islam, 150; jungles, 216–17, 219; maternities, 96; nail mythologies, 90; patriarchies, 88; pontianaks, 4; sexualities, 88; vampires, 7
Pontianak Beraya di Kampung Batu (Amor Rizan/Astro Ria, 2011), 6, 154–56, 158
Pontianak Bidan Gayah (Adam, 2003), 91, 192
pontianak films, 2–6, 8–11; animals and spirits, 37, 228–33, 236; animism, 37, 199, 201, 208–11, 213–19, 224–36, 259n59; anticolonialism, 9–11, 35, 41, 50, 68–69, 72, 76, 82, 99, 173–74, 223, 233; beauty, *85*, 89; Cathay Keris studios, 2–3, 9–10, 39, 73, 75, 84, 121; censorship, 102, 149–50; colonialism, 29, 38, 41, 52, 75, 76, 223, 224–25; decolonization, 1, 5, 9, 11, 21, 34, 39, 40–41, 50, 52, 65, 67, 99, 118, 158, 223, 225; environmental destruction, 37, 185, 193–96, 209–10, 235–36; ethnonationalism, 35, 65, 67–69, 117–18, 181; female agencies, 5, 101, 116–17; feminism, 4–5, 12–13, 32–36, 81, 83, 89, 100–9, 130, 165, 173, 180–81, 185–86, 187–89, 195, 224, 234; gender, 13, 36, 69–71, 83, 99–100, 112–18, 236; gender politics, 35, 86, 102, 118, 181; gender violence, 87–89, 97, 102, 104, 115, 140–41, 178, 180; generic codes of, 3–4, 162, 214, 229; geopolitics, 38, 81, 177, 181; *hantu* beliefs, 39, 69, 71–78, 133, 169, 195, 208, 229; heritage, 169–73, 185, 195–96; heritage films, 162–65, 169, 176; historicities, 164–65;

pontianak films (*continued*)
horror genre, 11–15; identities, 9, 35, 61–72, 73, 75, 83, 98, 99, 123, 128–29, 132–35, 140, 143, 157–58, 181, 183, 199; independence, 9–11; inheritance, 149, 182–89, 193; Islam, 105–6, 117–18, 143–44, 147–58, 208, 211; jungles, 37, 136, 192–93, 209–10, 212–19, 224–28, 235–36; *kampung* (rural Malay village), 37, 64–66, 69, 71–72, 73, 160–73, 174–77, 180, 185, 189, 224–25; land ownership, 37, 182–89, 195; Malaya, 35; Malay culture, 9–11, 40, 52, 64–65, 66–67, 75–76, 118, 172–73; Malay folklore, 52, 72, 97; Malaysia, 4, 5, 11, 13, 29–34, 140; masculinities, 13, 113–15, 180–81; maternities, 96, 109–11, 186–88, 215–16; misogyny, 32–33, 83–89, 102; modernities, 5, 37, 58, 72–78, 138–40, 143–44, 164–66, 174, 176, 179, 185–86; monstrosities, *85*, 113–14; multiethnicities, 5, 40, 69–70, 121, 130, 140; nail mythologies, 3, 87, 90–94, 154, 210; nationalism, 32–33, 64–65, 68, 75, 118, 171–72, 195; ontological status of, 72–78; patriarchies, 70, 75, 87–88, 92–94, 103, 115, 117, 154, 173, 176, 180–81, 259n59; politics, 5, 9–11, 13, 38, 41; postcolonialism, 5, 9, 11, 21, 33–34, 37–38, 72, 140–41, 158, 181, 193; queerness, 36, 109–18, 234; race, 36, 40, 50, 64, 69–71, 111, 121, 123, 127–42, 156–58, 183–84, 249n51; rationalism, 35, 73, 75–78, 117; religion, 36, 76, 78, 105–6, 118, 123, 149, 156–58, 185; revenge, 83–89, 100–9, 115, 180, 189; sexualities, 54, 84–89, 95–98, 102, 174; Shaw Brothers, 3; Singapore, 2, 4–5, 9, 11, 13–14, 20, 27, 30–32, 119, 140, 181, 192, 236; Southeast Asia, 158; television, 13–15; traditionalism, 165; transgender representation, 112–18; transnationalism, 5, 8, 45, 46, 49, 52, 131; vampires, 5–6, 7, 8, 26, 132, 153; Western culture, 77–78, 81; women's roles, 98–100, 109–10; world cinema, 27. *See also individual films*
Pontianak Gua Musang/The Pontianak of Musang Cave (Rao, 1964): animism, 229, 230–32; anticolonialism, 68–69; Cathay Keris studios, 2–3; directors, 47, 49; *hantu* beliefs, 73–78; heritage, 172; identities, 65–66; Islam, 253n88; jungles, 215–16, *217*, 235; land ownership, 186; Malaya, 2–3; Malay folklore, 97; maternities, 96; multiethnicities, 69, *70*; Orang Asli (indigenous peoples), 235; queerness, 112; sexualities, 84, 86, 95, 97
Pontianak Harum Sundal Malam 2/Pontianak of the Tuberose 2 (Shuhaimi, 2005), 103–4, 150, 172–73, 186–89, 214, 224
Pontianak Harum Sundal Malam/Pontianak of the Tuberose (Shuhaimi, 2004): *adat* (Malay laws and customs), 98; feminism, 4–5, 97, 101–3; inheritance, 185–86; *kampung* (rural Malay village), 169; land ownership, 190; Malay culture, 148, 172–73; nail mythologies, 93; pontianak films, 144
Pontianak Kembali/Pontianak Returns (Estella, 1963), 3, 56, 57, 75, 76–77, 90, 91, 143
Pontianak Masih Beraya di Kampung Batu (Ang/Astro Ria, 2012), 154–56, 225–26
Pontianak Menjerit (Yusof, 2005), 13, 113, 149–50, 162, 183–84
Ponti Anak Remaja (Nizam, Astro Ria, 2009), 12, 192, 209–11, 259n59
pontianaks: animism, 1, 5, 8, 37, 142–43, 152, 197–99, 202, 212–14, 216, 217, 222–23; anticolonialism, 1, 16, 98, 109, 190, 197, 236; beauty, 79, 91, 109; colonialism, 2, 9; decolonization, 21–23, 33, 37, 40–41, 95; decorative arts, 222; environmental destruction, 5, 95, 190, 192, 194–95, 209–10; ethnonationalism, 71; female agencies, 19, 33, 70–71, 76, 80, 81, 87, 99, 109; femininities, 5, 32–33, 36, 69–70, 81–83, 95–96, 100, 109, 121; feminism, 1, 19, 35–36, 80–83, 94–109, 130, 165, 189; gender, 1, 19, 33, 81–83, 87–88, 112, 199; gender politics, 81, 82, 94–100; gender violence, 1, 82–83, 101, 180; geopolitics, 23, 199; *hantu* beliefs, 1–2, 91; heritage, 163, 165; horror genre, 11–15; identities, 1, 19–20, 21, 23, 36, 61–72, 75, 81–83, 95, 119, 121–23, 130, 142–43; inheritance, 164, 187, 189; Islam, 5, 36, 37, 71, 82, 94, 121–22, 142–58; jungles, 3–4, 192, 199, 212–17, 222–23, 236; *kampung* (rural Malay village), 3–4, 151–52, 162, 165–66, 192, 199, 236, 254n18; land ownership, 21, 189, 190, 195; Malaya, 2, 9, 121; Malay culture, 1, 5, 9, 15–20, 23–24, 27–28, 35, 78, 81, 122, 142–43, 163, 176–77, 192; Malay folklore, 1–2, 5–8, 27–28, 33, 71, 122, 237n3; Malaysia, 2, 5, 8, 9, 15, 122, 143, 181; maternities, 1–2, 6–8, 28, 54, 79–80, 84–86, 96; misogyny, 36, 79–83, 95; modernities, 5, 19, 21–22, 26, 32, 33, 72–73, 82,

94, 95, 143, 164; monstrosities, 92–93, 111–12; multiethnicities, 19–20; nail mythologies, 6, 79; nationalism, 5, 40–41, 75, 82, 199; pandemic of 2020, 15; patriarchies, 18, 19, 32, 35–36, 79–83, 109, 165, 189, 197; politics, 20, 165, 176–78, 190, 205; postcolonialism, 1, 5, 9, 15, 21–23, 33, 81, 83, 94–100, 165, 189, 197; queerness, 33, 81, 82–83, 109–18; race, 20, 33, 81–83, 95, 119, 121–23, 127, 131, 142–43, 197, 199; religion, 33, 81–83, 95, 121–23, 142–43; revenge, 3, 18–19, 23, 28, 80–81, 88, 109; *semangat* (life force), 212; sexualities, 19, 20, 33, 81–83, 95–98, 108, 112, 152; short stories of, 16–20, 88; Singapore, 5, 9, 15, 17, 19–20, 33, 121–22, 136–37, 181; Southeast Asia, 5, 23, 27–28, 37, 81, 95, 108, 111; traditionalism, 5, 164; transnationalism, 5, 29, 45, 131; vampires, 8, 130–31; Western culture, 6, 16; world cinema, 24–29, 34–35; YouTube, 16. *See also* pontianak films

Pontianak Sesat dalam Kampung (Azmi/Astro Ria, 2016): gender violence, 89; Islam, 149, 150–51, 152–55, 158, 211; *kampung* architecture, 162, 170, 219; landscape images, 224; laziness, 168; nail mythologies, 93

pontianak short stories, 16–20, 88

Pontianak Teng Teng (Khan/TV3, 2014): family relations/women's roles, 100, 151; gender violence, 87, 89; jungles, 192, 225; *kampung* (rural Malay village), 162, 169; nail mythologies, 92; queerness, 113; as television, 14

Pontianak vs Orang Minyak (Afdlin, 2012), 114–15, 162, 213

Pontien: Pontianak Untold Story (Agung, 2016), 193–95

Ponzanesi, Sandra, 21, 34

Porath, Nathan, 208

postcolonialism, 159–96; animism, 34, 197–201, 205, 235–36; decorative arts, 223; environmental destruction, 38, 184, 191–92; feminism, 38, 83, 94–100, 188; gender, 38, 83, 95; gender politics, 99, 118; geopolitics, 31; *hantu* beliefs, 22; heritage, 163, 195; horror films, 21–22, 173; identities, 9, 115; *kampung* (rural Malay village), 165–66, 184; land ownership, 159, 181–82, 189–91; Malaysia, 31–32, 34, 35, 83, 98–99, 124, 165–66; modernities, 1; *Penulis* (journal), 59; politics, 38, 94–100; pontianak films, 5, 9, 11, 21, 33–34, 37–38, 72, 140–41, 158, 181, 193; pontianaks, 1, 5, 9, 15, 21–23, 33, 81, 83, 94–100, 165, 189, 197; queerness, 38; race, 38, 122, 124, 127–28, 130; religion, 38; Sim, 157–58; Singapore, 32–38, 50, 83, 130, 138, 166, 176, 223; Southeast Asia, 123, 157–58; world cinema, 29, 123; Yee, 107–8. *See also* anticolonialism; colonialism; decolonization

Pragmatic Prayers for the Kala at the Threshold (Zarina, 2018) (art), 223

premarital sex, 84–86. *See also* sexualities

Punggol Road End (Liv Rianty, 2015), 96

Pusaka Pontianak / The Accursed Heritage (Estella, 1965): advertisement, *31*; independence, 9, 40; inheritance, 182–83; Malay Film Productions, 3, 52; rationalism, 75, 77–78; transnationalism, 46, 49, 52

Putten, Jan van der, 57–58, 59

queerness: Fuhrmann, 23; gender, 34–35, 109–18; Goei, 176; Malaysia, 118; modernities, 34; monstrosities, 111, 113–14; pontianak films, 36, 109–18, 234; pontianaks, 33, 81, 82–83, 109–18; postcolonialism, 38

Quijano, Aníbal, 126

race, 119–58; animism, 198; *bangsa Melayu* (Malay race or nation), 68–69, 97; Britain, 62–63, 167; colonialism, 42, 47, 49, 123–27, 167, 223–24, 252n66; decolonization, 50, 131; ethnonationalism, 64, 68, 123–27, 223–24; geopolitics, 158; identities, 34, 62, 67–68, 97, 122–23, 132–33; inheritance, 195–96; Islam, 142, 145, 146, 150–52; jungles, 191, 235; *kampung* (rural Malay village), 128, 167; land ownership, 126–27, 167, 191; Malaya, 39–42, 62, 67–68, 123; Malay culture, 122, 125–26; Malaysia, 34, 36, 38, 42, 63, 97, 122–27, 133, 147, 223–24, 235, 252n66; Maria, 54; modernities, 165; nationalism, 61–62, 151; politics, 34–35, 38, 62, 124–27; pontianak films, 36, 40, 50, 64, 69–71, 111, 121, 123, 127–42, 156–58, 183–84, 249n51; pontianaks, 20, 33, 81–83, 95, 119, 121–23, 127, 131, 142–43, 197, 199; postcolonialism, 38, 122, 124, 127–28, 130; religion, 122–23, 142–43, 146, 152; Singapore, 36, 121–27, 130, 137–40, 181, 223–24; Western culture, 124, 127. *See also* transnationalism

Raffles, Stamford, 67–68
Raja Rohana Raja Mamat, 98–99
Rajhans, B. S., 44–45
Ramanathan, S., 45
Ramlee, P., 32, 49, 51, 58, 115–16
Rao, B. N., 2–3, 45, 48–49, 52, 58, 144. *See also individual films*
rape, 80, 86, 89, 91, 114–15, 138, 141. *See also* gender violence
rationalism, 35, 37, 73, 75–78, 117, 144, 152, 208–9
Rebiah Md Yusof, 46
Reid, Anthony, 67–68
religion, 119–58; *adat* (Malay laws and customs), 33; animism, 206–11, 257n1; ethnonationalism, 252n66; feminism, 82–83; identities, 34, 36, 142, 146, 184; Malaya, 206; Malay culture, 207; Malaysia, 34, 36, 122, 142, 146–47, 206–11, 252n66; modernities, 76; nail mythologies, 92; pontianak films, 36, 76, 78, 105–6, 118, 123, 149, 156–58, 185; pontianaks, 33, 81–83, 95, 121–23, 142–43; postcolonialism, 38; race, 122–23, 142–43, 146, 152; Southeast Asia, 143, 147. *See also* Islam
Renan, Ernest, 31
Return to Pontianak (Djinn, 2001), 4, 94, 129–30, 139–40
revenge: gender, 83–89; pontianak films, 83–89, 100–9, 115, 180, 189; pontianaks, 3, 18–19, 23, 28, 80–81, 88, 109; pontianak short stories, 18–19. *See also Dendam Pontianak/Revenge of the Pontianak* (Goei and Yap, 2019); *Dendam Pontianak/The Pontianak's Vengeance* (Rao, 1957)
Ringu / The Ring (Nakata, 1998), 27, 158

Saiful Arif Abdullah, 233–34
Saignantes, Les/The Bloodiest (Bekolo, 2005), 11
Salleh Ghani, 47–49, 212, 228. *See also individual films*
Samad Said, 168
sandiwara (Malay theater), 43–44
Sarena Abdullah, 220, 221
Sastry, K. R., 45
semangat (life force), 25, 212, 223, 227, 231
Sen, Meheli, 11
Senf, Carol A., 91
7 Letters (Khoo, Boo, Neo, Tong, Rajagopal, Tan, P. P., Tan, R., 2015), 119–22, 136–37, 165, 174, 214–15

sexualities: *adat* (Malay laws and customs), 33, 48–49; adulteries, 84–86, 88, 97; colonialism, 88; modernities, 34, 48–49; nail mythologies, 91; pontianak films, 54, 84–89, 95–98, 102, 174; pontianaks, 19, 20, 33, 81–83, 95–98, 108, 112, 152; pontianak short stories, 18; premarital sex, 84–86. *See also* rape
Shahrom Mohd. Dom, 45–46
Sharifah Zinjuaher H. M. Ariffin, 44, 47
Shariff Medan, 47, *48*, 49
Shaw Brothers: Khoo, 121; Maria, 53, 54–56; mouse deer, 230; multiethnicities, 64; pontianak films, 3; transnationalism, 42, 44–46, 51, 52. *See also* Malay Film Productions; *individual films*
Shuhaimi Baba, 98, 101–2, 148, 165, 185, 187. *See also individual films*
Siccin (Mestçi, 2014), 11
Sim, Gerald, 32, 138, 157–58
Singapore: animism, 198; anticolonialism, 50, 57; Bicentennial Experience, 232–33; Britain, 50, 232–33; Cathay Theatre, 13–14, 39; colonialism, 32, 35, 41–42, 130, 176; decolonization, 9, 21, 23, 40, 223–24; decorative arts, 223; environmental destruction, 233; identities, 140, 165; *kampung* (rural Malay village), 37, 74–75, 160; Malaysia, 35, 50–51, 178; modernities, 124, 138–40, 221; nationalism, 42; politics, 50–51, 124–25, 233; pontianak films, 2, 4–5, 9, 11, 13–14, 20, 27, 30–32, 119, 140, 181, 192, 236; pontianaks, 5, 9, 15, 17, 19–20, 33, 121–22, 136–37, 181; pontianak short stories, 19, 88; postcolonialism, 32–38, 50, 83, 130, 138, 166, 176, 223; race, 36, 121–27, 130, 137–40, 181, 223–24; studios, 2–3, 4, 11, 29–32, 34–35, 41–43, 46, 50, 56, 160, 215; transnationalism, 41–42, 46; Western culture, 140
Singapore Free Press, 15–16
Singapore Standard, 39, 160–61
Sinophone films, 27, 29
Sisters in Islam, 82–83, 147
Siti Zubaidah (Rao, 1961), 55, 56
Sitora (P. Ramlee, 1964), 230
Skeat, Walter, 2, 7, 79–80, 142, 206–7, 212
Skrbiš, Zlatko, 125
Smith, Angela, 24–25, 93
Soon, Simon, 207, 221–22

INDEX ❦ 289

Southeast Asia: animism, 143, 201, 205, 229, 233; colonialism, 8–9, 29, 221; environmental destruction, 193–94, 233–34; films of, 29–30; *hantu* beliefs, 22, 30; horror films, 8, 27; jungles, 234; modernities, 124, 143; multiethnicities, 124; pontianak films, 158; pontianaks, 5, 23, 27–28, 37, 81, 95, 108, 111; postcolonialism, 123, 157–58; religion, 143, 147. *See also individual countries*

Spivak, Gayatri, 21, 186

Sri Menanti/Moon Over Malaya (Majumdar, 1958), 215

S. Roomai Noor, 51–52, 57, 58

"State of Motion: A Fear of Monsters" (exhibition), 20

Stivens, Maila, 99, 184

Stoker, Bram, 6–7, 8. *See also* vampires

Straits Times, 9, 52, 55, 230

Strayer, Kristen, 27

studios. *See individual studios*

Sudarmadji, S., 49

Sultan Idris Training College, 76

Sumpah Pontianak/Curse of the Pontianak (Rao, 1958): animism, 229; Cathay Classic Film Festival, 13–14; Cathay Keris studios, 2–3; identities, 65–66; jungles, 216; *kampung* (rural Malay village), 71, 162, 166, 167–68, 169, 186; maternities, 96, 186; modernities, 78; nail mythologies, 92; patriarchies, 84; pontianaks, 4; queerness, 112; theater influence, 44; transnationalism, 52

Suraya, 47, *48*

Suspiria (Guadagnino, 2018), 12

Syed Husin Ali (Syed Hussein bin Ali), 207–8

Syed Hussein Alatas, 127

Syed Muhd Khairudin Aljunied, 124

Tan, Bee Thiam, 20

Tan, Kenneth Paul, 32–33, 81, 94, 130

Tan, Sandi, 19

TanahAirKu (Yee, 2018) (art), 222

Tan Sooi Beng, 43–44, 173

television, 13–15. *See also individual television titles*

Teo, Sharlene, 19

Teo, Stephen, 26–27, 94

Terowongan Casablanca/Casablanca Tunnel (Nanang, 2007), 86–87

Terpaku Pontianak (Emi Suffian/TV9, 2014), 28

Thompson, Kristin, 129

Toh Hun Ping, 166

Tolentino, Rolando, 46

Tolong! Awek Aku Pontianak/Help! My Girlfriend Is a Pontianak (J. Lee, 2011), 26, 92, 131–35, 140, 156

traditionalism, 5, 67–68, 69, 159–60, 164–65, 169, 176–79

transgender representation, 112–18

transnationalism, 41–52; Cathay Keris studios, 51; colonialism, 41–52; horror films, 12, 26–27; Malay culture, 32, 46, 48, 51; Malaysia, 62, 207; Maria, 53–54; pontianak films, 5, 8, 45, 46, 49, 52, 131; pontianaks, 5, 29, 45, 131; Shaw Brothers, 42, 44–46, 51, 52; Singapore, 41–42, 46; Singapore studios, 34–35. *See also* multiethnicities

Tsing, Anna Lowenhaupt, 28–29, 193

Tun Fatimah (Salleh, 1962), 54–55

2 or 3 Tigers (Ho, 2015) (video), 231–32

Tylor, Edward, 197–98, 257n1

Uhde, Jan and Yvonne Ng, 44, 74–75

Uhlin, Greg, 227

United Malays National Organisation (UMNO), 125, 145–48, 167

Universal Studios Singapore, 16–17

vampires, 5–11; colonialism, 8–9, 21–22, 29, 178–79; Endicott, 2; *hantu* beliefs, 5, 7–8; heritage and horror films, 163–64; Malaya, 6; Malay culture, 26; nail mythologies, 91; pontianak films, 5–6, 7, 8, 26, 132, 153; pontianaks, 8, 130–31; Western culture, 6–9, 26. *See also penanggalan* (birth vampires); pontianaks

Vandergeest, Peter, 191, 234

vegetal films, 227–28

Vieira, Patrícia, 233

Vinegar Baths (Fu, 2018), 12–13, 101

Virgin of Borneo (Krishnan, 1958), 51

Viveiros de Castro, Eduardo, 201–2, 227

Wada-Marciano, Mitsuyo, 27

Wade, Geoffrey, 127

Waller, Marguerite, 21, 34

War of the Worlds, The (Wells), 8

Weaver-Hightower, Rebecca, 37–38

Wells, Paul, 24

were-tigers, 11, 101, 203, 229, 230–32

Western culture: animism, 197–98, 201–5; ASAS 50 (Angkatan Sasterawan 50), 58–59; environmental destruction, 191; ethnonationalism, 61; film theories and studies, 24–26; *hantu* beliefs, 199; horror films, 24–27; landscape images, 224; Malay culture, 59–61, 99, 206–7; modernities, 60–61, 143; *Penulis* (journal), 59–61; pontianak films, 9, 77–78, 81; pontianaks, 6, 16; pontianak short stories, 18–19; race, 124, 127; Singapore, 140; vampires, 6–9, 26; world cinema, 24–26. *See also* colonialism; decolonization
White, Luise, 21
White, Timothy, 39–40, 44
whiteness, 35, 127, 128. *See also* race
Wicke, Birka, 193–94
Wicker Man, The (Hardy, 1973), 163
Wilkinson, R. J., 2, 207
Williams, Raymond, 166, 203–4
Winstedt, Richard O., 2, 68, 206–7

women's roles, 59, 83–84, 98–100, 109–10, 159
Wong Kar-wai, 179
Wong Tuck Cheong, 44, 49, 63, 148
world cinema, 8, 24–29, 34–35, 42, 123, 164, 200, 206. *See also individual countries' films*

Yap, Gavin, 12, 112–13, 165, 176, 180
Yasmin Ahmad, 157
Yee I-Lann, 19, 101, 107–9, 222–24
Yeo, Nicolette, 5–6, 96
Yeux sans visage, Les/Eyes Without a Face (Franju, 1960), 12
Young, Damon, 205
Yusoff, Norman, 102, 176

Zainah Anwar, 145, 147, 154
Zainal Kling, 234
Zakaria Ali, 221–22
Zarina Muhammad, 223–24, 234
Zubir Said, 32
Zwemer, Samuel, 208, 213

FILM AND CULTURE

A series of Columbia University Press

Edited by John Belton

What Made Pistachio Nuts? Early Sound Comedy and the Vaudeville Aesthetic, Henry Jenkins

Showstoppers: Busby Berkeley and the Tradition of Spectacle, Martin Rubin

Projections of War: Hollywood, American Culture, and World War II, Thomas Doherty

Laughing Screaming: Modern Hollywood Horror and Comedy, William Paul

Laughing Hysterically: American Screen Comedy of the 1950s, Ed Sikov

Primitive Passions: Visuality, Sexuality, Ethnography, and Contemporary Chinese Cinema, Rey Chow

The Cinema of Max Ophuls: Magisterial Vision and the Figure of Woman, Susan M. White

Black Women as Cultural Readers, Jacqueline Bobo

Picturing Japaneseness: Monumental Style, National Identity, Japanese Film, Darrell William Davis

Attack of the Leading Ladies: Gender, Sexuality, and Spectatorship in Classic Horror Cinema, Rhona J. Berenstein

This Mad Masquerade: Stardom and Masculinity in the Jazz Age, Gaylyn Studlar

Sexual Politics and Narrative Film: Hollywood and Beyond, Robin Wood

The Sounds of Commerce: Marketing Popular Film Music, Jeff Smith

Orson Welles, Shakespeare, and Popular Culture, Michael Anderegg

Pre-Code Hollywood: Sex, Immorality, and Insurrection in American Cinema, 1930–1934, Thomas Doherty

Sound Technology and the American Cinema: Perception, Representation, Modernity, James Lastra

Melodrama and Modernity: Early Sensational Cinema and Its Contexts, Ben Singer

Wondrous Difference: Cinema, Anthropology, and Turn-of-the-Century Visual Culture, Alison Griffiths

Hearst Over Hollywood: Power, Passion, and Propaganda in the Movies, Louis Pizzitola

Masculine Interests: Homoerotics in Hollywood Film, Robert Lang

Special Effects: Still in Search of Wonder, Michele Pierson

Designing Women: Cinema, Art Deco, and the Female Form, Lucy Fischer

Cold War, Cool Medium: Television, McCarthyism, and American Culture, Thomas Doherty

Katharine Hepburn: Star as Feminist, Andrew Britton

Silent Film Sound, Rick Altman

Home in Hollywood: The Imaginary Geography of Cinema, Elisabeth Bronfen

Hollywood and the Culture Elite: How the Movies Became American, Peter Decherney

Taiwan Film Directors: A Treasure Island, Emilie Yueh-yu Yeh and Darrell William Davis

Shocking Representation: Historical Trauma, National Cinema, and the Modern Horror Film, Adam Lowenstein

China on Screen: Cinema and Nation, Chris Berry and Mary Farquhar

The New European Cinema: Redrawing the Map, Rosalind Galt

George Gallup in Hollywood, Susan Ohmer

Electric Sounds: Technological Change and the Rise of Corporate Mass Media, Steve J. Wurtzler

The Impossible David Lynch, Todd McGowan

Sentimental Fabulations, Contemporary Chinese Films: Attachment in the Age of Global Visibility, Rey Chow

Hitchcock's Romantic Irony, Richard Allen

Intelligence Work: The Politics of American Documentary, Jonathan Kahana,

Eye of the Century: Film, Experience, Modernity, Francesco Casetti

Shivers Down Your Spine: Cinema, Museums, and the Immersive View, Alison Griffiths

Weimar Cinema: An Essential Guide to Classic Films of the Era, Edited by Noah Isenberg

African Film and Literature: Adapting Violence to the Screen, Lindiwe Dovey

Film, A Sound Art, Michel Chion

Film Studies: An Introduction, Ed Sikov

Hollywood Lighting from the Silent Era to Film Noir, Patrick Keating

Levinas and the Cinema of Redemption: Time, Ethics, and the Feminine, Sam B. Girgus

Counter-Archive: Film, the Everyday, and Albert Kahn's Archives de la Planète, Paula Amad

Indie: An American Film Culture, Michael Z. Newman

Pretty: Film and the Decorative Image, Rosalind Galt

Film and Stereotype: A Challenge for Cinema and Theory, Jörg Schweinitz

Chinese Women's Cinema: Transnational Contexts, Edited by Lingzhen Wang

Hideous Progeny: Disability, Eugenics, and Classic Horror Cinema, Angela M. Smith

Hollywood's Copyright Wars: From Edison to the Internet, Peter Decherney

Electric Dreamland: Amusement Parks, Movies, and American Modernity, Lauren Rabinovitz

Where Film Meets Philosophy: Godard, Resnais, and Experiments in Cinematic Thinking, Hunter Vaughan

The Utopia of Film: Cinema and Its Futures in Godard, Kluge, and Tahimik, Christopher Pavsek

Hollywood and Hitler, 1933–1939, Thomas Doherty

Cinematic Appeals: The Experience of New Movie Technologies, Ariel Rogers

Continental Strangers: German Exile Cinema, 1933–1951, Gerd Gemünden

Deathwatch: American Film, Technology, and the End of Life, C. Scott Combs

After the Silents: Hollywood Film Music in the Early Sound Era, 1926–1934, Michael Slowik

"It's the Pictures That Got Small:" Charles Brackett on Billy Wilder and Hollywood's Golden Age, Edited by Anthony Slide

Plastic Reality: Special Effects, Technology, and the Emergence of 1970s Blockbuster Aesthetics, Julie A. Turnock

Maya Deren: Incomplete Control, Sarah Keller

Dreaming of Cinema: Spectatorship, Surrealism, and the Age of Digital Media, Adam Lowenstein

Motion(less) Pictures: The Cinema of Stasis, Justin Remes

The Lumière Galaxy: Seven Key Words for the Cinema to Come, Francesco Casetti

The End of Cinema? A Medium in Crisis in the Digital Age, André Gaudreault and Philippe Marion

Studios Before the System: Architecture, Technology, and the Emergence of Cinematic Space, Brian R. Jacobson

Impersonal Enunciation, or the Place of Film, Christian Metz

When Movies Were Theater: Architecture, Exhibition, and the Evolution of American Film, William Paul

Carceral Fantasies: Cinema and Prison in Early Twentieth-Century America, Alison Griffiths

Unspeakable Histories: Film and the Experience of Catastrophe, William Guynn

Reform Cinema in Iran: Film and Political Change in the Islamic Republic, Blake Atwood

Exception Taken: How France Has Defied Hollywood's New World Order, Jonathan Buchsbaum

After Uniqueness: A History of Film and Video Art in Circulation, Erika Balsom

Words on Screen, Michel Chion

Essays on the Essay Film, Edited by Nora M. Alter and Timothy Corrigan

The Essay Film After Fact and Fiction, Nora Alter

Specters of Slapstick and Silent Film Comediennes, Maggie Hennefeld

Melodrama Unbound: Across History, Media, and National Cultures, Edited by Christine Gledhill and Linda Williams

Show Trial: Hollywood, HUAC, and the Birth of the Blacklist, Thomas Doherty

Cinema/Politics/Philosophy, Nico Baumbach

The Dynamic Frame: Camera Movement in Classical Hollywood, Patrick Keating

Hollywood's Dirtiest Secret: The Hidden Environmental Costs of the Movies, Hunter Vaughan

Chromatic Modernity: Color, Cinema, and Media of the 1920s, Sarah Street and Joshua Yumibe

Rewriting Indie Cinema: Improvisation, Psychodrama, and the Screenplay, J. J. Murphy

On the Screen: Displaying the Moving Image, 1926–1942, Ariel Rogers

Play Time: Jacques Tati and Comedic Modernism, Malcolm Turvey

Spaces Mapped and Monstrous: Digital 3D Cinema and Visual Culture, Nick Jones

Anxious Cinephilia: Pleasure and Peril at the Movies, Sarah Keller

Film Studies, 2nd Edition, Ed Sikov

Hollywood's Artists: The Directors Guild of America and the Construction of Authorship, Virginia Wright Wexman

Absence in Cinema: The Art of Showing Nothing, Justin Remes

Bombay Hustle: Making Movies in a Colonial City, Debashree Mukherjee

Music in Cinema, Michel Chion

GPSR Authorized Representative: Easy Access System Europe, Mustamäe tee 50, 10621 Tallinn, Estonia, gpsr.requests@easproject.com